the man who loved
CHINA

ALSO BY SIMON WINCHESTER

A Crack in the Edge of the World

The Meaning of Everything

Krakatoa

The Map That Changed the World

The Fracture Zone

The Professor and the Madman

The River at the Center of the World

Small World

Hong Kong: Here Be Dragons

Pacific Nightmare

Pacific Rising

Korea: A Walk Through the Land of Miracles

Outposts

Prison Diary: Argentina

Stones of Empire

Their Noble Lordships

American Heartbeat

In Holy Terror

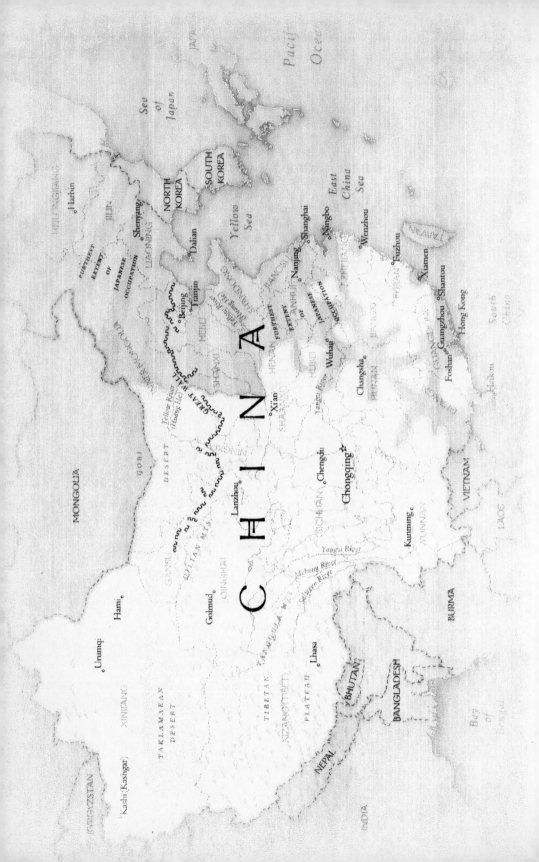

the man who loved
CHINA

The Fantastic Story of the Eccentric

Scientist Who Unlocked the Mysteries

of the Middle Kingdom

Simon Winchester

An Imprint of HarperCollinsPublishers

HarperCollins books may be purchased for educational, business, or sales promotional use. For information please write: Special Markets Department, HarperCollins Publishers Inc., 10 East 53rd Street, New York, NY 10022.

FIRST HARPERLUXE EDITION

HarperLuxe™ is a trademark of HarperCollinsPublishers

Library of Congress Cataloging-in-Publication Data is available upon request.

ISBN: 978-0-06-156276-1

08 09 10 11 12 DIX/RRD 10 9 8 7 6 5 4 3 2 1

FOR SETSUKO

Contents

Maps

Author's Note

Throughout Science and Civilisation in China Joseph Needham employed the symbols + and – to denote, respectively, dates after and before the birth of Christ, or during or before the Christian era. In this book, including all relevant direct quotations from Needham's writings, AD and BC are used instead, for convenience.

The Wade-Giles system of transliteration was in widespread use in China during the time of Joseph Needham's travels, and he applied it (together with his own somewhat eccentric modifications) in the writing of all of his books. However, this system, which gave us words and names like Peking, Mao Tse-tung, and Chungking, has now been officially and comprehensively replaced in modern China by the pinyin system, which offers transliterated forms of words that the linguistic authorities insist are closer to the actual native

pronunciation of standard Chinese—Beijing, Mao Zedong, Chongqing. To avoid confusion I have opted to use pinyin throughout the book, except in a very small number of cases when it seemed proper to be pedantically precise in offering up a contemporaneous quotation.

the man who loved
CHINA

PROLOGUE

On Flying and Aerodynamics

Someone asked the Master [Ge Hong] about the principles of mounting to dangerous heights and travelling into the vast inane. The Master said: *Some have made flying cars with wood from the inner part of a jujube tree, using ox or leather straps fastened to returning blades so as to set the machine in motion.*

—FROM THE BAO PU ZI, AD 320

From *Science and Civilisation in China,*

Volume IV, Part 2

The battered old Douglas C-47 Skytrain of the China National Aviation Corporation, its chocolate brown fuselage battle-scarred with bullet holes and dents,

shuddered its way down through the rain clouds, the pilot following the slow bends of the Yangzi River until he had the sand-spit landing field in sight in front of him and the cliffs of China's capital city to his left.

The pilot lost altitude fast in case any Japanese fighters were lurking behind the thunderheads, fixed his position by the batteries of antiaircraft guns guarding the runway approach, and lined up between the rows of red-and-white-painted oil drums that had been set down as markers. He trimmed his flaps, throttled back his two engines, grimaced as the plane lurched briefly in a sudden crosswind that was typical for this time of year, and then finally bumped heavily down onto the old riverbed that served as the nation's principal aerodrome. He braked; turned back and headed in past squadrons of parked American and Chinese fighter planes, toward the glitter of Quonset huts that served as terminal buildings; then slowed and taxied to a stop.

A lone British army sergeant was waiting beside the baggage trailer. As soon as the propellers stopped turning, and once the rear door of the aircraft was flung open and a pair of mechanics rolled the makeshift steps into place, he stepped forward to greet the aircraft's two passengers.

The first to emerge was a uniformed soldier much like himself, though an officer and very much older.

The other, the more obviously important of the pair and immediately recognizable as the VIP for whom he had been dispatched, was an unusually tall, bespectacled man, scholarly-looking and rather owlish, with a head of straight, very thick dark brown hair. He emerged blinking into the harsh sun, evidently startled by the sudden heat that for the past two weeks had enfolded the city like a steaming blanket.

Once this visitor, who was wearing a khaki shirt and baggy army fatigue shorts and was carrying what looked like a well-worn leather briefcase, had stepped down onto the soil, the driver stood to attention and saluted smartly.

"A very good afternoon to you, Dr. Needham," he called out over the clatter as the plane's cargo was being unloaded. "Welcome to Chungking. Welcome to the center of China."

It was late in the afternoon of March 21, 1943, a Sunday, and Noël Joseph Terence Montgomery Needham, a daring young scientist who was known both in his homeland—England—and in America as combining a donnish brilliance and great accomplishments as a biologist with a studied eccentricity, had arrived in this most perilous of outposts on a vital wartime mission.

He had been a long time coming. About three months earlier, he had set out on his journey, leaving

first by steam train from Cambridge, 8,000 miles away. He had then sailed east in a freighter from Tilbury, dodging Axis raiders all the while, heading out to the Orient by way of Lisbon, Malta, the Suez Canal, and Bombay, and eventually around India to the port of Calcutta. Here, late in February, he boarded an American Army Air Corps plane that ferried him high across the glaciers and peaks of the Himalayas and into the heartland of China.

Now he had arrived in its capital—or at least, the capital of the part of the country that was still free of the Japanese invaders—and he was eager to begin his work. Joseph Needham's mission was of sufficient importance to the British government to warrant his having an armed escort: the passenger with him on the aircraft was a man named Pratt, a King's Messenger who had been charged by London with making absolutely certain that Needham reached his final destination—His Britannic Majesty's embassy to the Republic of China—safe and sound.

The pair began their climb up into the city. They first walked across a rickety pontoon bridge that floated on boats anchored in the fast-flowing Yangzi. They were followed by the embassy driver and a small squad of *ban-ban* men, the well-muscled porters who had slung Needham's innumerable pieces of baggage onto

the thick bamboo poles they held yoked across their shoulders. The small group then began to clamber up the steps—nearly 500 of them, the lower few rows of massive foot-high granite setts muddy and slimy with the daily rise and fall of the river; the upper ones hot and dusty, and alive with hawkers and beggars and confidence men eager to trick any newcomers panting up from the riverside.

By the time they reached the top, and the lowermost of Chongqing's ziggurat of streets, Needham was perspiring heavily. It was well over ninety-five degrees that afternoon, and the humidity was as high as in Mississippi in July: people had warned him that Chongqing was one of the country's three "great furnaces." But he knew more or less what to expect: "The man who is selected to come to China," his letter of appointment had stated, "must be ready for anything."

The driver unlocked his jeep, and began loading Needham's gear. King's Messenger Pratt, his duty now complete, shook Needham by the hand, remarking gruffly that he hoped Needham would be happy in China, and that it had been a privilege to have escorted so remarkable a man. He saluted, and scurried off down a side street where a car was waiting for him.

Needham took a cigarette from a case in his shirt pocket, lit it, inhaled deeply, and gazed down to the

river below. The scene was mesmerizing: sailing junks, salt barges, and sampans made their way languidly across the immense stream, while armed patrol vessels and navy tenders pushed more urgently against the current, bent on more pressing business. The aircraft on which he had arrived took off with a roar, rose quickly, and turned away, diminishing into a speck above the mountains that ringed the city. Everything that he could see and hear as he leaned over the terrace—the boom of a siren from a passing cargo ship, the constant jangle of rickshaw bells in the streets beside him, the ceaseless barrage of cries and shouted arguments from within the tenements that rose about him; and then the *smells*, of incense smoke, car exhaust, hot cooking oil, a particularly acrid kind of pepper, human waste, oleander, and jasmine—all served to remind him of one awesome, overwhelming reality: that he was at last here, in the middle of the China he had dreamed of for so long.

It was all terrifyingly different from the world he already knew. Just a few months before, he had been comfortably harbored in the quiet of his life at Cambridge University, his days spent either working at his bench in his laboratory or studying in his small suite of rooms in the heart of a fourteenth-century college. The world he knew there was a place of English flower gar-

dens, new-mown lawns, ivy-covered courtyards, an ancient chapel, a library that smelled of leather and beeswax, and—rising from the city beyond its walls— the gentle sounds of the amiably disagreeing clocks chiming the hours and the quarters. It was a haven of civilized peace and academic seclusion, of privilege and exclusivity.

And now he had been transported to this ruined city, wrecked by years of war, a place still jittery and confused. He sat in the front seat of the jeep as his driver set off for the half-hour drive to the embassy. It was by now late in the afternoon; the sun was setting through the brown, smoky skies behind the hills; and lanterns were being lit in the darker streets as they passed.

On all sides were ruined or destroyed buildings—the Japanese bombers had hit Chongqing more than 200 times in the past three years. Very few buildings were whole and unscathed, and tens of thousands of people still lived in caves that were used as bomb shelters— Needham could see the entrance holes in the cliffs beside the road and, outside, their inhabitants clustered like wasps.

The narrow streets were fizzing with lanterns, jammed with stalls, and crowded with tides of human- ity, a jostling, seething mass who seemed to be occu-

pied mostly with eating, spitting, squatting, arguing, or waiting. At first it looked as though the crowds were made up of either the poor or soldiers from various armies. There were rivers of ragged peasant refugees newly in from the countryside. There were tired young soldiers wearing the uniforms of the Nationalist army, who looked as though they had just come from the front. There were platoons of cadets from the People's Liberation Army, all much more disciplined than the Nationalists and taking good care, Needham noticed, to keep themselves on the other side of the street.

Threading their way among them were legions of women, squalling infants clutched at their waists, struggling through the crowds with bags of vegetables brought up from the Yangzi-side markets. A few had enough pieces of copper cash to pay for the help of a *ban-ban* man; but most did the carrying themselves, and huddles of workless men with their bamboo poles and ropes stood useless beside them, thronged at street corners, shouting for jobs.

Once in a while there would be the ill-tempered blare of a car horn, and a large American limousine would push its way unsentimentally through the jostling mobs. The driver would be Chinese, stony-faced, and wearing dark glasses; and the passenger would invariably be a young woman, pretty, elegant, and cool in

her tight silk *qipao*, with a cigarette in a silver holder, being hurried to some assignation, perhaps, with one of the rich Chinese who lived high on the city's hills. The street mobs would be blithely unconcerned about the passage of the car, the crowds re-forming behind it like water flowing around a stone.

Needham's driver edged the jeep across a bridge jammed with military traffic, as other drivers waved genially to their colleague. Once across the river, he turned off through a grove of trees. He paused briefly at a gate where Chinese sentries carrying bayonets checked his identity and that of his passenger, then allowed the vehicle into the embassy compound. For a while the jeep wound confusingly through what looked like a park, with dozens of buildings dotted amid the woods, finally stopping at one of them. It had been reserved for Needham's use that night, said the chauffeur, and Needham was welcome to stay until he was properly settled. The servants would have prepared a light dinner for him, and would be there for anything he needed.

Before the driver left he handed Needham a substantial envelope of thick cream paper, with a British diplomatic seal embossed on its flap. It was the anticipated welcome letter from the ambassador, and it suggested a meeting in the office the following morning,

perhaps a late-afternoon cocktail to enable him to meet some interesting local people, and then, if he was agreeable, a private dinner afterward.

It was a perfect arrangement. Needham was all of a sudden very tired. The flight out had been rather ghastly—three hours of continual turbulence in a noisy plane with no oxygen and no heat, the pilot zigzagging in a series of twists, turns, and feints to put off any patrolling Japanese Zero whose pilot might be minded to attack. So the news that on this first night he would be left to his own devices came as a mighty relief. Not that he had any trepidation about the next day's program: he was a very sociable man; he liked parties and making small talk. He imagined that the ambassador could be an interesting fellow with some amusing friends; besides, there might well be some pretty young women on the embassy staff, and he would enjoy meeting them. Oh, yes, pretty women he loved.

But that could all wait for the next day. Right now he wanted simply to bathe, unpack, eat dinner alone, and sleep. Most important, he wanted to write a letter to the woman, now living in New York City, who was the main reason he had come here.

She was named Lu Gwei-djen, and she was Chinese, born thirty-nine years before in the city of Nanjing,

and a scientist like himself. They had met in Cambridge six years earlier, when she was thirty-three and he was thirty-seven and a married man. They had fallen in love, and Dorothy Needham, to whom Joseph had at the time been married for more than ten years, decided to accept the affair in a spirit of intellectually tolerant and fashionably left-wing complaisance.

In falling headlong for Gwei-djen, Joseph Needham found that he also became enraptured by her country. She had taught him her language, and he now spoke, wrote, and read it with a fair degree of fluency. She had suggested long before that he travel to China and see for himself what a truly astonishing country it was— so different, she kept insisting, from the barbaric and enigmatic empire most westerners believed it to be.

And he had taken her words to heart, so that now, on this hot spring evening in 1943, he was at the start of a diplomatic mission to China—a mission that, unknown to him, to Gwei-djen, and to all his many friends and colleagues at the time, would lead him in the most extraordinary and unexpected directions.

In years to come Joseph Needham would emerge from these travels as unarguably the foremost student of China in the entire western world, a man who undertook a series of difficult and dangerous adventures and who discovered, recorded, and then later made

sense of the deepest secrets of the Middle Kingdom, many of which had been buried for centuries.

At the time of his arrival the western world still knew very little about the place. To be sure, matters had evolved somewhat since Marco Polo's expedition in the thirteenth century, since the seventeenth-century travels of the Jesuit fathers, and even since the nineteenth century, when Americans, Britons, and an assortment of other Europeans first fanned out across China as warriors, explorers, missionaries, or traders: they all sent or brought back lurid tales of China as a land of pagodas, rice terraces, elaborate palaces, emperors enfolded in yellow silk, swirling calligraphy, disciplined order, keening music, ivory chopsticks, incense, bamboo-battened junks, the ceremonies of the kowtow and the "death of a thousand cuts," and the finest porcelain ever made. It was a place like no other on earth: vast, complex, and quietly superior; a cocoon of an empire that seemed to command among its neighbors—Japan, Korea, the various monarchies of Indochina—respect, fear, and amazement in equal measure.

By the time Needham arrived, this view had changed, reflecting the melancholy new reality of China itself. In 1911, with the suddenness of the gallows, the ancient Chinese empire had fallen and its ce-

lestial court had been consigned to ignominy. The country that was then beginning its long struggle to emerge from thousands of years of imperial rule was in a terrible state. It was shattered by the bitter rivalries of a dozen regional fiefdoms; it was seething with the conflicting ambitions of newly imported ideologies; greedy foreign powers were gnawing away at its major cities and at its outer edges. The culminating humiliation was the Japanese invasion, begun formally in 1937, which by the time Needham arrived had resulted in the military occupation of one-third of the country.

"This booby nation," the American poet Ralph Waldo Emerson had complained in 1824. He was well ahead of his time. Most of his generation saw China as an exotic Oriental enigma, pushed well beyond the mainstream of global culture, an irrelevant place that could offer to the outside world little more than silk, porcelain, tea, and rhubarb, and all wrapped in a coverlet of unfathomable mystery.

Some few took a longer view. John Hay, America's secretary of state at the turn of the twentieth century, remarked in 1899 that China was now the "storm center of the world," and that whoever took the time and trouble to understand "this mighty empire" would have "a key to politics for the next five centuries." But his was a view drowned out by the onrush of events—

not the least of them being the dramatic collapse of the empire itself. By the 1920s, when Chinese warlords were battling furiously with one another, when millions were dying in an endless succession of civil wars and millions were suffering from poverty of a kind that was hard to imagine elsewhere, the country was widely regarded by most outsiders with a mixture of disdain, contempt, and utter exasperation; and the more simplistic views, like Emerson's, were now widely held.

But Joseph Needham would alter this perception of China, almost overnight and almost single-handedly. Through his many adventures across the country this quite remarkable man would manage to shine the brightest of lights on a vast panorama of Chinese enigmas—and in doing so he would discover, like no other outsider before or since, that the Chinese, far from existing beyond the mainstream of human civilization, had in fact created much of it.

He found that over the aeons the Chinese had amassed a range of civilizing achievements that the outsiders who were to be their ultimate beneficiaries had never even vaguely imagined. The three inventions that Francis Bacon once famously said had most profoundly changed the world—gunpowder, printing, and the compass—Needham found had all been invented and first employed by the Chinese. And so, he discov-

ered, were scores of other, more prosaic things—blast furnaces, arched bridges, crossbows, vaccination against smallpox, the game of chess, toilet paper, seismoscopes, wheelbarrows, stirrups, powered flight.

The achievements turned out to be of such a scale—of such depth, range, and antiquity—as to mark off from everywhere else the country which first made them. They spoke of centuries of intellectual ferment that, though precious few were aware of them, had gone on to change the face of the entire world. They had also, moreover, created the very special circumstances—icy self-assurance, isolation, a sustained attitude of hauteur—that had made China seem so separate from all others. They had created the anthropological architecture that, in short, had made China *China*.

By making these discoveries, Needham slowly and steadily managed to replace the dismissive ignorance with which China had long been viewed—to amend it first to a widespread sympathetic understanding and then, as time went on, to have most of the western world view China as the wiser western nations do today, with a sense of respect, amazement, and awe. And awe, as fate would have it, was in time directed at him as well.

For Joseph Needham would assemble all his findings and their significance between the covers of a

book—a book so immense in scale and so magisterial in authority that it stands today alongside the greatest of the world's great encyclopedias and dictionaries as a monument to the power of human understanding.

The book, the first volume of which was published in 1954, and which had swollen to eighteen volumes by the time Needham died in 1995, continues to be produced today and now stands at twenty-four volumes, with 15,000 pages and 3 million words. It is called *Science and Civilisation in China*, and it is universally acknowledged to be the greatest work of explanation of the Middle Kingdom that has yet been created in western history. And all of it was planned and a huge proportion of it written by this bespectacled, owlish, fearless adventurer—a man who, since he was also a nudist, a wild dancer, an accordion player, and a chain-smoking churchgoer, was seen by some as decidedly *odd*, and who had first arrived at Chongqing airport aboard the battered American warplane in the spring of 1943.

But of course he knew nothing of this just now. This March evening in his embassy cottage in Chongqing he was no more than yet another bewildered newcomer, a man whose first encounter with the country had left him overwhelmed, astonished, and quite understand-

ably exhausted. He had no literary ambition on his mind—nor probably any ambition, other than getting his travel-stained self clean, fed, and well rested.

So he spent two delicious hours bathing, ridding himself of the accumulated grime of his journeying. Then he dined—and very well, since the embassy's Chinese cooks assigned to his care were highly skilled. He went out on the terrace to smoke an evening cheroot. Finally, with a whisky at hand and a cigarette freshly lit, he sat down at the writing desk, and in the impeccable hand for which he was renowned, he drafted a brief letter to Gwei-djen, addressing it to her in her tiny apartment on Haven Avenue in upper Manhattan.

His reason for writing, he told her, was first simply to say that he had arrived, that he was well, that he missed her desperately and longed for her to join him— as he knew she surely would once her research allowed. But he also wanted to thank her, and deeply, for starting him on this journey. He was at the commencement of an adventure, he felt absolutely certain, that would leave him a changed man.

He was more right than he could ever know. The extent to which China in time did change the life of Joseph Needham and the manner in which that change would affect the thinking of the entire western world lie at the heart of the story that follows.

1

THE BARBARIAN AND THE CELESTIAL

On the Worldwide Repute
of Early Chinese Bridges

Foreign admirers of Chinese bridges could be adduced from nearly every century of the Empire. Between AD 838 and 847 Ennin never found a bridge out of commission, and marvelled at the effective crossing of one of the branches of the Yellow River by a floating bridge 330 yards long, followed by a bridge of many arches, when on his way from Shandong to Chang'an. In the last decades of the 13th century Marco Polo reacted in a similar way, and speaks at length of the bridges in China, though he never mentions one in any other part of the world. . . . It is interesting that one of the

things which the early Portuguese visitors to China in the 16th century found most extraordinary about the bridges was the fact that they existed along the roads often far from any human habitation. "What is to be wondered at in China," wrote Gaspar da Cruz, the Dominican who was there is 1556, "is that there are many bridges in uninhabited places throughout the country, and these are not less well built nor less costly than those which are nigh the cities, but rather they are all costly and all well wrought."

—JOSEPH NEEDHAM, 1971

From *Science and Civilisation in China,*
Volume IV, Part 3

Joseph Needham, a man highly regarded for his ability as a builder of bridges—between science and faith, privilege and poverty, the Old World and the New, and, most famously of all, between China and the West—was obliged to make an early start in the craft, as the only child of a mother and father who were ineluctably shackled in a spectacularly disastrous Edwardian marriage.

Joseph Needham, the father, was a London doctor, a steady, unexciting, reliable sobersides. It was as a lonely widower, in 1892, that he met the young flame-

haired Irishwoman who was to become his second, and singularly ill-chosen, wife. It took him only six weeks to decide to marry Alicia Adelaide Montgomery, the daughter of the union between the town clerk of Bangor, County Down, and a French gentlewoman. It took him the better part of thirty turbulent years in the genteel London suburb of Clapham to repent.

Alicia Needham was generously described as having "an artistic temperament," which in her case meant a combination of wild, childlike exuberance and the staging of almighty tantrums, which were colored by her liking for throwing things (plates, mainly) at her husband. She was profoundly erratic, moods blowing up like storms, her torrents of tears being followed by gales of cackling laughter. She was fascinated by psychic phenomena, knew all of south London's local mediums, read tarot cards, held séances, was interested in ectoplasm, and took photographs of spirits. She spent money like a drunken sailor, her spending binges frequently bringing the family close to ruin.

It was eight years before she became pregnant. The son who in the closing days of 1900 entered this most fractious of households was to be their only child. Trouble began at the font: such was his parents' animosity toward each other that each chose to use a different Christian name for the boy: from the four he was

given at birth his mother selected Terence; his father, perhaps mindful of the time of year the child was born, instead chose to use Noël. The boy would sign letters to each with the name each preferred; but when finally left alone to choose, for both convenience and filial compromise generally used, and eventually settled on, Joseph.

His was a solitary, contemplative childhood, lived out in his fourth-floor room, where he played alone with his Meccano erector set and his building blocks and a large model railway layout, and was bathed, shampooed, and dressed by a humorless French governess shipped in direct from Paris. But it was also an intellectually stimulating upbringing. His severe and learned father, to whom he was by far the closer, saw to it that he had a solid grounding in worlds both bookish and practical. He taught the boy how to write when Joseph was little more than an infant (his mother banging hysterically on the locked door protesting that the child was far too young), leaving a lifetime legacy of the neatest handwriting, perfectly legible and elegant. He taught him woodwork, bird-watching, the geography of Europe, the taxonomy of the back garden, and an antimaterialist philosophy that would remain with him all his life: the need to "give things only a passing glance."

There was spiritual instruction, albeit of an unusually rigorous kind. The family took the clanking steam train up to the medieval Templars' church in the center of London each Sabbath day to hear the controversial mathematician and priest E. W. Barnes preach one of his so-called "gorilla sermons." Barnes, who would later become bishop of Birmingham, was at the forefront of a movement to remodel Christian doctrine in the light of scientific discovery—most notably Darwinian evolution, from which the "gorilla sermons" took their name.

He was an uncritical supporter of Darwin, denied the existence of miracles, opposed the fundamental beliefs about the sacraments, and outraged the orthodox members of the Church of England, who accused him of heresy and demanded his condemnation by Canterbury. And the schoolboy Needham listened to him enraptured. In an interview much later in life Needham explained the legacy that Barnes had left, summing it up by saying he had basically liberated religion from the "creepiness" that put off so many other people. Barnes and his modernizing zeal transformed faith, thought Needham, into the best of good sense.

Not content with keeping up the academic pressure on his son even on Sundays, the elder Joseph Needham also took the boy to France on study holidays. The

parents, ever fighting, invariably (and prudently) took separate holidays, and young Joseph, fearful of being embarassed by his high-strung mother, rarely went with her, except for a couple of times when he traveled to see a rather pretty niece who lived in Ireland. So much did he like France that he eventually spent a term at school there, at Saint-Valéry-sur-Somme, and was able to speak passable French by the time he was twelve, with some help from his gloomy governess.

It was also in France that, when he was twelve, he had his first social encounter with the working class from whom his parents had tried so sedulously to shield him. He and his father were stranded on a remote railway station platform in Picardy, in the village of Eu. The hotels were full, but a track worker cheerfully took in the pair. "I remember how he invited us in to his humble home and made us most welcome there." That men from classes shabbier than his own could be so decent came as something of an epiphany for the boy: he would reflect many years later that this small event in France played no small part in the construction of his later political sympathies.

A respect for tidiness, order, punctuality, and routine was also instilled in the boy by the fussy, kindly old doctor—but in the Needham family, unlike so many Victorian and Edwardian households, it was done af-

fectionately, not harshly. Maxims helped: "Never go upstairs empty-handed," his father used to say. "Never have three helpings of anything. Never put off until to-morrow what you can do today. More flies are caught by honey than by vinegar."

The library his father had built up at home was prodigious, and books spilled off the shelves in almost every room. Young Joseph was captivated by the collection, and consequently his reading habits were precocious in the extreme—he remarked that he was only ten when he swallowed up Friedrich Schlegel's *The Philosophy of History* in one go (learning to speak German en route).

There was one figure, a family friend, who helped nudge the young-ster toward his lifelong fascination with science. He was a diminutive, Napoléon-like Cockney anatomist who had originally been named John Sutton and was the son of an impoverished Middlesex "farmer, stock slaughterer and amateur taxi-dermist." He later adopted the surname Bland-Sutton, won a knighthood, and when he became a constant tea-time visitor to Clapham Park owned the kind of name and profession that the socially ambitious Needhams very much liked: he was now Sir John Bland-Sutton, baronet, surgeon.

The schoolboy Joseph found Bland-Sutton's tales

endlessly fascinating—how he had dissected no fewer than 12,000 animals, from fish to humans, and had investigated the anatomy of more than 800 stillborn babies. How he had developed a diet for pregnant zoo animals, had found a cure for rickets in lion cubs, and had discovered that lemurs were unusually liable to cataracts. And how his peculiar early love for teeth, jaws, and tusks was in time supplanted by a growing surgical fascination with the genitalia of women.

Bland-Sutton essentially invented the hysterectomy, though was widely criticized at the time for being a "criminal mutilator of women." He wrote two definitive books: one on ligaments, the other on tumors. He entertained on a Lucullan scale, and built a house in Mayfair that had thirty-two columns topped with bulls' heads and was modeled after the temple of Darius at Susa, in Persia. He had few close friendships other than a robust closeness with Rudyard Kipling—the pair, both top-hatted, were regulars on the London social scene.

When the boy was considered old enough—nine—Bland-Sutton let him attend a simple operation, an appendectomy, at Middlesex Hospital, and paid him a sovereign for assisting. And though Needham soon decided he would never himself make a surgeon, he worked in the operating theater as an assistant to his

father during his teenage years, handing instruments and catgut to the nurses while his father attended to the flows of ether and nitrous oxide that kept the patients asleep. Needham came to have a thorough knowledge of human anatomy as a result.

And then, in August 1914, with the German attack on Belgium came the outbreak of the Great War. Joseph Needham was swiftly sent off to Northamptonshire, 100 miles to the north, to study at one of England's oldest, costliest (he won no scholarship), and most distinguished public schools, Oundle. The education he received there was, for the time, unusual and excellent, and was due mainly to the school's still fondly remembered headmaster, F. W. Sanderson.

"Think," Sanderson would proclaim to his boys in every welcoming speech and in every valedictory address: "Think in a spacious way. Think on a grand scale." H. G. Wells was one of those in Edwardian England who heard the message and decided to send his sons to Oundle; eventually he wrote an admiring biography of Sanderson. It was an echo of the message that was then being conveyed by another Edwardian hero, Admiral Jackie Fisher of the Royal Navy, who often exhorted his audience to "think in oceans." Put aside the mean and the pettifogging, the details and the trivia, Sanderson would say: just stand back and *think big*.

. . .

While he was at Oundle, this child of two determinedly bourgeois parents first began to declare a real sympathy for the ordinary working-class man, and first began to display hints of the firmly socialist views that would eventually define his political life. His brief contact in Picardy four years before had suggested some early stirrings. Then one day in 1917 when he left school to visit a dentist in Peterborough, about thirty miles away, he opted to go by train, and delays forced him to wait for several hours. A kindly railwayman, who Needham recalled in old age was named Alfred Blincoe, took the bored youth up into his locomotive, stood him on the footplate in front of the controls, and taught him how to drive. After a few minutes of instruction, Needham remembered, "I could . . . take over the regulator and the Westinghouse brake and crack a walnut (as they say) gently between the buffers."

A passion for steam trains was born that moment— a passion for railway locomotion that would underline another of his father's axioms: "No knowledge is ever wasted or to be despised." But the hours he spent that day talking to Alfred Blincoe also spawned in Needham an enduring belief that politics based on enlightened ideology could perhaps alleviate the very obvious

trials of the laboring classes. It convinced him that he had a moral duty to become party to such ideologies as could help improve the lives of his country's workingmen.

Besides, this was 1917—a year that was most decisively marked by the events of the Russian Revolution. The teenage Needham immediately supported the Bolsheviks, and later horrified his father by marching into the family home one winter evening with a friend from Oundle, Frank Chambers, declaring that the Russian communists were "a jolly good thing," and that the dictatorship of the proletariat was the way of the future. How he came to this view intellectually puzzled him: he had never read any of the Marxists' classics, and in later years he suggested that his voracious appetite for the works of George Bernard Shaw and H. G. Wells, whom he came to know well, led him to believe in the possibility of a political utopia. Perhaps, he remarked later, his socialism was born more from an emotional response to his encounters with laboring men like Blincoe than from listening to theory or studying radical polemics.

It was also in 1917 that Needham formally acknowledged his talent and interest in science, and applied to a university with a view to studying medicine and,

like his father, becoming a physician. He was accepted quite readily in 1918, and despite being inducted into the Royal Navy Volunteer Reserve as an acting sublieutenant—the armed forces were by now critically short of medical personnel and tried to press into service anyone who knew how to tell a tibia from a fibula—he was able, by the great good fortune of the war's coming to its end in August of that year, to make it into the university in October. He chose Cambridge: it was here that his entire life would undergo a profound and utterly unimaginable change.

Cambridge University was a quiet, intense place, solemn and depleted at the end of the Great War, but brimming with brains and ambition. And perhaps in no other college was this more true than the one that had readily accepted Needham—the fourteenth-century gem known formally as Gonville and Caius, more generally referred to by its second name only, and that pronounced like the original surname of its second founder, John Keys.

Needham knew little enough of Caius when he applied. A friend at Oundle, Charles Brook, had opted for the college, and one summer afternoon, while he and Needham were idling in the long grass in the school fields, he had suggested that Needham might profit

from going there too—not least because the Master was then a doctor, Hugh Anderson, a specialist in the muscles of the eye, and Needham had thoughts of becoming a doctor himself.

His first days there were far from inspiring. Most of the rooms were still occupied by staff officers who had been billeted there during the war, their quartermasters apparently having forgotten about them. So Needham was given the only place available—a miserable ground-floor room, C-1, in what was then a most unfashionable college court, Saint Michael's, in a gloomy new annex across Trinity Street from the principal building.

As if being consigned to the college's social Siberia wasn't bad enough, in November 1918 Needham promptly came down with the flu—becoming one of perhaps 50 million victims of the infamous Spanish influenza epidemic. His college tutors took his infection with the greatest seriousness. One, W. T. Lendrum-Vesey, a somewhat mad minor Irish aristocrat who was a sportsman and classicist, very generously fed the patient grapes—but he tied them to the end of a borrowed walking stick and proffered them through the door in order to avoid approaching Needham's bed and catching his germs.

Initially Needham remained the shy and introspective young man he had been at school, given to taking

himself for long walks into the wintry countryside, pondering the great questions of science and medicine—and also, more important, the great questions relating to God. His Anglo-Catholic upbringing, half forgotten while he was at Oundle, reasserted itself in Cambridge, and he found it a comforting balm, a means of helping assuage his loneliness.

He joined a variety of societies that brought him into contact with churchly matters: he belonged to the Sanctae Trinitatis Confraternitas, for example, which organized plainsong recitals in various college chantries; and he became secretary of the Guild of Saint Luke, a body that helped to bring notable scholars to Cambridge to talk to medical students and doctors about the attractions and contradictions of humanistic scholarship. These talks impressed Needham, but not so much by their philosophical scope: he was most impressed, he recalled later, with the vast history of science they covered—with how the astonishing activity of the human mind in ages past had led to so vast an array of scientific experiment, thought, and theory.

Almost immediately on his arrival, he abandoned his schoolboy ambition of becoming a surgeon. The craft of a "sawbones," as he called it, was simply too mechanical, too nonintellectual. His first tutor, the great

food biologist Sir William Bate Hardy, insisted that he instead learn chemistry. "The future, my boy, lies in atoms and molecules," Hardy was fond of saying, and he cautioned Needham not to rein himself in by studying merely anatomy and dissection. Since Hardy was so romantic a figure—he was a deep-sea yachtsman of legendary skill and courage, a black-bearded figure with the cut of the jib of an Elizabethan admiral, and almost certainly the model for the heroic Arthur Davies in Erskine Childers's great spy novel *The Riddle of the Sands*—and since Needham found chemistry infinitely more absorbing than slicing up frogs and dissecting the knee joints of cadavers, he switched courses.

Three years later, by dint of a great deal of both work and, he insisted, prayer, he won his degree. He celebrated his success with a poem—one of a number of unfortunate pieces of doggerel he would write on the all too frequent occasions when he felt moved to do so. Some of his limericks and clerihews were mercifully brief; but his celebratory *Ode to the Chemical Laboratories of Cambridge*, perhaps not the most promising of titles, is longer. It is inconvenient to quote in full, but one stanza will suggest Needham's style, which some might describe as by Wordsworth out of McGonagall, with nods to Betjeman and Rupert Brooke, had either been writing at the time:

And so to work: distilling oils by steam
Titration, or whatever it might be
Until the hour of four o'clock shall seem
Convenient for making ourselves free
Then back in high gear straight down K Parade
In overcoat and scarf arrayed
At home, with Robinson of Christ's, to tea.

Despite now being armed with a degree, Needham was still somewhat rudderless; and since his father had just died—unexpectedly, at sixty—Needham felt he badly needed a father figure to help him decide on a career. So he turned for advice to a man whom he had met once before, at Oundle, and who was by now the unchallenged reigning monarch of the new science of biochemistry at Cambridge, Frederick Gowland Hopkins—known to all, even when in due course he was given a knighthood (for his part in the discovery of vitamins), as Hoppy.

Hopkins, who promptly asked the very willing and enthusiastic Needham to come and work with him, would provide him with both intellectual guidance and the benign paternal invigilation he needed. In addition, however, and purely fortuitously, Frederick Hopkins and his remarkable new laboratory in central Cambridge would offer Needham limitless access to one

unexpected source of good cheer that would continue to amuse him for the rest of his days—an abundance of clever young women.

"His place bristles with clever young Jews and talkative women," remarked one of Hopkins's colleagues. In those early days the department counted among its most distinguished members Muriel Wheldale and Rose Scott-Moncrieff, who both worked on plant pigments; Marjory Stephenson, who specialized in the chemistry of microbes; Barbara Hopkins (the professor's daughter), who worked on the metabolism of the brain; Antoinette Patey, whose field was the biochemistry of the eye; and three Dorothies—Dorothy Foster, whose interests lay in the inner workings of frogs; Dorothy Jordan-Lloyd, a protein chemist; and, most important, considering that she would one day become Joseph Needham's wife, Dorothy Moyle, who would become a world-famous authority on the chemistry of muscles.[1] To all of them, Joseph Needham, the clever, tall, rumpled, amusingly eccentric doctoral stu-

[1] There were many distinguished male researchers, too—among them the celebrated geneticist J. B. S. Haldane, whose line from the famous essay "On Being the Right Size" still haunts many. He was describing what happens when a variety of mammals of different sizes are dropped down a mineshaft: "A rat is killed, a man is broken, a horse splashes."

dent from a smart college and with a reasonably exotic family background, a man who was known for being a chain-smoker, a singer, and no mean dancer, became an object of immediate and studied fascination.

And as he did, the formerly shy, reserved young man began to blossom. Armed with a qualification and now occupied with a settled calling in the Biochemical Institute, Needham started to make the most of his stature and his studious good looks. As soon as he returned from a stint researching in Freiburg—during which he added a fair fluency in German to the seven other languages (including Polish) that he now spoke with comfort—he seemed to burst with a new enthusiasm and confidence. Moreover, since his father's death he now had a small annuity, with a sum of £6,500 invested in stocks. His uncle Arthur Needham was helping him look after it and draw its modest dividend income.

His academic standing began to rise. He was much liked by Hopkins, and was favored from the moment when he joined the team, in short order winning a coveted (and paid) research studentship. His position at the institute then evolved with some speed as he advanced from student to researcher to demonstrator to reader, the last post giving him a respectable salary. Before long he was able to show in both his work and his personal life the truth of an adage that was popu-

lar at Cambridge among those who admired and rather envied Hopkins's close-knit team: "All of Hoppy's geese," they said, "turn into swans."

Needham eventually acquired a little sports car— the first of a series of vehicles that prompted a keen tinkerer's interest and led to a lifelong fascination with speed and dash. In due course he bought a most remarkable vehicle, an Armstrong-Siddeley Special tourer, a bright blue six-cylinder monster machine that could thunder through the Cambridgeshire lanes at almost ninety miles per hour. This car, moreover, had quite a pedigree: it had once been owned by Malcolm Campbell, who during the 1920s and 1930s achieved worldwide fame by capturing, repeatedly, the world land speed record—and indeed managing, in a variety of cars all called BlueBird, to double it, from 150 to 300 miles per hour, in the ten years between 1925 and 1935.[2]

It was also during this time that Needham became an avid follower of what in the 1920s was called, with

[2] Needham's renowned ownership of Campbell's mighty car led to a reported encounter with Chairman Mao in the 1960s which, if it did indeed take place, was to have an enormous impact on Chinese society and, incidentally, on global warming. The details of the conversation will appear later in this book.

a somewhat necessary degree of tact, gymnosophy. He became an avid nudist.

He first embraced nudism when the newly formed and very daring English Gymnosophist Society, its membership hitherto confined to a small claque of metropolitan sophisticates, spread its influence close to Cambridge, to the little Essex town of Wickford, where a highly secretive gathering of East Anglian naturists named themselves the Moonella Group. The members gave each other nicknames, swore not to divulge to outsiders the address of the house and garden where they took their naked ease, and encouraged one another to wear nothing except colorful headbands and sandals, so long as they looked Greek.

Nudism soon became tolerated to a limited degree in the ancient universities, where most eccentric behavior was excused, just as long as it didn't frighten the horses. So like his counterparts at Oxford who flung their pink (and all too frequently flabby) bodies into the Cherwell at the site known as Parsons Pleasure, Needham knew he could not only cavort bare in the Moonellas' garden at Wickford but also swim naked in an informally reserved stretch of the river Cam, conveniently close to the college, more or less whenever he pleased. Charles Darwin's granddaughter, Gwen Raverat, remembered

from her childhood that any gentlewoman passing through this reach in a punt on a hot summer day "unfurled a parasol and, like an ostrich, buried her head in it, and gazed earnestly into the silky depths, until the crisis was past, and the river was decent again."

But Needham liked a little more privacy than this. So he would either take the branch-line steam train or cycle to the small village of Stow-cum-Quy, five miles east of the city. Here he could disrobe, and here was the nearest of the cool, limpid, almost motionless watercourses of The Fens, described by Needham quite memorably as a place that brought him bliss. The pool, he would write some twenty years later, was

> surrounded with reeds whose stems are almost white, but bear at the top their long green blades which stream unanimously out in one direction if there is a little wind. If you lie flat on the bank of the diving place and look along the pool you see a picture of the reeds in the best Chinese manner.

Though now certain of his academic heading, Needham had yet to direct the spiritual side of his life. For two years during this time of apparent flamboyance he seriously considered becoming immersed in a

fully organized religion. He went so far as to enroll as a practicing lay brother in an Anglo-Catholic monastic organization, the Oratory of the Good Shepherd; and for a while he tried to follow the strictly disciplined routines of the Oratory House.

But there was a problem: among the many strictures Needham was obliged to obey was celibacy—a vow that proved far too much for him. And so in 1923, after two full years, he left and returned to worship the deity on his own terms. In doing so—and because his bindings had now been loosed—he found himself allowed, among other things, to develop a keen personal interest in one of his young female fellow researchers in Hoppy's biochemistry lab—Dorothy Mary Moyle, five years his senior.

"Dophi" Moyle, as she was generally known—though Needham in his diaries referred to her rather more economically, using just the Greek letter delta—was born into a London family of Quakers. Her father was a senior official in the patent office. After attending a private school in Cheshire run by her aunt, she went to Girton, then still a women's college at Cambridge, and was soon summoned by Hopkins to work in his biochemical seraglio.

Her work on the chemistry of muscles—she specialized in the little-understood processes inside the cells of

an animal's muscle whenever it is made to contract[3]—was very different from Joseph Needham's research, which involved the processes inside eggs, mostly those of chickens, as they progress toward the moment of hatching. So when the pair met they did not do so for the purposes of comparing notes: their mid-morning coffee-room sessions rarely went beyond the purely social. But she overheard him often enough, and what she heard turned out to be much more intriguing.

For Needham had suddenly become exceptionally and unexpectedly boisterous. He was now recognized within the department for talking loudly and with wild enthusiasm to all who would listen about the secret mechanics of his calling—especially about the process of cell division, which he saw as a fascinating amalgam of pure science and deep philosophy. He was especially proud of one celebrated experiment that he conducted, in which he placed a morsel of boiled mouse heart into a living human embryo, and watched as it formed what he believed were the beginnings of a second human brain inside the unborn mass. This, he told his fasci-

[3] The topic intrigued Dorothy Needham for the rest of her life. Her only book, devoted entirely to muscle movement, was published when she was seventy-six. It was called *Machina Carnis*, roughly translated as *The Meat Machine*.

nated listeners, was science that delved into matters connected with the very origins of life.

Dorothy Moyle found herself quite swept away by the man. Late in the spring of 1923, he asked her out. They first took coffee and tea together in the cafés on King's Parade. Then they went bicycling, and as the friendship strengthened and the summer came and the days stretched out and warmed, they went to swim at Quy (though Dorothy shyly kept her clothes on while Joseph plunged in naked). They visited churches and railway stations. (Joseph was still fascinated with railways, and although not a train spotter, collected photographs of engine types and of stations he thought architecturally remarkable.) And during the university vacations they went away together, on trips—they were, after all, graduate students, and not subject to most college rules of decorum and celibacy.

They first went to Great Cumbrae Island in the Clyde estuary, outside Glasgow. Soon after that came more ambitious journeys, paid for by grants for the pursuit of biochemical knowledge: the following years they went together to Monterey in California, to the Woods Hole Institute on the south coast of Massachusetts, and to a French marine laboratory in Brittany. Ostensibly they went away to work on matters embryological, and specifically to check on the varying pH of the nurtured

fish eggs they found in each of these places. But in fact they spent much of their time talking about their shared interests in Christianity and socialism—and to judge from their rather saucy holiday snapshots, they had adequate time for erotic amusements, too.

In early 1924 Needham introduced Dorothy to his mother in London, and they then visited her parents in the Devon village of Babbacombe. He proposed to her in midsummer, and they married in the autumn, just before the start of the academic year, choosing Friday, September 13, as the date for the small ceremony, in a deliberate snub to convention and superstition.

Before the rites they had made it clear to each other and to their friends—though not to their parents—that theirs would be a thoroughly "modern" marriage. Whenever the need seized them they would pursue encounters with others. They would not be hobbled by the tedious, irksome, and thoroughly bourgeois demands of sexual fidelity.

If they had had a child, all this might have changed. But they were not able to conceive: Joseph's diary records encounters with Harley Street specialists concerned by his low sperm count, which may have been the reason. Still, they were philosophical about their situation. Having a child, they concluded much later, would have cramped their style—or at least his: from

almost the very moment they exchanged vows Joseph began to pursue his erotic enthusiasms with great and unstinting gusto.

Few Cambridge women of the time were left free from his attentions. Women who are now well on in years recall these attentions. They remember his wicked grin, his piercing gaze, his courtesy, his Old World charm, his offers of help and advice, and "his way of making you feel you are the most important person in the world to him—which of course at the time, you were." One now elderly woman, Blanche Chidzey, vividly remembers meeting him on a train, talking briefly to him, and then falling asleep, only to awaken when she heard him chatting quietly to a distinguished physicist who was also in the compartment. "Naturally I thought some lofty scientific topic must have gripped them—but then I listened, and it was all about me, in terms of chatting me up." But he was very polite, she added.

Of Dorothy, who was a more discreet person—a perfect saint, said one admirer, who perhaps heaped praise on her for putting up so stoically with her extraordinary husband—we are not so sure. Joseph was to hint in later years that perhaps his wife was somewhat more sedate than he. She was, he said, "not a flamboyant character, but a reasonable person, never *outrée* or unusual." Pic-

tures from the time tend to confirm this: she is small and sober, bespectacled, with her hair tight around her head, her coat plain black, her shoes sensible, her smile a little forced; he is tall and slightly comic-looking in a baggy double-breasted suit and scuffed Oxfords, with a small badge in his lapel and a cigarette between his lips, his smile puckish and distant, his mind evidently on other things, far away.

The fellows of Caius College did not give the young couple a wedding present. But in October of that year, they offered something of far greater value. Once he had presented and defended his thesis and been awarded his doctorate they elected Joseph Needham a full-fledged fellow. He now had a boundless access to the myriad of unique marvels an ancient university can provide. He had a cozy, firelit room of his own—with a nice symmetry it was K-1, the room once occupied by Sir William Hardy, who had been such an encouragement to him—as well as a library of fine books and a handsome chapel. He could come whenever he wished to the fellows' oak-paneled combination room to take a usually indifferent sherry or a rather better claret beneath paintings of forgotten divines of noble antiquity. He could bring guests whom he wished to impress or delight to the splendidly proportioned dining hall, where servants set down

excellent food at vast tables laden with old silver and porcelain.

His own combination of intellect and charm had been recognized very swiftly—he was still only twenty-four. People were beginning to say that he was on his way to becoming the Erasmus of the twentieth century, so sharp was his mind, so broad his intellectual reach. But however he compared with the great scholars of the past, one thing was certain: he was now settled, and for life. Academically at least, he was made.

His achievements as a scientist, and as a figure with extraordinarily well-rounded interests, were now being noticed well beyond Cambridge. By 1925 he had already edited his first book, a collection of essays by some of the great scholars he had encountered while organizing lectures for the Guild of Saint Luke. All of them Joseph Needham knew personally while he was still a young man: he was a consummate networker, and his social abilities were a further key to his later success.

Six years later he produced another book, *Chemical Embryology*, this time not an edited collection of other men's works, but a history of embryology entirely written by himself. He was just thirty-one when its three volumes were published by Cambridge Univer-

sity Press; and though the subject was esoteric and the sales were accordingly minuscule, the sheer scale of the work—and his obvious ability to think big thoughts—hinted at what was to come in Needham's later life.

Needham suffered something of a breakdown after completing the work, and for two weeks after handing in the typescript found it impossible to sleep because of hearing what he called "incessant music" in his head. Soon, though, he turned his insomnia to his advantage: Dorothy, who liked to recount stories of her husband's formidable mental powers and his near-photographic memory, said she recalled watching him lying awake in bed, mentally visualizing the books' page proofs, and then correcting in a notebook any errors or infelicities. Once this activity became too humdrum for him, she said, he further occupied himself by translating the selfsame pages from English into French, also in his head, and then correcting any errors that he fancied he could also see in this new translated text.

And there was more than merely the pride of achievement. The publication of the three volumes made virtually certain the honor that would be bestowed on Needham a decade later: in 1941 he was elected a fellow of the Royal Society, arguably the greatest scien-

tific distinction short of a Nobel prize.[4] His writing of a scientific classic while he was still so young a man and so untutored a researcher was something that the gray-beards of the Royal Society found wholly commendable, and impossible to overlook—but that some also envied, mightily.

Now that Joseph and Dorothy were married and settled and had established their sexually liberal style of living, it was time for this deeply religious pair to find a church to accommodate them. That might not be easy: not only had its prelates to be supremely tolerant regarding marriage vows, but it had to be a church entirely comfortable with the couple's socialist leanings.

The Needhams were not easily discouraged, and in 1925 they found just what they were looking for in the Essex village of Thaxted, twenty miles from Cambridge. Here they uncovered as left-wing an Anglican prelate as it was possible to imagine: Conrad Le Despenser Roden Noel, the infamous "red vicar" of

[4] Dorothy Needham was made a fellow seven years later—giving the Needhams the great distinction of being the only husband-and-wife team to be accorded the honor, aside from the honorific appointments of Queen Victoria and Prince Albert.

the Home Counties, the man the popular newspapers dubbed England's most turbulent priest.

Noel had been vicar of Thaxted since 1910, notorious as a firebrand, and having been forced from several livings by congregations who objected to his socialism. But among the parishioners of Thaxted he was to find a wellspring of liberal sympathy, and he flung himself into his role with ferocious enthusiasm. He asked the composer Gustav Holst, who lived nearby, to play his newly composed suite *The Planets* on the church organ; he threw out all the old fusty paintings and hangings in the nave and installed new, colorful linens and cottons; he found a tame pigeon and preached with it sitting happily on his shoulder; he staged a three-part Mass each Sunday, and greatly enlarged the choir to sing in it; and to display his support for revolutionary Christianity, the majesty of England, and the rights of the Irish to be free of colonial enslavement, he ran up the Red flag, the George Cross, and the banner of Sinn Fein all at once on his church's newly refettled spire. On hearing this, High Church louts from Cambridge swarmed into the village and climbed up the stonework to try to haul down the contentious flags; but Reverend Dr. Noel imported teams of striking policemen to guard them, and there was a standoff lasting some months before a consistory

court finally ordered the vicar to remove them once and for all.

Thaxted Church thus became, almost overnight, a place of great stimulation and fun. Before long Sunday Mass at Thaxted was one of the best attended in the county. Joseph and Dorothy Needham became committed members of the congregation, remaining supporters and friends long after Noel had died in 1942, and well on into their old age.

At Thaxted, Needham also became an eager practitioner of the peculiarly English country ritual of morris dancing. Conrad Noel had first brought the old dance back to Thaxted at the urging of his wife, who felt it important to preserve rural traditions, even though this one was of pagan origin and was held to encourage fertility and the growth of crops. And Needham loved it—he loved the flamboyance and the merriment; the feeling of liberation and joy; the men dressed in loose white fustian with colored baldrics crossing over their chests and backs, bells on their ankles, and flower-ornamented hats; the handkerchiefs waved and sticks whacked against one another; the pipe and tabor played tunelessly, but hauntingly, in the background.

Morris dancing was first brought back to England from the Muslim world during the Crusades—hence *morris*, from *Moorish*—and is the oldest unchanged

dance in England. To Needham it was one of the "pure creations of the working class," part of a series of dances which "will unite by their remarkable continuity the developed communism of the future with the antique primitive communism of the past." Not for nothing did morris dancers come out and perform their ungainly and unusual dances on May Day, as they still do today: their rituals celebrate the rural workingman, and as such they were, for Needham, a demonstration that true socialism—a caring solidarity among workers—was woven deep into the warp and woof of English society.

His claims may have been extravagant, or wishful thinking. But he danced for most of his adult life, learned the accordion so he could accompany his fellow academic dancers, and played a significant role in creating a renewed enthusiasm for morris dancing which still exists in southern England today. It seems noteworthy that amid all his other work he found time to address the International Folk Dance Congress in 1935: his topic was "The Geographical Distribution of English Morris and Sword Dancing." Like so many of the fascinations in Joseph Needham's life, what had started as an innocent weekend hobby ended up as a subject for academic discussion and high seriousness. "No knowledge," his father had said, "is ever to be wasted, or ever to be despised."

. . .

Britain's nine-day general strike of 1926 finally confirmed Needham as a man of the far, far left—mainly because it did not lead to any obvious victory for the workers. In fact it allowed the Conservative government of the day to pass laws banning such sympathetic strikes, consolidating in Needham's disappointed mind a notion that had been forming since he was a schoolboy: that his sympathies lay with the workers, totally.

He was by no means a Bolshevik, as he had thought himself as a schoolboy; nor would he ever become a full-fledged member of the Communist Party. But around this time he would devour both *Das Kapital* and the German edition of Engel's *Dialectics of Nature*, and he would throw his hat in with the far left wing of the British Labour Party now and for the rest of his life. But he was a stalwart who would also be firmly wedded to his creature comforts—such as his magnificent Armstrong-Siddeley car (though he did write to the company's founder, Sir John Siddeley, asking that none of the firm's money be used to finance military research, as it was once rumored to do).

He became very much an activist—a militant, almost. He was forever writing letters to newspapers, pamphleteering, designing placards, campaigning,

marching, taking up causes. He demanded, for instance, that Britain boycott the Olympic Games of 1936 in Berlin. He complained on behalf of the National Council for Civil Liberties about heavy-handed police actions at an airfield at Duxford, where pacifists had tried to hand out leaflets during an air show, and found themselves arrested. (They "should be shot," Needham records one local as muttering to him when he went to the show to see for himself.)

His colleagues on the National Council for Civil Liberties represent a roll call of the intellectual left of the day: E. M. Forster, Clement Attlee, Nye Bevan, Havelock Ellis, Dingle Foot, Victor Gollancz, A. P. Herbert, Julian Huxley, George Lansbury, Harold Laski, David Low, Kingsley Martin, A. A. Milne, J. B. Priestley, Hannen Swaffer (a former neighbor in south London), R. H. Tawney, H. G. Wells, Rebecca West, and Amabel Williams-Ellis.[5] All of them became firm friends. He addressed the University Socialist Society, finding himself lecturing to a comrade named Kim Philby, Trinity College representative, who would later become notorious as one of Britain's most celebrated

[5] The wife of Clough Williams-Ellis, the architect best known for creating the fantasy town of Portmeirion in north Wales (where the cult television series *The Prisoner* was filmed in the 1960s).

spies. Needham joined forces with the extraordinary social anthropologist Tom Harrisson, a founder of Mass Observation.[6] He was enormously influenced by the communist crystallographer J. D. Bernal, and joined Sir Solly Zuckerman's famous scientific dining club, the Tots and Quots. He was, in other words and in all ways, a figure of the left-wing establishment, his credentials never in doubt, his subscriptions and his fealties always paid in full.

All this frantic activity led to some predictable muttering in the college. A number of the older fellows of Caius said that Needham's socialist leanings suggested a growing eccentricity, and the possibility that he was becoming unsound. *Eccentricity* was generally a backhanded compliment; but *unsound* was as pejorative as any word in the establishment's lexicon. Needham was notably thin-skinned in his youth, highly sensitive to criticism of any kind: "I shall have nothing further to do with your journal," he wrote to the editor of the *Cambridge Review*, after the publication ran an essay lambasting him for his idealism and his left-wing

[6] For twenty years, beginning in 1937, this remarkable organization tallied the ordinary details of British life, using volunteers to perform such mundane tasks as asking people what they kept in their trouser pockets, surreptitiously noting down the rituals of working-class courtship, and reading messages written on banknotes.

views, "until your influence is decisively removed from it." But later, when he was more seasoned, Needham took attacks in his stride. He would quote an old Arab aphorism: "The dogs may bark—but the caravan moves on."

Not surprisingly Needham was an instantly recruited and enthusiastic supporter of the Republican cause in the Spanish civil war, to which every left-winger in Europe became magnetically affixed from the moment it began in the summer of 1936. He never went off to fight, arguing that he had a full-time teaching job. But he campaigned, spoke out, attended rallies, organized. He lobbied hard, for instance, for the welfare of a group of Basque refugee children who were marooned in the village of Pampisford, just south of Cambridge. He helped design and test for the Republicans a plywood-and-deal field ambulance, powered by an American Harley-Davidson motorcycle engine—but it ran amok and smashed down a garden fence, for which Needham paid personally, and promptly, saying it would do the cause much harm if the bill went unsettled. And, most crucially, he also became a significant contributor to the Cornford-McLaurin fund, set up by the British Communist Party to help the families of two Cambridge members of the International Brigade—John Cornford, a twenty-one-year-old poet; and the New Zealander

Campbell McLaurin, a mathematician—both of whom had been killed in the fight for Madrid in 1936.

The year was a grisly one, in Spain and elsewhere. Although in America the Great Depression was starting to lift and a cautiously optimistic country would re-elect Franklin Roosevelt to a second term in the White House, it was the wretchedness of Europe that preoccupied the world: the Spanish war, the Berlin Olympics (which Needham wanted Britain to boycott), the Nazis' occupation of the Rhineland, the world's growing awareness of Adolf Hitler, and even the sad farce of King Edward's abdication most properly defined the year. And for the world the following twelve months would scarcely be better—Europe would suffer the first real fear that it was soon to be plunged into one almighty war; and with an outbreak of shooting on a bridge outside Beijing in 1937, China and Japan were promptly plunged into another.

Yet for Joseph Needham 1937 happened to be a very good year, and one which marked a turning point for him. The crucial moment came late one sunny summer day when he was contentedly sequestered in his laboratory. There came a soft knock at his door. He had a visitor.

. . .

In June, in the hot, teeming city of Shanghai 8,000 miles to the east of Cambridge, a young and highly capable woman was preparing to board an ocean liner, bound for England, and for a new life immersed in a brand new science.

Lu Gwei-djen, the daughter of an esteemed apothecary in Nanjing and now a budding biochemistry researcher, was clever, glamorous, and thirty-three years old when she joined the Blue Star liner headed for its long sea voyage to the port of Tilbury, outside London. She was traveling to England, and specifically to Cambridge, for one reason only: to meet and work with the biochemical couple she admired above all others—Joseph and Dorothy Needham.

From what she had read in the technical journals—not least the reviews of his stunning three-volume study of embryology—she knew well to admire Joseph Needham's scientific work. She also knew that Dorothy Needham was in her own right an expert in the same field of muscle biochemistry as Gwei-djen. So for purely scientific reasons, Cambridge was the obvious place for her to go.

But there was more to it than the quality of the sci-

ence. Politics and political sympathy also played a part in her decision. From what she had read in those imported British newspapers and political weeklies that made their way to Shanghai, Lu Gwei-djen also knew that Joseph Needham was a prominent and eager member of the political left and so was very much in step with her own political ideals. Moreover, the vast range of his interests suggested that he was something of a Renaissance man, and she knew that the press had suggested he might be regarded as a latter-day Erasmus.

She had read of his interest in the Spanish civil war, an event that had especially captured the imagination of many of the young and more radical Chinese. She herself had wanted to contribute her mite to the Cornford-McLaurin Fund. The thought that these two promising young men had braved so much, and then had lost their lives to a cause that was so clearly good, was to her intensely romantic; and those who supported the fund—as she knew Joseph Needham had—must, she felt, be thoroughly admirable.

Her plan was to pursue a field of biochemical research that was then virtually unknown in China, so impoverished and troubled were the country's universities. Though a number of other universities around the world, particularly those in America, offered her places and opportunities, she wanted most of all to

come to England. Her keenest ambition was to work at Sir Frederick Hopkins's now world-renowned Biochemistry Institute, and perhaps while there to make contact with these two scientists who had become her faraway heroes.

The merit of her own work was all too evident, and on seeing her résumé Hopkins accepted her application in a flash. Dorothy Needham, to whom the professor had then passed her letter, agreed readily to help her as an adviser, and perhaps even to become her academic supervisor.

Lu Gwei-djen had been born on July 22, 1904, into a highly regarded Christian family. The first character of her given name, 桂, was chosen to signify the sweet-smelling osmanthus tree that blooms in eastern China in July, the month of her birth; and the second, 珍, signifies treasure, a thing of great value. As an infant she was plump, active, and widely adored—but her life got off to a shaky start, thanks to the civil wars raging across eastern China, and her family was forced to evacuate to Shanghai to get away from the battles being fought around Nanjing. She did not begin her formal education until she was nine, when the situation calmed down enough for her to come home.

She had started out as a rebellious and archly nationalistic child—as a teenager she had insisted to her

friends that she would never learn English, and that those Chinese who did so were no better than "traitors and fools." But then in 1922 she won a coveted place at a newly built American-run college that would soon be famous—Nanjing's Ginling College for Girls, the "little sister in the Orient" of Smith College in Massachusetts.

Under the soothing ministrations of this liberal American education, Lu Gwei-djen began to mellow. Within no more than a few months her early anger had all dissipated. She swiftly became fascinated by English, and within a year was fluent in it. She took up the piano with gusto. She studied—"with an intense desire," she recounted later—though her early choices of mathematics, religion, English, and hygiene slowly gave way to an all-science curriculum. She began this with the study of zoology and botany, before finally developing a keen interest in biochemistry and in particular the study of the mechanics of animal muscles.

She boarded a steamer at Shanghai in the early summer of 1937. Two other young scientists accompanied her—Shen Shizhang, who after studying with Needham went on to become a professor of zoology at Yale; and Wang Yinglai, who won fame by being the first to create synthetic insulin. The crossing from the Yangzi to the Thames took two months; their ship docked in London in late August.

After a first night in a cheap hotel in London the three took the train to Cambridge and found their digs, a small flat conveniently close to the railway station. From here it was just a short walk to Tennis Court Road and the renowned Biochemistry Institute. Sir Frederick Hopkins, his seventy-six years now very much showing in his evident frailty and his snow-white mustache, was on hand to greet them; and Dorothy Needham took them to their rooms.

Lu Gwei-djen remembered very well her first meeting, later that same day, with Joseph Needham. She recalled walking down the hall to his room, then knocking gently on the wooden door. She was excited, after months of anticipation. She imagined, she later wrote, that she would now meet "an old man with a bushy white beard."

She could not have been more wrong: instead of the hare-eyed boffin she expected, there stood before her "a young dark-haired biochemist, breathless from running from place to place and clad in a plain white overall with many holes caused by the acid of bench experiments." He was handsome, in a studious way. He was very tall, muscular, rangy. He wore tortoise-shell-framed glasses, and a shock of hair kept falling over his forehead, which he brushed back with his hand from time to time. His voice was strong, but it

had a silkiness, almost a lisp, that she found instantly captivating.

"I had absolutely no idea," she wrote later, "that the presence of my colleagues and myself would have earthshaking effects on Joseph Needham, for whom I supposed we would be no more interesting than any other research students working for their doctorates, and no more. But between us and Joseph Needham a strange magnetic force developed.

"As he afterwards wrote, the more he got to know us, the more exactly like himself in scientific grasp and intellectual penetration he found us to be; and this led his inquisitive mind to wonder why therefore had modern science originated only in the western world? Much later on, after he and I had started investigating Chinese history, a second question presented itself— namely why, during the previous fourteen centuries, had China been so much more successful than Europe in acquiring knowledge of natural phenomena, and using it for human benefit? Such were the mainsprings of the *Science and Civilisation in China* project."

The "magnetic force" was directed much more particularly at Lu Gwei-djen than at the other pair, and she was being tactfully disingenuous in saying otherwise. For there was little doubt: she arrived in late August; she took a room across the corridor from

Needham; and, during the autumn and winter of 1937 and 1938 the two of them fell headlong and hopelessly in love.

Needham's diaries record it all: the suppers in town, maybe at their favorite Indian restaurant, or maybe a blowout at the Venetian, which was then the best Italian place in Cambridge; the evenings at the pictures (*The Good Earth* had just arrived, and Sidney Franklin's rendering of Pearl Buck's epic novel offered Gwei-djen a chance to wallow in homesickness and nostalgia, and to weep); the arm-in-arm walks along the snowbound Backs, or down to Grantchester along the frozen riverbank; the brief holiday in France, in Avallon.

Dorothy Needham knew full well what was happening, not least because neither Joseph nor Gwei-djen made any secret of their affection for each other. She was entirely complaisant, uncomplaining both in public and in her diaries, to herself. During that winter the three often went out together as friends and colleagues—they had much science in common to discuss, after all, and Joseph and Dorothy both enjoyed introducing their visitor from China to the engaging minutiae of Cambridge life. As winter took hold in Cambridge, the three spent much time huddled in front of the glowing coke fire in their local pub. And by all accounts, and to judge from Dorothy's private letters, she very much liked Gwei-

djen, and admired her intelligence, her determination, and her spirit.

And the liking did not appear in any way diminished when Gwei-djen finally became her husband's mistress.

It was a good six months after Joseph Needham and Lu Gwei-djen first met that matters took this more decisive turn. Most probably, this happened late one damp evening in February 1938, in K-1, his cozy little room in Caius College in the gaslit center of Cambridge. The epiphany that is most relevant to this story is more linguistic than erotic, however. It occurred as the couple lay together in his cramped single bed in that sixteenth-century room, smoking companionably.

As they lay there, quite content, all was just as normal as such circumstances permit. Perhaps there might in due course be some kind of *scandale*, but this was the 1930s, and the event had occurred in Cambridge, and the parties involved—not least Dorothy Needham, who had gone away briefly to visit her family in Devon—and the university circles in which they all moved were socially progressive and sexually tolerant.

Needham's university diary of the time makes it possible to imagine the scene in some detail: the couple's energies being spent, it appears that Needham first lit two cigarettes, as was his habit—probably of his usual

brand, Player's—and he handed one to Gwei-djen. He then turned on his pillow to face his mistress beside him. We can imagine that he smiled at her, tapped on the cigarette, and asked simply: "Would you show me just how you write the name of this—in Chinese?"

And as the diary illustrates, she did indeed show him. Under her invigilation he then wrote on his diary page (and only a little haltingly, for his always had been and always would be a most precise hand) the Chinese character for *cigarette*—two separate components, nineteen strokes of the pen, and all signifying something that he realized was infinitely more lovely in its construction than its banal equivalent Anglicism: *fragrant smoke.*

He lay back, admiring his work. It was the first time he had ever written anything in the language of these people, alien and very far away—and when he did so, a distant door suddenly started to open for him, onto an utterly unfamiliar world.

"It was very sudden," Gwei-djen remembered. "He said to me: I must learn this language—or bust!" She was to be his first teacher, he demanded, urgently. And she agreed, readily: "How could I refrain from helping him to learn it, even though it was a little like going back to the nursery to receive, and reply to, his artless Chinese letters? But little by little he gained the

knowledge he sought, and was launched on the way to understanding Chinese texts of all ages."

Years later Gwei-djen reflected on Needham's sudden but very real enthusiasm for Chinese, coming when he was at the top of his game as one of the world's leading biochemists. "He was not a professional sinologist who had gone through the mill of formal academic teaching in Chinese," she wrote. "Nor was he a conventional historian, nor had he any formal training in the history of science; he had just picked it up in the way that broadly enquiring Cambridge undergraduates were always encouraged to do, while in the course of doing something else—in his case anatomy, physiology, and chemistry."

Gwei-djen had never taught before, but she knew from friends the first essential step. In order to commingle her pupil's identity with his linguistic passion, and thus more effectively bind him to the wheel, she gave him a carefully chosen Chinese name.

Usually Chinese names have three components or three syllables, signified invariably by three characters,[7] with the single-character family name first,

[7] There was a period during the Cultural Revolution when it was officially deemed more truly proletarian and patriotic to have just a single given name. A Chinese with an abbreviated name like Chen Hong or Li Guan suggests the bearer was quite probably born during

followed by the two given names—for example, Mao Zedong, Zhou Enlai, Chiang Kai-shek. Gwei-djen saw no reason not to follow convention. She gave him the family name Li, and the given names Yue-se. The Chinese character *li*, 李, can mean *plum* but is usually a surname. Gwei-djen chose it because she felt it was similar in sound to the first syllable of his English surname, Needham. She also chose his given names for the way they sounded—*Yue-se* sounded, she thought, like *Jo-seph*. In any case, Yue-se had been the standard transliteration of Joseph since the time of the Jesuit missionaries in the 1600s.

The character *yue*, 約, indicates *appointment* or *arrangement*; the character *se*, 瑟, signifies a musical instrument resembling a zither. *Arrangement-zither Plum* would be a strange name in English; but to a Chinese, *Li Yue-se* is both sonorous and dignified, a name that could belong only to a scholar. Learning to write, read, and say it on command turned out to be Joseph Needham's Lesson One and would often be repeated in his early study of the Nanjing-inflected dialect of pure Mandarin Chinese.

He was a good student, and he set about his studies in

the late 1960s, with parents who obeyed the instructions of their local Red Guards.

a methodical but unique way. He created, entirely from scratch, a series of homemade notebooks to be his vade mecums. There were eventually dozens of them, but initially he made just three: the first was an English-Chinese dictionary, the second a Chinese grammar, the third a Chinese phrase book. Slogging along day after day, with an obsession that, as he became ever more deeply immersed in it, made him by his own account "almost delirious with happiness," he filled in these notebooks, word after word, sound after sound, character after character. The total entries became scores, then hundreds, and finally the 5,000 or 6,000 that are considered necessary for full literacy in the language.

He organized some of the books in a fairly conventional way. His dictionary, for instance, has an index that he made himself, with hundreds of English words cross-referenced either by the way they are pronounced in Chinese or by the radical with which the written Chinese symbol begins. (Some might think that the first words for which he chose to learn the Chinese are subtly illustrative: his first index for words starting with the letter *v*, for example, contains only *vagina, value, vanish, vegetable, venture, very, village, virtue, virgin, victory, viscera, voice,* and *vulgar.* An early page devoted to *a* has just the words *ability, affair, add up, age, apologies,* and *allow.*)

He also drew up a series of complex, beautifully logical tables to display the various Chinese suffixes—one page of his dictionary is devoted to those that are basically pronounced like -*ien*; another page is devoted to those ending in -*iao*; and so on. To accompany these he drew four columns alongside each entry, one for each of the four basic tones of central Chinese speech. Once this was done, all he had to do was add a first letter—*m* to produce *mien*, say; or *t* for *tien*; *m* for *miao* or *t* for *tiao*—and then write in each of the columns what each tonal variant signified in English.

His matrix would then show that *mien*, when pronounced with the first flat tone, means *abolish*; that *mien* pronounced with the second rising tone means *cotton*; and that *mien* with the falling fourth tone means *face* or *bread*. *Tien* pronounced with the first tone means *heaven* (as in Tienanmen Square—the Square of the Gate of Heavenly Peace); *tien* with the second tone means *field*, or *sweet*; and *tien* in the fourth tone means *electricity*.[8] So impeccable and comprehensive is

[8] To add a further layer of complexity: Needham wrote his dictionary using the venerable Wade-Giles system of transliterating Chinese pronounciation into English. The modern pinyin system is very different—so the sound for electricity is not *tien*, as Needham had it, but *dian*, though in the same fourth tone; and *tien*, heaven,

the organization of this particular series of books that they could be used today as teaching aids.

The organization of some of his other books, however, shows Needham at his eccentric best. He constructed a second small Chinese dictionary that dealt neatly, if very unusually, with the 214 very basic Chinese characters called radicals. These fairly simple characters—most are made up of fewer than six strokes; those in the largest group are composed of only four—are designed to show the roots of various Chinese concepts, and they are placed usually to the left of (or less frequently above, below, or to the right of) other characters, so that the combined package makes up the intended, totally new word.

Usually a Chinese dictionary arranges these radicals in order of their complexity—listing those made with one stroke first; followed by those with two strokes; then by those with three, four, five, and so on. Needham realized that with his nearly infallible photographic memory he would be better served by a dictionary that arranged the radicals by the direction and shape of the strokes—putting all radicals that had vertical strokes on one page, all those with strokes that veer to the left

becomes *tian*, as in the usual contemporary spelling of the Beijing landmark Tiananmen Square.

on another, and so on. This was a highly eccentric way to do it—and no Chinese lexicographer or textbook author has seen fit to copy Needham's model—but it evidently worked for him.

He plowed on like this throughout the spring and summer of 1938—laboring during the daytime at his biochemistry, teaching with his usual eager flamboyance, continuing to present well-received papers to the technical journals, and then, once all his official university duties were discharged, reverting to his newfound intellectual passion. Late into each night he could be seen poring over his dictionary, a pool of light the only illumination in his room, a furiously scratching pencil the only sound, strands of blue cigarette smoke coiling up into the darkness.

By the time autumn had settled on the city, Lu Gwei-djen realized that her lover was well on the way to being fluent and usefully literate. It was a formidable achievement, and the two of them were vastly proud of it. Even Dorothy Needham was sufficiently impressed to offer congratulations, though she spent most of that year and the next sunk deep in her own studies, tactfully keeping out of the way, and pretending not to mind.

But when one is thirty-eight years old, the linguistic corners of the brain are notoriously difficult to

penetrate—and at a certain level, in trying to make the leap from simple competence in Chinese to the excellence he demanded, Needham ran into difficulties. He could absorb only so much. Confusion started to trouble him.

Lu Gwei-djen was there in the front line, of course, as helpful as she could be. Soon, however, he decided to bring over to his side some heavy artillery: Gustav Haloun, a young Czech who had been recently appointed professor of Chinese at Cambridge, agreed to give him more formal help, and through 1938 and 1939 the two devised an elaborate dual system for helping Needham learn the deep complexities of the language.

Haloun, who readily recognized his student's seriousness, decided first to get Needham to help translate an entire Chinese text. It was an obscure fifth-century treatise on philosophy, the *Guan Zi*; and the task, which took Haloun and Needham four or five hours each week, and which from Haloun's point of view represented a triumph of enlightened self-interest, utterly absorbed Needham: he later said he found the hours poring over the Chinese text and turning its hundreds of ideographs into elegant English prose a time of serene intellectual bliss. Studying Chinese, he once wrote, was "a liberation, like going for a swim on a hot day, for it got you entirely out of the prison of alphabetical words,

and into the glittering crystalline world of ideographic characters."

He positively adored learning to write the language; and though he tried hard to speak it as well, the written language most engaged him. He understood its particular value in China, and he amply appreciated the notion that a sophisticated and elegant style of writing is seen by all Chinese as a firm indication of intellectual achievement and moral cultivation. And so, by 1939, when war was breaking out in Europe, he began to advance his linguistic competence—and decided to try his hand at the peaceful and contemplative art of calligraphy. Cambridge might have been solace enough, and the ancient courts of Caius College even more so; but to immerse himself in making the sinuous swirls of brushstrokes was to become lost in timeless serenity.

From small Chinese shops huddled in alleys north of Leicester Square in London he bought brushes and scores of long sheets of training paper, traditionally marked with grids in which a student would write the characters. He bought an ink block and a grinding stone, and someone sent him a pad of scarlet seal ink for stamping his name on completed documents—"Under good care it should last you for twenty years," the donor wrote. And then, in the quiet of K-1, he began to write, with Gwei-djen initially encouraging him to be confi-

dent and graceful in his strokes, to find subtlety, to develop a personal style, to keep it legible though artistic.

Even the writing of a single horizontal line—the Chinese character for the number one, — *yi*, for example—will for a good calligrapher require five or six separate movements of the brush. This was the technique which Needham had to learn, and which occupied his hours during the prewar summer of 1939.

As time went by he did become quite good—*passing fair* is perhaps the best judgment. He developed a calligraphic style that is quite recognizable and is marked by almost schoolboyish energy and enthusiasm. He never became a master calligrapher, true; but friendly Chinese masters of the craft would tell him that his work showed a passion that made the art its own reward.

And through all this process, and in retrospect perhaps inevitably, he fell in love not simply with the language, but with China itself. He described his feeling as an intense connection, one that arose from his stupefied admiration for the people who, for the last 3,000 years, had made this ancient language the basis of their cultural continuum. The language *was* China: to love the language was to love China.

So, late in the unexpectedly warm autumn of that year, 1939, when the first German planes were appearing in the English skies and war was beginning to

engulf Europe, Joseph Needham decided that he had to get across the world, and see for himself what he now firmly believed was the manifold amazement of this country.

Eventually a war would take him there—not, however, the European war, but the war in the East that had already been raging between China and Japan for the previous two years.

Technically this was an undeclared conflict, widely seen by Europeans and Americans as something of a sideshow. Since it was not a formally declared conflict both Britain and America were officially able to remain aloof, at least to a degree. But it was a war of extraordinary viciousness, one which the writer Lin Yutang would later describe as "the most terrible, the most inhuman, the most brutal, the most devastating war in all of Asia's history."

The fighting had broken out in July 1937,[9] while Lu Gwei-djen was aboard her liner, edging toward

[9] The Japanese began softening-up operations in June, dropping experimental bombs on the Shanghai docks, and in the process rudely delaying Gwei-djen's departure for London. It was only thanks to a passing British destroyer that stopped and gave her a ride down the estuary that she made it to her steamer at all: she was drenched with spray from the Zeros' attacks.

London. She first learned of it on the day she arrived, when she read the evening newspapers. Every subsequent day in Cambridge she scoured the press avidly for news from home; and as China's tragedies unfolded and expanded, she and Needham followed as best they could the twists and turns of the conflict.

For Lu Gwei-djen it was particularly heartbreaking. Through the summer and autumn of 1937 the Japanese had mercilessly advanced against China's eastern cities. Pounding attacks on Shanghai alone during the late summer, just weeks after Gwei-djen had left, resulted in the killing of more than 250,000 Chinese soldiers. One of the most famous war photographs of all time—that of a burned, crying baby sitting on railway tracks in the midst of a bombed, ruined city—brought the war into households around the world. There was a tidal wave of sympathy from a public who saw a vulnerable but determined China being pulverized and humiliated by the forces of evil from Japan.

But no foreign government took action; no one helped. The Chinese, isolated and alone, fell back, and back, and back—"the tragedy of the retreat," in the words of a Chinese officer, "being beyond description." Japanese amphibious forces landed in November and, supported by bombers from the island then called Formosa and by heavy battleships moored in the Huangpu River, they

poured inland along both banks of the Yangzi, their advance not even briefly halted by the carefully built copy of the Hindenburg Line behind which the Chinese had naively thought they might defend themselves.

City by city, eastern China collapsed entirely. The Japanese forces left behind scenes of total ruin: all the buildings smashed, thousands dead, wandering dogs feeding on piles of corpses, and the few survivors staggering through the wreckage like ghosts. Within a month, by the middle of December, Japanese troops were at the old walls of Nanjing, China's capital, which was Gwei-djen's home.

The story of the next seven weeks of savagery, of the unutterably terrible "rape of Nanking," is now as well known as any of the atrocities of the European war. For Gwei-djen, unable to communicate with her family during that winter, the situation was almost unbearable. As it happens, her family survived; but tens of thousands of others died, and often in unimaginably awful ways—gang-raped, bayoneted, set ablaze, beheaded, eviscerated—and the terrified Chinese government was compelled to leave for a new fortress stronghold in the western mountains, Chongqing.

The West still did precious little to help. In America there was great public sympathy for the plight of the Chinese, and its leaders were seen as symbolic heroes.

Chiang Kai-shek's face stared down from the cover of *Time* magazine, not least because the publisher, Henry Luce, who had been born in China of missionary parents, knew and liked him and his American-educated wife. President Roosevelt offered soothing words—his family, too, had long and intimate links with China, the Delanos having been partners in one of the greatest Chinese tea-shipping firms, and his mother having spent much of her childhood in the family mansion in Hong Kong, Rose Hill.

But the president's words were hardly matched by any actions of consequence, at least in the first four years of the war. Neutrality was the policy to which the American government was committed, and neutrality was what (certainly in September 1937, two months into the conflict) more than ninety percent of the American public demanded, no matter how sorry they felt for China. Not even the lethal Japanese bombing attack in December 1937 on the American gunboat the USS *Panay*, moored off Shanghai, caused Washington to change its mind. The Japanese said it had all been a dreadful mistake, apologized, made offers of compensation, and organized a campaign of letter-writing from Japan in which schoolgirls sent handwritten (and identically phrased) condolences to the American embassy in Tokyo. At this stage in its plans Japan wanted

no military entanglement with the Americans. Washington continued to say it was appalled by what was happening in China but could and would do nothing. It could not, and would not, become involved. The Neutrality Act did not allow it.

In Cambridge Joseph Needham was apoplectic. He was even more furious when the British government made it perfectly clear there would be absolutely no policy of sanctions against the Japanese. No matter what was happening in China in the late 1930s, Britain would stay out of the conflict.

Not even the fact that the British ambassador to China, the remarkable Sir Hughe Montgomery Knatchbull-Hugessen,[10] had been strafed in his automobile in Shanghai by a Japanese fighter plane in August

[10] Knatchbull-Hugessen is most fondly remembered for having been the victim, when later appointed British ambassador to Turkey, of the "Cicero affair," in which his Albanian valet stole the keys to the embassy safe from his cast-off trousers. Defenders claimed that the injuries he suffered in Shanghai had rendered him so careless and forgetful. The obituary writer for the *Times* felt there was a deeper problem. The ambassador's career had been a successful one, said its anonymous author, because Knatchbull-Hugessen "was fortunate in never having had to meet a situation demanding more of him than he had to offer." Moreover, "it was also a definite advantage that he had a mind which, while agile and resourceful, instinctively eschewed complexities and so saved him from the pitfalls which, especially in

1937, was severely wounded, and was sent to a hospital for a year in any way diminished the official esteem in which Tokyo was held by Whitehall. Indeed, there was a quiet hope expressed in official circles in London that Japan might be so worn down by a prolonged conflict in the vastness of China that it would be too exhausted to pursue any further imperial ambitions. Cynics and proponents of realpolitik held the view that a conflict between China and Japan was, so far as Britain's wider interests were concerned, very nearly a good thing.

So British banks were fully allowed to continue doing business with Japan, British ports officially welcomed Japanese ships, Japanese exports were on sale in British shops, and British oil helped fuel Japanese tanks and warships. In other words, business as usual.

Needham's opposition to his country's stance on the war was born of his deep commitment to socialism on the one hand (which had been powerfully reinforced by a journey he had made to Moscow two years earlier), and a lover's solidarity with his mistress on the other. At every opportunity he went to London to march, and to hand out pins with red-and-blue lapel flags printed with his own version of the seasonal mes-

dealings with clever foreigners, beset the path of the overingenious intellectual."

sage: "Help China. Don't buy Japanese toys at Christmas." He wrote letters to the newspapers, always on the Caius College letterhead, which tended to guarantee their publication. He was also a prominent backer of the famous Left Book Club, which was a powerful champion of China's cause and which (by way of its publisher and founder Victor Gollancz) put out many of the pamphlets that explained—from a leftist point of view, of course—the situation in China to its 60,000 members across the country.[11]

His older and more staid colleagues in the Senior Combination Room at Caius made it clear that they were uncomfortable with his behavior, that they feared the erratic behavior of this proto-Bolshevik in their midst. But Needham remained adamantly defiant: the situation in China was dire, and he was not about to change his mind or remain quietly at home, simply because of the dignity conferred on him by his position as a Cambridge don.

Any of the old guard at Caius who suspected he might

[11] One of the half-crown paperbacks put out by the club in 1939 was the story of the Levellers, a seventeenth-century grassroots political movement. The author was "Henry Holorenshaw"—a nom de plume, it later turned out, for Joseph Needham (who also wrote a foreword under his own name, praising "this little book of my friend, Mr. Holorenshaw.")

have been slacking had only to look at evidence show-ing that he was still working diligently at his biochem-istry. Following his three-volume book on embryology in 1930, when he was just over thirty, he now completed a second massive book on morphogenesis—the pro-cess whereby a living creature becomes endowed with its particular shape and form—in 1939, before he had reached forty. "Dorothy and I used to walk from the laboratory to join him for tea in his rooms in College," wrote Gwei-djen. "Welcoming a break, he would jump up from his desk, stoke the fire of coal and wood logs, and make tea for us, humming and singing folk songs all the while. Then he would show us the pile of pages he had written on the typewriter that day."

Acclaim for the new book was well-nigh universal—especially in America, where he toured in 1940 to give lectures at the great universities of the East Coast. A reviewer at Harvard—who of course had no way to know what was coming two decades later—declared that *Biochemistry and Morphogenesis*, as the book was called, "will go down in the annals of science as Joseph Needham's *magnum opus*, destined to take its place as one of the most truly epoch-making books in biology since Charles Darwin."

Moreover, he completed this book while he was still campaigning in England and lecturing in America

for recognition of the plight of the Chinese, and at the same time was busy teaching his students, writing his half-crown monograph (as Henry Holorenshaw) on the history of a particular branch of English socialism, regularly giving morris dance performances, swimming naked, attending meetings of the Cambridge Communist Party, offering sermons from the pulpit at Thaxted Church, and living through the manifold complications of his peculiarly organized love life.

It was perhaps merciful that late in the summer of 1939 Lu Gwei-djen left Cambridge for California, initially to attend the Sixth Pacific Science Congress. She then decided to stay on: she had an offer from Berkeley that she felt bound to accept—and Needham, in Cambridge, agreed, because he was eager to further his mistress's career and because he came to America often enough. So the affair continued, at long distance, its ardor undiminished, with just the logistics making matters a little more trying.

Through this whirlwind of activity Joseph Needham started to become famous—and famous, above all, in England during the early days of the war, for being one of China's most vigorous champions. This fame was to become central to his future, largely because of a secret meeting in a house in North Oxford one foggy November evening in 1939, when a group of wise men

decided that, if it was at all possible, Needham should go to China on a mission.

The key figure in this endeavor was a young Chinese professor of philosophy, Luo Zhongshu, who was about to leave for China after a stint teaching at Oxford. He had held a professorship at a university in the city of Chengdu, and while he was at Oxford he received regular letters and telegrams from his former colleagues there, telling him in unsparing detail just how bad the situation was for them at home.

Japan, it turned out, was engaged in a full frontal assault on China's entire education system. The Japanese military apparently had a deep-seated loathing for China's intellectual community, and this disdain was now manifesting itself in acts of brutality aimed specifically at China's universities. Colleges in the cities of Shanghai, Wuhan, Nanjing, and Guangzhou had been selected as early targets for bombings. Nankai University in Tianjin had been repeatedly bombed, and its ruins were set ablaze with kerosene. The main university in Beijing had been initially stripped by looters, and its academic buildings were converted into brothels, bars, and stables for the use of troops, while its deanery and sanitarium were made into hospitals and barracks for the Japanese defense forces based nearby.

To people in England already steeled to the plight

of China's civilians—information about the "rape of Nanking" had leaked slowly and steadily out to the West, shocking all who heard it—the news of savagery being directed at China's intellectuals was stunning. And when Luo began to make speeches to university audiences across England claiming that of the 100 colleges then operating in China, no fewer than fifty-two had been destroyed or badly damaged in the fighting, his listeners were shocked. Any tragedy that extended its reach into a country's education system was seen as particularly dire. If China's intellectual community was not to go into a terminal decline, then the West—and Britain in particular—had to help quickly.

Professor Luo eventually took this message to a gathering where he thought that shock might be more readily converted into action. It was a meeting of senior wise men from Oxford and Cambridge who assembled on November 15, 1939, in Norham Gardens at the house of the famous religious scholar H. N. Spalding, who was then Oxford's professor of eastern religion and ethics. Luo stood before the group and launched into what his listeners remembered as a vivid description of a new and tragic development: because of the Japanese attacks, entire Chinese universities were now having to take the hitherto unimagined step of fleeing, pell-mell, into the supposed safety of the Chinese hinterland.

The audience members expressed their dismay—
and then a determination that the British government
should be persuaded of its moral duty to intervene in
some way, to help the cause of China's intellectual sur-
vival. It was swiftly agreed that a team of sympathetic
Britons should be sent to China immediately, and that
they should be charged with assessing the situation
further, with finding out exactly what was needed, and
how, precisely, any official help from the British gov-
ernment might best be directed.

It took little time to decide on the ideal candidates for
such an expedition. Two names presented themselves.
The first was that of a man on their very doorstep:
the Oxford University reader in Chinese philosophy,
E. R. Hughes, who had formidable connections to the
Chinese government, had a background of a quarter
century working as a missionary deep in the Chinese
countryside, and since his return to England had de-
veloped many connections to the inner sanctums of
Whitehall.

Joseph Needham was the second man to be put
forward. He was something of a wild card, since all at
the meeting knew he had never once been to China.
But his intelligence, his exceptional linguistic abilities,
and his very vocal passion for the rights of the Chinese
people counted for much. Once his name was put for-

ward that evening, it was unanimously accepted. And so Professor Luo wrote to him that very night, asking formally if he might be interested in taking part in a mission to China that would be of vital importance for the country's future.

Naturally, when Needham received the letter a few days later both he and Lu Gwei-djen (to whom he wrote in America) were excited beyond belief. All his months of marching, carrying placards, and writing letters—and perhaps even his halting attempts at calligraphy—seemed at last to have paid off, to be on the verge of bringing results. Someone was listening. The Chinese might get the help they wanted. And he might now actually be sent off to work in the country that so captivated him.

But there was nothing definite, and much work still to do. There were many meetings and exchanges of letters that winter—sessions in Cambridge, sessions in London, the formation of committees, exchanges of telegrams ("At this time of great danger your efforts have brought us some comfort," read one, from university professors stranded in Kunming), and finally the issuing of a number of formal "statements of intent" indicating that Britain's finest universities were now bent on full cooperation with their opposite numbers in China.

Needham wrote to the Chinese ambassador. "My wife and I are desirous of going to China to help the rebuilding of scientific life. . . . I had no interest in Chinese affairs until three years ago, but now I can speak and write Nanjing Mandarin." The ambassador was warmly enthusiastic, but he warned Needham of the conditions: "Those who have gone to China," he said, "have *a pretty hard time.*"

It took eighteen months of diplomatic dithering and negotiation before Britain finally made the decision to send him. The British Council—the culturally evangelizing arm of the British Foreign Office—was the first organ of Churchill's government to become formally involved. It did so first by way of a bland statement in the summer of 1941, to the effect that "it was extending its work into the field of Chinese intellectual cooperation." Six months later, in the spring of 1942, the head of the council's science department, J. G. Crowther—a former contemporary of Needham's at Cambridge and the science columnist for the *Manchester Guardian* who had famously first reported James Chadwick's discovery of the neutron—wrote privately to Needham. He had a vital and top-secret message:

An urgent request from high quarters has arisen for an Englishman to go to China. There are great

physical difficulties in transporting anyone to Chongqing at present, [but] it should be possible to secure the necessary places in planes.

He who goes would have to be ready for anything.

It was the moment Needham had been waiting for.

And it was a moment that had come simply because a diplomatic logjam had finally been cleared. Japan had attacked Pearl Harbor early in December 1941, and America and Britain had at last declared war. There was now no longer a need for any diplomatic niceties so far as Tokyo was concerned. Help could now be offered to the Chinese formally and publicly, and without even the slightest care as to what Japan might think.

Whatever Needham might have thought privately about these months of diplomatic realities, when he read Crowther's letter—as he did a dozen times over—there was no doubt. His heart leaped. He was now going to China, for sure. He had no idea just who "in high quarters" had come up with the idea, but it now appears that the request had an unlikely origin: the great scholar Sir George Sansom, an expert on Japan. At the time, Sansom was the senior civilian representative on a little-known body, the Far East War Council, which was based in Singapore and essentially decided how

Britain should best prosecute its side of the conflict in the world east of Suez. It was probably Sansom's suggestion that Needham, a Chinese-speaking fellow of the Royal Society, and a senior figure who was intimately connected with British scientific research, should be the one to go; further, it was likely that this decision would have been approved at a higher level still—quite possibly in Downing Street, by Winston Churchill.

It had been agreed, said Crowther over a lunch in London a few days later, that by living in and visiting learned institutions all across "free China," Needham could find out exactly what was wanted by the Chinese—textbooks, laboratory equipment, reagents, visiting experts—find out where it was wanted, and have whatever could be sent, sent. "I was to do everything in my power to renew and extend the cultural bonds between the British and Chinese peoples," Needham told a London newspaper. And that, he suspected, was only half of it. For he was to go out only partly as the Royal Society's representative; more prominently, he was to go as a diplomat—the head of a new body to be called the Sino-British Scientific Cooperation Office, which Whitehall had decided was to be officially attached to the British embassy in Chongqing.

During the summer the mechanics of his journey were worked out. His rank at the embassy would be

satisfyingly senior—that of counsellor—so his Chinese counterparts would take him seriously and accord him respect as a high panjandrum, a full representative of the British crown. His salary, while not likely to make him rich, would be such that "when you return to this country after your visit your bank balance would be the same as if you had not gone out to China." Anyone wishing to make contact with him by letter should write by way of the British Council at either Hanover Street, W1; the Dupont Circle Building in Washington, D.C.; or the Reserve Bank Building, Calcutta.

He first told Dorothy, who was naturally happy, but concerned about the very apparent dangers of the trip. First, he would have to get to India by sea, either in a naval vessel on convoy duty, or more likely in a cargo ship—a risky business in itself, since the European and Mediterranean waters were crawling with Axis raiders. He had done some research that suggested it might also be possible to get to India by way of New York and either Lagos or Durban, doubtful though this sounds. But the British Council dismissed this somewhat eccentric idea, arguing that delays in all three cities could amount to months.

He would be given only forty-eight hours' notice of his journey, so he would need to have his bags packed at all times. He also had to obtain an exit permit al-

lowing him to leave Britain. It would probably be un-comfortable onboard ship, and he would be obliged to share a cabin with as many as half a dozen others. They would probably be cooped up for as long as ten weeks: because of the zigzagging routes needed during the war, this was the routine time for a voyage between the Thames and the Hooghly in 1942.

Calcutta was the preferred jumping-off point for free China—the place where Needham would get his papers and his marching orders. He would then fly into China over the infamous "Hump," a rickety and spec-tacularly unsafe air bridge that was then being orga-nized by American freelance pilots, who flew Dakotas and kindred planes over the eastern Himalayan ranges between British Indian air bases in Bengal and the en-circled free Chinese cities in Yunnan.

Once the arrangements were made he decided to go to America and tell Gwei-djen. Her initial appointment in Berkeley had been cut short, because it turned out she had a nearly fatal allergy to the Bay Area's omni-present acacia flowers. After a stint at a hospital labo-ratory in Birmingham, Alabama, she took a research position at Columbia University in New York—which is where Joseph Needham, who had been writing to her weekly during her absence, decided to meet her in the late autumn of 1942.

The exigencies of war made his date with her decidedly nontrivial. To reach her he had to take Pan American Clipper's circuitous flying-boat route—first from Poole in Dorset to Foynes in southwest Ireland; then to Lisbon in neutral Portugal; then, since the early autumn weather was poor and the Atlantic headwinds were too strong, across to the coastal town of Natal in Brazil; and only after this giant leap by way of a further long flight up to the Hudson River landing site off Manhattan.

The Clipper's manifest, which listed him by his long-unused first name, Noël, stated his affiliation as "British Foreign Office." The American ambassador in London had used this ruse in a letter he had sent to the State Department a few days before, asking that the War Department grant Needham—"a friendly enlightened liberal"—priority on a plane to China, "via Brazil, Africa and the Middle East, or by way of Australia and India." But despite Needham's apparent willingness to get to China by way of almost anywhere on the planet, the department was unsympathetic: even if he could get permission, he would have to spend weeks cooling his heels at various American military airfields. It would be far less time-consuming for him to go by ship. So his journey to America on the Pan American flying boat may have been officially sanctioned—by

the British war minister, Anthony Eden—but it turned out to have little official purpose. It was an officially sponsored journey that enabled him, first and foremost, to visit his mistress.

The pair met at the Manhattan dockside, and immediately checked into a hotel. Her apartment on Haven Avenue was too small and, after all, it had been some months since they had seen each other properly. He had already written about the government's decision in principle to send him to China: now, after his dozens of meetings in London, he could flesh out the details for her, and he could ask for advice on places to visit and people to see. It was an exceptionally happy few days for both of them. His love affair with China, and his deep affection for her, had at long last borne fruit. He was off to China, and the very distinctive and very different second half of his life was about to begin.

During those few days in New York Needham also told Lu Gwei-djen of a kernel of an idea that had suddenly come to his mind.

It was an idea that had originated some weeks earlier. Among the letters that he had exchanged with Crowther during the summer of 1942 there is a reference to an essay that Needham was then considering writing: it would be on the history of science and sci-

entific thought in China. A few days later he received invitations—probably initiated by Crowther—from both *Nature* and the BBC, asking him to write impressions of his forthcoming trip. On the letter from the BBC he scribbled a brief note to himself. It said simply: *"Sci. in general in China—why not develop?"*

"Science in general in China," he seems to be writing—*"Why did it never develop?"* In New York, he discussed the idea with Gwei-djen, and wondered out loud if he might one day turn this thought into a book that would explain to the western world just how profound and enormous was China's scientific contribution.

He could hardly have wished for a better audience than his diminutive, intense, pretty, and very intelligent young Chinese paramour. For many years she had been hammering into his head a notion first planted in her mind by her father in Nanjing—that China had made an immensely greater contribution to world science and technology than anyone in the West had ever acknowledged. According to the generally received wisdom, only a handful of the more enduring inventions had actually originated in China—and yet this belief, she and her father had said repeatedly and insistently, was nothing more than an arrogant conceit of the West. The two of them were perfectly convinced that China had invented scores upon scores of other

things of which the West was conveniently ignorant. Perhaps, she asked, Needham could just try to find out what these things were.

By the time he got home to England, the press was in a frenzy. The communist *Daily Worker* had reported exclusively that one of its own—never a paid-up party member, to be sure, but a man quite content to be known as a fellow traveler—was off to China, to give the help for which socialists had long been campaigning. Perhaps, the *Worker* said, Dr. Needham would find time to meet and befriend Mr. Mao Zedong, whose revolutionary exploits the newspaper reported as often as it could, and whose ultimate political victory in China was a consummation, in the view of the paper's editorial writers, devoutly to be wished.

The mainstream press also reported on Needham's forthcoming trip. The *Evening Standard*, in particular, which wrote more than once of how this "big and exuberant man," who, "at 42, is one of the most brilliant bio-chemists in the world," was off to show that "he was perhaps the only English scientist who can discuss Chinese philosophy in fluent Mandarin."

There were a few weeks of limbo, when Needham went back and forth between Cambridge and London,

working out further details. He found it all rather irksome. "9 a.m. War Office," reads his diary for a typical day in London. "11–1 British Council. Lunch Dorchester. 3–4 House of Commons. Cavendish Café w/Ken Turner, U.S. Embassy; 5:49 home."

He also spent time lunching or having tea with people associated in some way with China. He met, for instance, the Foreign Office librarian, Sir Stephen Gaselee, whose formidable intellect (his obituary remarks that he was renowned as "a Latinist, Coptologist, medievalist, palaeographer, liturgiologist, and hagiographer") more than matched Needham's own. The American ambassador, John Winant, had him over; David Crook, the Stalinist spy and lifelong British communist, wrote a letter of introduction to an American journalist in Chongqing, Jack Belden, who he thought could introduce Needham to the Communist leader Zhou Enlai, and through him maybe to Mao Zedong; Julian Huxley, the biologist, called to wish him luck; Arthur Waley asked to meet Needham, in London; and the Chinese ambassador, Dr. Wellington Koo, took him to lunch. Needham remarked that he could well have spent the rest of the year dining with all those in London who had any interest in the situation in China, so eager were they to spend time with him.

. . .

But then, on November 19, there came a telegram from a junior official at the Foreign Office. The ship was ready, it said, and would begin boarding in a few hours. The sea journey east should take ten weeks at the outside: Christmas would be spent somewhere in the Red Sea; the New Year would be celebrated at Bombay. In the confidence that the vessel would tie up at the Hooghly docks in early February, seats had been secured on an American military plane which was due to fly over the Hump from Calcutta, and which was due to depart in the fourth week of the month. If all went according to schedule Joseph Needham should arrive in the Yunnan capital city of Kunming on Wednesday, February 24, sometime in the afternoon. He should get his bags and leave immediately.

The next entry in his diary shows that he did as he was told—for on February 3, 1943, he was indeed in Calcutta, performing a curiously unexpected task before finally leaving for China. He was, the officials explained in justification, a British diplomat who was about to travel in a country embroiled in a war with Japan. It was imperative, they told him, that he carried a sidearm, just in case. He had therefore been officially instructed that he was obliged to get himself a gun.

And so on that hot February day this tall, bespectacled, and in appearance classically absentminded professor left his billet overlooking the Calcutta *maidan* and walked to the Fort William army depot. From the armorer there he procured a pistol, a Webley No. 1 Mark VI—the classic British service revolver of World War I, deemed still suitable for a diplomat even though the soldiers were being issued a smaller and lighter replacement. He was given eighteen rounds of .455 ammunition, and warned that, should he ever have occasion to fire the weapon, it would deliver "quite a kick." He signed it out, agreeing that it was being issued on loan, and that it must be "returned when no longer required in connection with your present work."

Now, duly armed, and in all other senses bucklered and spurred, he was fully prepared for his expedition. He waited for three pleasing weeks—for Calcutta, in late winter during the war, was a city filled with amusement and delight. Finally came the appointed day: February 24, a Wednesday. He rose at dawn, as ordered, and was driven in a British army jeep to Dum Dum airport outside the city. Here he boarded a C-47 of the Army Air Corps Ferrying Command, bound for Dinjan in Assam.

The plane rose through a morning fog, headed northeast, and after two hours of juddering, noisy flying touched down on a soggy plateau in the valley of

the Brahmaputra. A quick refueling, a change of crew, and the plane was airborne again, heading now over the great rock pile of the Himalayas, and across to the international frontier.

Needham gazed out of the aircraft windows, far too excited to sleep. Range after range of gigantic mountains, glaciers uncoiling between them, rose up before and beneath him, their sharp peaks reaching closer and closer to the plane's underbelly as the pilot tried frantically, by making enormous spirals, to reach a safe altitude. The altimeter read 17,000 feet by the time they reached the top of the ranges, and everyone aboard was cold and gasping for breath.

He tried to write a poem to celebrate, but (perhaps rather happily for his readers) there was too little oxygen in the cabin, and his mind wandered. Instead he read some Lucretius, complaining in the margins about the translation. And then the frontier was crossed, and the plane began its slow descent over the deeply incised valleys of the Salween and Mekong rivers, for Yunnan.

This was the moment he had so long anticipated. It was Wednesday afternoon, teatime, on February 24, 1943; and just now, less than a score of miles ahead of the plane, all China waited for him.

BRINGING FUEL IN SNOWY WEATHER

On Oranges

There can be no manner of doubt that the original home and habitat of these [orange] trees was on the eastern and southern slopes of the Himalayan massif; a fact which is reflected in the presence of the maximum number of old-established varieties in the Chinese culture-area, also in the extreme antiquity of the Chinese literary references. It is also betrayed by the considerable number of single written characters denoting particular species—not only *ju* for orange and *you* for pomelo, but also *gan* for certain kinds of oranges, *cheng* for sweet oranges,

luan for the sour orange and *yuan* for the citron—always a sign of ancientness in the nomenclature.

—JOSEPH NEEDHAM ON THE CHINESE ORIGIN OF ORANGES, THE FRUIT FIRST MENTIONED IN THE BOOK THE *SHU JING*, PROBABLY DATING FROM 800 BC

From *Science and Civilisation in China,*
Volume IV, Part 1

It was the China of which he had dreamed.

He stepped off the plane at Kunming's military airstrip into a crisp early spring afternoon, the air cold but the sun warm, to be met by the British vice-consul and Pratt, the King's Messenger. He was driven off to the city across a fertile plateau along roads lined with poplars and irrigation ditches and through hamlets with small cottages built of yellow mud brick, their roofs blue-tiled and with gently upturned gables and ornamental finials.

By the time he reached the ornate buildings of the consulate he was immediately and uncontrollably happy. He fancied that the consul general looked like H. G. Wells, and the architecture was instantly delightful. He was also pleased to note that a grove of bamboos had been judiciously planted outside his bedroom window; and he was particularly overjoyed when he realized that the consulate's corps of venerable retainers—"said

to be promoted coolies, solemn but nice"—actually seemed to understand his painstakingly learned spoken Chinese. The consul, Alwyn Ogden, was astonished at his ability, too, and highly impressed.

Needham spent the late afternoon unpacking, listening to the crows cawing in the consulate garden, and watching the sun inch down over the far Tibetan hills, imagining himself—as he wrote the next morning in a long letter to his old friend Margaret Mead, the anthropologist—in the Cambridgeshire village of Duxford, in the garden of the local vicarage. Throughout his subsequent life in China he would make comparisons like this, comparing obscure places in Yunnan and Hubei and Xinjiang to beloved, cozy places in the country he had left behind, or else to spots—usually in either America or France—that he especially liked. It comforted him to do so: despite his goading wanderlust he was often overwhelmed by waves of introspection and homesickness. In any case he probably suspected that the conceit added some sense of fine romance to his writings—though some of his comparisons do seem improbable: in comparing the city of Kunming to the village of Duxford he was likening a city of almost 1 million to a rural community of no more than sixty.

He recorded with fine detail his impressions of his first thirty-six hours in China, in letters to Margaret

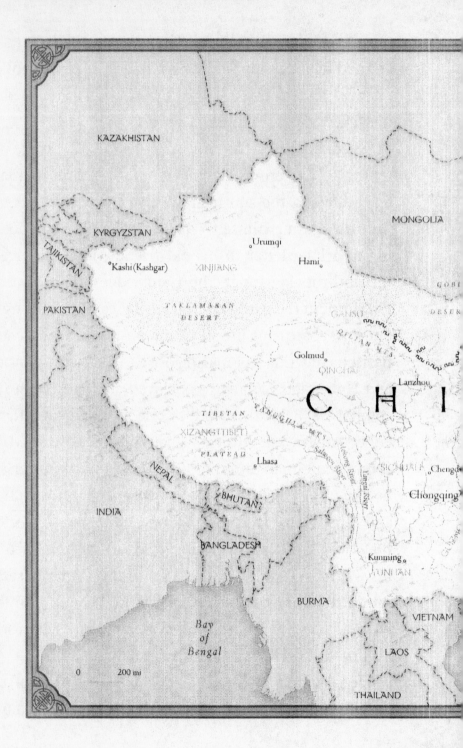

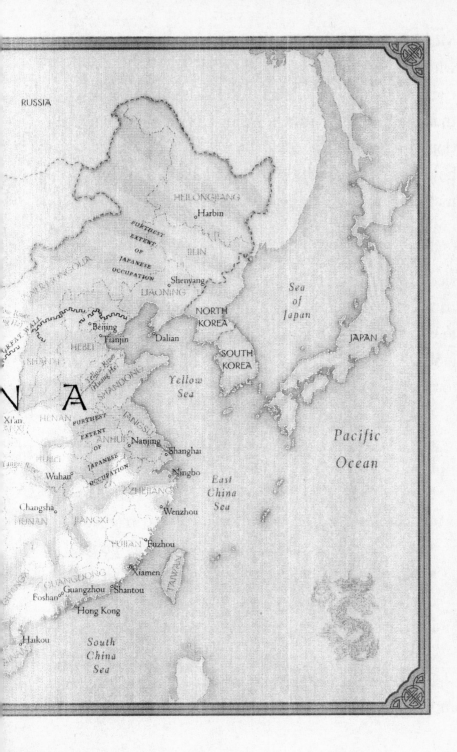

RUSSIA

HEILONGJIANG

Harbin

FURTHEST
EXTENT
OF
JAPANESE
OCCUPATION

INNER MONGOLIA

JILIN

Shenyang

LIAONING

Yellow River
(Huang He)

Beijing

Tianjin Dalian

HEBEI

SHANXI

Yellow River
Huang He

SHANDONG

NORTH
KOREA

SOUTH
KOREA

Sea
of
Japan

JAPAN

N A

Xi'an
SHAANXI

HENAN

FURTHEST
EXTENT
OF
JAPANESE
OCCUPATION

ANHUI

JIANGSU

Nanjing

Yellow
Sea

Shanghai

HUBEI

Wuhan

ZHEJIANG

Ningbo

Wenzhou

East
China
Sea

Pacific

Ocean

Changsha

HUNAN JIANGXI

FUJIAN Fuzhou

GREAT WALL

GUANGDONG

Xiamen

TAIWAN

Foshan Guangzhou Shantou

Hong Kong

Haikou

South
China
Sea

Mead and Lu Gwei-djen in America and to Dorothy—who was working in the biochemical laboratory in Cambridge. He told them all how he went for a stroll that first evening—the hills on the skyline in all directions seeming to him like the west of Scotland—and how he was charmed by the friendliness of everyone he met. People in the street smiled at him. The gardeners "in their little mongol caps" were all "amiable." The sentry at the gate of Yunnan University may have carried a rifle with a fixed bayonet, but was "pleased to pass the time of day." And he was charmed to be able to watch a circle of about 100 soldiers sitting on a lawn, looking on while a pair of them practiced kickboxing to the tune of a thin bamboo pipe:

> As I write there are many patches of blue sky. Everything seems so strangely familiar (my having thought about China for so long), yet like a dream—e.g. the old Chinese gardener in ragged blue coat and trousers with a wispy white beard who potters around smoking one of these long pipes with a tiny bowl . . . and a mongol cap, periodically performing elaborate grafting techniques on the plum trees.

He had evidently stopped to watch this old gardener, and not just because of the man's exotic appearance.

He realized that in following as closely as he could the manner in which the man was splicing, tying, and grafting the plum tree, he was actually witnessing something rather important. He was watching a performance—the carrying out of a technique, a craft, a science—that was very, very different from the performance of similar techniques he remembered at home.

Later he recalled his father working on the single apple tree that grew in the back garden of the family house in London—and if he closed his eyes he could see just what his father had done one long-ago summer day when he himself was just a child, while trying to top-graft this tree to help make it stronger and bear more fruit. The more he thought back, the more he realized that what his father had done was wholly unlike what this Chinese gardener was doing here in Kunming. Perhaps, of course, the difference was simply because the family tree had been apple, and this one was plum. But he doubted it. More probably it was because *in China they did things differently.*

A further thought struck him. Perhaps the Chinese not only did their grafting differently but may have done this different kind of grafting very much earlier than anyone in Europe had done anything like it. Perhaps this old man's technique was thousands of years old. Further still, quite possibly Needham could prove

it was thousands of years old by researching old Chinese books on botany—which of course he could now read with ease. He could hunt down any references to fruit grafting in ancient times, and then compare these accounts with published histories of gardening in the English language.

So he made a quick penciled note about the precise nature of this gardener's technique, and a reminder to check the ancient texts. This notation is historically important—it represents the very first piece of information that Joseph Needham ever recorded with the specific intent of one day putting it into the book he was thinking of writing. If this gardening technique was different, then maybe he would have discovered a vital piece of information showing that Chinese horticulture had an antiquity far greater than anyone in the West supposed.

He recalled once reading, in Cambridge, a treatise by the American missionary S. Wells Williams,[12] which roundly declared: "Botany, in the scientific sense of the word, is wholly unknown to the Chinese." Such a state-

[12] Samuel Wells Williams, a New Yorker with a lifelong fascination with the East, was the interpreter who in 1853 traveled to Japan with Admiral Perry, the American who helped bring about the end of the shogunate, the restoration of the emperor, and the beginnings of Japan's modernization.

ment, Needham was to write later, "could only have been made by one of a generation totally ignorant of the history and pre-history of science." Needham felt he needed to write his new book largely to overcome ignorance like this, and to purge the western world of prejudices against the Chinese that were based on such a wholesale lack of knowledge and understanding. Should a book ever be published, then observations like this, and the scores of others he now knew he would make—for this was only his first day in China, and he probably had chalked up one discovery already—would be sure to be included.[13]

Moreover, what Needham had achieved and planned while observing this gardener—watching his peculiarly Chinese uniqueness, noting down the details of his craft, researching the ancient Chinese literature on the subject, and then comparing these writings with similar literature from the rest of the world—was an investigatory technique he could apply with equal validity across the board. Everything he was about to see—how a Chinese farmer plowed, how a Chinese bridge was

[13] As indeed this one was. On page 107 of Needham's *Science and Civilisation in China*, Volume VI, Part I, *Botany*, there appears the first of many references to grafting techniques, starting with a description from the thirteenth century of how a Chinese gardener would make a graft on a red orange tree.

built, how iron was smelted in China, what pills a Chinese doctor handed out, which kinds of kites were to be found in a Chinese playground, what a Chinese siege cannon looked like, how a dam, a brick, a haystack, or a harness was built in China—was useful to him. He could see and note down all these things while he was performing his official tasks for the British government. There would in any case be plenty of overlap between his official duties of helping out the beleaguered Chinese universities, and his personal research. He could spend each day looking, searching, noting; he could spend each night reading; he would examine the foreign literature when he got home—and then, perhaps, there might well be enough material for a book.

And so even before he had reached his ultimate destination, Chongqing, the nation's capital, where his billet—the British embassy—was sited, he was fired up with inquisitorial energy. His experience watching the gardener persuaded him to take advantage of his few days of rest in Kunming to scour the city and its hinterland for ideas—and he discovered them in abundance, together with much that astonished him, in areas of technology that were both prosaic and abstruse. The Chinese, he kept discovering again and again, had the longest imaginable history of invention, creation, and the generation of new ideas.

He found and sketched, for instance, a bucket dredger, where coolies—his word—were winding up water from a deep ditch by hand. He ferreted out a local cytologist and discussed what he knew about British cell research. He went down local caves and found to his amazement scores of the finest measuring machines and scales squirreled away there, safe from bombings, with men in white coats patiently titrating and calibrating and weighing with Zeiss lenses and Griffin and Tatlock scales, hundreds of feet below ground. He was then even more astonished to find that Chinese scientists had a fathomless capacity for "make-do-and-mend": he noted that even in the "sylvan surroundings" of Yunnan, some students at the crystal physics laboratory were building their own radio valves, and others were making quartz crystals for receivers. Perhaps most surprising of all, technicians in one physics building were making their own microscopes and telescopes from scratch, grinding the lenses to the correctly calculated shape from blocks of raw optical glass.

On another day in Kunming he asked for and was given a history of Chinese mathematics from Dr. Hua, a man whose brilliance prompted Needham to describe him as the "Chinese Ramanujan"—until to his momentary embarrassment he discovered that Dr. Hua, like the legendary Indian scholar, had worked in Cam-

bridge alongside G. H. Hardy, Trinity's world-famous mathematics professor, and the two men knew each other well.

He visited a laboratory doing work on antimalarial and antidysentery drugs, and spent one entire lunch being talked to about "plant growth hormones, cathode ray oscillographs, egg respiration and what have you." Then that same evening he gave a talk on what he knew about the history of Chinese science, later noting with evident pleasure "the extraordinary good looks of the Chinese [that] came out remarkably as they were sitting round the fire. I like their long gowns, giving a monastic look to the scene, and they put their hands in their sleeves in a quiet way which is nice."

The very next day he decided to have a scholar's robe made for himself. The local tailors seldom had to fashion clothing for a *lao wai*, a foreigner, and they were astonished at Needham's height, which overtopped the average Chinese client by a foot at the very least. He decided on blue silk, with a black cotton lining and a lighter blue heavy silk for trim and enormous cuffs at the end of the baggy sleeves where he might hide his hands, as he had already seen Chinese merchants doing. The colors he chose denoted academia and thoughtfulness, the cutter told him.

He was fascinated by the entire two-day process—

not least by the arcane system of Chinese measurement which tailors still used (and which the older ones still use today), applying as it did such units as the *duan*, the *cun*, the *chi*, and the *zhang*. They then calculated the length of the silks required and the costs—first on a pocket abacus, and then as confirmation on a desktop machine, a venerable contraption of heavy teak spheroids and worn brass fixtures, which under the clerk's fast-flying fingers whirred like clockwork.

Needham was entranced. Here, again, was a shining example of a Chinese invention that, he imagined, probably predated any calculating engine made in the West. He sketched the machine in the tailor's shop: it was made of twelve rods, each divided by a bar into a short upper part and a longer lower one, with two flattened teak balls on each upper part, five on each lower part, and everything enclosed in a teak frame. The Chinese name for the contraption was *suan-pan*, a calculating plate; *wu zhu suan pan*, a five-ball plate. The idea, the shopkeeper added, was probably as ancient as the hills.

Just how ancient was something Needham would determine later—and by patient detective work he would discover that the abacus was not only of far greater antiquity than any calculating engine ever made in the West (Blaise Pascal is generally given the credit

for making the first, a machine devised in 1642, when he was twenty-one), but far older than had previously been assumed by scholars.

Students of Chinese science working in the West had concluded from documents—most notably a picture in a book dated at AD 1436—that the abacus was a fifteenth-century invention. Not so, Needham declared after just a little more digging: a treatise written more than 1,000 years before, in either AD 190 or AD 570, had references to a calculating phenomenon which in English was translated as "ball arithmetic." A further few days of detective work uncovered a full description, from a commentator named Chen Lun, of a device made "of a board carved with three horizontal divisions, the upper one and the lower one for suspending the travelling balls and the middle one for fixing the digit."

Within days of his arrival in Kunming, in other words, Needham was making discoveries about China that very few—whether Chinese or foreigners—had ever managed to make before. As a result, he was becoming ever more convinced. With no more than just a little inquiry he—a biochemist! an amateur!—was finding out things about China that the Chinese themselves didn't know, and that even the most revered members of the small *corps d'élite* of Chinese scholars in the West didn't know either. He was in consequence

coming to the very firm conclusion that the book about which he and Gwei-djen had spoken so many times truly deserved to be more than just a vague notion. It needed to be written, if for no other reason than to establish once and for all a just and proper reputation for China.

All this was a very long way ahead. But it was already beginning to seem as though nothing Needham would see, hear, or read over the coming years would go to waste. His late father's often-repeated saying, quoted here yet again—"No knowledge is ever wasted or to be despised"—had obviously remained with him.

And there was one other thing: if he had begun falling in love with China while he was still in Cambridge, there was no doubt about his feelings now: this brief sojourn among the western hills of Yunnan had rendered Joseph Needham entirely and hopelessly smitten.

Toward the end of March, Needham finally reached Chongqing, the Chinese capital, where his work would really begin. It was a measure of his importance to the government at home that he was escorted there by the same King's Messenger, Pratt, who had met him at the airport a month before. Members of the Corps of Messengers are usually employed to hand-carry secret documents to British embassies around the globe; only

very occasionally are they ordered to ensure the safe passage of critical personnel.

But Needham was a critical man—he had been directed there by Winston Churchill. So it was Pratt who, on March 21, came with Needham on the excessively bumpy three-hour journey; Pratt who watched nervously as the plane put down on the sandspit in the Yangzi that was the city's main wartime aerodrome; and Pratt who, after crossing the swaying pontoon bridge to shore clambered with Needham up the famous 480 granite steps, through the mobs of quarrelsome *ban-ban* men, the porters with bamboo shoulder poles eager for custom, to where the embassy motor cars were waiting. The messenger, like everyone else in the corps a former military officer, then saluted stiffly, his responsibility at an end; with the handshake from a waiting attaché, Counsellor Joseph Needham was now formally a member of the British diplomatic mission to China.

He found the embassy a welcoming sanctuary, though it was a good deal less grandiose than most other British legations he had visited around the world. There were no marble pilasters and caryatids and no gilt chandeliers here; the embassy was a ramshackle agglomeration of long, narrow buildings on a bewildering variety of levels on a steeply terraced hillside on the

right bank of the Yangzi. At the center was the reasonably imposing chancery building, with a proper porte cochere and a flagpole, and rooms at the back that led to caves carved into the mountainside, in case of an air attack. The half dozen other buildings where the lesser staff worked, and which were connected to the main embassy and to each other by a network of steep staircases running through the woods, had a cheap, temporary look, all lath and plaster and with bamboo sunshades. It was as though the Ministry of Works had built a temporary welfare payment office destined for some dreary English suburb but had set it down in China by mistake.

Visitors were dismayed by the dilapidation: plaster had fallen off several of the walls, exposing the bamboo matting beneath, and some of the buildings leaned alarmingly, especially those perched at the top of fast-eroding slopes that crumbled down to the riverbank. Moreover, the humidity for which Chongqing was notorious had wreaked havoc on the equipment inside all the offices, coating leather shoes, attaché cases, typewriter covers, and the plaster walls with a greenish mold. Happily this mold burned off once the hot weather arrived—though there was no such luxury as air-conditioning; electricity for the fans was uncertain; and comfort was all too seldom the order of the day.

The gardens of the embassy were home to some unfamiliar flowers, including some very fragrant ones that, Needham learned later that year, the local children turned into posies for men—selling them for one yuan at a time, to help mask the smell (like boiled meat, the Chinese complained of westerners) of their summertime perspiration.

The ambassador, Sir Horace Seymour, was a career diplomat of the old school, having come to China from Tehran, where he had been the British minister. Needham described him as self-effacing—in fact, "so shy that by a sort of mumbling he tries to prevent you hearing what he says." He had just struck what was perhaps the most important deal of his career: a few weeks before, on January 11, he had signed a document which formally ended all British claims on Chinese territory (except for those on Hong Kong), and which abolished all rights to the curious concept of extraterritoriality.[14] He was in consequence a mightily popular

[14] This principle had allowed the subjects of certain foreign imperial powers—Britain, France, Italy, and the United States among them—to be considered answerable only to the judicial systems of their home countries while living and working in China. British vessels operating on the Yangzi, for example, were subject not to Chinese laws but to the same laws that operated on the Thames or in the Bristol Channel. An American accused of assault in a bar in Shang-

figure locally, being seen in the capital as the man who had given back to China its long-sought birthright. He lived high on a hill overlooking the city, in a grand mansion which had been lent to the British by Chiang Kai-shek, the generalissimo. The setting was spectacular: both the Yangzi and the Jialing could be seen from the drawing-room windows; and from the dining room the magnificent mountains of Yunnan, blue and misty, could be seen in the far distance.

Needham spent his second night in Chongqing there, in an atmosphere straight out of Tunbridge Wells, with chintz sofas and curtains in old-rose cretonne, gold-edged and royal-crested Doulton china, and silver-edged portraits of King George VI and Queen Elizabeth. No Lady Seymour was present, though: she had elected to sit out the war in Wiltshire. But Needham did meet one of British diplomacy's dashing characters, the flamboyantly enigmatic explorer-cum-special agent Sir Eric Teichman, who had been at Needham's college, Caius, and had won a Blue[15] in 1903 for steeplechasing.

hai would be judged by an American court, since Chinese justice was considered peculiar and suited only to Chinese citizens.

[15] Winning a Cambridge "Blue"—for competing against Oxford in a sport—was often as important a qualification as an academic degree. George Hogg, an old China hand, wrote once of his surprise

Teichman had been invited along to describe for Needham the challenges of travel in remote corners of China. Few were better qualified. Like other Central Asian luminaries of the turn of the century, men like Aurel Stein, Sven Hedin, and Sir Francis Younghusband, Teichman was a traveler of enormous resourcefulness and courage. In 1935, despite having severe arthritis and still suffering the lingering effects of a youthful riding accident, he traveled by truck thousands of miles across the Tarim basin to the far western Chinese market town of Kashgar, then pressed on with a pony and on foot across the Pamirs and the Karakoram ranges to Gilgit, before finally reaching New Delhi. He said that this journey was his swan song as a traveler in Asia—for it was the last, the longest, and the most ambitious of his solo expeditions. He had been doing this sort of thing, disappearing on "special missions" and "fact-finding journeys" into this forbidding corner of the planet, since before the Great War.

The advice he gave that night proved invaluable, as would become clear during Needham's later epic

in learning that "a Double Blue is a necessary qualification for the best colonial posts, while two college game colours (squash rackets acceptable as one) will do for the Indian Civil Service." An Oxford Blue, awarded to sportsmen competing against Cambridge, would of course have the same value.

voyages through China. And Needham was hugely impressed—as much by Teichman's oddities as by his offer of assistance. Teichman, he wrote home, "is bent almost double, has a face reminding one of E. M. Forster, [and] comes out with a voice like a kind of harsh bell, extremely definite and clear and imitable."

The dinner over and the socializing eventually done with,[16] Needham promptly found his office, assembled such staff as he had been allotted, and got down to work. At first nearly all his tasks involved his official duties for the Sino-British Science Cooperation Office, of which he was the director, and which was housed in a tiny prefabricated building at the top of the riverbank. He enjoyed the assistance of only a driver, a part-time secretary from India, and one older man of uncertain responsibilities. The organization would grow, and mightily; but at the beginning, Needham and these three did all the work.

And the work, at least in the early days, was gruel-

[16] One of the other guests, with whom he briefly shared quarters, was the brilliant Dutch sinologist and novelist Robert van Gulik, who was stationed in Chongqing as counsellor at the Netherlands embassy. Van Gulik's main claim to fame was a series of Chinese detective novels centered on the exploits of a seventh-century magistrate, Judge Dee. Needham and van Gulik became firm friends, their relationship cemented by their vast intelligences, and a shared interest in erotica.

ing. By Easter Needham was grumbling to his diary, if reasonably amiably, about both the scale of the task ahead of him and the practical exigencies of performing it in the still besieged wartime city. While others might be taking their ease during the dawn hours on the Monday holiday after Easter, for example, Needham had not gone to bed at all: he was still up, writing in his journal—in part to get his frustrations off his chest, in part to offer up an illustration of the duties he had to perform.

On the Saturday before, he wrote, he had had an "exhausting" two-hour interview with China's minister for war, and had then had to return to his office and write letters to a variety of bodies—one being the Potteries Trade Research Association in England—as well as to several local addresses. He then rushed out to dinner with "medical people"; came back and worked until past midnight; then slept fitfully until the moment when, very early the next morning, Easter Sunday (a day not celebrated by the Chinese):

> word is brought that the secretary of the vice-director of the National Resources Commission has called, so he has to wait while I dress. Hardly have I had breakfast before I am called to a two-hour meeting with the Ambassador concerning the anti-

malaria situation, including claims by several vari-
eties of commercial crooks of various nationalities.
On return, with anxiety to get something done,
find piles of unopened letters waiting. . . .

The telephone service is very dim and the cars
also. Thus, five minutes before an important meet-
ing with some minister, I go along to the car park
with the wooden *paizi*, or token, indicating the right
to use a Chancery car, to find that Sir Eric Teich-
man or somebody has gone off with it, *paizi* or no
paizi, whereupon I return to blow up Blofeld in his
office, whereupon he flies round to the military or
air attaché's office begging for a car, but when we
get to it we find that a tyre is flat, or the driver isn't
there, or that it hasn't got any more petrol, or that
it is using power alcohol from molasses so that it
stalls on some awkward hill.

Chongqing is a city defined by its hills. It rises like
the prow of a ship, a great pyramid of jumbled rock
and humanity, at the meeting point of two of China's
mightiest rivers, the Yangzi and the Jialing. Even
though it is fully 1,500 miles from the sea, the Yangzi
is still immense here—a great gray winding-sheet of a
stream, littered with sailing junks, in places a quarter
of a mile wide, in parts boiling with currents, in others

slow and limpid, roaring imperturbably down from the Tibetan hills to where it pauses here in Chongqing, heavy with mud, on its passage through the great Red Basin of central Sichuan.

The confluence of any two gigantic streams often provides a natural place to build a city; and so Chongqing is understandably ancient, having first been settled in the fourth century BC, and it has been one of the country's greatest inland cities for at least 1,000 years. Foreigners were permitted to settle there from the beginning of the 1890s—it was the first of China's interior cities to be obliged by treaty to provide concessions for traders and diplomats. Most of them liked the place—it was always lively; the people were peppery and amusing; the food was spicy; the women were said (except by supporters of a rival claim from the eastern city of Suzhou) to be the prettiest in the nation. The major problem was the weather: Chongqing is one of China's three "great furnaces," blisteringly hot from April until November, the air like bundles of heated cotton-wool, thick and barely breathable.

In the early spring of 1943 the weather was not the major issue. The ruin and depredation caused by two years of nearly continuous Japanese bombing had pounded the city almost to death, and it was only now struggling painfully back to life, the people emerging

from their underground shelters, blinking, into the smoky sunlight. Between 1939 and 1941 there had been no fewer than 268 bombing raids, much of the central city had been gutted by firestorms, and thousands had died—more than 4,000 in one terrible two-day raid at the very beginning of the Japanese campaign.

The Chinese behaved with memorable stoicism during the bombing—which was arguably more sustained and terrifying than any other aerial bombardment inflicted on any other city in history. Robert Payne, a writer and teacher who befriended Needham in China—and who came briefly on one of Needham's great expeditions—talked in 1943 to an elderly Chinese professor who managed to put the campaign into the kind of perspective that Needham would have welcomed. Payne was discussing the American bombing raids on Tokyo the year before, somewhat approvingly, and the Chinese sage was nodding his head in a way that Payne assumed signified complete agreement. It was only after the man began to speak that he realized "for the thousandth time since I came to China that a man who nods his head may actually be expressing *the most profound disagreement:*

"I was in Chongqing during the bombardment," he said. "I have no wish that the Japanese should

share the same fate. Nothing is so terrible, nothing is so remorseless, nothing so revolting to the soul as a bombardment. The soul cannot suffer in peace after such indignities. Only now, two years afterward, can I think coolly of what happened, and I now praise God that China for centuries refused to harbour such things. The Chinese knew all about poison gases fifteen centuries ago; we invented an airplane, and quite rightly executed the inventor; we are the only nation that has thought continually of peace. I have no malice against the Japanese, who killed my parents and my brothers. I have pity, but it is not Christian pity, I'm afraid—it is the pity that burns."

Such conversations fascinated Needham, and as with the grafting of the plum tree and the making of the abacus, he avidly noted the details. But it turned out that he was not so interested in whether or not the Chinese felt pity for the Japanese, or in their views on the supposed indignity of bombing campaigns. It was the old man's idea that a Chinese inventor had come up with an airplane, and that other Chinese scientists knew all about poison gas—and so these two nuggets of information, two Chinese "firsts," if they were provable, went into the notes he was preparing, and also

went into his ledger with a simple notation: "Research this further."

The mission, which was officially to occupy Needham's next four years, was defined in all its aspects by the mechanics of the war that raged through China. By the time he arrived in Chongqing it was a conflict that had already steadied itself into an uneasy stalemate, and with the arithmetic pointing to one pitiless conclusion: Japan was going to lose.

Everything had changed after the attacks of December 1941 on Pearl Harbor, Hong Kong, and Singapore, when the Chinese government had at last declared itself officially at war with the invading armies from Tokyo. The Allies' coolheaded military analysts swiftly concluded that as a consequence the eventual outcome was inevitable: insofar as China was concerned, Japan had embarked on a war that for one simple reason—China's immense size—was absolutely unwinnable. China, 4,000 miles from Shanghai to Kashgar, 3,000 from Hainan Island to the Gobi Desert, was like a vast, shapeless sponge for any invading army: it could soak up, enfold, and suffocate endless supplies of men and matériel and still itself remain healthy, whole, and intact.

Joseph Needham remarked on this years later. There had evidently come a point in the conflict, he

said, when Tokyo also reached the same very simple realization: that even after it had fought over and then secured some town or village somewhere in China, its commanders would be obliged to leave behind sentries to guard bridges and culverts and tactically important sites: "and have you any idea how many bridges and culverts there are in China? Do you think Tokyo ever thought of this? Uncountable thousands. More men would be needed than Japan has in her entire army. The fact is, China is just too big, too complicated, for any other people in the world to come and dominate and control it. Japan was on a fool's errand, and by 1941, it had come to recognise that."

The Nationalist government in Chongqing had therefore decided to spend less of its time and effort in the early 1940s fighting the Japanese, and instead let the sheer size of China wear the invaders down. Chiang Kai-shek had chosen the redoubt of Chongqing as his capital deliberately, with this very fact in mind. Even if China were to lose fifteen of its eighteen provinces, he once famously said, "if we hold on to Yunnan, Guizhou and Sichuan," where Chongqing lies, "then we could defeat any enemy, recover the lost land, restore our country, and accomplish our revolution."

There was an additional reason for Chiang's optimism. Because the Allies would be fighting Japan on

the other fronts that had opened up since their attack on Pearl Harbor, Tokyo would be obliged to detach soldiers from its garrisons in China, weakening its presence in and its hold on China and so reducing the likelihood that China would lose any more territory. Therefore, a military policy of containment and survival became Chiang Kai-shek's priority—that and defeating Mao Zedong and Zhou Enlai and their Communist battalions, whose own ideological power had been growing steadily during the first four years of the war.

However, one major problem remained for the government in Chongqing—the supply of critically necessary food, weapons, and ammunition.

A fair amount percolated through the 2,000-mile frontier between free and occupied China, with Japanese troops sometimes colluding in the smuggling. However, since the Japanese had attacked and occupied the northern part of French Indochina, the main railway between Hanoi and Kunming—which had been China's lifeline, used for bringing in huge quantities of badly needed supplies from India—had been severed. The only other supply routes passed along the immensely difficult caravan trails from Russia into the deserts of Xinjiang, and were seen as wholly impracticable. China—and its army—thus faced a real risk of being slowly starved to death.

In an attempt to remedy this the Allies constructed the legendary Burma Road and the Ledo Road, hacked through well-nigh impenetrable jungles between India and China, in one of the most heroic engineering feats of any war, anywhere. They also arranged—most relevantly to this story—the air bridge over the Hump, the bridge by which Needham had traveled into China in February, and by which he would now want to bring in supplies for his own official mission. To do that, he would need permission. For his was a rather different task. The Allies were concerned most of all with keeping China's body alive, fed, and in as fair a shape as could be expected. Needham's duties were much more concerned with keeping the Chinese mind in good health, too—with making sure that the finest brains in the eastern world, legatees to the greatest civilization on the planet, were kept nurtured and in good spirits during all the trials of battle.

The specific official task of his Sino-British Science Cooperation Office—later called SBSCO—was to bring succor and comfort to China's academic community. He was to "cheer them up a bit" as Jimmy Crowther of the British Council had put it in London. He was to remind them they were not alone, that the world was thinking of them. But fine words butter no parsnips: what was really needed, Needham discovered as he

made his first rounds of the ramshackle capital city, was supplies—laboratory equipment, reference books, and scientific journals. The universities inside free China needed to know what was going on in the world outside, and thus informed, they needed to begin their own research all over again. Such considerations were uppermost in Needham's mind as he settled in at his new billet.

Once he had got its measure, he found that the city was not at all as he had imagined. He wrote:

> To start with, it is an extremely sprawling place, running along at different levels for several miles, so that there is plenty of green about everywhere, and the sound of cocks and hens even in the midst of the city. Hence there is a certain resemblance to Torquay, which the reddish earth and some of the masonry makes you think of, but the hills are higher. . . . At night, when the lights are out, and you hear the sirens of the river steamers (an ever-present sound, though not so frequent as in New York), the place is said to resemble Hong Kong. It also resembles Harpers Ferry, where the Shenandoah joins the Potomac, and the sirens of the B & O trains redound . . . but the scenery is on a larger scale here. It seems that the city contains nothing

old and beautiful architecturally, but rather masses of jerrybuilt structures put up after the bombings had destroyed everything that was there before.

Some people might suggest that Needham was wearing rose-colored glasses, since most visitors to Chongqing in wartime, even though they liked its hugger-mugger spirit and zest, found it much less congenial and terribly dirty. It had dingy steps, slime-slippery alleyways, the stink of sewage, rats the size of small dogs,[17] piles of rubbish spilling down the hillsides, scrofulous children, a million people crowded into a space originally meant for a third that number, and a cluster of immigrants and refugees so impossibly varied that communication was difficult, commerce frustrated, and service all but unobtainable. Moreover, the telephone service was virtually nonexistent, the electricity supply was fitful, there were no taxis, and living conditions generally were only tolerable. Because this was China, it was wartime, and everyone sent off

[17] Old-timers reported that Chongqing's rats invariably had bright red bellies; when found in hotels they would be chased away by kitchen boys who would throw vats of boiling water over them. This would scare them but not kill them. The scalding water would, however, instantly turn them bright pink, bellies, and all—a phenomenon that gave the kitchen boys an opportunity for great sport.

to live in the capital had been forewarned that a stiff upper lip was a sine qua non, stoicism was part of the furniture, and fatalism went with the territory.

But soon after Needham arrived he was able to effect an escape. Late in May the ambassador asked him to drive 200 miles to the west, on a first mission to practice the art of spreading good cheer in the capital city of Sichuan, Chengdu. It was a journey he anticipated with some eagerness—not least because one of the secretaries at the embassy, picking up quickly on his fondness for pretty young things, had written to tell him of the attractive women he might meet there. "If you like to see a beautiful girl, Lettice Huang. . . . Miss Kimmie Gao is also beautiful. . . . Don't bother to see her unless you are inclined to have some female company." He left the weary old ruins of Chongqing for the foothills of Chengdu with a certain spring in his step.

His route went west through the fields and paddy terraces of Sichuan to the city in the foothills of the Tibetan plateau. Nowadays, on a seamless superhighway, it is a trip of less than three hours, but in the 1940s it was a three-day journey. On his way, Needham found that, to his great delight, he was once again able to indulge his academic curiosity as he had done so freely in Kunming. He dropped in on an alcohol factory (where

he was able to speak in fluent German to the senior manager, who had trained in Frankfurt), he inspected a brine works, he gave lectures at two local universities, and he ferreted around in shops for old books—collecting on this first expedition a grand total of nine venerable volumes, including treatises, unavailable in any library back home in England, on the history of Chinese mathematics and astronomy, as well as books on Daoism and alchemy. After studying them, he slipped the volumes into the weekly diplomatic bag—the privileged embassy postal system—and eventually they made their way to Cambridge to await his return.

When he reached Chengdu, the situation was precisely as the secretary at the embassy had told him. He enjoyed his stay hugely—in part because he did indeed find beautiful women there. Wielding his two techniques of flattery and breathtaking directness, which would soon become familiar to their many victims, he flirted, and not infrequently he pounced. "I can't help writing to say what a charming person I think you are!" he wrote to one young woman, Zhu Jingying:

> I was much impressed when I first met you in the laboratory, and that was why I asked you to my party this evening, which certainly went with a swing. I have a good instinct about people: I

know the right sort the first moment I see them. At the party I was more charmed than ever, for you seemed an enchanting mixture of seriousness and gaiety, reminding me of a girl I met in Kunming who drank a toast to Li Po in a way I shall never forget. With something so bright, so intelligent, something (and this is rare in women) so witty. Being easy to look at too. A Polish woman biologist (who afterwards became one of my greatest and most intimate friends) said to me once *Je suis tout envahie de ton personalité,* and that is rather how I feel about you. You are not ordinary.

The reason I write like this is because in wartime life is rather uncertain and it may be that we shall never meet again: so I wanted you to know the admiration I felt.

Don't bother to answer this letter. Of course I do hope you'll look me up at the British Embassy if you are in Chongqing; and I shall look you up when I come back here in August.

There is no record that he ever met Miss Zhu again; nor is there any record of her reaction to this declaration. We shall never know whether she saw it as an honest and innocent expression of admiration, or as an artfully devised mash note.

. . .

Whatever the fate of that particular meeting, a much more significant encounter took place during Needham's brief stay in Chengdu. On this first westward venture, Joseph Needham met the young man who would be his secretary, confidant, and constant companion during most of his subsequent years of travel—and who would produce one entire volume of *Science and Civilisation in China* more than half a century later.

He was Huang Hsing-tsung, generally known as H. T., and at the age of twenty-three he was working as a science teacher at a technical school just outside the city. He had been there for two years, after a somewhat dramatically interrupted career.

He had been born in 1920 into the Chinese community of Malacca, on the south coast of the Malayan peninsula, and had gone to Hong Kong University to take a degree in chemistry. Shortly after he graduated, however, Japanese soldiers invaded and overran the tiny British colony—whereupon Huang decided to escape.

He was first smuggled in a boat up the Pearl River. Then he managed to get himself, by walking or by begging lifts in passing carts, into the uncertain and ever-shifting no-man's-land between the Japanese and the

Nationalist Chinese lines. Then, after almost a year of wandering and considerable privation, and by managing all the while to stay one step ahead of the invaders, he fetched up in the far western city of Chengdu, and comparative safety. He presented himself at the closest local boys' school, which was known as a Baillie School, after the Scots-American founder. Here, since he had a degree, spoke good English, and was evidently a man of considerable courage and initiative, he was hired as a teacher, almost on the spot.

A few months later, and quite unexpectedly, he received a letter from Chongqing—a letter that was notable chiefly, he said, "for its prominent seals and stamps, one which stated 'Sino-British Science Cooperation Office,' and which endowed it with an undeniable air of authority." It was from Needham, and it was brief and to the point. He wanted a secretary, desperately.

The contact had been made by way of Gordon King, a Scottish professor of obstetrics from Hong Kong who was one of Huang's former teachers, knew of Needham's towering academic reputation, and was now himself in China. He had suffered through a hair-raising adventure, leading more than 100 Hong Kong students through the Japanese lines to where he was now teaching at one of Shanghai's universities currently quartered in Chongqing. He found himself with Needham at an

embassy event, and learning that Needham wanted help, promptly told him of Huang—a brilliant young man, he said, currently boxing well below his weight at a boys' school across in Chengdu. It might profit Needham to make use of him in some capacity, King said—perhaps even as the very secretary he needed.

So, without further ado, Needham wrote to this apparently very clever refugee. Could he type? Could he drive? Might he like to wander around China for a while—perhaps in fact for a rather long while? Might he, in short, take the job? Needham would be coming across to Chengdu—he might even already be there by the time this letter arrived. He would be staying with a local family named Luo. Perhaps in the next day or so Huang might drop in?

The offer, said Huang, sounded "awfully attractive." He had no doubt. He went to the Luos' house with indecent haste, arriving before breakfast, and asked for their distinguished foreign visitor. It turned out that he was far too early. But still,

after ten minutes Needham appeared. Wearing a loose blue Chinese gown, with his hair slightly disheveled, he loomed large and forbidding, but his manner softened as soon as he started to speak. I introduced myself. He took a blank card from his

desk and proceeded to write my name in Chinese. After a couple of starts he wrote down all three characters correctly. He took out his date book, said he would be tied up all day, but he would be able to see me the next morning.

The next day, at a more civilized hour, Huang presented himself again, this time for the interview itself. He was fretful. Though the idea of wandering across China with a man so evidently remarkable and curious was highly alluring, the truth was that he could neither type nor drive, and he doubted that he would be hired. Moreover, when he turned up, two others were waiting.

Needham appeared, this time in an army khaki shirt and shorts—he seemed in a good temper, not least because he had had his breakfast.

After what seemed an interminable wait, the visitors departed and my interview with Needham began. I told him about my background, education and interests. I confessed I did not know how to drive a car, but played down the fact that my typing skill was negligible. Fortunately he did not seem particularly concerned about these issues. He talked about the circumstances under which

he had become interested in Chinese culture and language, the influence his younger Chinese colleagues at Cambridge had on him, his appreciation of the accomplishments of Chinese scientists under trying wartime conditions, and his effort to set up an organisation to help them obtain books, journals, equipment and materials from abroad. He expressed the hope that such an organisation could become the forerunner of an international science cooperation network after the war. An hour quickly passed.

He said the job was mine if I wanted it.

By the middle of May the embassy had confirmed Huang in his post, a dream job with a good salary and diplomatic privileges. He gave in his notice at the school and prepared to move to permanent digs in Chongqing. But the matter wasn't quite as simple as that. Needham, perhaps inevitably, suggested that the two of them journey back to the capital together, by a route that would be as complicated and as scientifically fulfilling as possible. It was to be a dry run for the much more ambitious journeys that lay ahead. Excerpts from the two men's diaries over the next twenty days of half-planned meandering provide an illustration of the manner in which Needham tried, relentlessly, to find out as much as he could from every encounter he ever made in China.

So they headed south out of Chengdu, not east, as the direct route home would take them. They first made their way by road down the Min River valley, to a point where the Min joins the Dadu River at Loushan, an otherwise undistinguished mountainside town that was the temporary wartime home of the University of Wuhan, normally 600 miles away. They spent five days here—looking over the department of physics, which had been housed in an old pagoda; investigating the colleges of art and law, which were in a Confucian temple; visiting a forestry research station, which was in yet another temple; and looking over, at its temporary housing in a godown several miles away from Loushan, the only microbiology laboratory then existing in free China. In Loushan Needham met a plant physiologist named Shi who fashioned apparatuses of bewildering complexity out of scrap metal. Needham described Shi as very "Cambridgeish"—an apparent compliment.

Needham was constantly delighted by the ability of the Chinese, at least in wartime, to improvise, which would have been a guiding principle of his late father's. He was invited by the BBC to give a talk a few weeks after this journey, and he related what he had found:

One may see, for example, a coal carbonization plant in which all the piping, scrubbing towers and

metal parts have been constructed out of old gasoline drums. Or one may find a steel rolling mill operated by a salvaged river-steamer engine, and an excellent blast-furnace made with steel plates from sunken river steamers. When a university laboratory ran out of elements for their electric heaters they found that gunborings from a nearby arsenal would do very well as a substitute, and when microscope cover-glasses could not be had, they used slips of natural mica.

Needham gave two hastily arranged lectures in Loushan, one of them followed by a short speech in Chinese, his first ever, which his listeners rather dutifully said they were able to understand "quite well." He also gave a dinner party—one of the "cheering up" duties with which London had saddled him—and said he found it hilarious, partly because of the good Sichuan orange wine; partly because Needham loved playing the host, and *ganbei*-ing—making toasts—each time the bottle was poured; but mostly because of the number of women he was able to round up, far more than at a customary Chinese banquet.

To Needham—with his wife in Cambridge and his mistress in New York—an abundance of women was an eternal delight, and their presence cheered him up

enormously after a hard day at work. After this dinner he took the whole party, who were by then well in their cups, off to see a Sichuan opera, which he said later he found amusing but rather too noisy, and "sorely lacking in violins."

He and H. T. then pressed on south toward Yibin, stopping en route to see, at various places, a 360-foot carved stone Buddha, a new salt well, a factory for making ethanol out of grain, something called a wood dry carbonization plant (no explanation given), and a monastery. At the monastery they were introduced to and then had lunch with a group that included a "living buddha," three itinerant Tibetan monks dressed in russet red robes, some rather sobersided Chinese monks kitted out in black, and the Australian ambassador to China, Sir Frederick Eggleston, who happened to be nearby, and hungry. Needham said he found it rather amusing that so austere a community was suddenly invaded by an antipodean diplomat and a fellow of the Royal Society, but imagined later that the monks had been less impressed than he, and had taken it all with properly spiritual equanimity.

Later that day he and Eggleston went to a teahouse and sat outside in the sun chatting idly about the beauty of their situation. It was perfectly safe for them to do so. Long gone were the days when foreigners were subject

to the kind of vilification and hostility that had marked Boxer times: in the 1940s the very few *lao-wais* who journeyed into the Chinese heartland were greeted with great warmth, the only inconvenience being, then as today, the occasionally overfriendliness of popular curiosity. Since Needham took great care to treat every Chinese he met with the same polite solicitude he would show to his own kinsmen in Cambridge—or perhaps with more reverence, considering the antiquity of their civilization—he was always well treated in return. Moreover, he remarked to Eggleston, in a conversation so notable that he would write about it fifty years later, there was little evidence of harshness in the conduct of China's everyday civil affairs. Chinese villages might be poor, but their inhabitants were generally happy, and people went about their business knowing full well their particular standing in society, but never having to be overtly reminded of it or warned about it. Bureaucracy was deeply embedded in every aspect of Chinese civil life, and it underpinned all aspects of their society, evidently in a peaceable way:

Seeing the common drain running down the middle of the village street, Sir Frederick exclaimed how mediaeval everything was, and said: "You could almost expect a knight and men-at-arms to come

by." I replied yes, indeed—but pointed out that it wouldn't have been a knight, but a civilian official, and the men-at-arms would have been represented by unarmed servitors carrying his titles and dignities on placards. It did not mean that the ultimate sanction was not force, as it has been in all human societies—but it was force much better concealed by the Chinese bureaucracy.

Everywhere he traveled, Needham later said, he would see village walls covered with an inscription that, he felt, quite deftly summed up the Chinese people's attitude toward their government: "May the Heavenly Officials Grant Peace and Plenty!" This is what both sides wanted. Authority was there, of course; and it could at times be exceptionally cruel. But to most Chinese the bureaucracy that sustained it was a benevolent entity, made up of men whose wisdom, tested in examinations, was accepted; whose propensity for corruption was kept within acceptable limits; and whose professed intentions for the common good and for the good of the nation were generally thought to be credible.

It was sixty more miles by road to Yibin city, where they would meet the Yangzi and take a riverboat home. Rather than continuing along the highway,

which was rutted and uncomfortable, Needham suddenly thought—in an impetuous moment of a kind that was later to be all too familiar—that it might be more amusing and valuable to go to Yibin by boat. So he persuaded Professor Shi, the "Cambridgeish" plant expert, who had connections—what in China are known as *guanxi*—to whistle up two of the river barges normally used for transporting salt and press them into service as temporary personal ferries.

Needham, Huang, and a somewhat bewildered Professor Shi were the only passengers, and their trip downstream was thrilling. The Min is a furious river at the best of times, and in early June, with the Tibetan snowmelt beginning to run off, it was in dangerously full spate. While Needham sketched the design of the craft (three covered sections—one for the salt, one for passengers, one in the stern for the owners—and a sternpost rudder of a unique type that the Chinese first invented), H. T. watched the men rowing. There were four of them, and they stood in the bow, he wrote later, two on each side "like ancient Egyptians," and used ultra-long trireme-size oars to help the steersman keep the boat straight in the rapids. They chanted lustily as they pulled away, the rhythm of their chantey reminding Needham of the first bars of the *Song of the Volga Boatmen*. The captain wore a long gray gown and a

white turban and looked, wrote Needham, like Sinbad the Sailor.

The journey down to the junction with the Yangzi, though only sixty miles or so, took two days, and it alternated between being an idyll and being a nightmare. Their companion boat was wrecked on the rocks and had to be repaired. Rapids, gigantic whirlpools, and boils terrified Needham, as did the constant threats of bandits, who were suspected of smuggling themselves aboard among the would-be river hitchhikers who swarmed onto the deck every time the craft stopped. And as if this were not enough, the weather, although it was almost midsummer, turned unexpectedly cold and rainy.

Thereupon Professor Shi—a tall, lean figure with a wide range of interests and knowledge—decided that the passengers' morale was falling, and that he ought to amuse them. He turned out to have an astonishing memory for poetry of the Tang and Song dynasties, and so he recited from memory stanzas which would amuse everyone—and which Needham immediately translated.

One of the poems was cheerful and rollicking, about wine and women and good times, and in terms of its art, thought Needham, rather slight. The other, though, which had been written by the tenth-century

poet Jiang Jie, had a peculiar melancholy about it that, in Needham's off-the-cuff translation, seemed entirely appropriate to their present adventure. He managed to render the classic in better than passable English, and what he achieved stands as an impressive reminder of his growing skill with the language:

As a young man, listening to the girls in a tower
I heard the sound of the rain,
While the red candle burned dim in the damp air.
In middle age, travelling by boat on a river,
I listened to the rain falling, falling:
The river was wide and clouds drifted above;
I heard the solitary cry of a teal borne on the
 west wind.
And now in a cloister cell I hear the rain again,
My hair is grey and sparse;
Sadness and Happiness, separation and reunion,
 all seem one,
They move me no more.
Let the rain drop all night on the
 deserted pavement
Till the day dawns.

Finally they reached Yibin, a grubby little city known today for little else than a distillery that makes a dis-

gusting Chinese version of Scotch whisky. It is here that the Min River joins the Yangzi, at a point that sailors generally think of as the effective head of navigation for the greater river. Yibin lies 1,800 miles from Shanghai and the East China Sea; and the Yangzi above the city turns menacing, with narrow, steep-sided canyons and a ferociously fast stream. Only a very few shallow-draft ferries with skippers who are courageous or foolhardy or both ever venture beyond the city limits. Needham prudently instructed his bargees to turn their boats smartly to the left as they entered the Yangzi, and to head with the current, downriver.

Here they said farewell to the remarkable professor, who returned to Loushan by road. He left behind one testament to the pervasive marvels of Chinese culture: it turned out that during the still of the previous night, after his poetry recital, he had prepared two scrolls with the texts of the two poems he had taught his companions, each poem written in a calligraphic style appropriate to its mood. He also left a Chinese couplet of his own composition, which Needham for some reason translated in the style of Alexander Pope: "Nature from growing trees we best discern, And man's estate from social order learn."

"Very Cambridgeish," wrote Needham in his diary once again, as Professor Shi strode away to the bus stop.

Shi was the kind of figure who is all too rare anywhere in the world, and who is nevertheless met almost at random in the Chinese countryside. "Really, China is an extraordinary place!" Needham exclaimed, neither for the first time nor for the last.

Huang and Needham then caught a succession of steamers down the Yangzi toward Chongqing—and yet even on this journey, brief and quite routine though it might have been (traveling on one of the bustling ferryboats on the navigable Yangzi is for the Chinese as unexceptional as taking a public bus), Needham managed to sift a good selection of pearls from the commonplace.

In the small town of Lizhuang, for example, they discovered a particular treasure. Nestled in the old town—a tiny area almost 2,000 years old, with classical temples and pagodas, courtyard houses, and narrow lanes paved with curious blue stones leading down to the river—there was a small German-Chinese University, whose professors positively fell on Needham as soon as they discovered he knew their language. (There was a Belgian embryologist on the staff, too, and Needham further impressed everyone by talking to him, in French, about the morphology of the developing human egg.)

He also discovered, totally unexpectedly, an Institute of History in Lizhuang, an outpost of the Academia Sinica—an organization much like London's Royal Society, or the Russian Academy of Sciences—whose offices turned out to be filled with the most amazing delights. And although one might easily say that Needham's entire experience in China was made up of a series of epiphanies, this particular find was of a quite exceptional importance, for two reasons.

The first can be discerned from his diary account of this unforgettable day, June 10, 1943:

> You wouldn't believe the treasures they have there.
>
> The Archaeological section has plenty of Han-time bronze and jade objects, but the marvel is the famous *oracle-bones* of Shang time from the tombs at Anyang (1300–1100 BC) which have *the most ancient* writing on them. The people here are running out of tissue paper on which to make their rubbings, so I shall try to get some from India for them.
>
> Then the Historical section has lots of the bamboo tablets on which the Classics were written in Confucius' time, and also marvelous Imperial Archives from the early Qing dynasty, including letters to the Jesuits and decrees to Tibet and a document

from the Chinese court appointing the Japanese shogun as King of that country. The Linguistic section has gramophone records of the dialects of every province. And so on and so on. The libraries are wonderful—authentic specimens of Song dynasty movable block printed books and the like. . . .

My numerous inquiries about the History of Science problems caused a general stir and various members of the Institute were running about digging out interesting stuff they'd come across, e.g. passages about firecrackers in 2nd century AD; accounts of great explosions; and decrees forbidding the sale of gunpowder to the Tartars in AD 1076, i.e. two centuries before Berthold Schwartz's alleged original discovery in the west.

His search for the Chinese origin of just about everything—the central obsession of his life, as both critics and admirers would later say—had thus been rewarded by this one visit to a small Yangzi-side town in central Sichuan. The Chinese invention of gunpowder was far older, he now suspected, than had hitherto been assumed.

The second reason for the importance of the visit to Lizhuang was his discovery of a remarkable man, a chemist named Wang Ling. Wang had come to the im-

promptu lecture Needham had given on the history of Chinese science—and without waiting to be asked, he immediately set about "digging out interesting stuff" for the visitor. He sensed exactly what was needed, setting himself to find out once and for all what had never before been explained—the entire complex saga of his country's discovery of and manufacture of explosives.

Needham, when he was eventually told, promptly asked Wang to help him more generally with his research, and in particular to help him prepare the very first volumes of his great book. And so the name Wang Ling of the Academia Sinica appears on the first title page of the first volume of *Science and Civilisation in China*, and there is a long, fervent appreciation in the first preface—and all thanks to a chance encounter on a Yangzi riverbank in June 1943, and a lecture that, in one small sense, changed everything.

Three days later Huang and Needham were back in Chongqing—though not before visiting a local military arsenal and seeing a variety of plants that made, among other items badly needed by the soldiery, gun cotton, liquid oxygen, glycerol, phosphoric acid, and protective clothing. The most extraordinary thing about the arsenal was that almost all the production units were housed inside a vast network of natural caves—prompting the

two men to wonder out loud, as their steamer sailed the last few miles downriver to the capital, how on earth all those immense machines, pipes, and distillation columns could have been moved through the gorges and across the fearsome rapids to be assembled in this remote riverside site. It was a further illustration of the imperturbable persistence of the Chinese people, for whom almost any task, it seemed, was ultimately possible.

Once he returned, Needham found on his desk at the embassy a telegram from London, a message that in his view vindicated all the travels he had just undertaken.

For the authorities had granted him permission at last to make use of the air bridge over the Hump to bring in supplies for the scientists who needed them. He had been allotted space on the inbound planes, and an acceptable tonnage, at least once a week, for a generous number of boxes that would be assembled in Calcutta on the basis of his requests. And so if a physicist in Chongqing needed copies of *Nature*, or a biologist in Chengdu wanted scalpels and a dissecting table, if the geologists at the Chinese Survey needed thin sections of rocks[18] or a list of the poisonous plants of the Shan

[18] These would be made for them by specialists at the Indian Geological Survey in Calcutta from samples sent down from China.

states, if a chemist in Kunming wanted the ninth edition of *Kaye and Laby*, and if the archaeologists at the Academia Sinica in Lizhuang needed the special brand of tissue paper that would enable them to transcribe the calligraphy from the old oracle bones—Joseph Needham could now get it all for them, and have the items flown in by the American military, all transportation costs to be borne by the British government.

He was overjoyed by the news. It meant that real, tangible scientific cooperation was now beginning to take shape, and that the universities of free China would soon feel the benefits of the largesse of the faraway British. The intellectual communities of the world's oldest civilization, lately almost comatose, would now soon begin to flicker back into life.

Needham would say later that one of the greatest pleasures of performing the tasks he had been assigned in China was that he was enabled to understand the country's culture and civilization without being constrained by the conventions of the type of people who in those days infested the country—the businessman, the missionary, the expatriate bureaucrat, and worst of all the "old China hand." The scientists were very different: pure science itself was a neutral calling; the topics of study were invariably detached from the triv-

ial political squabbles of nationhood. So the work that Needham performed brought him into direct, unmediated contact with men and women in laboratories and libraries who managed to be both aloof from the arguments of the day and yet fully aware and tenderly solicitous of the ancient culture of their country. No one to whom he spoke seemed to have an ax to grind—a situation he found gratifying and endlessly stimulating.

Moreover, his endlessly open-minded and unaffected curiosity about China brought him into contact with people whom it might ordinarily have been difficult to meet—Zhou Enlai, for example, who would later become China's first premier and foreign minister under the leadership of Mao Zedong, became a close and good friend.

Zhou and the Eighth Route Army Bureau—the larger of the two main Communist armies—happened to be based in Chongqing at the same time as Needham. Needham had been given contacts in London, which early that same summer brought him a meeting with Zhou—and Zhou made it abundantly clear soon after their encounter that he liked Needham's guileless interest in his country, that he admired his knowledge of and fascination with its past, and, most important, that he delighted in this Briton's enthusiasm (albeit dis-

creetly expressed, since the Briton was a serving diplo-
mat of the crown) for China's possible socialist future.

Needham made little secret of the left-wing leanings
for which he was so notorious in Cambridge. In his let-
ters home, he remarked frequently on the economic in-
equities he was already witnessing in China, an unfair
system that seemed to be fostered or ignored by the evi-
dently morally flexible government of Chiang Kai-shek.

It haunted him, for instance, that he had to pay so
very little—477 *yuan*—for those nine extraordinary
volumes he had bought in May in the bookshop on the
Chongqing–Chengdu road. What he had spent would
have bought him five pounds of rice at the local market.
Inflation was appalling. Wages in 1943 bought just one-
tenth of what they would have bought at the beginning
of the war in 1937. Single men could barely survive on
their salaries; men with families became desperate. And
yet the widespread corruption meant that many senior
government officials lived very well indeed—Needham
wrote to Gwei-djen that he would often see senior offi-
cials with silk-gowned mistresses cruising through the
streets of Chongqing in chauffeured American limou-
sines, on their way to extravagant banquets, or to stores
from which they would stagger with French perfumes,
American cigarettes, butter, oranges, and imported

coffee beans. While all this was happening, ordinary workers teetered on the brink of abject poverty.

Those in the academic world were particularly hard-hit. Students and their professors alike in the cities of free China lived in cramped squalor; their food was limited, their illnesses were chronic, and their morale was low. And if, in those cities that had academic communities and thus libraries, rare books occasionally and mysteriously appeared on sale, and for inexplicably low prices, then one did not inquire too closely as to their provenance. Human survival was important, and if some potential purchasers who were in the happy position of being paid in foreign currencies—diplomats and foreign soldiers, mostly—were able to afford to buy those books, and if the purchases permitted the former owners of the books and artistic treasures to live, then what of it? The loss of a book was a trifling price to pay if it could be exchanged for the survival of a family.

Small wonder, Needham remarked later, that once the war was over so many in China's academic community who had experienced such inequity willingly offered their support to Chinese Communists. For many who experienced the harshness of those wartime years, Chongqing would remain a bitter memory. That so many of China's cleverest and most creative men and women had to sell their books and their most precious carvings

and family seals to keep themselves alive, while corpulent Nationalists and their friends dined well in local banquet halls, gave them some right to schadenfreude.

Zhou Enlai, delighted that Needham shared at least the economic views of the party, made certain that Mao Zedong himself soon came to see Needham as an intellectual ally, someone with whom to keep in contact in the event that the Communists should ever win power.

Come October 1949, on the declaration of the People's Republic, Joseph Needham could well say to himself that in Chongqing, by cultivating his friendship with Zhou—and keeping his distance from the more obviously powerful associates of Chiang Kai-shek's Nationalist government—he had indeed backed the winning horse.

He became, in short, a true friend of China. He loved its past; and he believed in the trajectory of its future. And yet his fondness for the place transcended politics—it was more subtle, deeper, and more lasting. He once said he was genuinely and profoundly touched in later years when a famous Chinese meteorologist said of him that his work in Chongqing and his unalloyed support in later years, when China was going through trying times, exemplified the truth of an ancient Chinese definition of real friendship—that Needham was to China like "one who brings fuel in snowy weather."

THE DISCOVERING OF CHINA

On the Magnetic Compass

It was [Chinese pilots who were] the first to employ the magnetic compass at sea. This great revolution in the sailors' art, which ushered in the era of quantitative navigation, is solidly attested for Chinese ships by AD 1090, just about a century before its initial appearance in the West. . . . The exact date at which the magnetic compass first became the mariner's compass, after a long career ashore with the geomancers, is not known, but some time in the 9th or 10th century would be a very probable guess. Before the end of the 13th century (Marco Polo's time) we have compass bearings recorded in print, and in the following century, before the end of the Yuan dynasty, compilations of these began to be produced. In all

probability from the beginnings of its use at sea, the Chinese compass was a magnetised needle floating on water in a small cup.

—JOSEPH NEEDHAM

From *Science and Civilisation in China,*
Volume IV, Part 3

Joseph Needham swiftly realized that to accomplish all he had in mind in China he should now move very fast. He was certain that the British government would regard his mission as fully accomplished once the Japanese had been defeated and the war was over—and that might not be far in the future. Nearly all of the embassy's military advisers, and those on the staff of the American embassy in Chongqing, too, doubted that Japan could hold on in China for more than a couple of years. And so from almost the moment his plane touched down, and well aware that on Churchill's whim his duties could be brought to a sudden close, Joseph Needham began to whirl around China like a dervish.

He led no fewer than eleven full-fledged expeditions around some of the wildest and loneliest places in the country, in the process logging somewhere around 30,000 miles. He probably covered more territory than the most doughty explorers who had gone before him. He would later make the bantering remark that he cer-

tainly saw more of China than his Chinese Communist friends saw on their famous Long March. They did a mere 8,000 miles—although Needham readily conceded that his mileage was done primarily in a series of wheeled vehicles whereas theirs was accomplished almost invariably on foot.

Each of his expeditions had a threefold official purpose. First, he was to bring simple good cheer to the men and women working in China's more remote scientific outposts. By now he knew only too well of their poverty and their improvisations, of their cheerful attitude of recycle and repair. He had heard countless tales—of tuning forks made from the spars of Japanese planes that had been shot down; of weights for chemical balances made by melting down coins of former dynasties; of vaccines stored in caves and kept cool with blocks of ice sawed from the surface of the Yellow River. Needham wanted to help these people, and he was fast developing a missionary zeal for helping.

Second, to boost their morale—and to keep their vitally important scientific work going—he was to hand-deliver any equipment they needed. In performing this task he saw himself as something of a latter-day Father Christmas, delivering sacks of goodies to well-behaved, faraway recipients. Much later he recalled his pleasure in

delivering large tubes of rare gases to the Chinghua University Radio Research Institute; or driving to the Peiping Academy's retreat near the famous Taoist temple of Heilongtang with several substantial cases of optical glass, to help them in their courageous programme of manufacturing microscopes in the Chinese hinterland. A cathode-ray oscilloscope gladdened the hearts of the excellent physicists in Kunming, and a few grams of colchicines made all the difference to life at the Sichuan Provincial Agricultural Experiment Station. A consignment of rubber tubing arrived at a university in Fujian just at the moment when all research was coming to a stop because of the perishing of their previous stock. Electric motors in crates jolted over the road from Chongqing to Chengdu to help the excellent work going on in the Chinese Air Force Experiment Station there. A first-rate binocular dissecting microscope kept a first-rate embryologist full at work. These things are good to look back upon.

Third, there was the nakedly diplomatic motive: he was to travel around China waving the flag for Britain. Few of his colleagues in the embassy had been granted as much freedom—and as generous a budget—

to wander. It was felt that Needham—by traveling to unvisited nooks, places where the legendary Chinese suspicion of foreigners was still evident, and where few outsiders were ever seen or made welcome—might, if he acted judiciously, add a certain warmth to the rather cool official relationship between Britain and China. And if that happened, and once the Japanese were defeated and compelled to leave, London would be in a far better position to expand its influence, both in China (at whatever city the government might settle in) and then farther, across the region.

A fourth possible official purpose is seldom mentioned. During those war years Britain, like all interested western powers, was eager to get to know all it could about the Chinese Communists. Joseph Needham was halfway to being a committed communist himself, and his contacts with the party leaders in Chongqing, and especially his burgeoning friendship with Zhou Enlai, could be of considerable use to the intelligence services. There is no evidence that Needham was ever in any sense a spy: prudence and scientific neutrality were his watchwords; he was always careful to retain the trust of the Chinese Communists as well as that of the Nationalist government to which he was formally accredited. But he had unique access, and the insights he gained from his visits to Zhou's headquarters were

uniquely valuable. His subsequent dinner conversations at the embassy, and his occasional discussions with military attachés from other embassies—especially with the "China hands" at Clarence Gauss's American mission— were thus invariably listened to with great care, just in case Needham let some morsel of information drop.

His expeditions also had an unofficial purpose. He traveled—and his superiors knew and recognized his pressing need to do so—to further his own personal academic investigations into the nature of China. His appetite for inquiry intensified the longer he remained in the country, and the embassy staff could not help noticing the huge number of books and pamphlets he was sending back to Cambridge, as well as the ever-increasing number of notepads and diaries he was filling. It was never entirely clear what he might do with the fast accumulating store of information, but that he was on his way to being the embassy's premier China expert was becoming abundantly clear to all.

Of his eleven expeditions, seven were short trips that took him only a few hundred miles out of Chongqing. The four others were anything but short—they were epics that took weeks, sometimes months, and were often risky, dangerous, and in at least one case, downright foolhardy. One journey took him through the

jungles of southwestern China close to the frontier with Burma. Another went east and north, to Xi'an, the old capital city now known for its immense buried army of terra-cotta soldiers.[19] A third went southeast, close to the Japanese front line—a somewhat mobile and intangible frontier which shifted with the fortunes of war, with the result that Needham and his small party were almost captured and made prisoners of war.

The first expedition he undertook, beginning in August 1943, was the gem. This was by far the most complex and the most difficult—and, as it turned out, the most instructive and rewarding. Though many setbacks and minor disasters caused it to run months beyond schedule, it took him to the farthest northwestern reaches of China, far beyond the western terminus of the Great Wall and out into the hot and sandy deserts of what now is called either Sinkiang or Xinjiang but during the war was called, much more romantically, Chinese Turkestan.

[19] The first of the thousands of figures was discovered quite accidentally by a farmworker digging a well in 1974. When Needham visited the city thirty years before, it was known for its array of architectural relics—immense city walls, huge gates, temple complexes, royal tombs, and countless tall pagodas—attesting to its greatness as Imperial China's onetime capital and—under its former name, Chang'an—as the eastern terminus of the Silk Road.

On this journey he headed to one specific spot in the Turkestan desert where there was a very small cave. Western scholars have given it a number, 17, and it is one of the 400 man-made Mogao Grottoes that line a cliff outside an oasis beside the far western desert town of Dunhuang, which is otherwise known as a rest stop on the Silk Road, with restaurants that offer steaks cut from local donkeys.

For Needham, the importance of Cave 17 had nothing to do with his official duties. This cavern, whose doorway is so low that one must stoop to enter it, was the place where, thirty-six years earlier, in 1907, an

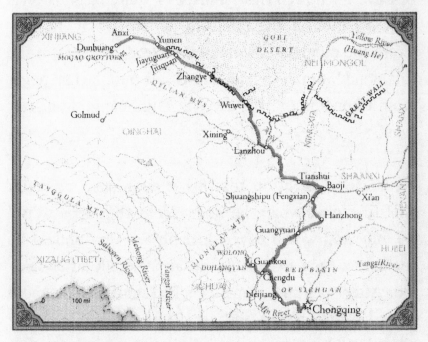

Map of Needham's Northern Expedition, Chongqing–Dunhuang

immense and ancient Chinese library had been dis-
covered, including a printed scroll that was now rec-
ognized as the oldest dated printed book in history. It is
known as the Diamond Sutra, and it had been printed
in AD 868.

That this book was made by a Chinese man demon-
strated conclusively that printers had been at work in
China six centuries before either Gutenberg or Caxton
set their own first books in type in Europe. If any one
thing in all creation gave the lie to the western notion
that China was a backward country, this was it. The
fragile document that had been plucked from the sands
of Cave 17 showed that China was, quite incontrovert-
ibly, a nation at the forefront of human civilization.
From the moment Needham first read the story of the
Diamond Sutra, he felt an irresistible pull: he had to get
from Chongqing to the caves at Dunhuang, no matter
what.

He decided early on that his expeditions—certainly
this first one, which he knew from the maps would
be long and would cover difficult terrain—should be
made in a rugged, reliable, go-anywhere kind of vehi-
cle. After spending some days kicking tires, he chose
a sludge-brown two-and-a-half-ton Chevrolet truck,
a converted canvas-covered American ambulance that

had been lent somewhat grudgingly by the Royal Air Force truck pool. He then hired to go with it a Cantonese driver, Guang Wei, whom he liked, and who agreed to double as a mechanic.

On Needham's instructions—given in English, since this was to be the common tongue among the participants, who came from London, Guangzhou, and Malacca, and so had three different linguistic origins—Guang painted "Sino-British Science Cooperation Office" in large white letters, as well as in Chinese calligraphy, on both of the truck's cab doors and on both sides of its body. In addition he mounted two small flagpoles beside the headlights: one flying the Union Jack of Britain, the other the blue-quartered red flag, a white sun in its quarter, of Nationalist China. (Despite his friendship with the Chinese Communists in Chongqing, Needham felt it would be imprudent to fly any hammers, sickles, or red stars. This was an official British diplomatic adventure, and as a diplomat he was officially accredited to Chiang Kai-shek's Nationalist government.) The flags would alleviate any possible doubt by friend or foe as to exactly who was traveling—and since stray parties of Japanese soldiers or strafing fighter planes had the habit of turning up in the most unexpected places, foes might well be encountered. Being able to demonstrate the mission's in-

nocently scientific purpose could, Needham thought, turn out to be a matter of life or death.

The team then packed the truck, first with the goods they were to deliver, and then with their own supplies—forty-gallon drums of fuel,[20] all the imaginable tools and spare parts they might need, camp beds, Primus stoves, the apparently purposeless lengths of string and oilcloth and sheets of tin without which no self-respecting Englishman would travel anywhere remote, and a very great deal of canned food—meats by Hormel and Fray Bentos, biscuits by Huntley & Palmer, mustard by Colman's or Keen's, as well as bottles of the undrinkable Paterson's Camp coffee, the rather better Fry's cocoa, and Cadbury's chocolate bars, seemingly by the ton.

They needed only to acquire the necessary permits: authorization notes had to be obtained from nine different organizations—the Foreign Office, the

[20] Needham was a strong advocate of the use of power alcohol, distilled from rice, maize, or molasses, and had his truck's engine converted to employ this fuel, which he found satisfactory "even over the great mountain roads." This was not the case with the many Chinese buses which had been converted to burn charcoal, and which would work properly only on the flat. Gasoline, though costly and difficult to come by, was made in some refineries from tung oil, or by a more complex process from pine tree roots and stumps.

Transport Bureau, the army garrison headquarters, and other arms of China's bureaucracy. Also, dozens of photographs had to be signed and countersigned in police stations and visa offices—a process that took the exasperated Needham several days. But eventually, at the end of the first week of August—armed with a bundle of chop-covered, seal-emblazoned, signed and sworn and notarized and diplomatically rendered official documents—they were ready to go.

They left Chongqing in what initially would be a two-truck convoy. Needham was in his own vehicle, with H. T. Huang and three other passengers: an American geologist, Ed Beltz, who was cadging a ride; the writer and teacher Robert Payne, who also needed a short lift to see a dying friend in Chengdu; and a young Chinese woman, Liao Hongying, a chemist educated at Oxford's Somerville College, who would act as Needham's amanuensis and provide him—though almost certainly platonically—with the female company he craved. She was extremely beautiful, as well as intellectually accomplished, and there had been much nudging and winking within the mission when the roguish counsellor had first selected her. (Considering what eventually befell Miss Liao, as we shall see, the whisperings at the embassy turned out to be most ironically misdirected.)

In another embassy Chevrolet truck would be Sir

Eric Teichman, who was being driven to a northern Chinese border city so that he could head west on another epic overland journey toward India, from where he would eventually fly home to Britain. The departure date for the two vehicles was set for August 7, a Saturday. It was expected that on this, their first Chinese adventure, the party would be staying away from base for eight weeks or so, little more.

For the duration of their expedition the Dunhuang caves were at the front of their minds: reaching them was the ultimate goal, no matter what the hardships. But there were other things to see on the way—other Chinese marvels. The first of these, which Needham managed to visit just a week after he left Chongqing, involved a subject that has captivated China since the beginnings of its history: water.

China is, basically, a gigantic plateau. tilted gently from west to east. The biggest of the Chinese rivers, the catchment of nearly all others, flow almost entirely in that general direction, from their sources in the Himalayas in the west to their estuaries on the eastern ocean. The rivers swell each springtime as a result of the melting snows and soon afterward become swollen again with rains during the southern monsoon. As a result, questions related to flooding and water control

became, almost from the nation's beginnings, a matter of overarching importance.

And this was not just local importance. The Chinese had long ago realized that, so far as flooding was concerned, local interests had to be subordinated to a wider national need. Swollen rivers did their damage or brought their benefits to huge tracts of land and to large numbers of people who, if they were prudent, and whatever their local loyalties, ought to come together to bring each river under control. So the creation of what one might call a supra-local national water authority, and a large bureaucracy to populate it, became of great importance early on in China's history.

As it happened, the immense power that such a body eventually acquired in early China helped to strengthen the fledgling imperial system as a whole— and it quickly became evident that whoever controlled the empire's rivers simultaneously wielded enormous power over the empire. Some sinologists go farther: the historically despotic nature of Chinese imperial rulers derived from one abiding reality—that the keepers of China's hydraulics had the wherewithal to do with China much as they pleased.

Water engineers were given formidable powers, and when they were successful, they earned formidable reputations. One of these engineers, in the Qin dynasty,

was Li Bing, who created a monster irrigation project on the Min River 2,300 years ago: astonishingly, it still stands. Part of Needham's plan when he set out that August was to inspect this structure: it was to be his introduction to the fact that ancient China could not only do small things very well—such as grafting plums and inventing the abacus and the magnetic compass—but also make achievements on a gargantuan scale.

Getting to the dam site turned out to be agonizingly slow. The men and Miss Liao traveled through the heat and dust of the Red Basin as slowly as sloths. Within the first moments of leaving Chongqing, they had been presented with a sight that unsettled their Chinese drivers. A funeral cortege passed directly in front of Sir Eric Teichman's truck. It turned out that the chairman of the Chinese Republic, Lin Sen, had died the previous week, and while climbing a hill on the way out of town the little convoy was forced to stop and wait for an hour as the white-robed mourners edged by. Teichman's driver complained that this was an omen: so somber a delay must mean that his journey—maybe everyone's journey—was ill-fated.

The village of Yongqiang, which now is just a ten-minute drive west of Chongqing, took Needham and his trucks took more than eight hours to reach. By the time the sun was setting on Saturday evening his little

convoy had bumped and strained over only sixty miles, reaching the town of Neijiang. They stayed that night at the China Travel Service inn, which

> in contrast to the old-fashioned Chinese inns is very clean (and there is no insect life to be found in their comfortable modern beds). In the old inns the beds consist of a just a few bare planks and the traveller is expected to bring his own bedding. Modern sanitation has of course never been heard of. In the old northern regions the beds, called *kang* in Chinese, are platforms made of clay which stand about two feet from the floor. A fire is supposed to burn underneath all night but invariably expires about three or four a.m. leaving one to freeze until dawn. The primitive central heating device can be temperamental in other ways; I have known it catch fire on occasion, and destroy the clothes of one of my Chinese colleagues.

Whether his own clothes caught fire or his truck broke down—it was already leaking oil, and the radiator was dripping—we do not know, but Needham made no progress on Sunday. He opted instead to meet and have dinner with a Chinese cavalry colonel whose card he had been given, who turned out to have been

educated at Saumur, and who spoke impeccable French. On Monday morning Needham went on a side trip to buy fuel—ninety gallons of power alcohol and an additional ten gallons of absolute alcohol, which he planned to cut with some low-octane gasoline he had bought in Chongqing. He irritatedly described the road toward the distant blue mountains as "rough going,"[21] though he was charmed to find someone selling sugar plums. He also bought apples and a basket of tomatoes, then managed to avoid the normally compulsory police check on the main northbound road, arriving in Chengdu just before suppertime, just in time to allow his mechanic to rush the flagging truck to a repair shop.

Then finally the blue range of mountains stood ahead, rising abruptly before them, with the Min River coursing out of a chasm with terrific speed. Needham knew the most important statistics—that the Min fell 12,000 feet from its headwaters in only 400 miles, so that it flowed down an average gradient of thirty feet

[21] Needham's diaries are positively littered with reminders of the breadth of his interests. At one point in his journey across the Red Basin of Sichuan he notes that the landscape reminded him of "Morna Moruna in Wm. of Ourob." The cryptic reference turns out to be to a mountain in a book of high fantasy, *The Worm Ouroboros* (1922) by Eric Eddison—said to have inspired Tolkien to write *The Lord of the Rings*.

every mile, which in riverine terms is a formula for exceptional danger. He knew also that in 250 BC the redoubtable Li Bing had worked to tame and harness the Min, creating the structure that stood before him now, which visitors before and since have felt should be listed as one of the wonders of the world.

The site is called Dujiangyan. As an irrigation project, it may not seem to deserve being ranked alongside the Pyramids or the Taj Mahal, but it is actually one of mankind's more extraordinary achievements. Needham liked to quote, approvingly, the ancient Roman engineer Sextus Julius Frontinus, who wrote famously in the first century after Christ that his aqueducts were indispensable, and would be remembered long after "the idle pyramids, or the useless, though famous, works of the Greeks."

Needham liked this quotation not simply because Frontinus was right about the Egyptians and the Greeks but also because his achievements in Rome had been made three full centuries *after* those of Li Bing in China. Moreover, unlike the highfalutin monuments beside the Nile and the Yamuna, Dujiangyan had been made purely for the common good, and it still works today just as it was designed to work, whereas many Roman aqueducts lie in ruins. The fact that Dujiangyan was still working excited Needham most.

In 250 BC Li Bing had been appointed governor of the province of Shu—modern-day Sichuan—under the kingdom of Qin, during the unstable period of the so-called Warring States, and shortly before the formation of the unified Qin dynasty, from which the name *China* is derived. Like everyone, he was only too well aware of the Min's deadly caprices. It was a river that either ran half-dry in the summer, leaving the paddy farmers of the plains starved for water, or else, more commonly, flooded uncontrollably and caused a swath of destruction and death all the way to Chengdu and beyond. The river needed to be brought to heel. Li Bing, after winning permission from the king of Qin, undertook what would in time be described as "the largest and most carefully planned public works project yet seen anywhere in the eastern half of the Eurasian continent."

To control the river, he decided to cut a new spillway and channel any excess water through it with a specially designed, adjustable diversion dam. It took him seven years to break through the mountain: he managed this by having workers burn piles of hay on the surface of rocks to make them hot, and then pour cold water to cool them down rapidly, letting the nearly instant contraction crack them open. This cutting eventually led to an opening seventy feet wide, and the Min River waters, which were shifted toward it by Li Bing's

clever fish-shaped dam, began to course through it the moment the final wall was broken open. The anniversary is still celebrated each year: a ceremony called the "breaking of the waters" is held every summer, commemorating an eastern engineering feat that was undertaken more than 2,000 years ago, when westerners (though not Plato, Aristotle, the Egyptians, or the Mesopotamians) still coated themselves with woad and did little more than grunt.

Needham was fascinated by what he found at Dujiangyan. The engineering achievement was astonishing, its design was aesthetically pleasing, and its long endurance was remarkable. He also loved the architecture of the temples that had been built on the hillsides centuries ago to commemorate Li Bing's work. He spent several pleasant hours gazing down at the river from a cool vantage point high on one of the pagodas in the forest.

Then he met the modern director of the irrigation scheme, who was technically Li Bing's successor. He encountered him walking around in the wet mist beside the main spillway, checking monitoring devices and reading water meters. He had a slide rule sticking out of his pocket and turned out to have been trained in Manchester. Needham said how impressed he was by the system—the spillway, the dams, the endless tor-

rents of water—and all of it created so long ago. No wonder, he said, that they had erected a temple to Li Bing. "To us," replied the director, smiling, "he was like a god. He surely deserved a temple."

Needham now turned north. His plan was to cross an outlier of the mountain range and head northwest to join the Silk Road—a route that could take him, in theory, all the way to Baghdad and to the Mediterranean at Antioch. Even this fairly modest leg of the journey turned out to be wretchedly difficult. His diary pages for the second and third weeks of August are filled with references to breakdowns, interminable waits, and unexpected disasters—interspersed, however, with a jocular perspicacity, as if despite the frustration he finds it all rather amusing and instructive:

> At 2.30 p.m. the alcohol gave out . . . changed the carburetor tops . . . took off feed pump, put grease between the leaves of the diaphragm. . . . Found 40 trucks waiting for the ferry so we put up in a little inn, open air. There was a storm alarm, and also a lunar rainbow. . . . Sir Eric in trouble with the gendarmerie for photographing a bridge. We are informed that the road is blocked and that we must wait. The hotel at Hanzhong was full, so

off we went to the China Inland Mission[22] and all of us were put up. Had an enjoyable visit to Bishop Civelli and his merry men.

Needham's enjoyment stemmed from his discovery that the bishop was Roman Catholic and conducted high mass each Sunday, in Latin. Needham and H. T. went along, Needham finding himself open-mouthed with delight—at seeing the entirely Chinese congregation lip-synching the Latin recitatives, and most of all at listening to sacred music he had last heard in his little church in Thaxted. He said he felt transported, back to medieval Europe, and back to Essex in the 1930s.

But Needham's greatest annoyance was the growing frequency of not being transported. At times his litany

[22] By this time the century-old China Inland Mission (CIM), set up to promote the interdenominational evangelization of China by missionaries who were expected to live in as Chinese a manner as possible, had some 350 stations across the country, offering Christian hospitality to travelers like Needham. They had reached their peak in 1934, having weathered the Boxer rising and the revolution and the sundry depredations of warlordism. The Japanese war caused the CIM immense trouble, and by the time of the Communist revolution the number of stations had dipped to fewer than 100. They were eventually branded as havens for imperialist spies. The remaining missions were shut down, and the last missionaries left by way of Hong Kong in 1953.

of woes—as when he tried to cross the Bao River, ten days out from Chongqing—would become a full-blown chorus:

Arrived at [the ferry stop in] Wuguanhe at 10 a.m. Awful big washout. Lines of trucks and endless mulecarts there all day. Hopeless organisation. An incident officer should have been appointed with full charges for as far as the traffic jam extends on each side. Here again, like the rotten bridges on the Sichuan side [they had crossed into the province of Shaanxi, notorious for its inefficiency], surely far more men, money and effort ought to be spent on this great national northwest artery.

Eggs and potatoes for supper. H. T. paid. Slept fairly well in and around the truck. During the night 100 more mulecarts came by and were only stopped at 3 a.m. by a driver behind us who drove his truck across the road.

Had a lovely bathe about 5 a.m. in the river and a good breakfast. At about 8.30 a.m. an awful air force officer forced passage with four southbound trucks—had an awful job stopping southbound traffic: Ed was stationed at the top of the road and H. T. at the bottom while we brought our truck down, breaking a support on the way. We were

ready to cross when miles and miles of army sup-
plies on foot came through, cutting us short and
making everyone wait. Finally got across at 12:10,
a 26 hour delay.

After several more days like this, Needham decided
to call a halt. They stopped at the small town of Shuang-
shipu, nestling in a hollow in the hills eighty miles away
from the Silk Road. He chose it for his caravanserai in
part for simple convenience, and to get repairs for his
truck's newly broken spring. But he also stopped at
Shuangshipu in the hope of seeing one of China's more
celebrated foreign residents—a man with the unusual
name of Rewi Alley, who thanks to this brief stop would
soon become a privileged member of Needham's inner
circle. "No better friend," said Needham much later,
of this formidable and controversial character, "and no
more reliable colleague."

Rewi Alley could lay claim to many things—one of
his biographical entries lists him as "writer, educator,
social reformer, potter and Member of the Commu-
nist Party of China"—and is also undeniably the most
famous New Zealander ever to have lived in China. He
lived there for sixty years, becoming a mythic figure in
his own lifetime, an intimate of the Chinese Commu-

nist leaders, a man regarded by his admirers as almost godlike and by his enemies as a charlatan, a traitorous propagandist, a libertine, and a pederast.

He was remarkable-looking—short, stocky, sunburned, with legs like tree trunks. He had been named for a Maori chief and was the son of a schoolteacher and of a mother who was an early suffragist. He was a fanatic about keeping fit, an eager nudist, and—an admission made much of by his detractors—an unabashed homosexual.

Alley first came to China in 1927, impelled at least in part by his eager interest in young Chinese men (he had been sexually initiated by a soldier from Shandong whom he had encountered in France when both were serving in the final months of the Great War). He lived in Shanghai, a city that offered him a wide array of erotic amusements, and worked there first as a fireman, then as a factory inspector. During his ten years in the city he learned Chinese well-nigh perfectly, wrote volumes of homoerotic poetry, volunteered for famine- and flood-relief projects and other humanitarian causes in the countryside, and demonstrated a passion for social work and improving the lot of the ordinary Chinese. He left a distinct impression on all who met him—including, in the mid-1930s, W. H. Auden and Christopher Isherwood.

But in 1937, when the Japanese bombers struck targets in Shanghai and their troops overran the city, he fled. He went west, settling initially in the city of Hankou on the Yangzi. Here, the following year, in the company of Edgar Snow and his wife, Helen Foster (who was also known as Peg Snow and by her nom de plume, Nym Wales), and the secretary to the British ambassador (the ambassador in those days was the colorful Sir Archibald Clark-Kerr, who wrote all his diplomatic dispatches with a quill), Rewi Alley sat down to help create a revolutionary new industry.

The guiding principle was simple. Since by now the Japanese either controlled or had destroyed almost all of China's major manufacturing capability, and since the Chinese military response to the mighty invading army was based on guerrilla tactics of harassment and surprise, why not organize guerrilla industry too? Why not build hundreds of factories which were light, flexible, and perhaps even mobile; which could operate in the far beyond of inland China; and which could simultaneously provide low-paid work for the locals and low-cost output for the national good? The idea—no one is entirely sure who at the meeting came up with the concept, but supporters of Rewi Alley like to say he did—was immediately and widely accepted as entirely brilliant. The Chinese government chipped in

some money; international appeals were launched to ask for more; and an organization known as Indusco, or the Chinese Industrial Cooperative (CIC), was formally set up.

By happenstance the first two characters of this new organization's Chinese name were *gung ho*—and though there was no linguistic connection, the two words were very soon afterward adopted as a motto by a friend of Alley's in the U.S. Marines. They became the battle cry of this marine unit, and such were the unit's successes on the battlefield that the phrase—much like "Up and at 'em!" or "*Banzai!*"—slipped into the American English lexicon. In short order *gung ho* acquired a new meaning—a little different from its start as a battle cry and a lot different from its Chinese industrial origins. It now signified unquenchable and almost careless enthusiasm. But since ironists might say that both spirits, old and new, also underlay the cooperative's efforts in China, there may be a certain symmetry to it all. (The fact that the phrase was first coined at a meeting of four foreign left-wing sympathizers in an office of the Yokohama Specie Bank in Hankou in early 1938 has, on the other hand, no symmetry to it at all.)

Once the supporters' money was received, messengers and organizers fanned out into the hinterland and tiny factories sprang up in remote towns all over China.

They were factories that generally employed just twenty or thirty workers—seven was the usual minimum, and rarely did a CIC factory ever have more than 100 in its workforce. The factories produced a bewildering variety of goods that war-torn China needed. They made candles and lightbulbs; they printed pamphlets and mined bauxite; they tanned leather, spun cloth, and hammered out boilers, tin roofs, small boats, and spare parts for railway engines—everything which was needed and which was not being made in the bombed-out factories in places such as Shanghai, Fuzhou, Tianjin, and Wuhan was being made in the countryside, by an energized, optimistic, and newly purposeful Chinese rural workforce.

Rewi Alley was invariably out in the field at the sharp edge of the process, while the Snows and the other theorists of the movement (which would be much admired by E. F. Schumacher and the adherents of his "*Small is beautiful*" movement in the 1970s) remained behind in the capital. Alley bicycled, walked, and hitchhiked for thousands of miles across China in the early 1940s, lecturing on the CIC's ideas, attracting volunteers, setting up plants, and then moving on. He was seen as a golden-hearted gypsy of a man, and by April 1940 *Time* magazine reported, clearly approvingly, that his wanderings had helped to bring into

existence some 2,000 CIC factories, which employed 50,000 workers and produced goods valued at $6 million each month, well beyond the reach or interest of the Japanese bombers.

Rewi Alley was often compared to Lawrence of Arabia—Edgar Snow, for one, wrote that "where Lawrence brought to the Arabs the destructive technique of guerrilla war, Alley was to bring the constructive technique of guerrilla industry. . . . It may yet rank as one of the great human adventures of our time." There was a sustained effort by Snow and other left-wing journalists and writers to advance Alley—with his formidable looks, his romantic past, and his swaggering, devil-may-care attitude—as the public face of the "Gung Ho" movement; and millions of dollars were indeed raised on the back of his story.

But he was a figure of much controversy, too. Later, when he was elderly and had moved to Beijing to live out his retirement as an official "foreign friend of the Chinese people" in a house donated by the government, he described the occasional precariousness of his position during the 1940s:

> I had many enemies, who stuck at nothing in the way of stories to pull me down. I was a British Agent, trying to get hold of Chinese industry;

a diabolically clever engineer trying to find out about Chinese resources for foreign interests; a sentimental religious adventurer out to make a name for himself at the expense of the Chinese people; a sex maniac with a wife in every big city in the countryside; how I took an actress to sleep with me on long journeys; a Japanese agent, spying for the Japanese. A Communist sympathizer. An agent of the Russians. An agent of the Third International, a fool who knows nothing of industry, a gangster who was piling away a fortune in banks in India.

By the time he got to Shuangshipu, his enemies had seemingly triumphed. In 1942 he had been summarily fired when it was alleged that some of his Gung Ho factories had been forging guns and weaving blankets specially for the Chinese Communist armies. The Nationalists were infuriated, not least because Chiang Kai-shek had personally seen to it that about $2 million in government funds had gone to help Gung Ho establish itself.

So Alley was removed as field secretary, and demoted. He remained on the payroll of the cooperative, but his duties were downgraded to those of a teacher in the schools that trained the Gung Ho apprentices. These were known as Baillie Schools, after the Ameri-

can missionary Joseph Baillie, who had first recognized the need for technical training. Since the students were invariably young and male, Alley took his demotion in high spirits, and by the time Needham came to meet him in the summer of 1943, he was contented and philosophical in his new incarnation as a master in a school for young boys.

The damage to the truck was far worse than Needham expected, and he would have to spend some time in town while the necessary repairs were made. So he set out to look for Alley, going first to the Baillie School behind the town gasworks, and then to Alley's famous cave house—but the great man was bathing. A servant was sent to fetch Alley; and while he waited, Needham looked in on a cotton-spinning cooperative that was just being built, and traipsed through a machine shop that had been set up some months before.

Finally Rewi Alley arrived. The men shook hands; took off for the curious cottage-cum-cave where the New Zealander had lived for the past year; and had high tea—corn on the cob, honey, the large flatbread known as *da bing*, eggs, tomatoes, and coffee. (Needham developed a peculiar liking for bread and honey from that moment on, and for the rest of his life. On his eightieth birthday Gwei-djen reminded him of how, "when one is hungry in China, and when one feels like

a sweet taste, schooled by Rewi Alley, one goes to the drug-shop and buys a jar of honey to eat with the cart-wheel Gansu bread."

The men next went to the school, where by now the boys, an irrepressible group numbering about sixty, most in their mid-teens, had been primed to line up and perform for their distinguished diplomatic visitor. They sang folk songs from the Chinese northwest, and both Needham and H. T. reported being deeply moved by one haunting melody—it was twilight, and as the boys sang the flag was lowered for the evening.

Then Needham took the stage and sang a medley of English folk songs, his thin, high voice clear in the evening air. He sang "Lilli Bulero" and "The Saucy Spanish Boy," and after concluding from the applause that it all had gone well, he decided to forget how foolish he might look in front of the children, ripped off his army jacket, rolled up his sleeves, picked up a heavy stick—and for fifteen breathless minutes performed a series of particularly wild and whirling old English morris dances, singing lustily all the while. To all who saw his performance that August evening the image of morris dancing in China remained profoundly haunting. It left the schoolboys open-mouthed with astonishment and, Needham later assumed immodestly, delight.

He said later that he felt that while he was no Fred

Astaire, what he lacked in elegance he made up for with historical accuracy and gymnastic enthusiasm. One of his colleagues agreed, writing: "Dr. Joseph Needham/ Dances with philosophic freedom./You'd better watch your toes if/You dance with Joseph."

The friendship with Rewi Alley was sealed. Needham did not care one whit if homosexuality kept Alley in China, or specifically in this remote corner of China. In later years Needham, though an ardent heterosexual himself, would champion the cause of gay men and women—and in all likelihood he did so in part because of his deep admiration for Alley, whose sexual habits were unashamed and flamboyantly expressed.[23]

His headmaster in Shuangshipu, a young, aristocratic Englishman named George Hogg, was later to write of life in Alley's peculiar house:

> The main distinctive feature of Rewi's cave in Shuangshipu is exactly the same as that of his former house in Shanghai—that at any time out of school hours it is filled with boys. Boys looking at

[23] At least, they were until 1949. After the Communist revolution Alley had to keep his inclinations hidden, since they were illegal. He was compelled to return to the closet, a fate which he found vexing.

picture magazines and asking millions of questions. Boys playing the gramophone and singing out of tune. Boys doing gymnastics off Rewi's shoulders or being held upside down. . . . Boys pulling the hairs on Rewi's legs, or fingering the generous portions of the foreigner's nose. "Boys are just the same anywhere," says Rewi. "Wouldn't these kids have a swell time in New Zealand?"

North of Fengxian the scenery changes almost in an instant. The mountains, which up to this point on the journey had been of unforgiving granite clothed with stands of bamboo, give way at the summits above town to soft rolling hills, all terraced and gorse-hedged and with small flat expanses for wheat, corn, or paddy, and with the soil, most significantly, a warm shade of yellow.

This yellow soil gave its name to the Yellow River, into the wide valley of which Needham's trucks were now beginning to make their long, slow descent. The Yellow River, the Huang He, is yellow because it tears away from its banks a huge amount of this rich soil— 1.5 billion tons each year—and carries it unstoppably down to the sea. This is the muddiest river in the world, thirty-four times as muddy as the *eau de Nil*–colored Nile. The mud, say many Chinese, *is* China. The

Huang He has long been known as "China's sorrow" because the river is tearing out China's heart and pouring it into the ocean.

The soil—fine, friable, and easily plowed—is known as loess and was so named in Germany, where geologists first noticed it. The common belief is that it is the windblown relic soil of the last great Ice Age. It is thick and extensive—loess deposits are found all over central Europe and central Asia, in vast tracts of northern China, and in the central plains states of America. It is much loved by farmers, being defined by one Victorian as "a loose light soil of prodigious fertility, and the joy of the agriculturist."

But it was not much loved by Joseph Needham, who discovered just outside Huixian that the Yellow River's tributaries are as loaded with silt and yellow loess as the great river itself. "We reached a difficult crossing—a sea of mud, the mountains dissolving like dilute brown cream. Rewi paddled and checked it." [24] Three trucks—

[24] Needham had taken Alley along for a ride to find new and safer quarters for a new Baillie School, since the Nationalists were starting to harass Shuangshipu, trying to press-gang boys into joining their battle-depleted army. In the end, and with Needham's help, Rewi Alley did find a new location in the old Gobi Desert town of Shandan. George Hogg, the English headmaster, then led the sixty children across the mountains on foot, a 600-mile epic that ranks with

Needham's two and one other, a stranger—were stuck for many hours in the torrents of mud. Needham, patiently waiting it out, contented himself with photographing the peculiar waveforms in the river.

Needham noticed one other change in the landscape. The first evidence of the presence of Islam appeared just beyond the town of Huixian. "Visited the mosque . . . very beautiful," he wrote in his diary. "Must be the most easterly mosque in Central Asia." He made a drawing of it and wrote a caption with an additional description:

> Mosque hall, garden, terrace with three old men sitting on it, ablution courtyard, road spirit wall; towers of three stories ([with a] muezzin) in Chinese style with Arabic as well as Chinese inscriptions. This included arch in lower storey. Mullah's house with his own ablution pavilion. Bamboo-shaped bricks in the arches. Brick panels of rhomboid-

the achievements of Gladys Aylward in the book *The Inn of the Sixth Happiness,* which recounts her trek with similarly displaced children to an orphanage in Xi'an. George Hogg himself died of tetanus en route after cutting his toe while playing basketball with the children: he was just twenty-nine. The Canadian director Roger Spottiswoode added a sprinkling of fictional elements to the saga and turned the story into a film, *The Children of Huang Shi,* in 2008.

shaped bricks. Trees very pretty. The whole well-painted and kept up. Everybody very friendly and obviously proud to be Muslims.

As it wore on, the journey became worse and worse, with the trucks behaving impossibly. Each day the party was held up because of broken head gaskets, oil leaks, transmission problems, flat tires. So accustomed were the travelers to mechanical upsets that a fractured piston or two seemed a mere bagatelle, and Needham met each episode with equanimity and good spirits. "Bought marvellous peaches," he would write. "Sun came out. Had nice breakfast." "Lovely rugs. Pots of flowers everywhere." In one village he found that the people were less than fetching, being "very poor and smelly," but he was thrilled to find that their daughters had *bound feet*. The village woman still wrapped young girls' feet in long cloths—having broken their toes, sliced into their soles, and pulled out their nails to speed the process of creating the "lotus feet" that men seemingly craved. Needham exulted over the discovery of a custom which, however barbaric, had not been completely eradicated. The republic had banned the practice from 1911 on and had ordered all women to unbind their feet—but the unbinding was as painful and crippling as the binding had been in the first

place. Needham, while revolted, found it all fascinating.[25]

He kept discovering treasures that he knew would be useful for his book. "Found Song dynasty pottery shards in a fort above the village," he recorded at one enforced halt—and then whiled away the time waiting for the mechanics to repair a water pump, or some such, by ruminating on the methods of early Chinese ceramicists, and of how their techniques of throwing, glazing, and firing had been much more advanced in China in Song times—the tenth and eleventh centuries after Christ—than they had been in Europe. Lord Macartney's China trade expedition of 1792 had brought newly created pottery from Josiah Wedgwood's factory in Etruria as a gift for the Chinese emperor: small wonder, Needham noted, that the emperor huffily refused to accept the pieces—English ceramics must

[25] Precisely why so many Chinese men were so entranced by bound feet has never been satisfactorily explained. Women's tiny lotus-shaped shoes were said to thrill some men—but most of these same men were aghast if a woman removed her shoe to display the wrecked foot inside. The so-called lotus gait of women with bound feet was also said to attract some erotic interest. Gladys Aylward, the missionary whose life was famously told in the book and film *The Inn of the Sixth Happiness*, was an early campaigner against the practice: her grandfather in London had made boots for the disabled.

have seemed primitive to him in comparison with the Chinese porcelain of the day. (Some scholars offer an alternative explanation for the emperor's refusal. By deigning to accept the gift of Wedgwood he would have been tacitly admitting that the English ware perhaps actually *was* of a quality equal to that made by his homegrown craftsmen. Such an admission would have resulted in a loss of face for every ceramicist in the empire.)

But then, as the problems with the trucks worsened, the mood turned more bleak. The head gasket blew again, and this time they had no more spares because— to Needham's intense chagrin—Eric Teichman's driver had taken them all. "Triple damn old Tai," the diary notes—the only profanity seen so far. There would be more.

That night they had to sleep in a room with a pig, which didn't improve Needham's temper. The next morning they tried to fashion a new gasket, first by hammering flat Rewi Alley's aluminum shaving-soap dish and covering it with cork. This blew out at the precise moment the truck was trying to cross a shallow stream. They were stuck in the middle when, alarmingly, another truck went by with the passengers all shouting "Flood! Flood!"—and sure enough within moments the stranded flagship of the Sino-British Sci-

ence Cooperation Office expedition was under eight feet of water, and what had been merely immobile was now inundated, to boot.

The next day they hauled the damp, damnable Chevrolet out of the mire and made another new gasket, this time out of an old canvas bag. It lasted for just five minutes. "NBG," wrote Needham: "No bloody good." Needham and H. T. then left the truck altogether and hitchhiked, riding first, and very uncomfortably for about sixty miles, on top of an unstable clutch of gasoline drums in the back of an army transport: it rained and was intensely cold and the pair huddled miserably under a tarpaulin—Needham wishing, no doubt, for a cozy fire and tea and crumpets in his rooms at Caius. The truck driver eventually dropped them off at a junction; they took a rickshaw to a village called Lizhishi; found an Indian-made gasket for sale; hitchhiked back again: and were at their own truck by nightfall. The mechanic installed the gasket, and the truck worked perfectly. But then Needham developed a crippling toothache, which put him out of action for two more days.

Eventually they crossed into Gansu province, and after another day reached its biggest city, Lanzhou, a dire place best known today as the most polluted city in the world. In Needham's time it was known for another reason: it was one of the few places where a

bridge crossed the Yellow River, and this bridge might be sturdy enough to take the convoy of trucks. If Needham crossed the river and turned left, then he would be on the old Silk Road, and well on the way to Dunhuang and the caves.

On Early Suspension Bridges

In this region (Chang-ku, now Tan-pa, on the Sichuan-Xizang border) there are three suspension bridges. Hundreds upon hundreds of stakes and piles are driven in on the two banks of the river, and stones heaped over them. Long bamboo cables are suspended between them, with wooden boards laid down, and large ropes at the sides to help the traveller to support himself. Passengers walking over these bridges feel their feet declining and sinking as if they were on soft mud. But such bridges can be built where no stone structure is possible.

—FROM *CHIN CHUAN SO CHI*, BY LI XINHENG,
SEVENTEENTH CENTURY

There is the site of a cable suspension bridge market just at the point where the line of the Great Wall crosses the Yellow River southwest

of Ningxia and turns northwest to cross the Gobi Desert and protect the Old Silk Road.

—JOSEPH NEEDHAM

From *Science and Civilisation,* Volume IV, Part 3

By the time they wheezed gingerly across the half-broken bridge into Lanzhou, everyone in the party was tired and dejected. Being mostly British and therefore generally phlegmatic, they elected to stay put awhile, so that full repairs could be carried out on their vehicles. They would replace all the doubtful-looking gaskets, springs, oil pumps, and piston connecting rods that had plagued them since Chengdu; and to do the work they hired a man named Liu who, it was claimed, was the finest mechanic in the Chinese northwest. Needham, his tooth recovered, promptly took off to explore.

For the two weeks of his enforced stay in Lanzhou he buried himself in as much book-related science and technology as he could find. He talked to biologists at the Epidemic Prevention Bureau, to a man who made windmills and was trying to detect water underground with a technique more sophisticated than dowsing, to experts on potato viruses and horse illnesses and to vets who knew all about the strange problems that afflict sheep in the Gobi Desert. Needham looked around a machine works, a dry battery factory, a flour mill, a

power station, and a hospital so modern that the lights in its operating room had mirrors incorporated inside them, the better to illuminate the patient. He took a raft across the Yellow River to see some people called Bairnsfather, found others with unusual names—a bishop named Buddenbrook, an American named Lowdermilk—and noted with pleasure that at the local technical school a man from Java was teaching two boys from the Tibetan frontier about engineering drawings, while a Chinese-Tibetan girl was doing the accounts.

He also did a series of routine, quotidian, and generally pleasant things—he had a haircut, bought himself a sheepskin coat and a set of wonderfully warm Gung Ho blankets, and stumbled across a German mission library where he luxuriated in being able to read year-old newspapers from Berlin. He found cartons of cheap but tasty Russian cigarettes and locally made, less tasty fat cigars. He also had soapstone seals carved with his Chinese name and various honorifics.[26] He ate moon cakes (during the Chinese autumn festival, which took

[26] His usual Chinese name, Li Yuese, had by now been augmented with two others given to him along the way—Shi Xin Dao Ren, which translates as "the Taoist of ten constellations"; and Sheng Rongzhi, which very roughly translates as "the master who is victorious over confusion." He had the Lanzhou carvers make all three, and used them sometimes to sign his letters, causing much confusion.

place while he was marooned), and bought wool and darned his own socks. Finally, he had a tailor run up some khaki cotton trousers, and wearing these and his freshly polished Sam Browne belt, took the local American consul out to dinner in a Muslim restaurant.

But Needham was also rather frightened, by a number of unsettling experiences and by a torrent of highly unsettling dreams.

Lanzhou was a city poised uneasily between battlefields, where conflicts of one kind or another were invariably in full flood—fights between Japanese and Chinese, between Nationalists and Communists, between untamed warlords, between frontier tribal rivals, between Russian invaders and frontier protection authorities. All of these left sad, struggling human detritus in their wake. Needham reported seeing, for example, large numbers of captured rebel soldiers "tied like hogs" and being led off to be shot. He saw "a tall country girl" trying to offer one of these wretches a bundle, before being struck full in the face by a guard's rifle and told to be off. He saw what he referred to as a "trachoma squad" of bewildered soldiers from Sichuan, who appeared to have no idea where they were and behaved like "the blind leading the blind." He came across groups of malnourished, waiflike children, military camp followers who, he noted with distress, kept

dying overnight. Eighty-eight of them died during one particularly ghastly stop, according to Rewi Alley.

After days of distressing sights like these, it was perhaps not entirely surprising that Needham's sleep suffered, and that his nights were interrupted with bizarre imaginings. As it happens, though, his nightmares had no obvious connection to the miseries of China, but were in fact all related to anxieties over his life in Cambridge. One of them was quite simple—he dreamed he had lost his readership in biochemistry, that he was arguing with the people at his laboratory, and that he thought he might not be allowed to come back to England once his stint in China was done. This was perhaps due to his anxiety over air travel, which he hated and had to steel himself to undertake.

Another dream he found less obviously explicable. He had been standing on a railway platform with his wife, Dophi—the notation in his China diary relating to her is in Greek, as was his custom—when an express train flashed past, collided with a vehicle, and threw out a woman's body, "which splashed." Seven other women then rose up, one from between the railway lines, and, terrified, they all rushed away. Then soldiers came, and Needham tried in vain to find the stationmaster to tell him what had taken place. "It was all very vivid and startling," he notes. "Was it a premonition of danger?"

If nothing else these dreams—and there would be others, especially when the nighttime weather in China was dramatically bad—reminded Needham that, however irritating the daily difficulties of travel, his life in China provided him with a great escape. The professional and domestic trials of his everyday academic and domestic life were far away and out of sight—and if his subconscious chose once in a while to nudge his elbow and force him to think of Cambridge, of biochemistry, of his religious convictions, of his mother (who by now was near death), of his wife and his mistress, and perhaps of the consequences of his normally careless liking for sexual adventure—then perhaps it was a small price to pay. A few bad nights in exchange for a life of such license as he now enjoyed seemed a bargain, he later wrote, that most would be willing to accept.

They left Lanzhou, their truck supposedly mended, in the middle of September. The team's makeup had changed somewhat. Ed Beltz, the American geologist whom Needham had very much liked—he was "49, an excellent chap, and tough"—had left to work at an oilfield in Gansu province. Liao Hongying, the beautiful chemist from Somerville, had opted to stay behind in Lanzhou, ostensibly to help in a local school. And Sir Eric Teichman had gone off, too, bound for the

far frontier. Needham was sorry to see him go, for although his high-handedness (particularly in the matter of requisitioning trucks and drivers) had caused some inconvenience, his intelligence and courage were of the first water.

As it happened, Needham was never to see Eric Teichman again, and for the most melancholy of reasons. After Teichman left Lanzhou he traveled along the outer Silk Road and across the deserts of the Tarim basin; crossed the Chinese frontier, as planned, for the Pamir Mountains; and finally arrived in India, his months of wandering passing without unanticipated incident. He was then flown home from New Delhi. But a few days after he had returned to his country home at Honingham Hall in Norfolk, he disturbed an American serviceman who was poaching on his land, and he was shot dead. He was just sixty years old.

Needham later described Teichman as a great mentor, and his death as a terrible loss. Perhaps the passing of the funeral cortege in front of Teichman's truck in Chongqing had been an augury, after all.

Rewi Alley alone would continue with Needham to look for a site to build a replacement school—and so the party heading up north now comprised merely Alley, H. T., and Needham, who wrote as they set off, "I

simply had no idea, before I took this North-Western trip, of the sort of thing it would be. Great mountain passes, overwhelming scenery, unpredictable roads, bridges broken down, roads washed away . . . strange places to sleep in night after night."

Beyond Lanzhou the road divides—to the left a main branch heads toward Tibet; and then to the right at a further junction, a small road heads off in the direction of the Tarim basin and the notoriously hostile Taklamakan Desert. Needham took neither of these, but opted instead for the first main branch to the right, along the narrow, 600-mile defile known as the Hexi corridor, the sole passageway for traders from the outer west into China, and for most of the country's history also the only way out.

His trucks bumped along what was then little more than an execrably surfaced track. They shook themselves free of the loess hills and the choking yellow dust and muddy rivers that had caused them so much motor trouble, and headed north toward the dry grit and cold of the Gobi Desert. For several hundred miles they marked their progress by following roadside markers and the path of the western extension of the Great Wall.

On the left rose a snow-dusted mountain chain, the

Nan Shan, which in Needham's time was known as the Richthofen Range, having been named for its discoverer, the Red Baron's explorer-geologist uncle, Ferdinand Richthofen. On the right ran what looked like a low line of adobe, twenty feet high, with dozens of caves hollowed out at its base. This rather sorry affair, crumbling and inhabited—for people lived in the caverns, and large mastiff-like dogs would rush out and bark violently on being approached—was the relic of the original Great Wall, formed of rammed earth, stones, sticks, and (it is said, surely apocryphally) the bones of its builders.

There was almost none of the brick-faced reconstruction which went on during the Ming dynasty of 600 years ago, and which gives the Great Wall elsewhere its look of impregnability and permanence. In the far west it is a rather pathetic affair, crumbled, weather-beaten, and—since it ends in a Ming fort at the village of Jiayuguan 200 miles from where it runs alongside the Silk Road—all too easy to skirt. Almost any Mongols and other marauders would have found it a comprehensively ineffective barrier, no better than an Oriental version of the Maginot Line.

It does, however, mark a frontier—topographical, geological, anthropological, linguistic—and so is a reminder of why it was first built. Within its supposedly

secure confines lies China. Without is the barbarian beyond, and the names of the towns and villages that lie on the far side of the Great Wall in the west—Ehen Hudag, Amatatunuo'er, Ar Mod, Qagan Tungg—are clearly those of an alien people, unconnected with the Chinese, other than being their neighbors and, in Needham's time, their vassals.

The high grasslands here, vivid green and speckled with grazing sheep, reminded Needham of the South Island of New Zealand, or the *machair* of western Scotland; and when he first saw the Great Wall there was a spectacle in the making, with a thunderstorm boiling over the southern mountain ranges, and little naked shepherd boys in fur cloaks running into the caves for shelter.

He loved the fact that the more distant hills rising out of the Gobi were called the Cinnabar Mountains, and he thought the whole conjunction—of names, weather, and great antiquity—was vastly impressive. He thought this even more when he crossed a cwm called Black Crow Sand Pass, raced down the slope on the far side to the nondescript village of Anyuan, lunched at a nearby mission, and discovered that its abbot was from England and, moreover, an Old Etonian. Only later that night, when the truck broke down yet again and he had to spend the night in a truckers' rest stop, did his equa-

nimity falter: his night, he said "was like sleeping in a public lavatory with cocks crowing under the bed."

Northwestward the scenery became harsher, more desertlike. Soon there were camels. At first most of them were solitary, but later Needham saw some harnessed together, in baggage trains. These were Bactrians, with two humps and a great deal of hair; and though they appeared to be numerous enough in Needham's day, an innkeeper in the oasis of Shandan[27] recently reported that they have become very rare, and are currently endangered. There are maybe 500 Chinese Bactrians in the world, the innkeeper said, most of them living and working in this lonely part of Gansu province.

Beyond Shandan was Jiayuguan, the rather ramshackle fort of turrets and angular baileys that the first Ming emperor threw up at the western end of the Great Wall in 1372. This, sited in what is known as the "First Pass under Heaven," was the place where exiles used to be sent, to be dispatched to the dismal lands of the great beyond, far away from the civilizing delights of

[27] This lovely old walled town was where Rewi Alley eventually decided to move his Baillie School, down from its threatened site at Shuangshipu. George Hogg and the sixty young pupils walked where Needham had driven, reaching there eventually (though without George Hogg, who died) after much adventure and heartache—sufficient of both to fascinate Hollywood.

the Chinese empire. Jiayuguan was also the site of the first imperial customs post. All who came here from the great beyond—all the camel trains that trekked in from Arabia, and came up and over the Pamirs and the deserts of Central Asia—could pay their first taxes and fealties to the representatives of the Beijing court, no matter that they still had 2,000 miles of trekking before reaching the capital. And even when the capital was at Chang'an, today's Xi'an, it was still 1,000 difficult miles away.

The westernmost entrance of the fort, the most distant from the Chinese center, is known as the Gate of Sorrows, and through it were sent all those doomed to be exiled. For those dispatched through it by imperial edict, it was a gate of no return, and it was popularly known simply as "China's mouth." To be within, to be "inside the mouth," was to be safe, whole, content, one of the Yellow Emperor's beloved children. To be beyond it, however, beyond the reach of the Celestial Empire, was to suffer a dreadful and unimaginable fate in a land of monsters who had red hair, drank milk, had eyes in their ribs, and wailed in perpetual pain.

In the final days before he reached his goal, Needham spent many nights at lonely hostels in the Gobi Desert. These were run by the New Life Movement, one of Chiang Kai-shek's half-baked schemes for reviv-

ing Confucian ideals. Needham liked the inns, noting that in one the spoons came from Leningrad and that another had been built into a sandstone fort resembling one he remembered in Dubai, in southern Arabia. The shops he found were stocked with Russian goods; the smuggled Japanese canned foods that could be found elsewhere had clearly not penetrated this far.

And then, at the end of September, almost two months after leaving Chongqing, and 300 miles farther on, he was finally at his destination, Dunhuang. Out of the sand suddenly rose the green trees of the oasis—and somewhere nearby were the caves.

At first it seemed as if this might be a bit of a let-down. Needham's diary suggests that he was somewhat underwhelmed. One has to imagine that after getting bogged down more times than he cared to relate in the fine white sand that surrounds the town, he was now simply dog-tired. His remarks relate to comfort far more than to culture: Dunhuang, he noted, was very clean, and the nectarines, the pears, the crabapples that looked like large cherries, and the Hami melons from the great Turfan depression some miles ahead were "most delicious."

The following day he did drive out, as planned, to see the town's famous caves, the hundreds of hidden cliff-grottoes which housed innumerable paintings

and carvings of the Buddha—and where the Dia-
mond Sutra had been found. But his notations are still
perfunctory—"worked on caves all day" is about his
only written remark, and seemingly written without
very much enthusiasm.

But this would all change, thanks to what, in view
of the earlier experiences of his epic journey, he might
well have anticipated. The truck broke down once
again—this time so catastrophically (its main bear-
ings sheared) that Needham and his party would be
stranded—not for the next six hours or six days, but
for the next six weeks.

The Dunhuang oasis, where palm trees and melon
vines suddenly rise out of the endless sands of Turke-
stan, exists thanks to a river called the Daquan, and
to a small body of crystal-clear water called Crescent
Moon Lake, which, despite being surrounded by fan-
tastically high dunes, is by some hydrological mystery
never filled in. The view from the highest range of
these dunes, the Hills of the Singing Sands, is unfor-
gettable. Dawn is the best time to climb: the sky (like
the lake) is invariably crystal-clear, the robin's-egg
blue of early morning. The lower dunes rise and fall
and glitter, immense sharp-sculptured waves of pale
yellow crystal, as far as it is possible to see. The sun
rises fast over a white-hot horizon. To the west, toward

the trackless wastes of the Taklamakan and Lop deserts, all is still dark, but cloudless, and the summits of the distant dunes are tricked out with gold as the sun catches their edges.

And then, rising from between the closer dunes, their vertical spires contrasting dramatically with the desert realm of the horizontal, are green trees by the thousands. There is water, somewhere nearby. This truly is an oasis, a place of refuge and settlement—and among the trees there are buildings that glint as the sun catches them, scores of structures, the upswept eaves of a nest of pagodas, the minarets of a mosque or two, a cluster of hotels.

Dunhuang is the most important junction of this section of the Silk Road, a place where the merchants and pilgrims of centuries ago had to decide whether to pass to the north or to the south. If they were heading toward India and Arabia, the southern route was the better; if bound for Antioch and the Mediterranean, they would strike out to the north. Dunhuang was where travelers on the outbound journey would rest and decide which route to take; and on the way home it was where they would rest and give thanks for having survived.

Of the hundreds who passed by way of the Dunhuang junction, the Buddhists in particular offered the

most profuse gratitude. They did this in three specific sites near the town, in gorges made by the river where the eroded cliffs stood tall enough and wide enough to allow the creation of what Indian Buddhists had long ago shown a liking for—scores on scores of intricately decorated caves, designed specifically for their mendicants and meditations.

Of the three cave sites, by far the largest and most important was a cliff, one and a half miles long, at Mogao. Wandering monks began incising caverns into the soft sandstone cliffs of Mogao and in neighboring valleys during the fourth century, and by the time the last cave was dug in the fourteenth century, more than 700 had been created—some as small as coffins, and made for sleep and shelter; others many stories high, containing gigantic statues of the Buddha, and used for worship and salutation.

One of the twentieth century's memorable explorers of Asia, the Hungarian-born British citizen and archaeologist Marc Aurel Stein, reached this set of caves in the spring of 1907—with consequences that were to have a considerable bearing on Joseph Needham's later work.

Stein, who was born beside the Danube in the city of Pest in 1862, took degrees in Sanskrit, Old Persian, and the new science of philology at the universities of

Vienna, Leipzig, and Tübingen. By the time of his discoveries in Chinese Turkestan he was in early middle age and revered for being doughty, implacable, imperturbable, and case-hardened to any trials that might befall him on the road. Since the beginning of the century, when he had completed a two-volume translation of a twelfth-century Sanskrit work, the *Rajatarangini*, he became obsessed with a single fascinating story: how Buddhism was carried from its birthplace in the high Himalayas of India, across the ranges and into the vast and protectively xenophobic empire of China.

There was no doubt that it had migrated there: the White Horse Temple in the eastern Chinese city of Luoyang had been built in the first century after Christ and was an unequivocal celebration of Buddhism. But how had something so very Indian become, in short order, transported, transformed, and transmuted into something so very naturally Chinese? Stein, plodding patiently through the deserts just north of the mountain ranges, was determined to discover the answer.

His research, and that of other scholars in France and Germany, showed that it was all the work of a number of determined and very peripatetic monks. Some of these monks were Indian, some were Chinese, and in the first decades of the first millennium they had managed, through grim determination and no

doubt some memorable heroics, to carry the message of the Buddha—usually by word of mouth—across the dangerous high-altitude passes between the two great empires. They brought their stories down to the main trade route between central Asia and China that would in time become known as the Silk Road—the same road Needham had been so patiently traveling for the last eight weeks.

Once on the road, the Buddha's word soon reached the Chinese court. As soon as the senior mandarins at Chang'an, or Xi'an, had been shown images of great golden statues of his calming presence, and told the finer details of his teaching, they officially declared themselves impressed. Over time the religion took firm hold in establishment China. When it was fairly well settled, Chinese pilgrims began to make the long, dangerous journey to its source, to see for themselves the fountainhead of their new faith. Groups of translator monks also began to journey and to forage for the details of Buddhism, and in the process began the collection, translation, and dissemination among the Chinese of the great Buddhist texts, the *sutras*.

One of these wandering monks is remembered today in particular, and with reverence. He was Xuan Zang, a scholar's son from the east of China. Tales of his adventures along the Silk Road in the seventh cen-

tury, and of his expeditions to Nepal and India and to present-day Pakistan and Afghanistan, became well-known in Chang'an and beyond. His stories, all based on diaries written with priestly precision, are full of such fantastic happenings that they have survived into modern times—they find their way even today into the comic-book world of Japanese *manga*.

The equally romantic explorer Marco Polo had once been to this same desert, and had also left voluminous writings that Stein studied. But it was Xuan Zang's adventuring that particularly inspired him. The memory and the accounts of this tough old monk led him, eventually and inevitably, to strike out for Dunhuang himself, to find the caves, and to uncover the astonishing treasure trove of Buddhist documents that would make him world-famous. This find would provide even more of an epiphany for Joseph Needham when he himself arrived in Dunhuang, dog-weary, highway-stained, and stranded, thirty-six years later.

4

THE REWARDS
OF RESTLESSNESS

**On the Invention of Words to Describe
Indescribable Chinese Traits**

Nosphimeric was a word which I invented during
the war years. While on my perpetual travels I
often encountered Bishop Ronald Hall of Hong
Kong, visiting one of his outlying Chinese
congregations, and one day we had a chance meeting
at Annan in Kweichow. Talking about various
things at dinner I happened to mention to him that
I needed a non-pejorative word for that squeeze,
graft and corruption which has always been so
characteristic of the bureaucracy in China, and
which had loomed so large in the eyes of the modern
western businessmen who tried to buy and sell
there. Both our trucks were being repaired that

night, and his was finished earlier, so he set off first—but not before giving me a piece of paper on which was written: "see Acts 5:1–11." When I got to the Bible I found it was the story of Ananias and Sapphira, who had promised a sum of money to the church, but then held back a portion of it, and accordingly died, blasted by St. Peter. Now the word used in the Greek New Testament for "to sequestrate" is *nosphizein,* and since *meros* means a part, we can form the adjective required.

—JOSEPH NEEDHAM, 1994

From *Science and Civilisation in China,*
Volume VII, Part 2

B y now Joseph Needham was about as far from the comforts of the West as it was possible to be, more deeply marooned in the outer fastnesses of China than it was possible to imagine. But though he was stranded, he took a calmly philosophical view: the weeks that he would be obliged to spend in the Turkestan desert—he had no idea just how long—would allow him the luxury of reflection, would give him time to take stock, to consider what he had achieved so far, and to plan for what remained to be accomplished.

His most immediate task was clear: the Mogao caves were just a few steps beyond his tent, and it would serve

him well to get to know as much as he could of their story, since it was unlikely, he supposed, that he would ever have the time or the funds to visit them again.

He had studied a great deal about Marc Aurel Stein, and regarded him as a hero, and by the time he reached Turkestan was full of admiration for a man so clever, cultured, intrepid, and inquiring, in many ways much like himself. Needham had no way of knowing that at the very moment he was beginning his own unexpectedly lengthy sojourn in Dunhuang, his hero was actually very close by.

Sir Aurel Stein (he had been given a knighthood for his services to archaeology in 1912) was eighty-one, but he was unstoppably curious, and in 1943 had come to the East again. He was just a few hundred miles away from Needham, across the Hindu Kush mountains, staying with the American legation in Kabul. He was there to realize, or so he thought, a lifelong dream: to mount an expedition to look for the fabled city of Balkh, which followers of Alexander the Great had supposedly founded 2,000 years before in deepest Afghanistan.

Needham also did not know—and would not know until he returned to Chongqing in midwinter—that Stein had fallen gravely ill in Kabul. On October 27, a day that for Needham happened to be quite diabolical—"packed up first thing, hoping to start . . .

became a nightmare day . . . couldn't start the engine . . . fifteen soldiers pushed . . . eventually got it going . . . bearing had been too tight"—Stein's illness worsened dramatically, and he died. It adds a certain irony to the story: the single greatest discovery Stein made at Dunhuang in 1907 was, in all probability, the single object that most inspired Needham to write his great work in China—and yet Needham's realization of this came, almost to the day, when Stein's own life came to a close.

The story of the discovery made at Dunhuang is that of legend.

Stein had left his exploration base in Kashmir the previous year. He had prepared well for a journey to this corner of Turkestan, from which he had heard rumors of fantastic finds—fabulous treasures that he believed the world at large should see. He made certain he was as well-equipped as he could be: his maps and books in tin-lined cases to protect them from ants, surveying instruments, ropes, leather repair kits, bamboo poles for the tents, plenty of guns and ammunition, telescopes, bandages, needles, safety pins, and a morning coat and pin-striped pants so that he might impress any mandarins he encountered. He left behind presents for all the friends whose birthdays he would miss while he was

away. And he took plenty of food for his dog, which—like all its predecessors and successors, seven in all—he called Dash. He was a scrupulous man—small, tough, and very attentive to detail.

It took him half a year to reach the western interior of China, and for most of the winter of 1906–1907 he was navigating the harsh sand deserts of Turkestan. During February and March he had been pushing eastward across the immensity of the Lop desert (where in more recent times China used to test atom bombs), with his men on donkeys and camels and with blocks of ice carried in straw baskets in lieu of water. The donkeys had died; the water was almost gone—and one day in late March an icy storm known locally as a *buran* was blowing a full gale, chilling everyone blue.

And then, suddenly he reached this oasis. A few miles later on—for he wanted to waste no time—he came to Mogao, and the caves.

They were quite fantastic. There were enormous sculptures, intricate rock carvings, icons. Most of the cave walls were covered with painted images. Some caves contained hundreds, perhaps thousands, of painted, brilliantly colored images of the Buddha, all identical, each hand-painted or block-printed onto the wall no less than 1,300 years ago, and so fresh they looked as though they had been completed yesterday.

And then there was the roof—every square inch of some of the caverns was similarly covered. These illustrations were all scenes—eighty-six of them, and each different—showing the various stages in the Buddha's life. They were from the Northern Zhou dynasty, which flourished from AD 557 until 588.

There were enormous white-limed and colored statues of women, horses, and Buddhas—Buddhas galore—and in other caves there were images of men and women who looked distinctly Indian. They had been created long ago by artists who saw Buddhism as a theology coming from below the Himalayas and having little about it that was Chinese. And two of the more enormous caves held stupendous Buddhas 100 feet high, huge and splendid and precious, thought Stein, for all mankind.

The best was yet to come. Just inside the main doorway of one cave there was an opening in the wall, on the right-hand side. This is the tiny cavern that has since come to be known as Cave 17. The fact that Aurel Stein saw it, and saw into it, has to do with a local Daoist monk whose name—Wang Yuanlu—is both revered and reviled today, for what he subsequently did.

Needham knew the story well. It started when Wang, who lived in Dunhuang at the end of the nineteenth century, decided to appoint himself guardian of the

caves. No one else was looking after them; no one ever visited them; and he feared that they were crumbling away and would soon be inundated by the ever-shifting sands. He thought he would try to do a little restoration of the crumbling statues and the peeling paint, and he started to do so with all the gusto of an enthusiastic amateur. While he was working in what is now known as Cave 16, repairing the statue of a horse, he noticed what appeared to be a hidden doorway to the right of the entrance, covered with stucco and painted over.

He ordered it broken open—and inside he found an immense trove of scroll documents, tens of thousands of ancient paper volumes, hundreds of silk banners, and yard upon yard of textiles.

Word of the find quickly leaked out. Officials in the Chinese capital ordered the treasures to be sent to a nearby city for safekeeping, but no transportation could be found; and so Wang was ordered to reseal the little cave and await orders. This he did—for a while. But he made his great mistake in May 1907, thirty-six years before Needham's visit, when he opened up the cave once again. This time it was to satisfy the wickedly persuasive Stein, who was on his collecting expedition for the British Museum. Stein had heard about the collection of documents, and realized that the answer to the question which had nagged at him for so long—how

Buddhism had come to China—probably lay within their texts. The contents of Cave 17 were Stein's Holy Grail, and he just had to have them.

"Heaped up in layers," Stein wrote of the contents that would in time come to be world-famous, "but without any order, there appeared in the dim light of the little priest's lamp a solid mass of manuscript bundles rising to a height of nearly ten feet, and filling, as subsequent measurement showed, close on 500 cubic feet. Not in the driest soil could relics of a ruined site have so completely escaped injury as they had here in a carefully selected rock chamber where, hidden behind a brick wall . . . these masses of manuscripts had lain undisturbed for centuries."

He wanted them. He wanted them badly—more than anything else he had ever seen. Scholarship needed them, he argued, so that once and for all the world could know how the Buddha came to China.

And so, by way of a bargaining minuet of elegance and subtlety, and by eventually shelling out just 220 of the English taxpayers' pounds—a paltry sum that all Chinese schoolchildren know well to this day, a grisly example of western perfidy—the visitor managed to persuade the poor, grinning, stupid monk Wang

Yuanlu to hand them over. To sell to a foreigner, in other words, virtually the entire contents of the cave.

Stein then began taking the papers away. He took, and he took, and he took. And by the time the orgy of taking was over the monk had handed over to the visiting Briton what would be twenty-four wagonloads of papers: thousands and thousands of ancient objects, comprising, everyone now agrees, one of the richest finds in all of archaeological history.

Most important of all were the scrolls that had been carried by wandering monks hundreds of years before, written in languages as different as Sanskrit, Manichean Turkish, Runic Turkic, Uighur, Tibetan, Sogdian, Central Asian Brahmi, and classical Chinese. There were also star charts—the oldest in the world, fashioned in the Tang dynasty between the seventh and tenth centuries, and showing the sky in the northern hemisphere, with the Big Dipper and Polaris as easily recognizable as they are in this morning's newspaper.

And there, too, was the primus inter pares, a fifteen-foot grayish-yellow scroll, which had a colophon suggesting, incredibly, that it be given away free to anyone who wanted a copy—and which is now known as the Diamond Sutra.

This was the object that answered the most urgent of

Stein's obsessions, the object that so impressed learned Britons in London when they first saw it, the object that so impressed Joseph Needham when first he heard of it in Cambridge in the early 1940s. This one document, covered with Chinese writings and with pictures of the Buddha and other sacred scenes, was not, as everyone had first supposed, a manuscript. Rather, the Diamond Sutra had been *printed*. It was the result of wooden-block printing, and in all likelihood hundreds, perhaps thousands, of copies had been made, and this was the only one to survive.

Until the discovery of this sutra in Cave 17 it was assumed—one might say it was arrogantly assumed—that a westerner had printed the first book. But here was firm evidence to the contrary: here was proof that a dated document—the Chinese translation of a Sanskrit Buddhist text—had been printed from blocks of wood 600 years earlier. Here was immutable proof that a technique long assumed to have been a monopoly of European inventors in fact owed much to far more ancient creators, in China. Here was a clear indication that China was no backward nation but for much of its great age a highly sophisticated civilization, the certain fount of at least this one human invention, and quite possibly the fount of just about everything else important that was known to the outside world.

. . .

Stein was (and still is) widely vilified in China for his trickery and plunder—as were a succession of greedy treasure hunters who came after him.[28] Dunhuang was eventually closed, so terrified were later Chinese governments that more foreign pillagers would take away the treasures. But when Joseph Needham arrived in September 1943 he went as a diplomat, and so was able to enjoy nearly unrestricted access to the grottoes, with no hindrance by fussy officials or soldiers. His access became even more complete once the mandarins in the local magistracy realized how sick his old truck was, and that he would have to spend many weeks on-site.

He made full use of this access, and of his time. Day after day he sketched and photographed the caves in great detail, to the point where he believed he might have enough material to publish a monograph—Dunhuang in those days being generally unknown and highly exotic. He was charmed by the sound of wind chimes at a temple, which he heard while sitting silently

[28] Among these was Langdon Warner of Harvard, an art historian who in due course carried off twenty-six of the Dunhuang caves frescoes, and did so with such dash and swagger that he became one of Steven Spielberg's models for *Indiana Jones*.

in the desert on a brilliant moonlit night. He cursed when robbers stole the razor blades he had bought in New York the year before, when he was with Lu Gwei-djen, to whom he now wrote a letter almost every day. He found and "poked about" in a Han Chinese fort and in any number of previously unvisited stupas. He celebrated the "double tenth"—the anniversary of the Chinese revolution, observed on October 10 every year, as it still is to this day—by eating a collation of chocolate cake while standing up outside the cave entrances with a pair of friendly lamas dressed in russet robes and wearing "beads and strange hats." He was chased by a pair of wolves and from then on had to keep fires going at night to scare others away.

He found shortly thereafter the jawbone of what he believed to be a monastery abbot, a discovery that triggered more disturbing dreams and robbed him of some nighttime peace; he swapped a carton of sulfa drugs for a box of locally grown quinces; he went donkey-racing on the dunes. He copied maps from various books about the Silk Road by the great American scholar Owen Lattimore. He attended an immense parade for a local city god and ate a very non-Chinese meat pie there. He bought and smoked Russian cigars and had a Gobi craftsman cut him a new set of stone seals. And once, when he spent a night at an inn, he

was lying in bed when, thanks to an overheated *kang* below, there was a sudden explosion that burned all of his roommate's clothes. Everyone else in the party had to give the victim spare clothing, whether it fit or not. Needham himself was not much given to wearing proper clothes out here in the desert: as the autumn temperature started to drop he wrapped himself simply in sheepskins or in locally woven rugs.

Before they became marooned for the winter—when the Turkestan deserts become fearfully frigid— Needham decided to send for help. He dispatched his faithful assistant, H. T., into the desert with a pair of donkeys. He told H. T. not to fret about not making it: the animals' own survival instincts, Needham tried to reassure him, would guarantee the survival of any man riding them.

H. T.'s ultimate mission—once he made sure his boss would be rescued—was to get home to Chongqing. He was supposed to ride the animals across the desert to a road where he might catch a bus, find his way by road to Lanzhou, then somehow find an airplane bound for the capital, and once there go to Needham's office and restart the work that the boss was having to ignore— supplying universities with their various needs and or- dering these goods from India.

But his trip home became just as frustrating as the expedition itself. H. T.'s bus slid into a ditch; a car he rented blew a gasket and had spark plug trouble; and when he finally reached the Lanzhou airfield he was ejected from every plane he tried to board, because all the aircraft had been commandeered to carry immense quantities of Hami melons to Chiang Kai-shek and his melon-loving wife.

He waited at the aerodrome for the better part of a month before deciding to return to Lanzhou. When he got there, he found that Needham's party had also made it that far. A crew of mechanics from a desert oil field had done some limited repairs on the engine, the truck had managed to limp to Lanzhou, and a more competent local technician there would make it ready for its 1,000-mile journey home.

There remained one small problem. Although Needham and H. T. were both in Lanzhou, Needham was south of the Yellow River and H. T. was north of it, and the bridge was down.

"So we both spent a great deal of time crossing the river each day," wrote H. T. some years later. "I particularly enjoyed . . . the sheepskin raft, which gave me the sensation of sitting right on top of the churning current. As the weather got colder, chunks of ice began to appear on the water and by early December

the whole river was solidly frozen. It was an awesome sight to see the mighty river turned into a solid sheet of ice, all within the space of two weeks."

By early December, with Needham having done all he could in the Chinese northwest, he joined a long list of people trying to get on the China National Aviation Corporation (CNAC) flight. He had connections aplenty, thanks to his journeying; and after a mere two weeks of waiting, one of them finally worked the necessary wonders. Room was found on a beat-up old American warplane, and crammed in with baggage, melons, and a few other hastily boarded emergency travelers, Needham took off. At five p.m. on December 14 the plane touched down at Chongqing's sandspit of an airfield, where there was an embassy official on hand to greet him. He had expected to be away for a month: he had been gone for four.

Meanwhile, H. T. Huang had still to get home in the wounded old Chevrolet truck. It took him a further month of misery—at one stage he ran out of lubricant and resorted to filling the engine with rapeseed oil. But in late January 1944, five and a half months after leaving, he and Needham were reunited, and the two men were able to breathe a sigh of relief, turn the truck over to the embassy garage, and never set eyes on it again.

There was one other pleasing coda to the journey—
a romance which blossomed right under everybody's
nose, and yet passed unnoticed by all, thanks to the
journey's abundance of difficulties. Liao Hongying,
the pretty young woman whom Needham had dropped
off in Lanzhou, met there a visiting British diplomat,
Derek Bryan. The pair had come back to Chongqing
in H. T.'s truck. During the journey Bryan remarked
on the discipline and efficiency of Mao Zedong's Com-
munist soldiers—and Liao realized that he was clearly
not a stuffed-shirt supporter of Chiang Kai-shek, as in
her view most foreign diplomats were, but rather was
"one of us, one of the people."

They fell in love, were engaged within the month,
were married soon after—and became subsequently
an abiding fixture, first in Beijing and then later in
England among the small corps d'élite who, during the
1950s and 1960s, campaigned in earnest and unwaver-
ing support for the ideals of the People's Republic of
China.

Bryan and Hongying were not communists but, like
Needham, committed socialists. Either way, though,
they incurred the disfavor of the British Foreign Office,
which eased Bryan from the diplomatic service in 1951
after he told an American diplomat that he rather ap-

proved of Mao Zedong's social reforms.[29] They were ardent Quakers, and with Needham they later helped found the Society for Anglo-Chinese Understanding, membership in which was one of the only ways for Britons to be permitted to enter China during its most exclusionary years. They taught Chinese, did research, then spent their retirement in Norwich. When they died—Hongying in 1998, the ninety-two-year-old Derek Bryan in 2003—they left a considerable sum in a trust to help support Chinese students who wished to come to Britain.

However arduous Needham's trip to the northwest had been, its route, as far as any risk from the war was concerned, was reasonably safe. There were essentially no Japanese soldiers to the west of Chongqing,

[29] The Foreign Office swiftly removed Bryan from Beijing, despite his having performed so ably in 1949 during the crisis over the Communists' capture on the Yangzi of HMS *Amethyst*, and offered him instead a post in the British Embassy in Lima. They told him that because of his views he could never return to China as a diplomat. He chose instead to take early retirement. Perhaps it was as well: he had already irritated the British ambassador by complaining that bathrooms at the embassy in Beijing were designated for Chinese or non-Chinese, a form of Asian apartheid.

and the Japanese air raids had more or less ended by 1941.

The same could not be said of the Chinese east. By 1943 Japan was in firm control of much of eastern China from Manchuria down to a point on the coast well to the south of Shanghai; and Tokyo also held tightly on to territory that ran from the old treaty port of Xiamen southwest to the borders of Indochina—Vietnam in particular. All of southern Guangdong province—including, since the surrender on Christmas day 1941, the British crown colony of Hong Kong—was ruled strictly by the mandate of the Japanese emperor. Where the two armies met—the more or less united Nationalist and Communist armies on the Chinese side, the Japanese imperial army on the other—was the ever mobile front. Cities in this swath of contested countryside changed hands with baffling frequency and experienced fighting, bombing, and all the manifold horrors of total war.

Nearly incredibly, however, the Japanese forces let one rockbound stretch of the eastern Chinese coast, 300 miles that very roughly ran along the seashore of Fujian province, remain free of their control. There are many theories as to why, but most probably the planners had decided it was more important to go for the major manufacturing centers and transportation links

and leave the more isolated and unpopulated country-
side to its own devices. So although much of Fujian had
been occupied briefly in the late 1930s, by 1944 it was
back in Chinese hands. And halfway along the coast
was the province's principal city, the former treaty port
of Fuzhou; it, too, was now stubbornly under Chinese
control, and continued to run as it had before the Japa-
nese arrived.

Needham was fascinated. For one thing, it aston-
ished him to discover a British consulate operating in
Fuzhou, in territory that was almost surrounded by
the enemy—the possibilities for espionage, or for other
kinds of mischief, were surely legion. Immediately, he
became curious about how the academic communities
were faring in this part of China, hemmed in tightly
either by the Japanese invaders to their north, west,
and south, or by the sea to the east. And so, with his in-
terest piqued by the extraordinary situation in Fuzhou,
he set out once again.

He began his great "South-Eastern Journey," as it
was later to be called, in April. A few weeks earlier,
his wife, Dophi, had arrived from Cambridge, to take
up the post of his chemical adviser. But he chose not
to take her along. His companion was once again to be
H. T. Huang, and their vehicle would be a converted
Chevrolet ambulance, very similar to the ill-starred

wreck they had taken before, though slightly smaller and less powerful. It was similar but, crucially, it was not the same.

In any case, because of the geography of the Japanese occupation Needham and H. T. had to drive the truck due south[30] and then get aboard a steam train. They rented a flatcar to carry the truck and hooked it onto the back of the train, and for the next five days the railway-obsessed Needham was in an adolescent rapture—"saw first train, with British-looking 2-8-0 with two day-cars and two bogie wagons."

His enthusiasm for trains was much like his ardent devotion to young women, and in his diary he expressed the keenest interest in both almost every day. "Saw many pretty Miao girls in bright kilts"; "face of woman cooking . . . perfect curve under black hair"; "lovely boat-woman, strong and handsome"; "found very nice Jap-trained girl at observatory"; "shared compartment with nice girl of purest Red Indian appearance." His

[30] Their southbound route was not without interest: on their first day they found themselves praying out loud as their truck inched carefully over a mountain pass near Zunyi so steep that the road had no fewer than seventy-two consecutive hairpin bends. A relieved Needham, attempting nonchalance, wrote later that the pale blue irises in the next valley were especially beautiful.

excitement sometimes carried him away: the "Red Indian" girl turned out to be Chinese, from the same school Lu Gwei-djen had attended in Nanjing; and the giant 2-8-0 railway train he discovered was not British at all, but made in Czechoslovakia.

Needham and H. T. soon settled into the routine of train travel, and Needham would get off at every stop to talk to the engineer or to make notes about the various steam locomotives he spotted shunting in the yards. American and British soldiers were everywhere, helping the Chinese hold the front line against

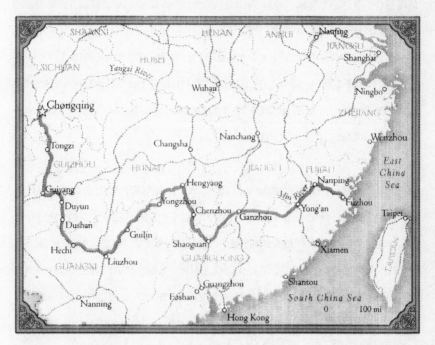

Map of Needham's Eastern Expedition, Chongqing–Fuzhou

the Japanese—and in traveling to their various billets these foreigners took up most of the first-class seats and sleeping compartments.

But one advantage offset the crowding: Americans often traveled with interpreters, and if these interpreters were young women and pretty, the genial old dog from Cambridge had an opportunity to befriend them. On the first day he found Miss Zhao Baoling, a fine soprano whose seemingly inexhaustible repertoire of Chinese folk songs entertained Needham for hours. H. T. felt obliged to write the lyrics down for posterity, for the archives. "It is all *research*," Needham would say. "Sure it is," said H. T.

There was plenty of military activity to keep the soldiers busy: few days passed without Needham's noting an air raid or some other scare suggesting that the Japanese were up to something.

Train should have left at 1:50, but then came air raid alarm, two balls raised [on the signal-box flagpole], train shunted back into the country and everyone dispersed into the wooded hills. The two balls came down, but nothing happened so people drifted back to the train. Then sound of planes: everyone ran into the woods. Seven U.S. fighters, probably P40s, circled four times and went away. Everyone drifted back

to the train again. Sound of planes; everyone ran to the woods; two unidentifiable planes flying rather low, circled once and withdrew. At last all-clear gongs went and the train left at 4 p.m.

Unknown to Needham and his superiors at the embassy in Chongqing, the Japanese were indeed planning something.

Tokyo had at long last wearied of the inconvenient existence of the Allied-held salient in their eastern Chinese holdings, and had ordered its local commanders to either annihilate or throttle it. And so, at almost the same moment that Needham and H. T. began their train journey toward Fuzhou, the Japanese air force and army were moved to seal off the area completely, to close the gaps that allowed the Chinese to bring men and matériel—and visiting scholars like Needham—into the region.

So just as they were venturing farther and farther into this seemingly carefree part of eastern China, the Japanese were slamming closed all the entrances and exits. If Needham didn't move swiftly, or have enormous luck, he would find himself trapped—and as a very high-value prisoner of war.

. . .

But he knew nothing of this, and as April ended and May began ("bush tunic and shorts this morning—first time this year"; "morning nice and hot . . . violent storm with rain, lightning and thunder in the afternoon") he continued merrily on his way. Just as he had on the northwestern journey, he devoted as much time as possible to visiting universities, factories, and schools; giving lectures; collecting shopping lists for the flights over the Hump; flying the flag; and generally keeping up morale.

But all this was much more difficult as the days wore on. The Japanese skirmishing attacks were becoming more numerous, and though no one knew why, their increased frequency was making many Chinese fretful or physically ill. A college librarian Needham met in the town of Pingshi, whom he described as "nuts, but rather nice," was newly suffering, as was his wife, from a chronic form of malaria. "Compared photos of them in Canton before the war when she looked very spry, and they had a car as well as a house, while now they both look yellow and haggard. But he has carpentry as a hobby, and is making dolls' houses."

Needham seemed to find amusing people everywhere he went. In one small town he reported meeting a parasitologist squirreled away in a back street, doing very little science but happy with the arrival of a dozen

microscopes which had just been smuggled in from
Hong Kong. At a small observatory he discovered a
Princeton-educated phoneticist who had recently been
captured by bandits and held for four months in a cave.
In Ganxian—which is where Rewi Alley was once sta-
tioned, which Needham declared was the cleanest and
most prosperous-looking city he had seen in China
thus far, and which had colonnaded buildings like the
center of New Delhi—he found a young Chinese man
who spoke good Greek. The two had tea, and, with
Needham applying his formidable linguistic abilities,
"an enjoyable chat."

Needham might have been justified in describing the
malarial librarian as "nuts," but his own oddities fre-
quently surfaced, as H. T. discovered time and again. In
Ganxian, for example, Needham's unusual breakfasts
caused comment and some consternation. He always
liked his morning toast burned black. The charcoal, he
said, brought inestimable benefits to his stomach. The
cook at the China Travel Service inn, where they were
staying, had his own ideas on what constituted prop-
erly made toast and he served it to Needham brown.
Three times an increasingly impatient Needham sent
the toast back to the kitchen, and the matter was not
resolved until H. T. applied the invaluable combina-
tion of diplomacy and chemistry that described his job.

"We have here a famous and very eccentric Professor from England," he explained. "Please tell the chef not to worry about getting the toasts burnt. That is the way he really likes them—and the carbon is good for his digestion."

In mid-May the car needed repairs—they had retrieved it from the train and were now driving over the Fujianese hills, which Needham said reminded him of the Jura—and so they took the opportunity to have it looked at while they waited for local flooding to subside. For three days they had nothing to do and no visits to make, so Needham, ever a man for improving each shining hour, decided to translate some Chinese folk songs into English while keeping the original meter (the exercise proved woefully unsuccessful), and to teach some passing Chinese lovelies how to sing the three songs he knew best: "Gaudeamus igitur," the communist "Internationale," and the "Horst Wessel Song," a tune then beloved of all good Nazis.

He also wondered briefly—while being interrogated by a Chinese chemist he met—about a supposedly distinguished British scientist whom the Chinese gentleman was certain was named Queenie Woggin. After some head-scratching Needham realized he was being asked about Dame Helen Gwynne-Vaughan, an expert on fungi who went on to be head of the women's branch

of the British army. She most certainly had a queenly manner, which he supposed might have accounted for the error. Walking swiftly away from his interrogator, he fell into a hole in the road, up to his neck, a feat which he later said greatly amused everyone, particularly the women. He took himself off to a neighbor's verandah to restore his bruised dignity, lit his evening cigar, and spent an hour gazing in rapture over the blue hills of Fujian, the masses of rhododendrons trembling in the cooling breeze, the scent of gardenia in the air.

He wrote down, quite simply, that China, at moments like this, was surely the loveliest place on earth.

Finally, after they had spent a month on the road, their destination was in sight. Wearying of driving over mountain ranges, they decided to travel to Fuzhou—an island of westernized civility set down in a sea of Japanese malevolence—on a steam-powered riverboat. The Min courses placidly down to the sea from its source in the Jura-like mountains to the west, and Fuzhou sits foursquare at its mouth—so a boat was a far more reliable means of getting to the town, and Needham loved boats almost as much as he loved trains.

While he was waiting for the steamboat in the riverside town of Nanping he happened—again, typically—on an American whom he thought of principally as an ornithologist, John Caldwell. Needham, an amateur

bird-watcher, had long owned a copy of Caldwell's definitive work *The Birds of South China*. More officially, however, John Caldwell, China-born and a native speaker of Chinese, was something else altogether.

Ostensibly he was employed as a journalist for the U.S. Office of War Information. But in fact, like many of the racy, mysterious foreigners who then operated in this part of China, he was a spy. And he was quite a talkative, matter-of-fact spy. He seemed to know what was going on locally, and felt that all of a sudden the situation seemed ominous. There were, he warned Needham, faint—but to him unmistakable—indications of a gathering storm. He told Needham that he was "getting jumpy" and was preparing to evacuate his father and mother, who lived nearby. It was a subtly coded message that Needham well understood: from now on, be very, very careful; the Japanese were planning something.

Yet whatever it was, Needham still had a mission to accomplish for the Crown. The boat to Fuzhou left in the dark on the appointed day, Needham sitting happily in the bow as it lurched down the infamous rapids of the Min. The voyage took a little over twelve hours, and the first man he met when the boat tied up at the Fuzhou docks that afternoon turned out to be a spy also. This time, though, his new acquaintance was a

British spy: Murray MacLehose, who at the time of their meeting was on a top-secret mission. Eventually, MacLehose would manage to escape from the murky business of espionage and embark on a glorious and very public diplomatic career.

Murray, later Lord, MacLehose was a giant of a Scotsman who spent almost all of his life—aside from a brief spell in the late 1960s when he was unaccountably made British ambassador to Denmark—working in the East, and who ended his career as probably the most fondly remembered of all the colonial governors of Hong Kong. At the start of his working life, when he joined the Malayan civil service, he was sent to the Chinese treaty port of Xiamen, then known as Amoy, a couple of hundred miles down the coast from Fuzhou, where he was now posted, and where he could learn the local coastal dialect of Hokkienese. But in December 1941 the Japanese captured Amoy and hauled off whatever British diplomats they could find, including MacLehose. At first they interned the British; then, accepting the terms of the Geneva Convention, they called in the Red Cross as an intermediary and sent them all home to Britain.

MacLehose might have remained at home, except that the wily old men of the British intelligence services had other plans. They decided to send this ambitious,

impressive-looking, linguistically competent young Scot right back to China—to the port of Fuzhou, which was still free. He would work there under cover of being the British vice-consul and would train Chinese guerrillas to operate behind Japanese lines and carry out sabotage. This was what he was doing, officially but covertly, when he and Needham first met, beside the old Fuzhou river bridge in May 1944.

Because of the secret nature of this work, Needham chose to remove all material relating to MacLehose— who was arguably one of the most interesting and celebrated Britons Needham ever encountered in China—from all his subsequent published works on China. "The following morning we took the river-steamer down to Fuzhou," he writes in his book *Science Outpost*, "where we spent an enjoyable five days. The narrative resumes after our return." And that was that.

Even the few references to MacLehose and to the British consul, Keith Tribe, that appear in Needham's private and unpublished diaries are fairly circumspect, and anodyne. He says that MacLehose took him to stay in the consulate in the old Foreign Concession—which reminded him of Clapham, where he grew up. He writes that it was a lovely old property full of objets d'art, and that H. T., being Chinese, was asked to stay in a hotel across the street. He says his bedroom

was enormous, with a very large bathroom. They had tea—rolls, honey, jam—and he could close his eyes and imagine himself back home.

The men then evidently went on to have a grand old time. They had elaborate massages; took a junk out to the Pagoda Anchorage, where the China tea clippers used to take on cargo; spent time at the still elegant Fuzhou Club, whose bar was frequented by prosperous western swells; visited a number of the lacquer and ceramics factories for which the city is famous; and dined on fish with the equally well known Fuzhou sauce of fermented red rice and wine, the making of which—the mash contained *Monascus* yeasts—excited Needham greatly (he noted down the details for his book). They also visited two great antiquarian bookshops for which Fuzhou was well-known.

Needham had to purchase two enormous rattan trunks in which to ship all the volumes (including fifty-six that were presented to him by members of the Fuzhou Club) back to Chongqing. Most were devoted to the history of Chinese science, and all are still housed in Cambridge today, in the great East Asian science library he accumulated over the years.

All told, the five days passed in a whirlwind of activity, much of it undertaken with Murray MacLehose— and yet Needham did not leave behind one remark,

either in his published book or his private diaries, relating either to their conversations or to the vice-consul's duties. Once in a while the man's initials appear, as in "lunched with MM" or "MM at dinner"—but that was all. Others get much fuller treatment: a Mr. Pearson is described as "pompous and talkative," Keith Tribe as "interesting and nice." But there is nothing of Murray MacLehose.

And then Needham and H. T. set out for home—this time, because of the reports from the consulate (and presumably from the two spies) that the Japanese were now bent on quickly closing the net.

It was a race. Almost every town they passed through had already been visited by Japanese bombers whose crews were softening up targets ahead of an infantry push. They often had to take long diversions to get around ruined buildings and broken roads. On May 29, the Chinese state radio broadcast the news that a Japanese offensive had started—and within hours the highways began to choke with panicked refugees, and the air came alive with waves of aircraft, mostly American and Chinese, heading west and north to head off the enemy incursions.

Needham still insisted on visiting places of interest—a tungsten mine here, a gasworks there, an epidemi-

ology laboratory in this town, an experimental farm there—but H. T. was pressing him ever onward. H. T. understood Hokkienese, as Needham did not, and was fully aware of the growing danger. The crucial point on the journey came with their attempted crossing of the great Xiang River bridge at the city of Hengyang—a crossing they had accomplished without a moment's thought three weeks before.

Now the Japanese were licking at their heels, and for the first time Joseph Needham's legendary calm showed signs of crumbling. If they didn't cross this bridge ahead of the Japanese, they would be trapped, imprisoned, interned—or very much worse. Usually he was indifferent to the vicissitudes of war, preferring to read his *Chinese-English Dictionary* as the attacks went on. But now, on June 2, he called a council of war with H. T. He had wanted to visit a number of factories in the provincial government center of Taiho, but he was worried. He wrote in his journal: "Even if Changsha holds out, there may be severe dislocation of traffic at Hengyang, preventing us getting to the west with our truck and the valuable records so far. So decided—not to go." They now had to make for the bridge, or bust.

They heard alarming reports—that Hengyang had been bombed continuously for three days; that the Americans had bombed and destroyed twenty-two

Japanese steam locomotives at Hankou; and, most ominously, that Japanese troops were racing north from Guangzhou to meet those streaming south from north of the Yangzi, and the two armies would soon meet in a giant all-crushing pincer movement. Needham started taking all this very seriously, at times even listening to the radio—"I can hear the American plane pilots and the ground staff talking!" he exclaimed excitedly.

They decided to race for the bridge. They stopped briefly at a second tungsten mine and watched men washing the wolframite from the crushed quartz—H. T. grinding his teeth in frustration—but then pressed on, the urgency growing by the hour, the situation becoming ever more perilous.

Saturday 3rd June. After lunch passed an unusual number of trucks . . . mostly full of gasoline for the American airfields . . . some evacuating office or factory personnel. Passed several miles through an inferno of activity—thousands of men and women carrying loads of stone, no doubt for a new airfield. Not a day to be lost now.

Sunday 4th . . . progress interminably slow . . . air raid alarm, so we pulled out of the station and waited in a thick drizzle. Regrettably the decapitated corpse of a coolie between the rail-

way tracks . . . after such an accident the railway people leave the results lying around for hours with a crowd of people looking on and saying "ai-ya"— perhaps *pour encourager les autres.* Afterwards, as dusk fell and moonlight came on, smoked a cigar with H. T. . . . beautiful mountainous countryside in the night all around.

The steam engine strained slowly up the final range of hills before beginning its slow coast down into the Xiang River valley. From time to time it would stop unexpectedly, sometimes because of air raids, sometimes to allow passengers in their long gowns to clamber unsteadily down to the tracks and scuttle off into villages hidden in the woods. Each time they stopped, though, many more would-be passengers were clamoring to be let on the train, to escape the steady progress of the Japanese infantry. Needham and H. T. made way for newcomers until their compartment was crammed with sweating, frightened humanity; with baggage; and with a variety of farm animals. From time to time Needham tried to lead the refugees in song to keep their spirits up—but they were too nervous, and most of them kept staring anxiously out of the dirt-encrusted windows. Above all else they loathed the Japanese, and were gripped by fear at just what the troops might do.

Tuesday 6th. Hengyang at last. Saw stationmaster who says he will put us across the river by the great railway bridge in 3 hours or so . . . situation very calm and normal except for soldiers making machine-gun posts and putting the station in a posture of defence. The railway is putting on three expresses daily in the Guilin direction, which is clearing the evacuees pretty well.

Throughout the day great air activity, squadron after squadron of P-40s, and other fighters with the Chinese star on them, coming up from the airfield just east of the station and heading north—other squadrons returning—a marvellous sight—the planes often flying very low, with the tiger-faces prominent. Two trainloads of evacuees from Changsha, several trainloads of rails, signals and miscellaneous railway equipment, going across the river, to comparative safety from the Japs.

On the platforms some very good Chinese soldiers, tough-looking, with swords, fans and umbrellas, as well as rifles, listening to a talk by a captain with a revolver and a walking stick.

Examined two large (4-8-4 and 2-8-2) engines, English and German respectively, too badly damaged to be repaired; and then finally, about 5, when all hope seemed to be gone of crossing this

day, engines came and remarshalled us and set up
a train to go across.

Not off till 7 though, and then stood on the
bridge approach for a long time—a lovely target.
Sat on our own flatcar in the brilliant moonlight and
smoked cigars. Bathed in a pool, then fell asleep.

It must have been the deepest of sleeps—because
Needham's next notation reports the outcome:

Woke at 11:30 to find *we were already across,*
and in the West Station.
So we got some tea.

They had escaped just in time. Two days later the
Hengyang bridge was blown up, and the east bank of
the Xiangjiang was irretrievably lost. Within a matter
of days, just as had been feared, the entire Chinese sa-
lient in eastern China was forcibly folded into the Japa-
nese empire. Chongqing, the country's capital, would
now be totally cut off from the east for the remainder
of the war.

Needham decided to take the long way home. He
spent time with his old friend Alwyn Ogden (H. G.
Wells's look-alike), the consul in Kunming, which was
still untouched and just as peaceful as before. He recon-

nected with a woman friend there, who had a week's vacation owing. The couple went deep into the Yunnan countryside, walking in bamboo forests, gathering wild strawberries, and bathing nude in the natural hot springs—all in the name of recovering from having been so close to a Japanese army that so unexpectedly had gone on the offensive.

And then, on July 1, with the Ogdens' help, he managed to find a seat on a flight to the capital. He ended his account of his great Southeastern Journey simply, and laconically: "There was no-one to meet me, but got a lift in Brigadier Wilson-Brand's car. Found Dophi at dinner."

Needham would make many further journeys around the country, though none so ambitious as these. The most dangerous was the one he undertook in 1944, when he tried to get to the Burmese frontier. Fighting was continuing there, between the Japanese on one side and the British and Americans on the other. The Japanese were now in deep trouble,[31] and were fighting

[31] Three months before Needham traveled toward the front, the Japanese advance westward had been halted, decisively, at the famous battle of Kohima in the Indian state of Assam, described variously as the "Stalingrad of the East," "Britain's Thermopylae," and "one of the greatest battles in history." Between April and June 1944 a small

with the tenacity of the cornered and the desperate. Yet it was not war but the region's geological instability, and the resulting landslides, that presented Needham's expedition with its greatest nuisance. It did not help matters that his truck crashed and overturned while he was zooming down one side of the Mekong River valley. The party lost much of its equipment, but no one was hurt.

During this tropical adventure he visited botanists, plant physiologists, and nutritionists—finding out, among other things, that they had just discovered the world's richest source of vitamin C, the plant *Emblica officinalis*, which was known locally as the Chinese olive, "but which in fact belongs to the Euphorbiaceae." [32] Others were working on ways to improve the resin production of the lac insects, from which shel-

British contingent held off thousands of Japanese, the climax coming in the legendary "Battle of the Tennis Court," hand-to-hand fighting in the gardens of the deputy commissioner's bungalow, ending on the tennis court's center line. Kohima was the most westerly point the Japanese ever attained: after June they were being relentlessly pressed back toward Tokyo, and fought like tigers as they went. In Kohima there is today a simple cross to the fallen British: "When You Go Home/Tell them of Us and Say/For your Tomorrow/We Gave our Today."

[32] One hundred grams of the pressed juice of what is now generally known as the Indian gooseberry provides almost one full gram of

lac is made. Someone was producing a "Guide to the Caterpillars of Yunnan," "with special reference to the pests"; and someone else was about to finish a comprehensive guide to Yunnan's flora.

And that was in only one building. In another he came across scientists who were looking at the electric responses of plants, at the underground fruiting of the peanut, at the metabolism of silkworms, at creating a taxonomy of mushrooms, at how wheat blight is spread, and at making a vast catalog of the pharmaceutically useful plants found in China—this last project being conducted in an old village temple with a gigantic image of Guanyin, the Buddhist goddess of compassion, gazing down with impassive approval.

Many of the scientists were French speakers, a fact that reflected France's colonial influence in this corner of China, and the closeness of the Cochin-Chinese territories of *l'Indochine*. The European tradition was strong: all the courses in the medical school were being taught in French, and one of the researchers in the biology department had been raised in Germany, and talked to Needham in her adopted tongue about her studies into the anatomy of frogs' noses.

vitamin C, and so not surprisingly it is widely available at health-food stores.

Outside the city, in a town called Lufeng, Needham spent time with the geologists who had just astonished the world by finding a nearly complete fossil of the small plant-eating dinosaur that is now called *Lufengosaurus.* He also bought a number of pairs of scissors, since before Lufeng became associated with the beasts of the Jurassic, it was famous for its cutlery, and its sharp edges were treasured throughout the old empire.

In a Confucian temple nearby he then found dozens of statisticians working under a stern image of the sage inscribed on a golden tablet. Needham, delighted beyond words with his visit, remarked in his diary that Confucius would have been pleased to see his temple so used, in the service of a people of whom he had once, in Analects 13, so famously written, "Enrich them first, then educate them"; and in Analects 12, "What is needed in governing is sufficient food and sufficient weapons; as for the people, make them sincere."

Yet Needham did find moments to stop, and wonder. The most important came just as he was leaving the city for his failed attempt (thanks to the later truck accident) to reach the frontier. In his diary he considers that although Kunming showed how the learned Chinese have a fathomless capacity for inquiry, there remained one mystery: why, if the Chinese were so clever and so

endlessly inquisitive, inventive, and creative, had they for so long been so poor and scientifically backward?

Why had the kind of inquiry into the natural world, which Needham's research suggested they had been pursuing for a thousand years and more, evidently become moribund for so very long? The question bothered him, nagged at him, vexed him—and always stayed in his mind, no matter how impressive the efforts of places like Kunming might be today. It was an expansion of the note he had scribbled on the BBC letter two years before: *"Chinese sci. Why not develop?"* Something had happened, perhaps hundreds of years ago, that somehow blighted the promise of those earlier times. Needham vowed that one day he would determine just what that something might be.

This would later become famous as the "Needham question." It is a puzzle that manages to define China and Chinese history. And as far as the world's academic community is concerned, it is a puzzle that also helps define Joseph Needham.

Joseph Needham would remain in China for eighteen months more. By the time he left he had visited 296 Chinese institutes, universities, and research establishments; he had arranged for the delivery of thousands of tons of equipment and chemical and scientific journals;

he would read, endlessly and voraciously, the various thousands of documents which he had collected and which he felt certain would enhance his knowledge of China; and he spent much of his final months laying the foundations for a diplomatically privileged organization to support Chinese science—an organization that would continue to function without him long after he had left.

Despite now having Dophi with him he was rather lonely. He missed Gwei-djen sorely: he wrote loving notes to her in his diary, and there are moments of great poignancy that seem almost to have brought him to tears. He recorded a moment in western China when he came across an American forces' post exchange, where he could buy shoes to replace his own—if he could pay in American cash. In his wallet he found one five-dollar bill, left over from his trip to New York to see Gwei-djen two years before. He was overwhelmed, he wrote, by a sudden, terrible wave of nostalgia. Needham wrote her a long letter, one she later said she treasured above all others. It remains as much as anything his testimonial to China:

Nothing could exceed the impact which your country and your people has had on me since I first came here. It has been a time of much confusion,

but for that very reason I have been able to pen-
etrate everywhere into the life of villages and towns
(roughing it of course a great deal in the process);
and bend my solitary steps into Confucian, Buddhist
and Daoist temples, often deserted, able therefore
to savour to the full the great beauty of the tradi-
tional architecture in its setting of age-old trees and
forgotten gardens. And I have been free to experi-
ence the life in Chinese homes and market-places,
and see at first hand the miseries of a society in col-
lapse, awaiting the dawn which must come soon.
And when I say "roughing it" this is no exaggera-
tion. Sometimes I set up my camp bed in an empty
temple, sometimes at the back of a cooperative
workshop. Besides all the usual insect pests there
are rats in plenty—they used to bump up and down
all night on the canvas ceiling when I was lying in
bed at Jialing House with a temperature of 104°
from the Haffkine plague vaccine. But on the other
hand, what gastronomic delights I have found, and
often from stalls in village streets; things to eat that
most conventional Westerners (and indeed some of
my Embassy colleagues) would fear to enjoy. Noth-
ing could ever make me forget *doujiang* with *bing
tung* and *you tiao* taken in the open air on a spring
morning at Ganxian in Jiangxi, or the *you zha bing*

of Guangdong straight out of its boiling oil, or in a Lanzhou winter, the *huo guo* and the *bai gan'er* to warm even the soul, while the icy wind blows through the torn paper on the windows.

But then there came an unexpected opportunity to see her. By chance in early 1945—when it was clear the war was winding down—Needham was asked to fly to Washington for a regional diplomatic meeting and to discuss a postwar plan for the United Nations which would later involve him. A succession of military aircraft brought him to the American capital. Once his meetings were done he took the Pennsylvania Railroad express to see Gwei-djen in Manhattan, and told her immediately how intolerable it was for him to be apart from her. She, to his great delight, then asked if perhaps she could come out to China. Her work at Columbia was done, after all, and she would very much like to come to her home country, to be with him and perhaps, once the Japanese were defeated, to see what had happened to her family.

And so, late in 1945, Needham cunningly contrived to have Gwei-djen sent to China from New York, to be brought onto his staff as a salaried employee, classified as an expert on nutrition.

The war was over by then—Germany and then

Japan had surrendered—and as a newly impressed diplomat Gwei-djen was able to come to China by air, quickly and fairly easily. Needham was impatient for her to arrive, and he wrote "Groan!" in large letters on the closing page of the diary he kept on his last major trip, to the Chinese north, when he got back to the embassy and found that she had not yet arrived. But a few days later she did make it; and Dophi records the two of them taking afternoon tea together with the ambassador's wife [33] in early December. Dophi goes on to note that her husband's mistress spoke eloquently that afternoon on the need for China to be allowed to import "the right kind of soybean," not a low-fat variety that some foreign firms were then trying to sell. Joseph Needham's love life was evidently back to normal.

But the arrangement did not go down at all well with his colleagues. Gwei-djen's appointment caused a fluttering in the diplomatic dovecotes because it seemed so blatantly nepotistic. There was no pressing academic need for Gwei-djen to come to China, and she remained there only long enough to take one trip across the south.

[33] Lady Seymour had returned from her self-imposed wartime exile in Wiltshire to join her husband once the peace was signed and it was deemed safe for her to be back in Chongqing.

No complaint was as vitriolic in tone as one formal memorandum that found its way back to the head office in London, having been written by one of the more remarkable—and angriest—members of Needham's team, the biologist Laurence Picken.

Picken, who died in early 2007, was a polymath like few others. He started his career in biology as a specialist—rather like Dorothy Needham—in the elastic properties of muscle. He joined Needham's team in China in late 1943 as a biophysicist and an agricultural adviser. But then, fatally for his biological career, he learned to play the *qin*, a seven-string Chinese zither. From that moment, muscles had to move over. Picken became hooked on music—especially its ethnology, ranging from the social aspects of birdsong to the modern adaptability of Tang dynasty court music.

A colleague of Picken's at Cambridge recently described him as "a bachelor don of the old school, an established scholar in the fields of biochemistry, cytology, musicology, Chinese, Slavonic studies and ethnomusicology, world expert on Turkish musical instruments, Bach cantatas, ancient Chinese science and reproduction of cells. You could pick up from him an amount of knowledge on any number of subjects—from Baroque keyboard ornamentation to the vinification of Bur-

gundy, from the wave structures of the benzene ring to the translation of the Confucian Odes, from Frazer's theory of magic to the chronology of Cavalcanti—and the very irrelevance to the surrounding world of everything he knew made the learning of it all the more rewarding."

But in the autumn of 1945 it was evident that Picken was a man with a mean streak. His memorandum, sent to London and addressed to a mandarin on the British Council, Sydney Smith, was a rant of some style:

> [Needham] has talked the Science Department into appointing a Chinese nutrition expert to the staff. God knows what she will do (she will be drawing a salary bigger than I or Sanders). But the real reason for the arrangement seems to be that she is *one of his mistresses.* You would scarcely credit it, but her personal file (on which are all papers relevant to her appointment) contains letters otherwise official from Needham to her with marginalia in JN's dog Chinese such as *Little Joseph Longs for Younger Sister's Fragrant Body.* Dophi reads these letters but does not understand Chinese! Usually Joseph keeps these locked up, but it had to be consulted the other day in his absence. Incidentally, when he does get back from Xi'an (where he has been for two months)

he has got to face the query: was his journey really necessary? The Council has at last sent out a Finance Officer and Administrator, and JN will have some pretty difficult explaining to do. His little jaunt to the only region where he has not been in Free China, where there are none but third-rate institutions, and very few of these, will have cost the Council £3,000. The attraction [is that] of the ancient capital of Chang'an, second in beauty and historic interest to Beijing. If he had a cast-iron excuse for going there he could fly in three hours. But his God-complex is titillated by going by truck, and so he goes that way, spending several weeks on the journey and spending I don't know how much money. Dophi has gone along too, and one of the staff as companion for Dophi, and an interpreter. For the female companion it is a holiday at the Council's expense, and with her salary paid too. She is another affinity.

But I think he's had his last fling. With the exception of old Percy Roxby [a geography professor sent temporarily to China from the University of Liverpool], who is a noble soul and sees no wickedness in anyone, all the British staff and some of the Chinese are aware of this situation. As JN said himself on one occasion—*I am not serving the Council; the Council is serving me.*

Needham was stunned when he got home from his trip and saw the memorandum. To be sure, he was fond of repeating the calming Arab maxim "The dogs may bark, but the caravan moves on," but at the same time this irritated him, and he was determined that Picken would not get the better of him. So he promptly wrote to Smith in London, assuming the air of authority that he felt was proper for him as head of SBSCO: "You'll have seen Picken's letter—the man's going mad . . . he has been going queer for many months past . . . possibly some disappointment in the affairs of the heart."

With that, he imagined, heading off any possible inquiry from London, he then proceeded to get his own back. He wrote a formal assessment of Picken, which was to lie like a deadweight in Picken's personnel file for the remainder of his career: "A more unfriendly and disagreeable colleague I never hope to meet . . . unpleasant and indeed inexplicable." The venom was diluted, the vitriol repelled.

It would be idle to imagine that *l'affaire Picken* had any significant effect, so towering and unblemished was Needham's standing in China, in London, and in Cambridge. Yet less than six months after the memo was written, though probably the two events were quite un-

connected, Joseph Needham's first great adventure in China was at an end.

He decided to leave, and this decision came with bewildering suddenness. One morning in early March, out of the blue, he received an urgent telegram from the biologist Julian Huxley, his old left-wing friend at Cambridge.

For the last three years Needham had been involved in discussions about the possibility of establishing, once the war was over, a worldwide scientific organization to encourage cooperation in research. Others had had similar ideas, and by 1946 the plans for creating a much wider organization—one that would embrace culture and education more generally—had found favor. So, Huxley asked—would Needham care to come to England, on the double, to help form this new organization, which would be created under the auspices of the successor to the League of Nations, the United Nations. The body was to be called the United Nations Educational, Scientific, and Cultural Organization (UNESCO), and it was designed to promote world peace by encouraging cultural exchange and cooperation. Everyone, including Huxley, thought that because of his experiences in China, as well as all his correspondence about such a body (and his one trip to

Washington, in February 1945), Needham would be the ideal man to set up its Division of Natural Science.

He would do a great deal more than that. That March morning he acted speedily. He replied to Huxley, accepting the offer. He told his ambassador, Sir Horace Seymour, that he was leaving—but it turned out that Seymour had already been told, and moreover had been asked by the Foreign Office to give his official blessing for the departure of his senior diplomatic colleague. Needham sent a telegram to Dophi, who had already gone back to London to recover from tuberculosis, which she had contracted in China earlier that winter. And finally, he told a delighted Gwei-djen. She was to pack, he said. The two of them were leaving forthwith. They would travel in three days' time to Nanjing, Shanghai, and Beijing, and then to Hong Kong, from where the Royal Air Force would fly them home. There was no time to be lost.

There followed two days of frantic housekeeping, with books to be packed, files to be organized, keys to be handed over, bills paid, and expenses settled—and for the gun and ammunition he had drawn in Calcutta to be handed in to the British military attaché for return to Fort William. A number of lunches and dinners were hastily arranged to allow the Chinese community to say farewell. Needham was not a sentimental man:

once he received his new orders, he wanted simply to turn on his heel and go. But the Chinese had to observe the protocol, and he knew it. Hence at each banquet he smiled his way through an interminable list of dishes and an insufferable parade of speech makers.

"He is leaving us in two days," said the secretary-general of the Chinese Academy, his voice cracking. "We are sad. . . . He is family to us, and we do not want him to go. Friends in time of need are the friends who are missed most."

Needham promised in reply that he would be back in five years. One imagines he already communicated this notion to Zhou Enlai's headquarters: as a good socialist Needham naturally hoped that the Chinese Communists would wrest power from the Nationalists now that the war was over, and all the evidence indicated to him that they would indeed triumph, and before too much longer. And if so, then he wanted to be on good terms with the new government, which presumably would be led by the Communist Party chairman, Mao Zedong. He knew Mao only slightly; Zhou, however, he considered a friend who he hoped would put in a good word for him, when the time came. For one thing, he would need a visa next time he came to China, and he suspected that it might be difficult to acquire.

Needham was capable of tact and discretion, and that

spring evening he kept his expectations of a communist victory from his audience. The thought that he might soon return seemed to cheer everyone up, however, although one man told the diners that his own melancholy could hardly be dispelled by the hope that Needham would come back. "Returning from seeing a friend off at the shore," he said, quoting the Daoist philosopher Zhuangzi, "one feels as far away as the horizon."

They gave Needham a commemorative scroll as a leaving present, and filed silently from the room. China would be an altogether changed place, outwardly barely recognizable, the next time he visited.

On a blustery April English morning three weeks later the aircraft carrying Joseph Needham and Lu Gwei-djen bumped down onto the tarmac of Northolt aerodrome, west of London. Shivering in the cold, the couple made their way to the terminal building. It was exceptionally crowded today because Northolt, usually a military field, had been opened to civilian aircraft that were unable to use the grass strips at nearby Heathrow, which were being paved for its enormous postwar expansion.

Waiting for them was the man who had first secretly invited Needham to China four years before: J. G. Crowther, the British Council's science officer

and former correspondent for the *Manchester Guardian*. He had just resigned from both positions, since his outspoken criticism of the atomic bombs dropped on Japan the year before had distanced him from the scientific establishment. Huxley had hired him, however, and now he was campaigning for science to be included in this new organization's mandate—science, he and Needham had long argued, was the property of all mankind, and its corruption by capitalism should be resisted. He took the couple in to central London, talking excitedly about Huxley's plans for the new body—almost to the exclusion of asking Needham about his time in China.

Within days Needham had a new London office, in Belgravia, and he became a commuter. The Needham family house at No. 1 Owlstone Road in Cambridge was still intact, as was his old room at Caius College. He began a new routine: with permission from the biochemistry department, which had become accustomed to Needham's long absences, he began his two years of work for the United Nations. In time the UNESCO office was moved to Paris; but in 1946 the new body was in a terrace house near Victoria Station, so small and cramped that Needham's first interviews, for a team of secretaries, had to be conducted in the bathroom.

It was not long before the press discovered him. "Doctor Needham is home!" wrote one of the London newspaper columnists shortly after he arrived, travel-stained and weary. "A very tough egg is Dr. Needham—large, muscular, a chain-smoker, 46, with a scalding brilliant tongue and no time for fools. I do not know whether he inherits his tongue from his father, the anaesthetist, or his Irish mother Alicia, the pianist. On his way to Chongqing he had a brush with bandits—any tackling him now would be lucky to get away with a black eye and an earful of deranged epithets. Dr. Needham can learn anything—he has been answering all sorts of riddles, about sugar beet and foxglove seeds, yeast cultures and wooden shoes for Chinese airmen."

Needham missed China dreadfully. He also worried about neglecting his biochemical research. But in the end he agreed that, for the time being, and out of a sense of polite public obligation, he would indeed do as Huxley had asked. He had, after all, been intimately involved in the long-distance planning of the new body, knew how best to cut his way through the bureaucratic thickets that are inevitable in such a project, and so would do all he could to help UNESCO's founders realize their dreams. He could and would, as his admir-

ers later said, "put the 'S' into UNESCO." [34] After all, the work gave him ever more standing and status, he was pleased that it took him to Paris frequently, and he generally approved of UNESCO's stated aims—though he found the preamble to its constitution, "Since wars begin in the minds of men, it is in the minds of men that the defences of peace must be constructed," a little rich for his taste.

He stayed in the traces for two years. In Paris he watched with grim fascination, from his temporary offices in the Hotel Majestic, as the victors of World War II—Britain, the Soviet Union, France, and the United States—squabbled over the precise role of the new body. Some people assumed it was really a cover for espionage. Needham's idea of placing scientific field offices around the world, modeled on his own SBSCO in China, was to the more paranoid minds no more than a thinly veiled means of putting spies in place, under deep cover.

The Americans were the most suspicious. The Cen-

[34] Until February 1945 the body was tentatively known as UNECO. During Needham's visit to the United States in February 1945 he argued vociferously for the inclusion of science in its responsibilities, and handwrote a memo suggesting that it be called UNESCO instead. This was formally agreed on in November.

tral Intelligence Agency's station in Paris placed the Majestic Hotel under immediate surveillance, and by February 1947 was alarmed enough to warn President Truman specifically that UNESCO was being infiltrated by communists. General Hoyt Vandenberg, director of the CIA, wrote a top-secret memo to the president, dated February 15, 1947, in which he pointed to Needham as the principal problem:

> Embassy Paris reports that Professor Joseph Needham, a temporary British UNESCO official, who is apparently a protégé of Julian Huxley (Director-General of UNESCO), is a member of the Cambridge University Communist Group. Huxley dismisses the matter with the observation that Needham is a "good" Communist. Pursuant to authorization from the UNESCO general conference Needham proposes to negotiate an agreement between UNESCO and the [Soviet-backed] World Federation of Scientific Workers. . . . The announced plans for UNESCO, together with the recent conviction of another British scientist, Dr. Allen Nunn May, of giving uranium samples to the USSR, point to the grave dangers implicit should Communists occupy strategic posts in the scientific projects of UN.

Alarm bells started to ring. Within a month President Truman's administration had placed numerous bureaucratic hurdles in Needham's way, and had flatly refused to allow UNESCO to hand out grant moneys to any scientific unions that Washington deemed left-wing. To the surprise of very few, Needham promptly resigned, relieved to be getting back to his studies and away from the fratricidal feuding that characterized this period of the cold war.

By March 1948 he was in Cambridge, and the only souvenir of his time in Paris was an immense oak directors' desk, ornamented with gold anchors at the corners. It had belonged to a German admiral, who had been based at the Majestic and had been in charge of Axis naval operations during the war. Needham had done his UNESCO paperwork at this magnificently Teutonic piece of furniture, and Julian Huxley agreed it should be sent back to Cambridge with him, in gratitude, and as a memento.

Now he was back in his university, with his wife and his mistress on hand, and his mass of books beginning to trickle in from China. His love for his Chinese muse was now fully settled, his obsession with China was firmly held, and he would now start to implement the task that would define the remainder of his life.

Spring was just beginning, a time when Cambridge is at its prettiest, a time of freshness and new beginnings. He thought it perfectly appropriate that he was back, away from the grim infighting of Paris. Now he could immerse himself in the joys of scholarship. His traveling—the first phase of his research—was over. Now it was time to begin his mission—to create the volumes that he felt sure would put China's reputation in its properly deserved place in the pantheon of the world's leading nations. It was time for his book to be born.

THE MAKING OF HIS MASTERPIECE

On the Fundamental Ideas of Chinese Science
Heaven has five elements, first Wood, second Fire, third Earth, fourth Metal, and fifth Water. Wood comes first in the cycle of the five elements and water comes last, earth being in the middle. This is the order which heaven has made. Wood produces fire, fire produces earth (i.e. as ashes), earth produces metal (i.e. as ores), metal produces water (either because molten metal was considered aqueous, or more probably because of the ritual practice of collecting dew on metal mirrors exposed at night-time), and water produces wood (for woody plants require water). This is their "father-and-son" relation. Wood dwells on the left, metal on the right, fire in front and water behind, with earth in

the centre. This, too, is the father-and-son order, each receiving the other in its turn. Thus it is that wood receives from water, fire from wood and so on. As transmitters they are fathers, as receivers they are sons. There is an unvarying dependence of the sons on the fathers, and a direction from the fathers to the sons. Such is the Dao of heaven.

—FROM *CHUN QIU FAN LU*, BY DONG ZHONGSHU, 135 BC;
EXPLANATIONS BY JOSEPH NEEDHAM, 1956
From *Science and Civilisation in China*, Volume II

Senior members of Cambridge University usually are granted, as one of the perquisites of their standing, permanent rights to a college room or suite of rooms fashioned for two functions: scholarship and sanctuary. Some rooms in the relatively modern colleges are rather ordinary, more monastic than majestic. Some, such as those looking out over the river and the lawns at King's, are enormous and sought-after: ancient grandeur personified. A room in a court at the heart of Gonville and Caius College, one of the senior collegial institutions of the university, is—because of its vast history—likely to be a particularly agreeable place, a perfect little gem, a home to be cherished by anyone fortunate enough to be granted the right to live there.

The entrance to such a room will probably be a pair

of ancient oak doors folded one against the other, the outer one to be occasionally closed, or "sported," to indicate "Do not disturb." There will be small mullioned windows, edged with weathered limestone, that look out onto a panorama of lawns and shrubberies. There may be a window box, with gillyflowers or honeysuckle, their fragrance wafting in during the long summer evenings. There will be a small sitting room, with a stone fireplace that is slightly larger than necessary, ensuring a fug on even the rawest of winter days. Often there will be a two-bar electric heater, to take the chill off the room first thing. The bedroom will be tiny, spartan, and seldom with enough cupboards. The plumbing will be elderly, and British.

Of course it is quite possible for the occupant to make himself toast or crumpets on a fork in front of the electric fire, and perhaps even to brew tea in a pot suspended over the coals. But other than that there is no need to cook, since both the combination room and Hall are just a stroll away. Tradition requires that the college provide the service of a congenial woman of uncertain age known as a bedder, to look after your laundry, wash your dishes, and empty your wastepaper baskets.

A good college room at Cambridge, where generally the only disturbance comes from fellows crossing the lawn (students are forbidden to cross it), or from the old

clocks around town chiming the hours, is very much a place to keep. It is a place that, once granted, is to be held on to with tenacity and pleasure, to be abandoned only for the grave.

Joseph Needham had secured his tiny suite of ground-floor rooms, identified (since they were on staircase K) by the initials K-1, in 1930. He had been given them on the retirement of their previous occupant, his old tutor, the biologist Sir William Bate Hardy. They were ancient—they had been designed in the 1560s to house an entire group of students—and despite having been paneled in the early eighteenth century and redesigned for the use of one student alone, they were still very cramped. Needham further compressed the available space by cramming it with floor-to-ceiling bookshelves so that only the tiniest of assistants could creep between them. He liked their snugness, however, convinced that it helped keep them warm and cozy through the bleakest Cambridge winters.

Much happened during the six and a half decades of his tenancy. Dozens of wars would be started, fought, and finished. Communism came and, at least from Europe, mostly went. Four monarchs presided over Britain's affairs during his stay, and thirteen prime ministers—Ramsay MacDonald being the first. Herbert Hoover was in the White House when Need-

ham first occupied his room. And whereas other dons tended to work in libraries or laboratories, Needham made most use of this tiny bastion of scholarship deep in the old center of his college: for all the many years he occupied them, the rooms were witness to a ceaseless whirlwind of thought, activity, and creation.

The work began almost immediately, and Needham let it be known throughout the college that his firm intention was to hit the ground running. He arrived from Paris in March. He spent most of April unpacking, brushing the combined dust of China and France from his well-worn boots, and reestablishing himself among the other dons of the Caius combination room. By the end of the month he rolled up his sleeves, opened a fresh packet of the tiny black Burmese cheroots he now liked to smoke, and set about typing out the formal beginnings of his project. Two weeks later, on May 15, 1948, he sent off by college messenger a short document: it was addressed to Cambridge University Press and it was red-stamped with the single word "Confidential."

The document was twelve pages long, and it was headed "Science and Civilisation in China"—the first time these five words had been assembled into the title that they would eventually form. Needham immediately got to the point. This, he wrote, was a "Preliminary plan of a book by Joseph Needham, FRS. It

will be addressed, not to sinologists, nor to the general public, but to all educated people, whether themselves scientists or not, who are interested in the history of science, scientific thought, and technology, in relation to the general history of civilisation, and especially the comparative development of Asia and Europe."

As a statement of intent this single sentence would remain unchanged through the entire making of the book. It was a statement that indicated, if subtly, that the book was going to be two things.

Needham intended the book to address, on one level, the entire history of science in China. But on another it was also—and perhaps rather more importantly—to be a history of how the science and civilization of all humankind had developed, and the story of how over thousands of years China, *in relation to the general history of civilization*, had contributed to this development. It was Needham's considered view that China had contributed to a far greater degree, and far more actively, than all other nations, and moreover had done so far more than was either known or recognized.

He underlined this point in a speech to the China Society in London: "What is really very badly needed is a proper book on the history of science and technology in China. . . . It would have a wide bearing *on the general history of thought and ideas.*"

The notion that China had for centuries been unconnected to these thoughts and ideas, and had stubbornly remained on the sidelines of the world's development, was now to be swept away, once and for all. With this set of books, Joseph Needham—a man who was neither a specialist on China nor a historian but a biochemist with no reputation for scholarship involving the story of human civilization—intended now to bring out the evidence, thrust the Chinese into the spotlight, and tell the world in detail of the debt it owed to these remarkable, ancient, highly cultured people.

Cambridge University Press accepted Needham's proposal readily, with little debate or demur. Not that anyone at the press had any illusions: the undertaking would surely be formidable and very costly, and as a commercial venture was unlikely to make a profit for decades. But university presses are not generally established to make a great deal of money, and Needham's early plan did not make the project seem unmanageable: the initial proposal suggested he could accomplish all in a single volume, and the letter of reply from the press dated May 22, 1948, formally accepted this as a target. Within weeks, however, reality apparently struck home, and Needham revised his estimate upward, dramatically. He could now do it in seven volumes—no more! he felt obliged to promise—and

moreover he could finish them all with what in the academic publishing world might be regarded as dispatch. With the same self-confidence—or hubris—that had characterized the founding editors of the *Oxford English Dictionary* a century before, he airily told the Syndics, the wise men who form the editorial board of the press, that his project could and would be finished in what for an academic work would be fairly short order. Ten years, he thought, at most.

Not everyone accepted the plan with the same equanimity. It was swiftly pointed out by a small group of naysayers that as a reader appointed by the university, Needham was still officially supposed to be teaching—that, after all, was why he was paid. Some graybeards in some combination rooms felt that instead of writing a book about China he should simply stick to teaching undergraduate embryology and carry on with his research into the mysteries of such biochemically fascinating substances as inositol, which had occupied him six years earlier, before he had taken off for Chongqing in 1942. It might be better for all concerned if he simply stopped meddling in matters for which he was not officially qualified, and which thus should not concern him.

But luckily only a very few took so stringent a view, and within weeks Needham's interest in China was for-

mally recognized by the university, and he was granted official leave to teach just biochemistry. He no longer had to be cumbered with the irksome responsibility of supervising graduate students. That was one small victory. A few weeks later came a second: he was told he need no longer teach at all; nor did he even have to turn up again at the department of biochemistry. He could instead remain in his college and draw up his plans for the books there, full-time.

This eventual consensus from his academic colleagues was a credit to his very apparent doggedness. Everyone suddenly came to realize that this extraordinary man would go on to create his magnum opus one way or another. Moreover, if it was ever completed it might well bring luster to the university's reputation— and so it would be foolish to let such details as teaching the complexities of the Krebs cycle to nineteen-year-old undergraduates stand in the way of the project. From the summer of 1948 on, he was essentially set free. "It was a schizophrenic period," he was later to write, "but in the end I was able to follow my star without distraction."

So pleased were the fellows of Caius College to have the undivided attention of their most eccentric member that they then allowed him to act as temporary librarian, a task which suited him perfectly. Still, when he

first visited the Caius library, ancient, revered, and rich with the smell of old leather and beeswax, he was vividly reminded of the insularity of those among whom he worked: vast oak bookcases were devoted to subjects such as constitutional history, ecclesiastical history, local history, and European history; but there was just a single tiny shelf labeled "Outside World." It was an imbalance he set himself promptly to correct.

Despite Needham's manic energy and infinite resourcefulness he quickly realized—especially when looking over his own ever-expanding library—that he was going to need an assistant. The man he chose, who would loyally remain with him for the following nine years, and help oversee the publication of the first three volumes, was the Chinese historian Wang Ling. The two men had met in China in June 1943, when Needham stepped off a downstream ferryboat and found the almost evacuated headquarters of the Academia Sinica, in the city of Lizhuang on the banks of the Yangzi.

Wang had been so stimulated by a lecture Needham had given to the academy members that he decided, there and then, to research all he could possibly discover on the history of gunpowder. So impressed was Needham by his eventual efforts that he asked Wang to come to Cambridge once the war was over, and lend him a hand with the project, if it ever took off.

Five years later, almost on the anniversary of their first meeting, Wang Ling arrived in Cambridge from Shanghai to take up a position at Trinity College, and to assume a formal post as assistant editor of *Science and Civilisation in China*. The pair collaborated, became fast friends, and remained inseparable for the rest of their lives. In the early days Needham even shared half of his university salary with Wang, until the Cambridge University Press saw fit to pay Wang a decent wage.

Before work could begin, Needham realized he would have to assemble in one place his ever-enlarging research collection of books and papers on China. There were thousands of them—some valuable, some worthless. All of them had been sent from China piecemeal as the war dragged on, or had been flown back by the Royal Air Force at the end of Needham's tour, as part of the nearly limitless allowance that was then offered to repatriated diplomats. The boxes and crates that the Chinese freight loaders had jammed into the holds of westbound cargo planes held pile upon pile of books, papers, and manuscript texts that Needham had begged, bought, or borrowed during his years in China. Among them were some very rare items: he had bought ancient wood-block books, for instance, whose export would be strictly banned once Mao came to power in 1949. But Needham had good friends at both

the Ministry of Culture and the Academia Sinica, and he continued to be sent banned materials until at least 1958, whatever the regulations.

All through that early summer Needham arranged these books, shelved them, classified them, and filed the papers. The task seemed to require an almost superhuman fortitude. And it was to become, very suddenly, a great deal worse.

Without any warning a large number of wooden tea chests and still more crates and cartons began to arrive at the Caius porters' lodge—and each one held a vast quantity of even rarer and more obscure papers and books, not one of them collected by Needham or by anyone especially familiar to him. They were, it turned out, a gift.

The boxes had all come from a man Needham had met in China but had almost discounted at the time and had quite forgotten since his return. He was a paleometeorologist, Dr. Zhu Kezhen, who in 1944 was president of Zhejiang University, called the "Cambridge of the East." As with so many Chinese universities, the war had obliged Zhejiang to move from its site near Shanghai to a temporary home in the grimy, impoverished town of Zunyi, in China's farther west.

Dr. Zhu, who had a particular interest in the climatic history of China, had been doing his level best

to maintain Zhejiang's national reputation—and part of his plan was to ask for a visit from Joseph Needham of the British embassy, who might supply British and American textbooks and equipment. Yet he evidently had made little impression on Needham, who mentions him only briefly in his contemporaneous notes, marking him down simply as "China's leading meteorologist" and reporting no special conversations or memories.

Needham did tell Dr. Zhu that he planned to write a history of Chinese contributions to world civilization, but that was all. Needham's diaries note that he was actually much more captivated by researchers at Zhejiang who were doing work on the mechanics of silk, color-pattern inheritance in ladybirds, the presence of flavonoids in jujubes, and the high levels of ascorbic acid in the local Chinese rose hip.

He had no inkling of the enormous impression he made on Dr. Zhu—who seemed, as he later recalled, a rather taciturn and distant man. Zhu, however, had thought deeply about Needham's plan to write a book and realized that he could be in a unique position to help.

So as soon as Needham had returned to England, and by the time the Japanese had scurried home and the political and military situation in China became

somewhat more stable,[35] Dr. Zhu started collecting books and papers for him, packing them securely, and sending them to Cambridge by ship.

One particular item Zhu sent turned out to be of extraordinary value, in terms of both money and of usefulness. It was a complete copy of an edition of 1888 of what was then and remains today perhaps the largest book in the world: the imperial Chinese encyclopedia, *Kuchin Tu-shu Chi-cheng* (*Gujin tushu jicheng*, in pinyin) or *The Complete Collection of Illustrations and Writings of Ancient and Modern Times*. This was a distillation—or rather a conflation, since nothing seems to have been left out—of everything that was known to the greatest minds of the capital city of the Celestial Empire. It was the sum, in other words, of all Chinese knowledge.

The book[36] had been commissioned in 1700 by

[35] Except for the roiling civil war between the Communists and the Nationalists, which ended in 1949 with victory for Mao and Zhou Enlai.

[36] Two other works traditionally rival the *Gujin tushu jicheng* for length and magnificence. The *Yongle dadien, The Great Canon of the Yongle Emperor's Era*, was produced in the fifteenth century, in early Ming times, and had 11,000 manuscript volumes, of which only a few hundred survive, most held privately; and the *Siku Quanshu, The Complete Books of the Four Imperial Repositories*, was produced by the Manchus of the mid-Qing dynasty and exists in

the Kangxi emperor—one of the earliest of the Qing emperors, and, with his reign of sixty-one years, the longest-serving in all Chinese history. It took its authors twenty-six years to complete, and when first published, having been printed with movable bronze type at the Peking Imperial Printing House, it reputedly contained 10,000 volumes and 170 million characters.

The definition of *volume* was then somewhat different from our own—the word *section* or *fascicle* might be more appropriate. The edition Needham received, which was created a century and a half after the first (and which, because of its fragility, is now packed away in boxes in Needham's archive), comprised very nearly 2,000 books: the edition currently at the Library of Congress in Washington sports almost 6,000. Also, the word *anthology* might describe the work most accurately—it is not alphabetical but topical, and it is essentially a collection of everything important that had ever been written down in Chinese. Its usefulness to Needham was paramount. His debt to Dr. Zhu

no fewer than 36,000 volumes. The Forbidden City's original, repaginated into 1,500 leather-bound volumes, is in the great National Museum in Taipei, with a photographic reprint at the Needham Research Institute in Cambridge, and with condensed facsimile copies— and a CD-ROM edition—available for considerable sums in folding money.

turned out, as he later readily admitted, to be incalculable.

Once the books were in place and the rooms more or less in shape, a routine was soon established, as well as a commute. Joseph and Dorothy owned a house a little more than a mile away from the college, at 1 Owlstone Road. When Lu Gwei-djen returned from Paris in 1957 she would live a few yards away from them on the same street, at number 28, conveniently for all purposes. The walk between home and college—or the drive; Needham loved driving, and at irrationally high speeds—was fantastically pretty: in springtime and in summer the half hour it took to cross the lawns of King's College, to stroll under the chestnuts beside the Backs, to pass down along the Cam by way of Newnham Road, and, finally, to cut through the rabbit warren of Edwardian houses to Owlstone Road, presented as perfect a cross section of Cambridge's loveliness as any tourist might desire.

Although Needham kept a vast amount of Chinese paraphernalia at home, most of the work on the great project was accomplished in his rooms at Caius. Day after day he and Dorothy left early each morning—if the weather was dry, going by one of several footpaths across Coe Fen; if it was drizzling, keeping to the streets and crossing the Cam by the Silver Street Bridge—then

walking together first to Dorothy's biochemistry department on Tennis Court Road. Then Joseph would finally press on alone along King's Parade and to the porter's lodge of Caius. If he was for some reason on his own, and the weather was fine, he rode his bicycle.

He cut an impressive figure, at least in part because he was so tall and broad, built like a bear. He invariably wore a dark suit, pin-striped, double-breasted, rumpled. The collar of his shirt, freshly laundered, was nevertheless always disarranged; his tie was askew; and his shoes, though clean, were scuffed, the laces frequently broken and retied. He kept his brown tortoiseshell glasses well polished, however. He parted his thick hair on the right, and was careful always to have it well brushed, though it was usually just a little too long.

There was a dusting of ash on his lap, but during the composing of the book he set a firm rule: he would take no cheroot or cigarette before noon. He was fiercely disciplined in this: as the morning wore on he would peer anxiously at the college clock—with one cylinder of tobacco already out on the desk, and his box of Swan Vestas at the ready—and the moment it struck twelve he would light up, and then smoke like industrial Pittsburgh for the rest of the day. He kept the cigarette in his mouth all the while, his head wreathed in ribbons of curling blue.

Once in K-1 he sank into a brown study, and remained there, stolid and undisturbable, for hour upon Chinese hour. Only Wang Ling could interrupt his reverie, to pass him a paper, look up a reference, or translate one of the finer points that no dictionary or encyclopedia could settle. Once started each morning, Needham worked nonstop, often until long after dark.

He employed neither a typist nor a secretary. He typed everything himself on one of his Royal typewriters—either a black portable, which he carried in its venerable case, covered with airline stickers; or a large Royal desk machine[37] with an extra-wide carriage. He used only two fingers, and yet managed to type at a fantastic speed (as many two-finger typists mysteriously do). His typing was always very accurate; his first script was always his final draft, and it was from these drafts that the Cambridge University Press prepared its galleys (these, by contrast, usually required

[37] His favored use of this elderly typewriter led to the accidental birth of a new Needham system of Chinese transliteration. Whenever he tried to type a word with an aspirated *h*—a word like *Ch'iu*—he found that his apostrophe would not work, and so he represented the aspirate with a double *h*—*Chhiu*. This made its way into print, and remained the case in all volumes of *Science and Civilisation in China*, all editors assuming that it was a deliberate invention of Needham's rather than a shortcut necessitated by a problem of writing mechanics.

many changes—edits which he often performed in his head, while lying awake in bed).

He did not take kindly to interruption, and though generally a polite and thoughtful man, could be crashingly rude if disturbed. Once when his old friend Julian Huxley, who had been the first director general of UNESCO, telephoned from the porter's lodge to announce that he had arrived for a visit, Needham said, with glacial courtesy, "I am frightfully busy. You come without an appointment, so I am afraid I cannot see you." Huxley promptly returned to London, his day entirely wasted.

On another occasion Sir Ronald Fisher, an eminent geneticist, knocked on the door of K-1, opened it without waiting for a response, and was halfway in when Needham barked out "I'm frightfully busy" and went on hammering away at the machine. Fisher tried to explain that he had come simply to say that yes, as Needham had asked at breakfast that morning, a pair of visitors from China could indeed make use of Fisher's college rooms for the coming weekend. He raised his voice. No response. Then he shouted to Needham over the clattering din of the typewriter, "You asked me, and I say 'Yes.' " And then he left abruptly. Needham, despite having been granted a favor, never even bothered to look up.

On one occasion he relented, and happily so, since the interruption proved of great benefit. A stranger telephoned, explaining that he had just arrived from France, and badly needed a reprint of a paper he had seen mentioned in Needham's trilogy *Chemical Embryology*. Needham barked at him politely, telling him he had no such reprint and would he kindly not disturb him any further?

But the man persisted, inviting Needham to lunch, pleading once again that he had come all the way from France. And so Needham, who was something of a trencherman, agreed. The man then described how making use of an obscure embryological point mentioned in the trilogy had completely transformed his egg-producing business in France. And then he did what he had really come to Cambridge for—he handed Needham a check for an enormous sum of money.

Needham seldom dined in the college, preferring to work through the dinner hour and then go home late. Christopher Brooke, a prominent medievalist who was a junior don when Needham was beginning his work on China, recalls that on those few occasions when Needham did turn up in Hall he would forcefully quiz his dinnertime colleagues on matters that seemed relevant to his book, and would carefully jot the answers down on the backs of menu cards and on paper napkins. The

younger men liked talking to him: they found him rum, not dangerous. And they knew how he worked, really worked, and that he was often exhausted as a result. Once he flopped down into one of the chairs at the high table right beside the young, nervous Brooke, declaring simply: "Make amusing conversation to me: I'm really very tired."

Wang Ling recounted a story about how preoccupied his boss became when he was in the middle of working nonstop:

The Chinese have a proverb to describe a hard-working scholar reading books all the time, even *reading while travelling on horseback*. Needham travels by train, always buying a first-class ticket, not because of any snob value but because only the first class has empty compartments where he can spread his books and manuscripts around, jotting down notes. . . . Even while travelling by car, while driving he always discussed some topic of his book. However, there was one occasion when he did not discuss the book. He was driving at top speed on our return journey from a meeting in Oxford. He was engrossed . . . [when] suddenly he noticed the passenger seat beside him was empty. As one would expect, a Chinese was too polite to ask him

to stop the car in order to secure the latch on the door, which was not properly closed, so I had fallen out of the fast-moving car. Fortunately I landed on a pile of snow or else I would not live to tell the story. Joseph turned back to look for me and I got back in. He was upset beyond description—but I have survived to tell the tale. And the offending car-door was thereafter secured with a dog-chain.

Despite Needham's occasional air of autocratic disdain, people were eternally eager to help him, support him, and surround him with care. He employed a woman whom he called Auntie Violet to make him breakfast and tea: she worked for him, buttering the crumpets he liked to toast on his electric fire, until she was well over ninety. And once it was realized that even a Stakhanovite like Needham could be tempted to join others for afternoon tea, a variety of distinguished men and women, crumpet lovers and tea drinkers all, would stop by to dine informally with him, often memorably.

One professor stopped in to talk about rain gauges—whereupon Needham discovered for him, quite accidentally, a reference to what turned out to be the first rain gauge ever made, in a book on mathematics in the Yuan dynasty. During a teatime conversation about sternpost rudders with a team of acknowledged ex-

perts on shipbuilding from London, Needham turned out to know far more about the subject than any of the specialists. They returned to the Maritime Museum in Greenwich chastened, rubbing their eyes in astonishment both at the marvels of ancient China and, in comparison with Needham, their own newly revealed ignorance. And a Russian scientist arrived for tea, and asked, just in passing, if Needham knew who had translated one of the Russian's own books, published in Moscow, into English—whereupon Needham reached around and fished the very book out of his shelves. He looked at it and nodded, remarking that, yes, the title did sound familiar. Yes, he said again, after thinking for a few more moments—he himself had actually been the translator, when he was an undergraduate. But he doubted that he could repeat the feat: his Russian was not so good today—though his German, Greek, French, and Italian, and of course his Chinese, were still well-nigh impeccable.

But aside from such meetings as these, what exactly was Joseph Needham doing in his rooms? Just what was he trying to sift out from all the material he had gathered, and from all his memories? And, once he had it all, how exactly would he go about assembling all the building blocks into this massive, multivolume work?

He decided initially to make a great historical list, a list of every mechanical invention and abstract idea—the building blocks of modern world civilization—that had been first conceived and made in China. If he could manage to establish a flawless catalog of just what the Chinese had created first, of exactly which of the world's ideas and concepts had actually originated in the Middle Kingdom, he would be on to something. If he could delve behind the unforgettable remark that Emperor Qianlong had made to the visiting Lord Macartney in 1792—"We possess all things. . . . I have no use for your country's manufactures"—if he could determine what exactly prompted Qianlong to make such a claim, then he would perhaps have the basis of a truly original and world-changing work of scholarship. But he needed evidence, and a great deal of it.

Accordingly, he and Wang Ling spent the remaining months of 1946, and most of the next five years, searching for every invention and original idea that was mentioned in the ancient Chinese literature.

Needham proceeded in a patient, methodical, ruthlessly efficient way. He was an extraordinarily well-organized man. He was, for a start, a copious and fanatically driven note taker and file maker. In the piles of boxes that remain today in his archives in Cambridge are dozens of green steel card indexes, most

of them filled nearly to bursting, not with index cards bought by the quire from stationers, but with menu cards from teahouses that he was forever cutting up in a process he called "knitting"—snipping, slicing, and folding—which would drive mad those uninitiated few who might accompany him to the café for a cup of Typhoo and a toasted tea cake. He would sit there cutting, cutting, smoking, and cutting—and a day later the cards would all be stacked in their boxes, each one covered with details, in his almost perfect copperplate, about arcane creations from China's distant past. On the reverse side would be a half-legible copy of Today's Special Lunch or Today's Fare for Afternoon Tea.

And one by one, he and Wang began to find things. True, he had made discoveries while he was in China— the antiquity of the abacus, for example, and techniques of grafting plums. But buried among the papers and the documents he had assembled in Cambridge there was much more. He was able to note excitedly:

What a cave of glittering treasures was opened up! My friends among the older generations of sinologists had thought that we should find nothing—but how wrong they were. One after another, extraordinary inventions and discoveries clearly appeared in Chinese literature, archaeological evidence or picto-

rial witness, often, indeed generally, long preceding the parallel, or adopted inventions and discoveries of Europe. Whether it was the array of binomial coefficients, or the standard method of interconversion of rotary and longitudinal motion, or the first of all clockwork escapements, or the ploughshare of malleable cast iron, or the beginning of geo-botany and soil science, or cutaneous-visceral reflexes, or the finding of smallpox inoculation—wherever one looked, there was "first" after "first."

Needham first found a geographer of the Song dynasty named Shen Gua, for instance, who, in a document firmly dated at AD 1088, described the technique of using a magnetized needle suspended from a length of a silk to determine the direction of south—a full century before the first reference (in AD 1188) to the use of a magnetic compass anywhere else in the world. "I shall never forget the excitement which I experienced when I first read these words," Needham wrote later. "If any one text stimulated the writing of this book more than any other, this was it."

He then found that Chinese ironworkers experimenting in the sixth century BC had managed to make iron that was malleable and not brittle, and that farmers had fashioned a plow from this metal, and added

a moldboard to it, thus making a plow that was a vast advance on the primitive scratching device known as an *ard*, which was used in Europe at the time.

He uncovered old writings and drawings showing that the Chinese had invented breast-strap harnesses for horses in the third century BC, when Europeans still had their horses and oxen drag plows by the cruel and inefficient means of a rope looped around their necks. The Europeans would continue to use neck ropes for at least 1,000 years more.

He found that Chinese emperors, goading their subjects with the familiar valediction—"Do this, tremble, and obey!"—had built immense dams, irrigation projects, and canals (like the Grand Canal, which was started in the fifth century BC) hundreds of years before people in the waterlogged rest of the world (Mesopotamia excepted) thought they might be able to control their own rivers. Needham found documents showing that the Chinese created a tradition of subduing nature's excesses while people in the West were simply lying back and cursing the inevitability of fate.

The Chinese learned how to cast iron, for example, and to smelt it with coal. From the fourth century BC on, they were able to make long-lasting pots and pans, axes, chisels, saws, and awls—and a number of tall pagodas, some still standing today. In the seventh cen-

tury after Christ an ironworker made a palace tower 300 feet high and weighing 1,300 tons, topped with a massive iron phoenix and covered with gold leaf. In the tenth century, when Chinese ironmaking was unequaled, foundrymen working for the emperor in Hubei province in central China made him an enormous commemorative cast-iron lion, twenty feet high and weighing forty tons, which still stands as a memorial to a defeat of Tartar invaders.

But the founding of cast iron marked only the start of China's remarkable metallurgical progress. By the second century BC foundry workers were managing to produce a much more malleable and less brittle version of the metal, which today is called wrought iron, doing so by way of a process to which they gave the culinary term *chao*, since it involved "stir-frying" the molten mass very slowly for hours at a time, to remove the excess carbon. Contemporary ironworkers would call the technique puddling. To further strengthen the puddled iron—which could be used by a blacksmith to make such things as stirrups and swords—some Chinese engineers of 2,000 years ago reintroduced a very carefully calibrated amount of carbon by hammering particles of it into the metal surface, producing a kind of crude steel.

The puddling method, which the classic encyclo-

pedia of the second century, the *Huainanzi*, called "the hundred refining method," was often fancifully reckoned to be the *fons et origo* of the Bessemer process. The myth seemingly started because in 1855 the American steelmaker William Kelly hired a number of Chinese "experts" to work alongside his ironmasters in his mills in Kentucky, to give advice. In fact these "experts" were no more than manual laborers hired from a teahouse in New York City, men who had no special knowledge of steelmaking of any kind. They were simply cheaper to hire than the local Kentuckians. China had indeed an advanced and very ancient ability to make useful iron and some primitive kinds of steel—but Henry Bessemer's process, like William Kelly's, was entirely homegrown.

Countless other clever devices followed. Chains were invented—permitting, among other conveniences, the making of the chain drive, which Needham discovered appearing in Chinese life in the tenth century, seven centuries before it was first seen in Europe. Long before that, in the first century, illustrations started to appear of the mysterious-sounding square-pallet chain pump—an enormously practical device that allowed farmworkers to raise water from rivers and streams by as much as fifteen feet, and so allow the irrigation of waterless fields. To operate it men drove their feet against

large wooden paddles attached by sprockets to a chain of small wooden buckets: the device is in universal use in China today, so perfect a creation that it remains essentially unchanged after 2,000 years. Chains also meant chain suspension bridges, aeons before western suspension bridges were first made. Many of these Chinese bridges also remain today—the most famous being the nearly legendary Luding Bridge, which was built in 1701 across the Dadu River in Sichuan.

In those corners of the empire where iron was less easy to obtain, engineers contrived to use stone for bridges crossing rivers, creating what is now known as the segmental arch bridge, a type of construction that remains perhaps the greatest feat of China's early civil engineering.

Three hundred years before the Italians copied it, entirely thanks to the close observations of Marco Polo, this one type of Chinese bridge was to have an influence on communication and architecture like few others. The principle behind the bridge was first established in the seventh century by a northern Chinese engineer, Li Jun. Li had built many ordinary arch bridges—like those built by the Romans as early as the first century after Christ—but he realized that a bridge incorporating only the very top of a circle into the arch could be stronger, lighter, and more enduring than a tall, stone-

hungry semicircle-arch bridge. He began experimental constructions at the end of the sixth century, and his first completed and truly segmented arch bridge, more than 120 feet long, was thrown across a river in Hebei province outside Beijing. It is still standing today— 1,400 years after its construction in AD 605, and after centuries of floods, battles, and earthquakes.

Less obvious and less dramatic improvements in human life were being made in China all the while, and Joseph Needham worked patiently during 1946 and 1947, through the most terrible British winter of all time, when most of the world outside Cambridge was flooded and miserable, assiduously chronicling each of the discoveries.

Some were purely practical: the wheelbarrow, for instance, or the fishing reel. The sternpost rudder came about in the first century after Christ; and once the compass had been perfected it was possible for Chinese sailors to venture, as they did, to Australia, to Mogadishu, around the Cape of Good Hope, and on rather less daunting adventures to the Philippines and Indonesia. Then again, the rolling of the ships at sea caused a problem that another Chinese domestic invention neatly solved: it was a device of interlaced metal rings which keeps a light permanently upright and which is generally known as a set of gimbals, later used to hold

a compass, a chronograph, and the ship's gyroscope. And there was much, much more: the umbrella, the spinning wheel, the kite—and the sliding measuring instrument that engineers in the west copied and called a pair of calipers.

Needham then discovered a genius of the Han dynasty, Ma Jun, who lived around AD 206 and specialized in making automated figurines, "automata of dancing girls who played music, men who beat drums and played flutes, wooden images dancing on balls, throwing swords about, hanging upside-down on rope ladders, showing government officials in their offices, cocks fighting . . . and all continuously changing with a hundred variations." Ma was a polymath: he also improved the silk loom, explained the operation of the south-pointing chariot (a nonmagnetic steering device that was already ancient in his time), irrigated gardens with man-powered square pallet chain pumps, and invented the rotary ballista, a flywheel with stones attached that was a kind of rock-hurling machine gun.

And there was a profoundly simple but world-changing Chinese invention known in the West as the stirrup—a contraption just six inches high that weighed no more than a pound or two, but conveniently allowed a man to remain firmly and comfortably on a horse even though it might be going at full tilt and jumping

every obstacle in its path. This was an invention that had an effect on mankind out of all proportion to its size and to its apparent early significance.

Many early Chinese inventions were devised for idling and pleasure, or for elegance—for example, playing cards, tuned drums, fine porcelain, perfumed toilet paper,[38] the game of chess. The origins of chess are still hotly contested: many people like to think that the game began in India or Persia, though Needham's discoveries demonstrated that it began with the game of *xiangqi*, invented by the Chinese in the second century BC and exported westward to the Indian subcontinent. But the stirrup offers a reminder that China, despite its attention to the peaceable aspects of civilized life, was also involved in warfare, defensive and offensive, conducted internally and across its frontiers, from very early times.

[38] This has been a very popular commodity among rich Chinese for centuries; it became fashionable in the fourteenth century: records show that particularly impressive orders for quantities of this "thick but soft" aromatic paper were issued in 1393. Large sheets, two feet by three feet, were made for general use at court; smaller and better-quality sheets, just three inches square, were designed for the more sensitive and economically shaped bottoms of the imperial family. Records show that the first manufacture of paper for such purposes took place in the sixth century.

. . .

And then, at the beginning of 1950, Needham decided that he had found enough, or at least enough to get started. His first discovery period was officially declared to be over—though looking for and finding Chinese firsts would be a continuo throughout the making of the series.

Needham was ready to acknowledge that, however long and impressive this list of firsts might be, the items and ideas on it did not necessarily constitute either science or civilization, but merely hinted at creative ferment within Chinese society. But what a ferment! Depending on the way the arithmetic is done—and considering only the most intellectually fertile phase of China's history, between the Han and the Ming dynasties—Needham pointed out that in every century the Chinese dreamed up nearly fifteen new scientific ideas—a pace of inventiveness unmatched by the world's other great ancient civilizations, including the Greeks. The nature of the inventions was remarkable enough, Needham wrote; but the *rate* at which they came was like nowhere else on earth, and like no other time in history.

. . .

The role these firsts played in the actual construction of his book was crucial, because they were to serve rather like surveyors' marks, flags that would show how the complex work would be encouraged to grow—which Chinese invention would be placed in what part of the new structure, which creation should by rights be close to which other, which fields of thought should be examined and in what order. And as in the building of any immense structure, the placing of these precise markers took time—in fact, most of the cruel English winter of 1947 was devoted to working out this structure, long before any real building could actually begin.

By the early 1950s such markers as were definitely known were all firmly set down and the foundation trenches between them were dug—so that now the books themselves were ready to be organized, and the first of them could be written.

Needham initially decided to arrange the work in seven sections. He would later call these the "heavenly" volumes of the series, the major topics of Chinese learning and invention, at least as he saw them. It was a neat blueprint, except that both he and Wang Ling seriously underestimated how out of control everything would rapidly become. Nearly every one of their seven major headings of knowledge would produce innumerable di-

visions and subdivisions of subsidiary knowledge, almost every one of which, on Needham's close inspection, he thought deserved a full volume of its own. It was the making of these subsidiary books—which Needham came to call the "earthly" volumes—that caused the project to have such an elephantine gestation period.

In the very early days, the initial magnificent seven volumes were somewhat shakily organized.

Needham first suggested that Volume I, the Introduction, should address an overarching question: what science had emerged from China over the centuries? It should also address the context—the geography of China, the history of China—in which this question should be considered.

Volume II would look at Chinese philosophy: how the Confucian and the Daoist traditions regarded science, and how the tradition of experimentation and observation—of deductive reasoning as compared with inductive reasoning—originated and then developed (to the degree that it did develop at all) in the Celestial Empire.

Needham would devote much of Volume III to what he called the Chinese "pre-sciences," or what today would be called the pure sciences—mathematics, astronomy, meteorology, geology, geography, physics, alchemy, botany, zoology, and anatomy. This one book

would thus have an enormous span—though precisely how enormous Needham had, at this stage, precious little idea.

Volume IV—a similar monster that in its early form would also hint at unimagined vastness to come—would examine Chinese technology, the impure or applied sciences, which included such topics as engineering, papermaking, ceramics, navigation, chemical technology (including the making of explosives and the details of the long argument over who made gunpowder first, and for precisely what purpose), biochemistry (including fermentations and the science of nutrition), mining, metallurgy, architecture and painting, agriculture, medicine, pharmacology, and martial technology, including the science of making war.

Volume V would investigate the "Needham question." It would try to fathom what changes suddenly occurred in the China of five centuries ago that made it necessary for modern science to develop not in China but elsewhere, principally around the shores of the Mediterranean. The reality was obvious: in the middle of the fifteenth century virtually all scientific advance in China came to a shuddering halt, and Europe then took the leading role in advancing the world's civilization. Why might this be? The various factors—geographical, hydrological, social, economic, bureaucratic, linguis-

tic—that might have played a part in China's sudden change would each be considered in turn. Did China's reliance on an ideographic writing system, for example, inhibit the development of Chinese science? Did the immense bureaucracy play a part? Could the huge imperial investment in controlling the annual flooding of the Yangzi and the Yellow rivers have any bearing? Joseph Needham planned that this volume would offer all the answers.

According to the original plan, Volume VI—given the overall scheme for looking at China's development *in relation to the general history of civilization*—would examine other societies that had developed in parallel to the Chinese: the Egyptians, the Greeks, the Babylonians, the Indians, the Aztecs, the Maya, the Japanese. It would note, in detail, similarities and major differences.

And then, as the grand finale, Volume VII would ask quite simply and robustly: what next? What would be China's future, its wealth, its political systems, its systems of beliefs, its place in the modern world? Could the nation possibly recover from the setbacks of five centuries before? Could China ever climb back to its once preeminent position in the world? Had the nation abrogated its position forever? Or could China once again set the direction for human civilization,

as it had done so ably and for so long, thousands of years ago?

Like all plans, this one mutated and evolved. By 1950, when Needham and Wang were finally assembling Volume I and the book was well on its way to completion, the six succeeding volumes had already substantially altered their focus. All had expanded hugely. Many of them had spawned offspring.

For example, in 1954 the table of contents for Volume II, which was as yet unfinished, illustrates how enormously complex the study had become, and how just one volume had to be extended out of all proportion to its original dimensions.

The initial plan for Volume II might have seemed relatively simple: to describe Chinese philosophical approaches to science, and how the Daoist and Confucian attitudes toward experiment, observation, and theory varied over the centuries. By 1954, however, matters had become infinitely more complicated.

Confucianism, according to the plan, was to be first delineated and described in eight sections—"Theories of the 'Ladder of Souls' "; "The Ambivalent Attitude toward Science"; "The Humanism of Hsün Ch'ing"; and so on. Daoism was then to receive the same treatment—"Daoism and Magic"; "Ataraxy";

"The Return to Cooperative Primitivity"; "Gymnastic Techniques"; "Sexual Techniques." Scores of pages were then allotted for a thorough examination of "The Fundamental Ideas of Chinese Science" with essays on such topics as omen books, trigrams, hexagrams, the *Book of Changes*, and the Chinese knowledge of "Pythagorean" numerology and symbolic correlations.

And this was not even a quarter of the way into just one planned volume. Before Needham and Wang were done, there would be essays on such unrecognizable arcana as "Scapulamancy and Milfoil Lots," "Oneiromancy," "Glyphomancy," "Wang Chun's Struggle with the Phenomenalists," "The Judicial Trial of Animals," "The Neo-Confucianists and the Supreme Ultimate," and "The Buddhist Evangelisation of China."

When the volume finally appeared, in 1956, it was almost 700 pages long. The essay on "Tantric Sexual Techniques" alone took up seven full pages, and it included authoritative paragraphs showing how tenth-century Daoist manuscripts with titles like *The Book of the Mystery-Penetrating Master* and *Important Matters of the Jade Chamber* could offer reassurance to anxious Chinese men. The manuscripts calmed them by offering messages such as "Sexual continence is as impossible as it is improper" and "Celibacy is a practice that leads to neuroses." For titillation—probably

unintended, despite Needham's personal leanings—
the same chapter in Volume II also offered a catalog of
exotic Daoist bedroom behavior from 1,000 years ago
that beggars belief today.[39]

Needham had decreed early on in the process, as
he watched each volume begin to swell and threaten to
burst out of its covers, that no one volume should be
"too big for a man to read comfortably in his bath."
But it was happening nonetheless. Whereas Volume I
had been 248 pages long, with thirty-six illustrations,
fifty pages of bibliography, and twenty pages of index,
Volume II ran to 698 pages and Volume III to 680, with
127 illustrations, a bibliography that was 115 pages
long, and an index that was itself as long as a novella,
at fifty pages. The books were developing an alarm-
ing case of middle-age spread, and something had to be
done.

[39] Needham's known interest in the erotic tempted more than
a few letter writers to make contact. One communication, in the
spring of 1948, came from Mr. P. Ye, who described himself as a
"38-year-old virgin male" from Fudan University in Shanghai. He
was concerned that because of "sexual radiation" his eyelids oscil-
lated whenever he masturbated, as he did five times daily. He wrote a
lengthy technical inquiry, but its arrival was delayed, mainly because
he had addressed it to "Dr. Joseph Needham, Cambridge University,
London."

The consequence of all this was a rapid onset of cell division[40] (somewhat dismayingly for the beleaguered Cambridge University Press, which was obliged to tolerate the constant expansion of the project). One book became two, three, or four. Volume V, a special case, became not five, but *thirteen* formal subsidiary parts, each one of them big and complicated enough to be made into a separate, self-standing, and equally enormous new volume of its own.

The books are all about detail. They were assembled with a painstaking concern for even the smallest facts of Chinese life, and each volume was an exploration, as Needham put it, "of the limitless caverns of Chinese scientific history." He thought the individual volumes should demonstrate that they had been assembled using an approach "which tried always to avoid generalizations, and instead lingers lovingly on the fineries." The archives Needham left behind in Cambridge offer some clues about how each of the books was so scrupulously assembled. The volume that most admirers consider

[40] A series of separate monographs also emerged from the overmatter. Among them were *The Great Astronomical Clocks of Mediaeval China*, published in 1960; *The Pre-Natal History of the Steam-Engine* in 1962; and, most commercially successful of all (not least because of its clever title), *Celestial Lancets: A History of Acupuncture*.

the shining example of Needham's craft was published to nearly universal acclaim in 1971: Volume IV, Part 3, *Civil Engineering and Nautics.*

The book's organization is elegance itself, with its two basic themes segueing into each other quite seamlessly. The formula is deceptively simple: first there is stone, then there is water. *Civil Engineering,* which opens the volume, covers the making of Chinese roads, walls, and bridges—creations that are largely fashioned from stone. Next comes a graceful transition provided by the history of the Chinese canals over which these bridges pass—water and stone, combined. And finally comes the beginning of *Nautics*—water itself, alone—which tells first the story of the Chinese ships, rowing boats, and junks that use these canals, and then discusses the evolution of Chinese navigation, propulsion, steering, and the "techniques of peace and war"—under which heading are included such topics as anchors, moorings, dock and lights, towing and tracking, caulking, hull-sheathing and pumps, diving and pearling, the ram, armor plating, grappling irons, and the tactics of firing naval projectiles.

Most amazing is the detail, and the sheer variety of topics undertaken by the authors—who were listed on the title page as Joseph Needham, Wang Ling, and (after her return from her UNESCO duties in Paris in

1957) Lu Gwei-djen, the project's holy trinity. Some of the chapter headings hint at the scale and scope of the volume: "Constructional Features of Junks and Sampans." "Star, Compass, and Rutter in the Eastern Seas." "The Mat-and-Batten Sail: Its Aerodynamic Qualities." "Sculling and the Self-Feathering 'Propeller.' " "China and the Axial Rudder." "Armour-Plating and Grappling Irons." "Sluice-Gates, Locks, and Double Slipways." "Water-Tight Compartments, Hull-Shape and Its Significance."

Inside are diagrams and woodcuts, ancient scroll paintings and explications. For example, one page begins: "Then, before 1450, as we shall see, came a fundamental change in policy. The anti-maritime party at court, for reasons still somewhat obscure, got the upper hand, and the long-distance navigations were at an end." This was Needham's briefly discursive history of the fifteenth-century decline in Chinese exploration, brought about after Zheng He's famous expedition, which got as far as Mogadishu (some say a great deal farther), bringing home booty that included a hapless African giraffe which Zheng thought might amuse the emperor, but which in fact frightened him unconscionably.

The manner in which the trio worked on the volume—the years of research, the months of writing, the ceaseless flow of arcana—is just hinted at by the

contents of the boxes of papers now sedulously cataloged at the Needham Research Institute in Cambridge, in which are held all the letters and documents that Needham was able to use in deciding what to write.

One of the countless boxes, selected at random, contains the following:

1. A collection, held together with a rusting paper clip, of articles about coracles, including a long description of such a vessel from Cochin-China, which was caulked with a mixture of cow dung and coconut oil.

2. A picture of Lord Montgomery of Alamein inspecting a Chinese catamaran.

3. A letter from a correspondent in France (telephone BAlzac 3839) about Indo-Chinese sailing rafts.

4. A book entitled Floating Objects.

5. A collection of ten monographs, *Le Jonque Chinoise* by L. Audemard.

6. An advertisement clipped from the communist newspaper *The Daily Worker* for books on Chinese sailing vessels by G. R. G. Worcester.

7. An essay, "The Exploits of Sir Francis Drake."

8. Notes written on a table napkin, calling for definitions for the terms *lee-shore, double-canoe, Lepanto, tonnage, slavery, bamboozle.*

9. On a sheet of writing paper, a rhetorical question in Needham's hand: "How much did Ancient Egypt influence the design of the Chinese junk? Perhaps F. H. Wells in *China Journal* of 1933, he adds, has the answer?

10. Tsao-Fang's paper *On Canal-Boats and Canals Generally.*

11. *Dictionary of Sea Terms* (1933).

12. A painting from 1672 of a European cargo barque, said to be the first Chinese representation of a foreign vessel.

13. Notes on Viking vessel design.

14. A book, *The Sung Navy, 960–1279 AD,* by Lo Jung-pang.

15. A paper "On the Techniques of Straddling Shots."

16. A letter from a Mr. John Saar, of 30 West 75 Street, New York 23, offering information on

junks and remarking that on a recent visit to Caius College he had been "so well treated that he had lost all his left-wing and anti-elitist prejudices."

Day by day Needham, Wang, and in due course Lu Gwei-djen collected such material, sifted it, filed it away, then inserted it into the proper places as the chapters were planned, organized, and written. The material in this particular *Nautics* box might have been placed, perhaps, somewhere in the four pages devoted to "The Aerodynamic Qualities of the Mat-and-Batten Sail" or the eight allotted to "Textual Evidence for Early Chinese Use of the Axial Rudder" or the seven diagrams and drawings and essays on the subject of "Oars." Or maybe it was not used at all: maybe it was discarded, replaced by even richer sources, by even better evidence that has been consigned to others of the scores of boxes lying in the institute's archives, cataloged in detail awaiting their examination by some thesis writer of the distant future.

"I sometimes despair," Needham wrote once, "that we will ever find our way successfully through the inchoate mass of ideas and facts that are so hard to establish."

But he did find his way. He typed out the pages for

the *Nautics* chapters, all of them with two fingers, all of them at a furious rate, day after day through the late 1950s while at the same time he was working on other volumes and parts that dealt with wholly unrelated topics such as gold, tilt hammers, parachutes, segmental arch bridges, and reservoirs.

He finished the pages and sent them off to specialists—among the forty-odd who dealt with the *Nautics* volumes, all giants in the field, were James Fitch of New York, Klaus Fessel of Tübingen, Alfred Lieber of Jerusalem, Clough Williams-Ellis of Penrhyndeudraeth,[41] and G. R. G. Worcester (then the greatest living expert on Chinese junks) of Windlesham. He then recast his chapters on the basis of their advice; sent completed texts to his long-suffering collaborator at Cambridge University Press, an apparently saintly editor named Peter Burbidge; and awaited publication.

This one volume eventually emerged in 1971. Needham dedicated it to the memory of the following:

[41] The deliciously eccentric British architect—always dressed in breeches and canary-yellow socks—who created, among other magical places, the Welsh fantasy village of Portmeirion, and advised Needham on building techniques.

CHI CHHOA-TING
Historian of China's water ways and works
a friend beside the Chialing River
Economic and financial leader in a resurgent land
and of
HERBERT CHATLEY
Once Professor of Engineering
at Thang-shan College
and
Chief Engineer of the Huang-po Conservancy
an "Old China Hand" who loved the Chinese people
Historian of the engineers of Cathay and Manzi

It had taken fifteen years to make. No doubt someone will one day measure the tonnage of supporting paperwork or the footage of shelf space that the paperwork occupies, and come up with a statistical analysis that will rank this book alongside the compilation of enormous dictionaries or encyclopedias elsewhere. And this was just one volume—just one of many volumes that were compiled for *Science and Civilisation in China* as a whole. And all made, in essence, by this one fascinating man.

As word of the project spread, the honors began to trickle in. One that caused a peculiarly British kerfuf-

fle came from the Republic of China, and was called with appropriate grandiloquence the Order of the Brilliant Star with Cravat. Needham was told about it by the Chinese embassy in October 1947, was naturally thrilled, and casually asked his former bosses at the Foreign Office if accepting the honor would cause any diplomatic problems or offense. To his considerable astonishment he was told that yes, it would, and under no circumstances was he going to be allowed to wear a foreign honor unless given personal permission by His Majesty the King.

It took nearly two years for this permission to be secured. Letters from lofty figures in the various dusty British government departments that dealt either with protocol or treaties or had access to the corridors of Buckingham Palace tut-tutted their way around Whitehall. Eyebrows were raised at the notion that any foreigner could legitimately honor a man so exalted as a British diplomat (which is what Needham had been during the period for which the Chinese wanted to honor him). Discreet working lunches were held in offices at Westminster, and even more hushed dinners were held in clubs on Pall Mall, all to discuss this unprecedented (and to some, rather impertinently sycophantic) gesture.

Finally, in June 1949, Sir Alan Lascelles, a courtier

of huge distinction at the monarch's side, agreed that Joseph Needham's work had done much to better relations between London and the Nationalist government, now back in Nanjing. He thus wrote to Needham at Caius College saying formally, "His Majesty King George VI has been Pleased to Give Restricted Permission for N. J. T. M. Needham, Esq. To Wear the Order of the Brilliant Star with Cravat Essentially while in China and in the Presence of High Officials in China."

The irony of fate intervened. It all turned out to be much too late. In China the Communists were fast assuming power; the People's Republic was declared the following October; and four months after the king had given his permission, Chiang Kai-shek, who had signed the warrant for Needham's award, fled for Taipei. Joseph Needham's much-vaunted honor, the source of so much fuss in London, had become overnight no more than a bauble, recognized only in Taiwan, and except as a collector's curio, barely worth the paper it was written on.

Moreover, at about the same time, suddenly, and without any warning, Joseph Needham made the most terrible blunder.

He made a decision, based on his lifelong romantic flirtation with international communism, that very

nearly killed the entire project, almost before the first volume ever appeared. It was a fall from grace, and one for which Joseph Needham had no one to blame but himself, and it haunts the project even to this day.

It all came about by way of a mysterious telephoned invitation from a conference room in the capital of Norway. The caller was Chinese, and once the static on the line had cleared, he turned out to be one of Needham's oldest wartime friends. Would Joseph care to leave Cambridge for a while, the caller asked, and come back for a spell to China?

PERSONA NON GRATA: THE CERTAIN FALL FROM GRACE

On the Early Chinese Use of Biological Agents in Bombs

For this bomb you take tung oil, urine, sal ammoniac, faeces and scallion juice, and heat them so as to coat a lot of iron pellets and bits of broken porcelain. Then fill in (with a gunpowder core) to a casing of cast iron, making a fragmentation bomb. When it bursts it breaks into pieces which wound the skin and break the bones (of enemy soldiers) and blind their eyes. Even birds flying in the air cannot escape the effects of the explosion.

—DESCRIPTION OF THE "BONE-BURNING AND BRUISING FIRE-OIL MAGIC BOMB" FROM *THE FIRE-DRAKE MANUAL* BY JIAO YU, MID-FOURTEENTH CENTURY

From *Science and Civilisation in China*, Volume V, Part 7

Did the American armed forces use biological weapons during the Korean War? That question—which more than half a century later has still not been satisfactorily answered—very nearly proved the undoing of Joseph Needham, and his reputation remains haunted by the furor it provoked.

This allegation against the American military first arose in 1951, just a year after tanks of the North Korean army had crossed the thirty-eighth parallel and the communist leadership in Pyongyang declared war on the Republic of South Korea, which was backed by the United States. By the summer of that year—when the Chinese army had become fully involved on the side of the North—the war had become utterly bogged down in the stalemate which was its principal, bleak characteristic. Enormous numbers of troops—1 million on the communist side and very nearly as many among the twelve armies fighting under the flag of the United Nations—were sweeping back and forth along the mountainous, often bitterly cold, pitiless terrain, gaining territory, losing territory, demolishing cities to deny their use by an onrushing enemy, blowing up bridges, bombing railways, and in all manner of cruel ways wrecking the lives of millions, and for decades to come.

While the two sides were locked in this desperate

and unwinnable struggle, reports began to surface suggesting that something sinister might be afoot. Newspapers in Moscow reported that American agents had poisoned North Korean water wells with cholera bacteria; that anthrax had been used to infect cattle on farms in the far north of the country; and, most bizarre of all, that lepers had been parachuted or otherwise infiltrated into areas held by the communists, where they were left to infect as best they could the enemy around them. The reports caused anxiety and commentary in left-wing newspapers around the world, but otherwise, because of their suspect provenance, they were roundly ignored. For a while things calmed down.

But early in 1952 fresh reports—similar but rather more dramatic—surfaced again, this time in the Chinese press. It was said that mysterious diseases were breaking out in Korea and Manchuria, and that they were inconsistent with either the region or the season. Cholera, a hot-weather ailment, was found in a Korean village in January, and doctors were baffled. Infected insects were found lying on top of patches of snow— and they were always found, it seemed, just after the United States made nighttime air raids.

One instance remains a contemporary Chinese legend. In the early spring of 1952, villagers in a Chinese county close to the North Korean frontier

reported that during the night hundreds of small vole-like rodents fell from the skies, landing on their roofs, scattered into their haystacks, and even wriggling onto the *kangs*, the platforms on which women and children were still sleeping.

By the time the day had fully broken, the men of this village's local communist leadership knew exactly how to react. They acted quickly—skeptics would later say too quickly. They assumed these were alien and probably disease-ridden animals that had been dropped by American planes coming across the Yalu River from their bases in Korea. They had been warned that this might happen, and so, as they had been fully trained to do, they organized a hurried collect-and-destroy campaign. According to North Korean accounts, by the end of the day every single vile American vole had been tossed onto a pyre, and all traces of possible infection that the dastardly American generals had tried to inflict on the villagers had been purged.

By coincidence—or by supposed coincidence—China was at that moment in the middle of a state-directed public health offensive, the Patriotic Hygiene Campaign, run with all the manic energy for which the Chinese Communists were becoming known. It took just a single exhortation from the country's Great Helmsman to get things started. "Let us get mobi-

lized," Mao Zedong wrote the week before in a memorial presented to the National Health Conference in Beijing. "Let us attend to hygiene, reduce the incidence of disease, raise the standards of health, and crush the enemy's germ warfare."

His words were immediately echoed by Zhou Enlai, China's premier and foreign minister—who by now was a good friend of Needham's from their sojourns in Chongqing nine years before.[42] That Zhou agreed wholly convinced Needham of Mao's plan: China's hygiene campaign, he said later, was just the kind of first-rate national effort of will that was so hugely impressive in the early idealistic days of the Chinese Communists. Needham truly believed—though many said he was naive to do so—that a properly compassionate nation could and should marshall its efforts just like this, selflessly and for the common good. A capitalist system, he thought, would simply never be up to the task, since the need for profit would always mask and distort the mission's ultimate goal.

So he was more than a little surprised to read that

[42] So close were the men that Needham dedicated the first of the two volumes of *Science and Civilisation in China* devoted to military technology—Volume V, Part 6—to Zhou, for his role as "a constant encourager of this project."

Zhou had taken his theme somewhat farther than the idealistic goals behind the plan. The premier told his audience that he supported an accusation just made by the North Korean foreign minister, saying that the Americans, in dropping sickly voles on Chinese villages, were clearly up to no good. He was quite specific: "I charge the United States government before the people of the whole world, with the heinous crime of employing bacteriological weapons." He called on "the world's peace-loving peoples" to "take steps to put an end to the frenzied, criminal acts of the American Government."

The world had to take notice. Zhou's evidence was at best slender, and largely circumstantial. There were said to have been outbreaks of plague, respiratory anthrax, and encephalitis in northern Korea and southern Manchuria, and local people reported that germ-carrying insects and animals, such as rats, mice, and voles, had been found on the ground in the affected areas, scattered randomly as if dropped from on high. Teams of Chinese scientists concluded that America, desperate to tip the strategic balance on the Korean peninsula, had been waging a particularly cruel secret war that involved the dissemination of lethal bacteria and viral agents.

Evidence or not, this was certainly within the

bounds of credibility. It was known to a limited degree at the time to the intelligence agencies—and is known more widely today—that America had for some years after World War II been developing biological weapons. After the capture of the Japanese army's notorious Unit 731 "Water Purification Camp" at Pingfan, near Harbin in Manchuria—where an elite Japanese team conducted unimaginably terrible biological experiments on living human prisoners (the same was done at a similar camp in the center of Nanjing)—a deal was struck, whereby American military researchers gained access to all the Japanese data in exchange for freedom, or very light prison sentences, for many of the principal experimenters.

Much of America's subsequent research—using animals and a very small number of human volunteers—was then conducted by the U.S. Army at its chemical warfare research center at Fort Detrick in Maryland.[43] The success of this work then led to an enthusias-

[43] Other research using live biological agents was also conducted in eight American cities between 1950 and 1966, according to testimony given before a Senate committee in 1976—a disclosure that shocked most of America at the time and led to widespread popular revulsion against biological weapons generally, and a widespread reaffirmation of a decision by President Nixon in 1972 to ban the possession of such weapons by the United States.

tic memorandum, approved by the U.S. Joint Chiefs of Staff in February 1952, declaring that henceforth the United States should be ready to deploy biological weapons "whenever it is militarily advantageous."

While these developments were taking place in America, Mao's government announced a number of sweeping public policy campaigns—such as those involving public health, with the people being regularly mobilized by party cadres to find and destroy outbreaks of disease (and to catch houseflies). That the efforts of this campaign turned up so much illness in 1952 may be regarded as a testament to its success—or its results may simply have been engineered to provide the government with some very useful propaganda. Whatever the motives or the effects, the coincidence was stark: the American military now had an admitted ability to wage germ warfare, and the Chinese hygiene campaign was turning up inexplicable outbreaks of illness caused by germs. Two and two could easily be added together to produce—at least from the propagandists' point of view—a highly desirable result.

Two months after Zhou Enlai's intelligence staff told him of America's memorandum about biological warfare, he made the connection, and then gave his hostile and highly tendentious speech. And following that, Communist China's new spin machine was cranked up

and presented to the world at large the full extent of the atrocities the Americans were now charged with committing.

This was the point at which Joseph Needham became involved. About six weeks after Zhou made his charges, he sent Guo Moruo, who was the head of the Chinese Academy of Sciences and an old colleague of Needham's, to Oslo for a meeting of the World Peace Council, a body set up three years before, and largely funded by the Soviet Union, to promote nuclear disarmament and, as its name suggested, world peace. At this meeting Guo swiftly turned up the temperature by issuing a formal request for an International Science Commission to investigate the charges. The International Red Cross had first been suggested, but the Chinese and North Koreans said that a report issued by this body, which was based in Geneva, would probably be biased in favor of the West, and dismissed the idea out of hand.

Guo told the conference that what China and North Korea wanted was a group of six or seven "impartial and independent scientists . . . known for their devotion to humanitarian causes." This last phrase was unfortunate, since it was a code that in those years of the cold war suggested to critics an ominous hint of fellow travelers, and automatically placed the valid-

ity of any work they might do under suspicion in the West. Guo was a Chinese Communist; the Peace Council was "left-leaning"; "humanitarian causes" meant, in apparatchik-speak, "our cause." From its inception, then, the International Commission had problems with credibility.

Nonetheless, seven scientists were quickly found, and only one of them, a professor of biology named Zhukov from the Soviet Academy of Medicine, was from an overtly communist background. Others were more obviously neutral. There were reasonably well-respected biologists from the universities in Rome, Bologna, and São Paulo. There was the director of the main clinical laboratory of the hospitals in Stockholm, and also the head of a well-known French animal physiology department.

But then came a coup de théâtre, which startled the academic world. Guo still remembered Needham from their wartime meetings in China, and he was able to telephone from Norway to Cambridge to ask if, for old times' sake, Needham might consider joining the group. Guo piled on the flattery, as he had been instructed. All Needham's friends in China were longing to see him, Guo said. The newly liberated China was a sight well worth seeing. It was the socialist dream made

real—and all of Needham's travel expenses would be paid, all his quarters would be comfortable, all his companions agreeable. Needham withered under the pitch. He apparently needed little persuasion, and that same evening agreed readily to go and see for himself if the charges against the American forces were true or false.

And so on the following morning the news was formally announced: the International Commission would be led by Joseph Needham, a Cambridge biochemist of towering reputation, a man who had spent four years in China during the Japanese war and who was—of crucial importance for the commission's study of documents and interviews with witnesses—fluent both in written and spoken Chinese. There should be no doubt, said Guo, that the commission and its work would eventually be taken seriously, since its conclusions would be underwritten by men of the greatest integrity and a commitment to unbiased scientific inquiry.

It was to turn out very differently.

The team arrived in China in June, on a mission designed to last two months. Needham, a man given to moments of intellectual vanity, promptly decided that the colleagues with whom he had been saddled were of rather lower caliber than he had hoped. In letters home he fretted that the participation of such "undis-

tinguished" scientists might well tarnish the legitimacy of the commission's work.[44] So to compensate for this, he threw himself into his allotted tasks with typical vigor, traveling to the sites of the alleged vole attacks, interviewing villagers, translating and writing reports, and compiling vast quantities of notes.

The others in his team may have slipped on their white coats and gone to laboratories to conduct experiments on the material that had been collected as evidence. But Needham, delighted to be back in China for the first time since 1946, eager to see his old friends, and thrilled beyond words to be able to offer some support to the party that now held power in the People's Republic, stayed either in Beijing or the south Manchurian city of Shenyang, or went to the various sites where bombs and canisters of animals had allegedly been dropped. He pointedly did no scientific investigations. His only regret was that neither he nor anyone on the team had the "good fortune" to see anything being dropped from the air—though they met a great many Chinese people whom they named in the even-

[44] Needham's letters and other papers relating to the commission are preserved not in the Cambridge University archives, but, in consideration of the sensitivity of the topic of germ warfare, in the rather more secure surroundings of London's Imperial War Museum.

tual report, and who had said, apparently credibly, that they had seen such things.

On his germ-hunting tours of north China Needham was very much the same man he had been six years before. He reveled in the parties and soirees that his handlers staged for him. He commented on a "v. pretty" female tractor driver who performed Manchu and Mongol folk dances for him at one site of the alleged vole attack. He was happy to be photographed beside the containers in which, it was alleged, noxious bacteria-rich concoctions had been dropped from American bombers. And if he had any suspicion that the displays and the reminiscences of the villagers who supposedly saw the bacteria-laden insects, birds, or rats infest their fields were to any degree staged, then he supposed it was merely part of the all too familiar Chinese theatrical approach to welcome and hospitality, and so was entirely innocent.

Needham did become a little skeptical, however, when he visited Gannan county on the Korean border, where the first reported dropping of voles occurred. He was invited to sit back and watch as a technician in full protective gear of mask and rubber gloves went through the elaborate motions of examining microscope slides in a mobile bacteriology laboratory which had been set up on a day of quite blinding Manchu-

rian summer heat. "I have the feeling," he wrote the next day to Dorothy in Cambridge, "that this may have been a *mise-en-scène* for one person." He was blithely unaware of just how true that would turn out to be.

He was staggered—and reading between the lines of his notes, initially just a little depressed—by the changes he saw. There was a drab colorlessness to everything in China now. People were dressed in gray and blue, or else in military uniforms, and the only other clothing he glimpsed was in a few rather threadbare theatrical performances, when minority tribes wore their traditional dress. There were portraits of Mao and Zhou posted on buildings, and exhortations in enormous red characters, telling people to produce more, to be honest, to trust the party. No Christian churches seemed to be functioning. The telephone service was patchy, and people whose numbers had worked during the 1940s had apparently now been disconnected, or perhaps had moved away.

There also seemed to be less food in the shops, fewer cars on the streets, more broken windows and broken-down trucks. He sensed listlessness—but at the same time, he wrote more cheerily, there was also a very evident lack of excess, little evidence of the old corruption, a far better hospital service, and what appeared to be many more public buses. But if he was more than

a little disappointed at the changes, he said nothing in his journals to suggest this. He had long held the view that it would take many years for a true revolution to make itself felt in so huge a country as China. Patience was consequently essential, as well as an optimistic faith that Mao, Zhou, and all the other architects of the People's Republic would hold on tight and await the realization of their dream.

And in any case most universities were still running, and they were back safe in their home cities. He entirely trusted, he wrote, the dozens of Chinese scientists he interviewed on behalf of the commission—all of them were first-rate bacteriologists, and many were men and women he had known personally in the 1940s and could vouch for.

In the end it was Needham's blind trust in these Chinese scientists that led him to the conclusions he made—and to present the final report, which would bring him so much trouble and would briefly put his entire literary project in peril. He had total, uncritical faith in the honor and integrity of these men and women. He simply could not bring himself to believe that any scientist worth his salt—and certainly none that he knew and had chosen for this task—could change his or her powers of observation and analysis merely because the government's ideology had changed. True, it had been

an almost unimaginably profound change—from capitalism to communism, from Chiang Kai-shek to Mao Zedong—but it could surely not affect the conclusions of the kind of scientists with whom he had become and had remained such close friends. Surely not. It was just inconceivable.

He helped select some sixty of the local specialists who would carry out technical investigations for his report, and much was made of their foreign credentials. Twenty-three of them had PhDs from American universities (including Cornell, Berkeley, and Harvard), a dozen came from British schools, and nine had doctorates from the well-regarded Japanese colleges that had been set up in the old puppet state of Manchukuo. The presence of so many foreign-trained scientists would, it was hoped, bolster the credibility of the eventual report.

And credibility was very much needed when the 665-page report (most of it in the form of appendixes) was finally issued, initially in French, on September 15, 1952.

This document confirmed everything Mao and Zhou Enlai had claimed. The people of China and Korea, Needham stated at a formal government-sponsored gathering in Beijing on that Monday morning, had indeed been the hapless targets of American bacteriological weapons.

These have been employed by units of the U.S.A. armed forces, using a great variety of different methods for the purpose, some of which seem to be developments of those applied by the Japanese army during the Second World War. The Commission reached these conclusions, passing from one logical step to another. It did so reluctantly because its members have not been disposed to believe such an inhuman technique could have been put into execution in the face of its universal condemnation by the people of the nations.

When Needham arrived in London a week later, he was immediately and rudely exposed to the world of misery in which he would now have to live. His first clue should have been the two-hour grilling by a vehemently skeptical press. He stood on a podium at Hotel Russel in Bloomsbury, still wearing his army fatigues, looking like an overgrown Boy Scout, and, once the questioning became unexpectedly harsh, wincing with discomfort and embarrassment. He had never been subjected to an onslaught like this. One imagines that he began to stutter, to blink, to look uneasy, to seem suddenly quite out of his depth, and as if he didn't have the slightest idea of just how little the western press wanted to hear the news he claimed to bring.

He managed to splutter weakly that he was "ninety-seven percent certain" that the Americans had used infected insects and small animals as vectors to spread diseases such as anthrax, smallpox, tularemia, typhus, and plague in China and Korea. He was not able to say why they had done this; nor could he be certain how successful the alleged biological warfare campaign had been, militarily—but that it had occurred he never had any doubt. No, never. Well, hardly ever. It would be too kind to say that at this moment Needham seemed just like the well-bred captain of the *Pinafore*. It was a great deal worse than that.

Not a single question asked that day was friendly. The writer of the one in-depth interview he granted, for a paper he later described as "reactionary," painted him as a traitor, a stooge, an Ishmael. He returned to Cambridge, chagrined and bewildered, and for the next several months had to endure a firestorm of criticism, first in his own country, then across the Atlantic.

The establishment turned its guns on him as only the British establishment can do. A hitherto unknown government organization, the Intelligence Research Department of the British Foreign Office, mounted a fierce campaign of character assassination against him, directed at friends within the press and malleable members of Parliament. Fury rained down on him from all

quarters. He was ostracized in his college. He came under intense pressure to resign from his academic posts and as a fellow of Caius. An invitation to accept an honorary degree in Brussels was withdrawn, though only temporarily. He was condemned even by colleagues in the Royal Society, despite the Society's motto *Nullius in verbia,* "On the words of no one," which normally suggests that its members have a certain healthy skepticism toward authority. Two former presidents of the Royal Society wrote a letter to the *Times* officially distancing the society from the commission's report; the master of Corpus Christi College in Cambridge sent a letter to the *New Statesman* saying that Needham's involvement showed that "it is not always easy for even an experienced scientist to discard a favourite hypothesis when the evidence fails to support it"; and even one of Needham's closest scientist colleagues, the left-wing Sinophile Bill Pirie, remarked that the commission's report contained "a lot of nonsense."

One prominent fellow of the Royal Society, the Nobel prize–winning physiologist A. V. Hill, widened the attack by writing a scathing letter to the *New York Times,* alerting Americans to the commission's existence, to its report, and to its principal author—all the while telling them not to be too concerned, since no one of any standing in Britain had taken much notice.

In a very similar letter to a London newspaper he suggested baldly that Needham had used "the prostitution of science for the purpose of propaganda," but for his transatlantic readers he was rather more insidiously critical. "Our Americans friends can be reassured, "he said, because

> the only British member of this "impartial and independent" party (invited, it is true, by Chinese agencies) was Dr. Joseph Needham; and British scientists appear to have applied spontaneously to him the advice which the Archbishop of Canterbury, Dr. Fisher, gave earlier about the Dean of Canterbury—that any public importance he might seem to have in this connection would evaporate if no serious notice was taken of him.

The letter briefly fascinated Americans, revealing for the first time the existence of this clearly hostile Red in the fens of Cambridgeshire. This was, after all, the height of anticommunist fervor in the United States, and Senator Joe McCarthy, investigating the alleged infiltration of the U.S. government by communist agents and fellow travelers, was coming to the top of his game, intimidating, harassing, naming names, providing lists, shamelessly creating a mood of despair,

and driving suspects to depression, self-loathing, and worse.

One good friend of Needham's, the anthropologist Gene Weltfish, was abruptly dismissed by Columbia University at about this time, for no more serious a crime than publicly agreeing with Needham's conclusions about the use of germ warfare by the United States. Twenty years later the university president who had fired the popular and accomplished Weltfish confessed that he was pressured to do so by the board of regents. He was directed to weed Dr. Weltfish out as undesirable, an agitator, and a Red. For the following nine years she was essentially unemployed, and when finally her good name was publicly restored she was ailing and thoroughly embittered by her experience.[45]

Others who spoke out in support of Needham were similarly censured: for example, a seventy-two-year-old market gardener in California, a Briton, was threatened with deportation for publicly accepting Needham's verdict. Generally it was wise to keep quiet—and few in

[45] By chance my own copy of Joseph Needham's book *Science Outpost*, which recounts his four wartime years in China, once belonged to Gene Weltfish. He had inscribed it, "Gene! With love from Joseph, Jan. 1949. Write me how you like it." Senator McCarthy and the regents of Columbia would doubtless have found its possession a useful piece of additional evidence for their crusade.

the American intellectual community dared utter anything severely critical of the American forces' behavior in the Korean theater; nor did American intellectuals criticize too harshly the politicians' decisions on how best to fight the war. To be branded in any way "un-American" was to risk ostracism of the harshest kind.

For playing his part on the International Commission Joseph Needham was banned from traveling to the United States, was declared persona non grata, and was put on a blacklist by the State Department. All this was more than just a slight to a senior British scientific figure, a former diplomat, and a fellow of the Royal Society: it was a tremendous inconvenience, since his academic life required him to make scores of visits to America to attend conferences and give speeches. He had spent three months in America only a short while before, speaking at Berkeley and Stanford, in Colorado, and in Texas, and to a fund-raiser in New York for Rewi Alley's Gung Ho cooperatives in China. He went to the Ivy League schools with metronomic regularity. And he undertook frequent official missions across the Atlantic on behalf of UNESCO and the British government.

He pleaded, as did his many sponsors, but all came up against the fortress Senator McCarthy had constructed against incursions by the Reds. Needham remained on the blacklist until well into the 1970s, and

even after it was withdrawn, and by the time he had become master of his Cambridge college, he still often faced trouble regarding his visa when traveling to the United States. And the matter is still a source of some sensitivity: his files at the Central Intelligence Agency remain off-limits, and requests under the Freedom of Information Act to have them declassified and released have been consistently denied, without anything other than pro forma explanations.

Some people have suggested that this refusal to release Needham's files is an imputation of guilt by the American government. Recent information from Chinese, Japanese, and Soviet sources, however, suggests that the United States has very little to fear from revealing the entire truth about Korea, since it seems likely that no American germs ever did rain down on China or North Korea, and that Needham had simply been naive. He had been foolish, eccentric, out of touch, and, in the words of one very hostile obituarist, a "fathead." Needham was intellectually in love with communism; and yet communist spymasters and agents, it turned out, had pitilessly duped him.

In 1998 a number of hitherto secret documents from the Soviet Union's presidential archives relating to the Korean war were published in Japan, and academics

studying those papers that related specifically to the work of the International Commission and its visit half a century before noticed something quite remarkable: that the sites to which Needham and his colleagues were taken during their investigations had all been *created artificially* by, or with the help of, intelligence agents from the Soviet Union.

The papers, which in due course were published in English in Washington by the Carnegie Institution's Cold War International History Project, offer in fascinating detail a narrative of what may really have happened during the summer of 1952, at the time of the investigating party's arrival. Much seems to have concerned vicious factional infighting in the Kremlin after the death of Joseph Stalin.

The first revelation came in an explanatory formal memorandum, sent by telegram in early April 1953, from a senior agent of the KGB named Glukhov to the minister for state security in Moscow, Semen Ignatiev, who was known to be a supporter of the ambitious Nikita Khrushchev. This memo was copied to the North Korean Public Security Ministry, to whom Glukhov was attached as an adviser. It began:

The Koreans stated that the Americans had supposedly repeatedly exposed several areas of their

country to plague and cholera. To prove these facts, the North Koreans, with the assistance of our advisers, created false areas of exposure. In June–July 1952 a delegation of specialists in bacteriology from the World Peace Council arrived in North Korea. Two false areas of exposure were prepared. In connection with this the Koreans insisted on obtaining cholera bacteria from corpses which they would get from China. During the period of the work of the delegation, which included Comrade N. Zhukov, who was an agent for the Ministry of State Security, an unworkable situation was created for them, with the help of our advisers, in order to frighten them and force them to leave. In this connection, under the leadership of Lt. Petrov, adviser to the Engineering Department of the Korean People's Army, explosions were set off near the place where the delegation was staying, and while they were in Pyongyang false air raid alarms were sounded.

Two weeks later, in Moscow, Lavrenty Beria—who had almost certainly been involved in Stalin's murder the previous month, and was now jockeying (in vain) for power against the allies of Khrushchev—was informed by a senior official in the KGB that Soviet agents had helped spread false stories about American

efforts to disseminate smallpox among the North Ko-
reans. Moreover, all the allegations that had been made
around the world about the use of bacteriological weap-
ons in China and the north of Korea had been invented
either in Beijing or Moscow—and invented so well that
even Kim Il Sung, the North Korean leader, believed
them and was reportedly afraid of falling victim to a
germ attack even though "there are not and have not
been instances of plague or cholera in the PRC and
there are no examples of biological weapons."

A week later Beria was reporting to Georgy Malen-
kov and the Presidium of the Soviet Union about the
creation of the two false areas, adding some macabre
details: in one of these areas "two Koreans who had
been sentenced to death and were being held in a hut
were infected. One of them was later poisoned."

The political consequences then took a turn that
was somewhat unexpected. The Presidium declared
that the invention of these stories about the Americans'
use of germ weapons had in fact done the Soviet Union
great diplomatic damage—clearly Moscow thought
that few in the West actually believed the stories,
and that Needham's mission had in fact been either
widely discredited, or ignored. This, of course, was
entirely true: the British Foreign Office had very ef-
ficiently seen to that, and Needham had spent many

solitary weeks in Cambridge, shunned by most of the noncommunist scientific community, his report gathering dust, largely unheeded.

In view of this, said the Kremlin, an ax had to fall—and in a memorandum dated just three days after Beria's message to Malenkov it was recommended that for helping organize the subterfuge, the Soviet Union's ambassador to Pyongyang be recalled, fired, and prosecuted; and that the minister of state security, Ignatiev, who had first authorized the plans after the ambassador told him about them, be demoted and stripped of his membership in the Central Committee.

This small and unnoticed bloodbath was one of many in Moscow during these frightening times. Beria was to be executed soon afterward, once Nikita Khrushchev had won power and had started to reverse many of Stalin's policies and to purge their architects. But however mundane or bizarre, the episode had a certain sweet relevance to Needham's later reputation.

The revealed telegrams showed that he had operated in China and Korea in perfectly good faith, and had been a victim of a very clever and adroitly organized campaign of disinformation. He was, in other words, much more of a fool than a knave—and in truth not too much of a fool, even then.

His worst crime was to have taken at face value the

word of a great number of Chinese bacteriologists, men and women whom he trusted and in whom he firmly believed. In professional terms Needham was after all an exceptionally honorable man, a scientist given to following the scientists' code—hypothesis, theory, experimentation, observation, discovery, and proof—which at every step demands a commitment to honesty and integrity, and which holds as a moral certainty the idea that results can never, ever be fudged, manipulated, or falsified.

Given his absolute adherence to this guiding principle Needham simply could not imagine that, even with so profound a change in the regime in Beijing, the minds of so many scientists, hitherto as honorable as he, could possibly become so perverted merely in support of a new political dogma. Today we would regard that as naiveté; in 1953 cynics could only really say that by agreeing to join the commission he had set out on what was no more than a fool's errand. Those who were his fans would remark, wearily: *even Homer nods.*

There was to be a sad sequel to the story. In 1956 three American radicals then living in Shanghai—John and Sylvia Powell and Julian Schuman—were charged in a federal court with the grave crimes of treason and sedition. Their offense was that they had published, in their magazine *China Monthly Review,* two treacher-

ous articles. The first exposed the secret details of the deal allegedly struck between the United States government and the Japanese commanders of the Unit 731 terror camp—data about human experimentation in exchange for amnesty. The second article offered generally sympathetic coverage of the findings of Needham's commission. The Powells' readers would expect no less: they all *knew* that germ warfare had been conducted in Korea, and the commission's report simply confirmed it.

The defendants' lawyer asked Needham to fly to America and testify on their behalf—his expenses would be paid, and the court would order a temporary American visa to be issued. But Needham refused. It was now four years after the commission had reported. By now, he said, his life was beginning to return to normal. The fellows of Caius had forgiven him, and he had been appointed to the college *consilium*. His work on *Science and Civilisation in China* was now occupying all of his life, and he did not wish to be subjected yet again to abuse and ostracism. So far as he was concerned, and sorry though he might have been for the "dreadful plight" of the three accused, the matter was now closed.

As it happened, the passage of time eventually closed the case for the accused as well. As the 1950s ended and the 1960s began, a mood of tolerance began to find its

way back into the American body politic. Public opinion turned against the witch hunters, and in consequence, in 1959, toward the close of the Eisenhower administration, the charges of treason were abandoned after a judge dismissed the case for lack of evidence. Two years later the U.S. attorney general, Bobby Kennedy, dropped the sedition charges also, and the Powells returned to their native San Francisco to run an antiques business. At the time of this writing John Powell, who was born in 1919 in Shanghai, remains in California, a survivor of a curious period in American history.

As to whether the Americans ever did use bacteriological weapons in Korea or China, one has now to suppose they did not, but at the same time one suspects that the story has still not been fully told. It was the investigation itself that in the end, at least in academic circles, became the event most remembered from that time—and it was an event that took an inevitable toll on the stature and standing of the man who led it.

But then came the publication of the first volumes of his book, and his precipitous fall from grace was suddenly, and impressively, arrested. And as the long line of massive volumes began to thunder from the presses, Joseph Needham's once formidable reputation, so unexpectedly battered and bruised, began to recover.

THE PASSAGE TO THE GATE

Two Last Recorded Wishes

My concluding thought is that by an extraordinary series of events modern science was born, and swept across the world like a forest fire. All nations are now using it, and in some measure contributing to its development. We can only pray that those who control its use will develop it for the good not only of mankind but of the whole planet.

—JOSEPH NEEDHAM, 1993—HIS FINAL WORDS IN THE ESSAY
"GENERAL CONCLUSIONS AND REFLECTIONS"
From *Science and Civilisation in China*,
Volume VII, Part 2

Joseph: I had at one time hoped to be with you when the last volume was published, but I promised

that even if I was not on the bridge the ship would sail safely into port. . . . I am sure that day will come.

—KENNETH ROBINSON: FROM AN IMAGINED
CONVERSATION WITH THE LATE JOSEPH NEEDHAM,
CAMBRIDGE REVIEW, 1995
Reprinted in *Science and Civilisation in China*,
Volume VII, Part 2

Publication day of the first volume of what everyone was now referring to simply as *the book* was August 14, 1954, and Joseph and Dorothy Needham celebrated the event in a quietly deliberate style—and at a place he chose quite specifically, and for a raft of complicated reasons, some good, some less so.

He had already been working hard on the proofs of the second volume when, late in July, he and Dorothy left Cambridge for Paris, taking the Dover packet. They were bound for Budapest, where both were due to speak at the International Physiological Conference of 1954. They stopped along the way—first in Paris, to meet Gwei-djen, who was still working with UNESCO (it would be another three years before she returned to Cambridge to become involved with the book full-time). The trio retired to a restaurant to open a bottle of celebratory champagne, three weeks in advance of

the happy event. Joseph and Dorothy then boarded the Orient Express for a journey that Needham, railway mad, later pronounced a nearly total delight, despite atrocious weather and a broken heating system in their wagon-lit. The dining car served splendid food, and the steam engines that pulled the train were liveried and magnificent, with drivers who liked Needham's adolescent enthusiasm for their craft.

They stopped for a while in Mainz—Joseph making a point of visiting the "local Orientalists" to remind them courteously that their hero Johannes Gutenberg was (thanks to the discoveries at Dunhuang) not quite what they had long liked to suppose. Then the travelers stopped in Vienna for a weekend holiday, before pressing on to Hungary. Both gave well-received papers at the conference, though Joseph seemed rather distracted: his diary records that he had discovered a small steam railway in the forested hills above Buda, which was operated for children and only for fun, and he spent hours questioning the locomotive driver about the intricacies of its miniature workings.

Once done with the congress, the other scientists from western Europe then left for their various homes or their next destinations in convoys of cars—but the Needhams did not go home. They had their driver take them back through Austria and Liechtenstein and

via Basel on the Franco-Swiss border to Tours, in the Loire valley. They made their own way from this point to where Joseph planned to spend publication day: the small medieval town of Amboise, fifteen miles upriver.

The couple chose the place for a number of reasons. The happiest of all was that Amboise was the town where Leonardo da Vinci had spent the final three years of his life—and Joseph Needham had said, only partly in jest, that he wanted to spend this most memorable day beside the house and the tomb of the most remembered Renaissance man who had ever lived.

He wrote all this to Gwei-djen in Paris, also saying how much he missed her. In one letter he told her that when he had arrived the day before, Thursday, he had ventured into the château of Amboise, as he had done with her some years before—only this time he had gone to see what the two of them, in their rapture, had evidently missed: the flamboyant gothic chapel of Saint-Hubert, where Leonardo's bones had been interred in the early sixteenth century.

He wished she could be there to see it now, he wrote—not least because she would have been amused by an elderly Englishman whom Needham had met outside the church and who said he had overspent his holiday funds. To raise money to buy himself lunch, he had sold Needham one of his ties.

Joseph and Dorothy marked the publishing event with dinner and a bottle of good local white wine, a 1947 Vouvray. On an impulse they then decided to visit the château at night. As he wrote to Gwei-djen the next morning,

> one ascends the illuminated spiral ramp to the strains of sixteenth century music from loudspeakers, and on the top level the buildings are all floodlit, especially the beautiful chapel on the wall where Leonardo da Vinci is buried. His statue among the trees, standing where the collegiate church once stood, is also finely illuminated. He is there now in solitary possession. There are no statues of the kings, queens and nobles who were so much more self-important when he was living!

The public remembrance of great scientists, he concluded, could endure well beyond that of people whom mere accident of birth had made famous in their lifetimes. This had been the case with Leonardo. Perhaps, he suggested, it might one day be the same for him.

But there was more to his choosing Amboise than merely rubbing shoulders with the memory of Leonardo. He was also burying himself in the depths of

rural France because, in a sense, he was hiding. He was keeping out of sight because of all that had happened to him in the eight years since he'd returned from China.

It had been a difficult time, largely because of his agreement to investigate the allegations concerning the Korean War. His reputation had been savaged. The security of his academic position had started to seem tenuous. His judgment had been called into question. He had been subjected, for the first time in his life, to an earthquake of criticism and insulting commentary. Some people called him a dupe, others a traitor, a few simply a crank. The gelling of his political convictions—not least his admiration for Mao—and his now unswerving support of the revolutionary left had also isolated him socially and intellectually from much of the British mainstream. He was in consequence lonely and unusually joyless.

In Cambridge the senior members of his college were no longer as collegial as they might have been, nor as supportive. The glacial mood had started early. Needham had been elected a fellow in 1924, but because of his youth, callow manner, and evident eccentricity he had been less than entirely welcomed then. He was seen by some of the Edwardian throwbacks at the high table as *unsound*, however bright. So he spent most of his early time squirrelled away in the laboratories, or

at home with his wife and in time his paramours, and then he was wont to go away for long sojourns in the East—making himself scarce, keeping out of the way of the grand, stiff-necked fellows who formed the college establishment.

When he first returned from China in 1946 he found that the situation had changed a little; the mood had lightened somewhat. After his stay in Paris had ended in 1948, and when he had returned home flushed with the success of helping to create UNESCO, the atmosphere got even better, and his reception in the college had become almost congenial. But then five years later came his decision to lend his name and reputation to the International Scientific Commission in Beijing—which, as far as his standing in Cambridge was concerned, was a total disaster. Everything came tumbling down. He was excoriated in the press, denounced in Parliament, and shunned by many, and almost all sympathy that had survived in his college rapidly and steadily drained away.

By this time few of the senior Cambridge figures on whose support he could usually count were still around. His greatest onetime champion, the biologist Sir William Bate Hardy, had died in 1931, as had Stanley Cook, the Semitist who had taught Needham much about the Jews of antiquity. The zoologist Munro Fox had retired

early (having been run over by a horse-drawn bus) to pursue his private passion for the study of ostracods. Reginald Punnett,[46] an expert on heredity in chickens, had retired to Somerset and seldom returned to Caius, other than to come up by train to inspect the exceptional clarets he kept in his private cellar there. Only Frederick "Chubby" Stratton, the memorably amusing astronomer and bachelor fixture of the senior combination room, remained a firm supporter. So aside from his settled family friendships—and with Wang Ling beside him, and Gwei-djen across the Channel in Paris—Needham spent much of the early 1950s in the college largely alone, and often shunned.

He also did barely any teaching now, and though he had been officially excused from these duties, the exception rankled among some of his colleagues. Much of the uneasiness was motivated by envy that his life was so seemingly easy, in Cambridge terms. Much was also made of the casual way he had apparently invaded the turf of two other disciplines for which he had not the slightest qualification. He had no standing in the department of Chinese—and yet he pontificated on China at every opportunity. He had taken not one hour

[46] A strawberry-growing relative of Punnett's invented the small wooden basket now known, shorn of its terminal *t*, as a punnet.

of formal training in history—and yet he had persuaded the university's august and ancient press to let him write a great history of science. This deliberate straying into fields not his own was seen by some as merely impertinent, by others as positively threatening.

So a lot was resting on the initial publications of *Science and Civilisation in China.* If the books were well received, then their reception alone might restore his good name and ensure his return to acceptance and academic respectability. But he could hardly be sure that the reviews would be good. He was only too aware that he was writing for an audience already highly prejudiced against China and the East, a group of skeptics among whom even the cleverest were bound by an almost unconscious certitude of the West's cultural and intellectual supremacy. The very reason he had begun the project was to try to change people's minds. But now he was not so certain that he could. The task had grown very substantially since he began his work—not least because popular antipathy toward China was, in the 1950s, founded on not one but now on two quite separate arguments, one of which had been added, with cruel irony, since he first had his basic idea for writing the book.

In 1942—when he jotted down "*Sci. in China—why not develop?*"—the West was prejudiced against China

for all the old, well-known reasons. China was thought to be backward, cruel, rigid, a place cut off from what Hegel had termed the *world spirit*. The prejudice was really quite simple, based essentially on racial dislike, fear, and cultural arrogance. Political ideology played little or no part in the antipathy: the Chinese were disdained *because they were Chinese.*

But now, twelve years later, and to the shock and general dismay of westerners, Mao Zedong's Chinese Communist Party had settled itself firmly into power in Beijing. This new China—Red China—was to many in the West a fully certified public enemy, and was held in disdain, particularly by Washington, just as the Bolsheviks who ran the Soviet Union were disdained.

There was thus a second reason for loathing China. Old-fashioned prejudice had now been joined by vehement anticommunism, a strident antipathy to Mao, to Zhou Enlai, and to their revolutionary cadres. Anyone supporting Red China was now seen as innately hostile to America. Supporting China had long seemed merely eccentric and wrongheaded. Supporting Communist China was, on the other hand, downright treachery.

Needham's left-wing sympathies were well-known; the anti-American conclusions of the report by his commission were still widely reviled; and even on normally liberal American university campuses the attitude

toward him had now changed. He was now being quite widely criticized—not for his science, not for his history, and not for his intelligence, but for his politics, for his sympathies, and for his friends. And all that before a single word of his thesis—his essentially dispassionate, nonpolitical, and purely academic thesis—had been published.

So for him to have written a book—a series of books, no less—that trenchantly challenged the traditionally prejudiced view of China, and that roundly supported China's claim to a proper place in the story of the making of the world—was suddenly, from Needham's point of view, fraught with risk. The reviews could be savage, and personally devastating.

Moreover, the first volumes, as he had planned them, did little more than set out the thesis for the series. People might be tempted to wait, to see if the subsequent volumes—Volume III and the rest—would merit their full attention. There might be no reviews at all, perhaps none for some years yet, no final verdict, no vindication. And in that case the waiting would perhaps be an even greater agony.

He was consumed by nerves, and understandably so. As the first volume was about to emerge, a part of him wanted desperately to hide—and for that purpose he chose Amboise. He had no idea how the world would

react to his work, and judging by what had gone before, he feared the worst.

But as it turned out, he need hardly have worried. Such reviews as did appear—and he was right; many reviewers decided to wait for future volumes before committing themselves—were truly extraordinary, all of them entirely positive. Despite his fears the world's intellectual community, it seemed, actually cared very little about his politics. If he chose to support Mao and Zhou, and if that had gotten him into hot water with the Americans—well, this was still a superb work of scholarship. Ideological differences were set aside: a chorus of the most extravagant praise was sounded.

Arnold Toynbee praised it in *The Observer;* Sir Cyril Hinshelwood in the *New Scientist;* Richard Boston in the *New York Times;* and Arthur Hummel, the dean of scholars studying the Qing dynasty, in the *American Historical Review.* Old Laurence Picken, the embittered ethnomusicologist who had ample cause to give the foulest of commentaries, wrote in the *Manchester Guardian* that Needham's achievement was "prodigious . . . perhaps the greatest single act of historical synthesis and intercultural communication ever attempted by one man." And the Russians said that Needham's work showed "a deep respect for the Chi-

nese people, their creative genius, and their great contribution to Chinese civilisation."

It was a triumph, evidently a complete vindication. The entire printing of 5,000 copies of Volume I sold out, and Cambridge had to go back to press at regular intervals in the following years. The book remains a classic, an essential work, and it has never yet been out of print.

In the short term, however, this critical success did surprisingly little for Needham's standing in Cambridge, where, as in many academic communities, venom can take decades to dissipate. When he returned to Caius after his weeks of hiding away in France, he had few opportunities to escape the atmosphere of opprobrium. There was little comfort for him anywhere. He was frequently excoriated in the college. He could no longer seek solace in the biochemical laboratories. Christianity seems to have offered him less spiritual sanctuary than it might. Gwei-djen remained in Paris. Dorothy was deeply immersed in her own academic work. There was still scoffing in the press, perpetually reminding him of his much diminished status.

All he had left for comfort was China. It is impossible to overstate the role that China played in securing Needham's foundations during this trying and uncer-

tain period of his life. China—its people, their language, his own memories—provided Needham with the spiritual sheet anchor he needed, and with the necessary intellectual comfort.

Not that these were the most propitious years for him to be nailing his flag to the polities of Peking. Peking—Beijing today[47]—was in decidedly bad odor in the West during the 1950s, particularly in America. Since the founding of the People's Republic in 1949 and since China's involvement in the Korean War, the U.S. government's official position was a firm and unyielding hostility toward Communist China, combined with a firm and unyielding support for the Nationalist regime on the island of Taiwan. A treaty to that effect was signed in 1954, giving American presidents the formal authority to use arms to defend Formosa, as Taiwan was then widely known, in the event of an attack from the mainland. Following the principle that

[47] There is still much resistance to the use of the pinyin name *Beijing* for the current Chinese capital. Not only are very few outsiders able to pronounce the word accurately; its use also flies in the face of the more general use in English of "English" names or pronunciations for distant cities or countries. Roma is called Rome, Deutschland is called Germany, Suomi is called Finland, and Zhongguo is called China. Many who accept this logic would like *Peking* returned to common currency, but doubt that it will ever happen.

the enemy of my friend is my enemy, Communist China was seen, at least by America, as a foe.

So Communist China was consistently ostracized by Washington throughout the 1950s and 1960s. There was no official American diplomatic recognition; Americans were by and large forbidden to go to China; there was a total trade embargo; there could be no financial dealings; and America did its best to keep the Communist Chinese from occupying China's seat at the United Nations.[48] "The United States holds the view that Communism's rule in China is not permanent and that one day it will pass," stated the official American doctrine of the day. "By withholding diplomatic recognition from [Beijing] it seeks to hasten that passing."

Yet Needham—who had openly wept with joy when Mao announced the formation of the People's Republic—remained an unabashed supporter of the Beijing government. He stated as often and as publicly as he could that the communist system was the best possible social and political framework to govern a country as immense as China. He consistently de-

[48] The United States finally bowed to reality on this issue in 1971. Since then, Taiwan has been excluded from the UN, and it is regarded now as a part of the People's Republic, which has the single Chinese seat in the General Assembly and on the Security Council.

nounced American policy at every opportunity—and by extension he also denounced what he considered anti-Chinese British policies, though they were fewer and less stridently expressed.[49] And he fully accepted that by doing this he kept himself stubbornly out of step with much of the rest of the world.

In 1955 he underlined his support for Mao and Mao's regime in a small but practical way, by helping to found and becoming the first president of a briefly powerful and always controversial group, the Britain-China Friendship Association. He did this with Derek and Hongying Bryan, the couple whose marriage Needham had helped to inaugurate in China ten years before. All three of them were prominent in this unashamedly left-wing ginger group—and its eventual 2,000 members spent a furiously active decade engaged in what they saw as an essential bridge-building exercise: criticizing Britain's lukewarm policy toward the People's Republic, lobbying for an increase in trade between Britain

[49] Britain was not so rigid in its approach to China as America during the cold war. London had recognized the People's Republic almost immediately after its inception, but had exchanged diplomats—junior officials sent as chargés d'affaires—only from 1954 onward. This halfhearted approach, which nonetheless managed to survive the Korean War, finally evolved into the sending of a full ambassador in 1972.

and China, and arguing the case for China's membership in the UN.

When challenged on his belief that China was now a free nation—a view that was patently absurd to anyone who knew anything of Mao Zedong's policies—Needham would retort that "the first freedom is to eat—and now the Chinese people are being fed." It might have been the best he could do, but it was reckoned generally—and certainly by the members of Caius—an exceedingly lame response. Few could understand Needham's firm adherence to the Maoist line—even when he attempted to explain that if Mao's policies were seen in the context of the sweep of Chinese history, they would win wide outside sympathy. There was no doubt that his stubbornly held and trenchantly expressed views—his trenchancy always tempered, however, by his gently courteous manner—contributed significantly to his unpopularity during the 1950s.

During this decade and the 1960s he intensified his support for almost every cause that was dear to the left. He joined, or spoke to, the Progressive League, the New Left Review Club, the Tawney Society, and the British Peace Society; he contributed to the Scientists Protest Fund; he cofounded Science for Peace. He marched to air bases and bomb plants with the Campaign for Nuclear Disarmament. He wrote letters to

the *Times* attacking, variously, America's development of advanced nuclear weapons, the suggestion that Latin be dropped as an entrance requirement for Cambridge, and the proposal that representatives of the Viet Cong be forbidden to visit London.

He held a public inquiry into an assault on a number of young Britons who went to a left-wing jamboree in East Berlin: American border guards had beaten them, Needham said, and yet the British government took no interest. He campaigned in vain to save Julius and Ethel Rosenberg from execution; he was also unsuccessful in demanding that a visiting American academic, a communist named J. H. Cort, be allowed to stay in Britain.[50] He campaigned vigorously in favor of reforming laws against homosexual acts, protested the United States' seizure of the scientist Linus Pauling's passport, and took part in demonstrations against the military rulers in Greece.

And he traveled, frantically. He spoke to or attended conferences in Warsaw, Jerusalem, Budapest, Beirut, Rome, Milan, Brussels, Prague, Munich, Florence, Salzburg, Madrid, and the town of Stralsund in East

[50] Cort was told to leave, and suspecting that he would be arrested if he returned to Senator McCarthy's America, settled in Czechoslovakia instead.

Germany. He was also invited to conferences in New Hampshire, San Francisco, Chicago, and New York, but the American embassy in Grosvenor Square in London persistently declined to issue him the necessary visa—without saying why—and so he was obliged to withdraw. And though he was also invited to India to travel around the country and give a series of talks—his left-wing writings had made him enormously popular with Indian intellectuals—there was a sudden outbreak of border fighting with the Chinese, and Needham, who tended to favor the Chinese position in almost every dispute, decided it would be imprudent to go, and accepted a last-minute invitation to lecture in Romania instead.

For years, then, the now late-middle-aged Joseph Needham was all over the map—wandering, campaigning, marching, working. And though his travels did not cease, his urgent need to get away did suddenly subside, and at a specific moment, in the late autumn of 1957. That was when a series of coinciding events occurred to change Needham's life again, improving it and setting him on the path he was to follow for the rest of his days.

Lu Gwei-djen returned from Paris that autumn, and this very much helped his mood. She settled back into her modest terrace house just 100 yards down the street

from the Needhams. The three saw each other almost every day, an arrangement that appeared to suit everyone.

The second volume of his book appeared in 1956, and the third was grinding its way toward design and the start of production two years after that. The reviews of even the two first "throat-clearing" volumes had now, nearly universally, become quite lyrical: "a supreme achievement of European scholarship," wrote the reviewer for a journal in Calcutta; "a book which is bound to modify all subsequent histories of Chinese thought, and indeed the histories of thought the world around," said the critic at the *Far Eastern Survey* in New York; "a masterpiece of modern scientific study" was the description given by a journal in Beijing; and the *Times Literary Supplement* noted, "The important fact about this work . . . is that it is very exciting." Needham's temper improved with every newspaper he read.

Then came the most important and most surprising change: the slow unbending of attitudes within Needham's ancient college, Gonville and Caius, suddenly started to accelerate. In the combination room a group of activists was slowly forming; eventually its members would stage a rebellion at the high table that would precipitate the most profoundly beneficial alteration in Joseph Needham's standing.

College historians will insist that this revolution started as a direct result of the war. The gerontocracy of dons that had so vehemently doubted Needham in his early years was now being thinned out by natural attrition, and a new group, made up of men who were younger, more widely traveled, and more worldly, was slowly infiltrating the cloistered halls. In October 1957 one of them, the Hungarian-born Peter Bauer—later to become Lord Bauer, one of Margaret Thatcher's favorite economists—staged what has since become known (supposedly because of the English translation of his name) as the "peasants' revolt." He was joined in the endeavor by the biologist Michael Swann, who would also later become a peer, and chairman of the BBC. These two men were exasperated by their lack of power in making college decisions and, to mutterings that suggested a scandal of the first water, they stood up and said so at that year's famous and long remembered Michaelmas term general meeting.

And despite the mutterings and the opposition from the older members of Caius the rebels won a healthy measure of support—Needham's included. A vote was taken. For the first time in decades a modest change in the college rules was brought about, sufficient to ensure that the College Council, for which elections had never before been contested, would now be open

to the candidacy of all fellows, and not limited merely, as had been the case for centuries, to the chosen favorites of the old guard. The placemen who had hitherto held power, most of them administrators rather than university teachers and researchers, were immediately weeded from office. Democracy, never in the fullest flower in either the Oxford or the Cambridge colleges of the times, took a tentative and eventually a firm hold: and the ruling oligarchs' grip on college matters was slowly, but very steadily, released.

This was to have enormous consequences for Needham. In 1959, thanks to the adroit maneuvering of his new allies, he was elected to no less than the presidency of the fellows—an unprecedented elevation for someone who just a decade before had been perhaps the most ill-favored figure in the senior combination room.

The election came at a particularly propitious time. The third volume of *Science and Civilisation in China* had now just been published, and although critical reaction to the first two books had been good, with the appearance of the first "real" book, which dealt with mathematics and astronomy, there could no longer be any doubt: Needham's much-vaunted project was going to be a vastly important monument of scholarship, an undertaking which, when completed, would rival James Murray's *Oxford English Dictionary* and Leslie

Stephen's *Dictionary of National Biography*[51] as among the great intellectual accomplishments of all time.

The changed reaction to Needham in the college also reflected a new attitude toward him outside it. All of a sudden he seemed to have been transmuted from a revolutionary villain into a figure who was being met with growing respect for what was clearly shaping up to be a formidable achievement. He was creating something for which he, his college, his university, his country, and a steadily enlightened West could be illimitably proud. And the new respect he was winning thereby helped to make his new job at the college a great deal easier—not, it has to be said, that this was among the most challenging of positions.

The presidency of Caius College, at least in the 1950s, required only largely ceremonial duties—in the absence of the master, Needham would preside over

[51] The vastly admired *Dictionary of National Biography* (DNB) was begun in 1885—under the editorship of Stephen, the father of Virginia Woolf and Vanessa Bell—and sought from its inception to include essays, some decidedly opinionated, on anyone of significance or notoriety in British life since Cassivelaunus, the chieftain who tried to oppose Caesar's second invasion in 54 BC. The present edition, which runs to sixty volumes, includes 55,000 lives. Queen Victoria's entry is the longest; among the many more obscure biographies is that of an eighteenth-century wrestling harpist, the Welshwoman Marged ferch Ifan.

dinner in Hall and over dessert in the combination room, and that was about it. But during his years as president, new duties would be added to his portfolio, to the point where by the middle of the turbulent next decade he held the post of college vice-master—giving him a set of responsibilities that proved ideal training for his next advance, which Needham, a dark horse, won by a majority vote of forty-five of the seventy-five fellows who were present at a formal meeting in early December 1965. This was when he became no less— and even at this remove the simple fact of his election beggars belief—than the master of the college.

In academic terms Needham had made, in a little over forty years, an ascent from back-courtyard rags to high-table riches. He had achieved a stunning climb to power that rendered him now not merely a force to be reckoned with in the academic and literary worlds, but a figure of stature and power in one of the greatest universities in the world—and so a force in the realm as well. All of a sudden Joseph Needham was a man who, at work in the corridors of power of British life, very much mattered.

He remained master for ten years, directing the ancient college through a time of almost unprecedented disturbance in the student world. Almost from the moment he undertook his duties, and had moved him-

self and thousands of his books into the master's elegant lodging house beside the chapel and the Hall, the outside planet's politics went badly awry, and the zeitgeist became relentlessly mutinous.

The causes of the upset were many. With the disaster of the Tet offensive in 1968, the Vietnam War had entered a peculiarly violent phase, and Lyndon Johnson had announced his withdrawal from politics. In China the Cultural Revolution was at its height. The "Prague spring" had set Czech students in full opposition to their communist masters. Riots at universities had spread from Nanterre to engulf all of France, and the army had to be called out to suppress them. Students had been shot dead in Mexico. Martin Luther King and Robert Kennedy had been assassinated. Columbia University in New York had been shut by protests. There were riots outside the London School of Economics.

And in the spring of that year the students in Cambridge also rebelled in solidarity. For a brief while this most genteel and affable of cities became the scene of sit-ins and marches, bottle throwings and arrests, littering and shouting and scuffles. This was no Kent State; but the cascade of events was serious enough to prompt an official inquiry, and to some degree it tested Needham's mastership.

It did so only to some degree because, we should remember, the master was very much a committed Socialist—even a communist, though still never a formal party member—and so was in general ideological agreement with the political aims of the students around the world, including those who were camped outside the back door at Caius. One student recalled that during a peaceful sit-down a window in the master's lodgings was briefly opened a crack, and a weathered hand emerged holding a folded piece of paper. The student took it and the hand withdrew.

"I wish you to know," said a note written in ink in an impeccable hand, "that I support entirely all the reforms for which you are demonstrating today." It was signed: Joseph Needham. His had been the window, his the hand.

His leftist views were in no way dimmed by his prestigious position—though in many ways he was a great traditionalist, and he restored all manner of ceremonials and feasts to the Caius calendar. He wrote an elegant essay for the college chaplains on the numerous figures who, through the seven centuries of its existence, had given money or help to keep the institution going: he directed that the anniversary of each chaplain's death (when it was known; he guessed the date when it was not) be memorialized in the chapel and celebrated by

an oration followed by a black-tie dinner in Hall. Needham liked to eat, to dress up, to drink, to give cocktail parties, and to smoke cigars;[52] a Cambridge college is the perfect place to indulge such habits, and the death of an ancient benefactor the perfect excuse for doing so: even the most restrained of fellows thought it would be churlish to complain.

He was not able, however, to persuade the college governing body to admit women, either as fellows or as undergraduate students, during the ten years he held office.

His traditionalism occasionally spilled over into areas where one might have supposed he would be a flaming liberal. For example, he forbade the installation of a condom-dispensing machine in one of the Caius bathrooms. Considering his own fondness for erotic amusement, this might seem to verge on hypocrisy; he justified it by explaining that while he favored the free association of the young, he thought that having condom dispensers installed in college would encourage "instant sex," and of that he was not in favor. Far

[52] He also kept a hookah, which he had bought at a Uighur market in Chinese Turkestan. Though the device lies today in the Caius archives it is not known if he ever smoked it, either privately in his room or, even less probably, among the other fellows in the relaxed coziness of the senior combination room.

better that students who wanted sex take time to walk to the drugstore in town to buy their supplies, and think about the implications while they did so. This was a curious lapse in his understanding of human behavior—perhaps a willful one.

He was by no means a killjoy, however. He was an exuberant man, given to partying, to spontaneous public singing—he would have adored karaoke, a friend remarked—and he danced wildly, if not well. The cultural anthropologist Francesca Bray, who would later write, more or less entirely, the volume on agriculture, has already been quoted: "You'd better watch your toes if/You dance with Joseph."

Since 1963 he had also been giving regular sermons from the pulpit of his favorite old church, in Thaxted. The memorably turbulent priest Conrad Noel had long gone, though Noel's son-in-law Jack Putterill remained vicar until his death in 1973, and the radical, tolerant approach to Christianity which had so attracted Needham after his undergraduate years was still very much in evidence. He spoke on some forty occasions—ringing declarations, all well attended, on such topics as "Political Prisoners and Torture," "Christianity and Marxism," "Jealousy," and "Robots and Unemployment." He became embroiled in a brief controversy in

1976 when the Reverend Peter Elers, who was then the vicar, declared himself gay, and had to endure a torrent of criticism. Needham came swiftly to his side:

> I have felt for many years that there is a great necessity today for a thorough reformation and modernization of the traditional theology of human sexuality. We are no longer living in patristic times, or the Middle Ages, and the new knowledge of itself which mankind has acquired since the Renaissance is something which the church must absorb in order to be able to exert the full force of its eternal message.
>
> The present movement for tolerance and acceptance of wide variations in human relationships is only another part of the same general struggle for socialism and against oppression, in which Thaxted has been in the forefront for half a century.

Soon thereafter, and to hammer the point home, he made certain that he gave a rousing sermon at the memorial service for a celebrated homosexual member of Parliament, Tom Driberg, so that there should be no doubt as to his very public tolerance. He gave his last sermon a little more than a decade later, on the fourth

Sunday after Trinity, in the summer of 1987: his theme then was "Greed and Capitalism." Politically, nothing had changed.

He still traveled, though his joints were beginning to creak. After a pause following the Korean War—in the mid-1950s he had felt that further trips to China would make his situation at home intolerable—he started going to China again. He was now one of the founding leaders of the Society for Anglo-Chinese Understanding (SACU), which he, the Bryans, and others had formed after their Britain-China Friendship Association collapsed in a welter of Stalinist recrimination. In the late 1960s, a visa obtained through SACU was just about the only way for a Briton to gain access to China; the young filmmaker David Attenborough was one of the first to do so. Needham remained its president for thirty-five years, and was able to get visas to China with ease—so long, his later critics pointed out, as he remained staunchly uncritical of the regime's excesses.

He flew back to China first in 1964, and found to his delight that he was to be greeted officially by the government, and by no less than Zhou Enlai, who treated him like an old friend. The economic privations of the time were very obvious to Needham—the after-effects of the Great Leap Forward were painfully evident, though he assumed they were little more than the

teething troubles of the new regime, and he returned to Cambridge with his faith unshaken.

But in 1972 he went back again—and this time to a raw and very deeply altered China, just emerging from the incredible suffering of the Cultural Revolution. This time he was not so sure. He found himself deeply depressed because so few of his old friends were available for him; he was puzzled that some seemed to have disappeared altogether, often in unexplained and occasionally sinister-seeming circumstances. His guides in China that year were neither so helpful nor so friendly as before, and his freedom to travel was quite severely restricted. He was puzzled, almost hurt.

His abiding love for the essence of China and its people remained intact, as it would for the rest of his life. But in the aftermath of what had so evidently altered the face and feeling of China now, he began for the first time to question the wisdom of the policies. He wondered, at first in silence and then in a series of essays, if Mao's kind of socialism really was the answer—and he speculated in print as to whether some of the errors, if errors there were, might not have done terrible damage to the science for which China had so long been famous. One article in *Nature* in 1978, in which he called Mao's policies toward science "disastrous," attracted considerable attention: he seemed

almost to be on the verge of breaking ranks—except that Mao had died two years before, making such criticism easier to express. Needham also issued a scathing public denunciation of the Gang of Four—the architects of the Cultural Revolution—but only after their fall, and after the new leadership in Beijing had condemned them. Criticism in Britain made him reply, weakly, that he was no China watcher, merely a historian of Chinese science.

Mao and his acolytes had done their best to keep such a formidable ally on their side. During the journey he made to China in 1972 the leaders were entirely unaware of his seeming unease, and they behaved in an exceptionally good-natured way to the man they regarded as one of their most vocal British supporters. It was Mao's last opportunity to be so friendly. One story from that visit (a story one would prefer not to think apocryphal, though it cannot be confirmed) perhaps sums up the relationship which had grown up between Needham and Mao in the quarter century since they had first become aware of each other in Chongqing.

Needham was apparently invited, at very short notice, to come to Mao's office on an "urgent matter of state business." He dressed quickly, in a suit, and hurried along Chang'an Avenue to Zhongnanhai, the complex of lakeside palaces beside the Forbidden City

where the Chinese leaders have their headquarters. Guards escorted him to Mao's offices, where he found the chairman sitting in a relaxed mood, drinking tea.

They exchanged pleasantries for a few moments. Then Mao got down to business. He spoke in slow and heavily accented Chinese, which Needham could barely understand. He was aware, said Mao, that Yuese, in his early years at Cambridge—Mao used Needham's Chinese name, Li Yuese—had driven a fast car, a sports car called, Mao astonishingly remembered being told, an Armstrong-Siddeley. The perplexed Needham nodded his head. Yes, he had. He had loved cars, and still did.[53]

"I thought so," said Mao. "You are the only westerner I know well enough, and who knows about motor cars. So I have come to you, Yuese, to ask for a small piece of advice on an important matter of state business."

Needham straightened his back, waiting.

"I am aware of developments in the outside world. I have to decide whether to permit my people"—Mao gestured expansively—"whether to allow my people to

[53] By now he had sold the magnificent Armstrong-Siddeley and had replaced it with a rather more prosaic car, a Ford Cortina. But had Mao known he would have approved: Needham had ordered the vehicle painted *jingtailan,* a word now taken to mean cloisonné, but in fact meaning an exquisite Chinese shade of pale blue.

drive motor cars, or whether the bicycle is better for them. What, my dear Li Yuese, do you think?"

Needham, amazed, paused. He thought for a moment—of the thousands of bicycles moving along Chang'an Avenue like a ceaseless sea, just a few yards away. He thought of the uncomplaining discipline of the riders, of the near-silence of the onrush of people, of the occasional flash of elegance as a beautiful young woman would glide past on her Flying Pigeon, swanlike and lovely. He was transported. He was in a reverie.

Mao coughed. His visitor snapped back into reality. He was in the office of the chairman of the Communist Party of China, the guiding light, the Great Helmsman of the mightiest nation on earth. He had been asked a question. A reply was needed.

"Well, Mr. Chairman," responded Needham, stuttering slightly. "To be honest with you, I find that back in Cambridge where I live, my very old bicycle is perfectly satisfactory for almost all of my needs."

He was going to say more, to add that perhaps in a major industrial nation it might indeed be better to use cars, and it might be beneficial to allow private citizens to drive. But Mao was grinning. He had heard what he wanted to hear. A decision was in the making.

"So, Yuese, you who like China so much find the bicycle perfectly satisfactory?" He rubbed his hands

together, then spread them apart. He had made up his mind.

"Right, then. Bicycles it is!"

And with that Needham was invited to leave, and he emerged blinking into the sunset onto an avenue that was jammed solid with the two-wheeled conveyances of the evening traffic jam. He suddenly felt he had made some contribution, in some strange way, to the future of all of these people—at least for the next few years.

No record of the conversation in Zhongnanhai exists. Maybe it never took place. But two things are certain. Joseph Needham did occasionally ride a bicycle. And China is now well on the way to becoming the world's greatest producer—and soon the world's greatest consumer—of automobiles.

Whatever Mao said or did not say to Joseph Needham on that summer's day in 1972, he was dead four years later, and his successor, Deng Xiaoping, was to be bent single-mindedly on bringing China into the forefront of the modern world. And if that meant, as far as transportation was concerned, the wholesale scrapping of millions of Flying Pigeons and a nation shackled to a lifetime of pollution and traffic jams and countless miles of new roads to be built, then so be it.

. . .

Throughout this time there was a cascade of honors. In 1971 Needham was elected to a fellowship of the British Academy, so that now, in common only with the philosopher Karl Popper and the historian Margaret Gowing, he was a fellow of both the Academy and the Royal Society. Honorary degrees, academe's device for publicly declaring the gratitude of the intellectual community, began to be offered: Cambridge got in early, and then Brussels, Norwich, Uppsala, Toronto, Salford, the two main universities in Hong Kong, Newcastle, Chicago (the U.S. government finally giving him a visa to permit him to receive it), Hull, Wilmington (North Carolina), Surrey, and Peradeniya University (outside Kandy, in the central tea-estate hills of Sri Lanka). (The last reflected his keen interest in what was then Ceylon, when he chaired the country's University Policy Commission in 1958).

There was an oddly chilling coda to Needham's brief visit to Chicago in the spring of 1978. He had been invited to give three public lectures at Northwestern University. For his second talk he decided on the topic "Gunpowder: Its Origins and Uses." One of those who came to hear his lecture was a wild-haired loner of a mathematician, a tragic, brilliant man named Ted Kaczynski.

A short while earlier, professors at a Chicago branch

of the University of Illinois had summarily rejected a brief essay Kaczynski had written on the evils of modern society, and one mathematician there had heard him mutter, bitterly, that he would eventually "get even" with those who had spurned him. On May 24, six weeks after sitting through Needham's lecture, Kaczynski fashioned a wooden-cased explosive device made of gunpowder and match heads, and mailed it to one of the professors who had rejected him. It was intercepted, exploded, and injured a campus security guard.

There were no clues as to who was the perpetrator of the crime, and the incident marked the beginning of an extraordinary, bizarre, and frightening period in modern American history. Over the next two decades Ted Kaczynski, who lived alone in a remote shack in the mountains of Montana, went on to send waves of carefully made and ever more lethal bombs to academics, killing three people and injuring more than twenty. The press and the FBI called him the Unabomber. He remained at large until his arrest in April 1996.

Few knew at the time that he may have initially been schooled in his deadly craft, though entirely unwittingly, by Joseph Needham. One can only wonder what would have happened—or might not have happened— had the State Department's ban on Needham remained

in place, denying the Unabomber the opportunity to hear him and to learn about early Chinese techniques for the manufacture of explosives.

In addition to Needham's collection of degrees there were medals galore, to join his Order of China's Brilliant Star—which the British government still prohibited him from wearing at official functions. There were memberships and fellowships in bodies and institutes and academies from India to Denmark and China and then finally, once the State Department had relaxed its ban on his entry in 1978, from the great American organizations: the National Academy of Sciences, the American Historical Association, and the Yale Chapter of Sigma Xi.

His roving eye remained undimmed, even as he aged. There was much alarm in the mid-1970s when he became captivated by a distinguished Canadian Chinese woman, H. Y. Shih, who was a former director of the National Gallery of Canada. There was even talk of a divorce, and a marriage. Under great pressure from all his friends—including a joint attack from both Dorothy and Gwei-djen, who acted in what old Chinese families would recognize as the "concert of the concubinage"—the affair eventually fizzled, to widespread relief.

And through it all, the *book*. During the ten years

of his mastership four more volumes were published—
one on mechanical engineering; two on chemistry; and
in 1975 the mighty 400,000-word tome that is gener-
ally reckoned the finest and most comprehensive, the
famous Volume IV, Part 3, *Civil Engineering and Nau-
tics.* Seven volumes were now out on the shelves; ten
more were in the process of being written, edited, and
proofread; another ten were still in Needham's over-
furnished but impeccably organized mind.

And the chorus of admiration for the works was
becoming ever more enthusiastic. George Steiner, the
critic and public intellectual whose imprimatur was at
the time perhaps more sought after than any other, re-
marked that in *Science and Civilisation in China* Need-
ham had re-created a world of extraordinary density
and presence:

He is literally recreating, recomposing an ancient
China, a China forgotten in some degree by Chi-
nese scholars themselves and all but ignored by the
west. The alchemists and metal-workers, the sur-
veyors and court astronomers, the mystics and mil-
itary engineers of a lost world come to life, through
an intensity of recapture, of empathic insight which
is the attribute of a great historian, but even more
of a great artist.

The books could be favorably compared, wrote Steiner in a review in 1973, with *À la recherche du temps perdu*—for both "Proust and Needham have made of remembrance both an act of moral justice and of high art."

An artist was commissioned to capture Needham's image, for a painted portrait in the Hall at Caius. Needham decided to wear his long blue Chinese gown, the color blue having been regarded in imperial days in China as recognition of a high level of achievement, matching the high level of achievement in Britain that was suggested by the portrait itself. The older portraits under which members of the college dine are of ruffled, velvet-clad divines; Needham is among the more recent, and above him in his eastern getup are stained-glass windows depicting, not people, but the actual achievements made by other Caians—a colored-glass Venn diagram, and a delicately rendered double helix of DNA, conceptualized by Rosalind Franklin, James Watson, and Caius College's Francis Crick.

Needham's retirement from the mastership came in 1976, and with it came the beginnings of a slow and steady downward spiral. For the first time Needham was beginning to realize—and, moreover, to admit—that he might not manage to cover the entirety of Chi-

nese science within the limits of his lifetime. Perhaps, he wondered out loud, he might have bitten off more than he could chew. It was clear that he needed help— and not simply the kind of assistance that Wang Ling and Gwei-djen had been able to offer. He needed someone who could perhaps write an entire volume, could look after an entire topic of Chinese scientific history on his or her own.

Though he gritted his teeth about having to delegate, he eventually did: Francesca Bray was the first to be handed one entire subject (agriculture, eventually becoming Volume VI, Part 2). But T. H. Tsien's Volume V, Part 1, about paper and printing, actually came out first, in 1985, and with a note from Needham publicly admitting that in freeing himself from the burden of sole authorship, he had now reached a turning point. The project was still his—he was its architect and the builder of the first courses of brickwork. But the upperworks, parapets, dome—these would be the work of others. Life was too short for it to be otherwise.

Moreover, he had now reached a venerable stage of life. He was seventy-six when he left the Caius mastership; eighty-five, frail, and bowed when Tsien's volume on printing came out; then two years short of his nine-tieth birthday, and ailing, when Francesca Bray's volume on agriculture emerged. The wisdom of years

was prompting him to envisage just how the series would progress when he was no longer competent to write it, and also how it could progress when he was no longer around even to direct it.

According to a tradition at Gonville and Caius, those who are most intimately associated with the college will in their lifetime make use of two ancient gates built in the college walls. They would enter as undergraduates through what had been known for 700 years as the Gate of Humility; and at death, if their life had brought distinction, fame, or both, they would leave through another, more ornate and topped by a sundial. Called the Gate of Honour, it was seldom opened, and then only for momentous occasions. Joseph Needham's appointment with this second gate would now be not too long in coming, he suspected.

And yet he was content: those whom he had gathered around him in these closing years would be sure to finish everything, come what may. Cambridge University Press was in full agreement: *Science and Civilisation in China* was too bright a jewel in the publisher's crown—in Cambridge's crown, in the nation's crown—for anyone ever to entertain any thought of abandoning it.

Needham and Gwei-djen moved adroitly to ensure

the lasting physical security of the vast collection of books and manuscripts they had accumulated. Needham had long before persuaded the college that two rooms were necessary to house the project, and after a battle royal in the mid-1950s (for rooms in Oxford and Cambridge colleges are the scarcest of commodities, and one has to be of the greatest distinction to be permitted more than one), he was given the right to use both his old room, K-1, and K-2 next door. He installed Gwei-djen in the latter, their books in both. The crush of bookcases became unmanageable: it was still necessary for research assistants to be very small, the better to squeeze along the tiny corridors between these shelves.

Soon after Needham stepped down as master—being permitted as a courtesy to retain the rooms for a while—the pair amalgamated their book collections. They then formed a trust that had two aims: to keep the project going and to find a permanent home for it. The trust then underwent mitosis, remaining in existence, but joined by two sister organizations, one based in Hong Kong to raise funds for the project's home, the other in New York to seek money for the book's continued publication.

Needham and Gwei-djen began a rigorous program of shuttling to Asia, making speeches, attending din-

ners, jumping the hurdles and ducking through the various hoops that were the necessary rituals in persuading rich men and foundations to part with their money. Almost every time the couple went to China, they had to endure the gastronomic purgatories of banquets, often laced with awards. But Needham remained courteous and in puckish good form throughout: at one moment after he was awarded yet another plaque or medal or brooch or scroll of calligraphy, he turned to the camera crew recording the event: "All this," he asked "—all this for *little me*?"

The couple's greatest success was with a former bicycle repairer in Cambridge, David Robinson, who had made a small fortune in the 1950s renting televisions to Britons too broke to buy them, and had then invested the resulting cash in horse racing and turned it into a very large fortune indeed. In the late 1970s he was endowing a new college at Cambridge near the University Library (and across the road from one of Britain's few Real Tennis courts), and after a meeting at dinner and a series of long conversations, he offered to give Joseph Needham's East Asian History of Science Trust a plot within the college site. He offered land—something that in the city of Cambridge was rare and precious.

On this piece of land, Robinson imagined, there would rise a building to house all of Needham's books

on China, serve as headquarters for publishing the remaining twenty-odd volumes of *Science and Civilisation in China*, and allow research to be conducted on various aspects of Chinese history. And in time all this came to pass: Robinson College opened its doors in 1980, and the Needham Research Institute in 1987, just as David Robinson was coming to the end of his long and remarkable life.

The queen opened the college; her husband laid the foundation stone of the institute; and the university vice-chancellor and the Chinese ambassador were both on hand to declare the Needham Research Institute open for business.

But it was a project that had taken its toll. The financial crises attendant on its opening were profound, complicated as so often is the case by politics and competing egos. At one especially low point an anonymous donor gave sufficient money to keep the project tottering along—this turned out to be Lu Gwei-djen herself, who handed over part of her estate in Nanjing. Both she and Needham gave the titles to their houses on Owlstone Road—his at number 1, hers at 28—for the benefit of the trust. And from his personal funds (which were not inconsiderable: he was as judicious in financial matters as in his scholarly work) he paid Francesca Bray during her research for agriculture, much

as he had paid Wang Ling for his help with the early volumes.

But more poignantly, the work was taking its toll on the health of the three now very elderly and increasingly frail protagonists of the story. Everybody noticed. Some observers were aghast. In the winter of 1986 Needham showed up in Hong Kong, walking slowly and painfully with the help of a stick, to ask for yet further funds from people with unimaginable fortunes. As he stood up after giving a talk, and hobbled off, one his oldest friends in the room, Mary Lam, cried out: "Those people in Cambridge are so cruel, sending such an old man to go around asking for money. Give Dr. Needham what he wants!" (This they did, to the tune of $250,000.)

Dorothy Needham was the first to die, three days before Christmas in 1987. The affection she and Joseph had displayed for each other never dimmed. The loving tone that marked their early correspondence—seen in hundreds of postcards and letters from Switzerland, Albania, Babbacombe, the Isle of Mull, O'Donnell's Sea Grill in Washington, D.C., and everywhere imaginable in China—remained intact for all of their lives.

Dorothy—Li Dafei, "graceful plum blossom"—had begun to suffer the symptoms of Alzheimer's disease soon after Needham retired. Thereafter she could

travel very little, and was unable to take part in any discussions about the science to which she had once devoted her life. While still able to comprehend, in 1979, she had been elected an honorary fellow of Caius—one of the first women to be admitted, three years after her husband's mastership had ended. Very occasionally the couple would dine in the college. When confused, she had to be led to her table by a steward, while Needham, now being wheeled through the college in a chair pushed by colleagues, would be hauled up to the hall in the dumbwaiter from the kitchen, along with the vegetables.

Dorothy Needham's last academic testament and magnum opus, written in 1972, was a book, *Machina Carnis*, on how muscles work: antiquarian booksellers still stock it, charging as much as $250, and it remains a classic. It had been a puzzle to her that despite her distinction and what her husband had once called her "complete freedom from worldliness," she remained officially unrecognized by her university, and existed only on research grants, which were the basis for a hand-to-mouth existence and for which she applied and reapplied year after year through the decades of her active life.

She died peacefully at home on December 22, 1987, at age ninety-two, having lived just long enough to be

told that her husband's institute had opened its doors—
though it is doubtful that she ever truly understood. A
flotilla of nurses were her final companions. The sad-
ness of those close to her at her death was mixed with
very evident relief that the ten long years when she was
non compos mentis were finally at an end.

Gwei-djen was not well, either. Though she—unlike
Needham—had stopped smoking, she had had serious
bronchial complaints for years, probably brought on by
the chain-smoking of her youth. As far back as 1982,
when she and Joseph had traveled to the mountains of
Sichuan to investigate a cave painting that illustrated
the first Chinese gun, she had just had part of one lung
removed, and she had to be carried up to the caves
on a litter. Some time soon after that, she was found
staggering around the college in the dark—Joseph
and Dorothy were at the movies—and was rushed to
a hospital with a perforated appendix. In 1984 she col-
lapsed in a hotel in Shanghai and had to be removed to
Hong Kong, where she was treated. She recovered well
enough to accompany Needham to Taiwan, where they
had what both agreed was a wonderful time. But her
collapse seemed ominous, and from then on she had a
frail look about her, seeming very different from the
tough little spitfire she had been in her youth.

There was an unanticipated coda to this story. In the

early autumn of 1989, Joseph Needham and Lu Gwei-djen married.

The woman from Nanjing, who had been named for the sweet-smelling osmanthus tree and as a thing of great value, had first met Joseph Needham in 1937 and had fallen under his spell in 1938. He had been thirty-seven years old, she thirty-three. They had become lovers, and ever since had been inseparable boon companions. Now, after fully fifty-one years of waiting in the wings, during which her essential presence in Joseph's life was wholly accepted by Dorothy, Gwei-djen was at last to marry the man with whom she had shared this undying passion.

For more than half a century he had given her his unwavering affection. She, by way of return, had given him a great deal more: she had committed herself to him entirely, but she had also given him one further and incalculably valuable gift: China. "Joseph has built a bridge between our civilizations," she had remarked in the 1960s. "I am the arch which sustains the bridge."

The couple married in the Caius College chapel on the morning of September 15, 1989, a Friday. The wedding photographs show the two ancient lovers as they emerge through a sandstone archway, both stooped and with pure white hair, Joseph—the frailer of the pair—supporting himself with a tricycle walker and

his chestnut stick, Gwei-djen leaning on a silver-tipped malacca cane. She is wearing a blue cheongsam with a bold peony print, he a crumpled double-breasted blue suit that had seen better days, and a blue bow tie. A lapel button shows his Chinese Order of the Brilliant Star. Both wear sprays of lilies, and are smiling broadly. "It may seem rather astonishing," said Joseph at the celebration lunch in Hall, "for two octogenarians to be standing here together, but my motto is: *Better late than never.*"

It was to be a very brief marriage, lasting just a little more than 800 days. Late in the autumn of 1991 she slipped and fell in a dark Cambridge restaurant, breaking her hip. A few days later, lying immobile on her back in Addenbrooke's hospital, she found it increasingly difficult to breathe, her cough worsened, and antibiotics offered to treat the very obvious infection in her already badly damaged remaining lung became ineffective. Early in November the doctors decided to send her home, where she died, peacefully, on November 28. The official cause was bronchial pneumonia. She was eighty-seven.

She had been inspired throughout her life in the West by one simple truth, something her father—Lu Shih-kuo, the "Merchant-Apothecary in the City of Nanking" to whom Needham dedicated the first

volume—had said before she left China in 1937: "However strange the doings of the old Chinese might be in the eyes of modern people in the West, they always knew what they were doing, and some day the world would recognize this."

There was some untidiness following her death. A number of hitherto unknown relatives wrote urgently to Needham, having heard that she had left a small fortune in carefully managed stocks and shares, and demanding ample portions of it. She died intestate, and though Needham tried to make certain that his late wife's wish—that the bulk of her estate go to the charitable trust—was fully honored, he had his lawyers fire off a barrage of letters to the various aunts and uncles and in-laws who had written so importunately from China, Canada, and New York state, rejecting most of their requests. Some claims, however, were still unsettled nearly two decades later, in 2007, and were being painstakingly handled by Lu's executors. The outstanding cases have been of a complexity and a duration to rival *Jarndyce vs. Jarndyce*. It is grimly supposed by many that the lawyers, working at a glacial rate, will consume an all too large portion of the remaining proceeds.

Yet there was a curious reason Lu did not make a will. In the late 1970s and early 1980s, work on the

book was proceeding in a way that some critics found puzzling. Needham, now well on in age, seemed somehow to lose his early grasp on the need for a coherent plan for completing the project—managing to write no fewer than four separate (but magnificently irrelevant) volumes on alchemy, for example, and to shoehorn them uncomfortably into the series. This caused some ructions: not a few people in Cambridge began to fret that if Needham became subject to increasingly eccentric editorial whims like this, the series might never be finished.

The worry became so intense that it prompted one unalloyed supporter of the book and its founder to fly to New York to reassure the principal American financial champion of the project—the futurist and computer guru John Diebold—that all was in fact well, and that *Science and Civilisation in China* would be completed (and he was quite direct in saying so) by 1990. It was the most foolhardy of predictions—and when it became clear to Diebold that the target date would actually be missed by decades, he became understandably furious.

This led to much argument and recrimination between Cambridge and New York, with the conviction growing in the minds of the aging and stubborn Needham and Gwei-djen that some kind of plot was now being hatched in New York, and led by John Diebold, to

shut down the project completely. In consequence, and by the time she married Joseph, Gwei-djen determined that she should not in fact make a new will—as she should have done—until she had engineered a financial structure that, whatever the villains in New York might do, would guarantee the future of the books, or as she and Joseph then insisted on calling them, "our children." But she died before completing her plan.

Needham was devastated by her death—much more so than he had been by the passing of his wife four years before. Moreover, he was now very much alone, for the first time since he had married Dorothy seven decades before. The sudden and unanticipated lack of female companionship evidently unhinged him, and he swiftly and impetuously (but serially rather than simultaneously) wrote proposals of marriage to three women—all of them East Asian, one the Miss Shih of Toronto with whom he had enjoyed a brief but intense relationship twenty years before. All three women turned him down.

His loneliness was exacerbated by the fact that all his academic contemporaries were now gone, and the people at his institute were young men and women who—though they waited on him hand and foot, treating him like an emperor and behaving with all the deference of courtiers in the Forbidden City—had little in

common with him, and were much more absorbed in their own fields of study.

Physically, too, he was weakening. He was bowed over with scoliosis and had developed Parkinson's disease and a variety of other ailments. But his mind remained sharp—waspishly so, said those who got on his wrong side—and he continued working through the early 1990s at the Sisyphean task he had set himself nearly half a century earlier.

To make his life a little easier, he had sometime before been moved into a house that stood in the grounds of Robinson College just next to the institute, no more than a two-minute wheelchair ride to the sun-drenched office where he liked to work. The house, built in the minimalist style of the 1930s, had been designed for one of the university's most celebrated couples: the economist Michael Postan and his historian wife, Eileen Power. Needham would have been amused to learn of one unexpected connection: in 1930 Eileen Power, traveling in China, became engaged to Reginald Johnston, who was the immensely handsome tutor[54] of the last emperor of China, Pu Yi. The engagement was called off in 1932.

[54] Played by Peter O'Toole in Bertolucci's film masterpiece *The Last Emperor* (1987).

In 1992 Needham was awarded the Companionship of Honour, and was brought to Buckingham Palace to receive this most exclusive of British awards from the queen. One of his caregivers—since Gwei-djen's death he had a full-time helper, Stanley Bish—dressed him in a black silk Chinese robe for the ceremony. Needham was supposed to have said—but outside Her Majesty's hearing—"About time!" There were many who thought that he should have received an honor rather earlier in his life, beyond the purely academic recognition he had amassed. But he was content with his lot, and cherished the uniqueness that this particular honor conferred: "Joseph Needham, CH, FRS, FBA," said a notice published by the Royal Society: "one can count the number of living holders of these three titles on one finger of one hand."

He worked until the very end, faithfully taking a ginseng pill each morning—just one; Gwei-djen had long before told him that his previously customary two were excessive—in the belief that it would lengthen his life. He loved his office: he loved being surrounded, almost encased, entombed, enwrapped, and swaddled by the accumulated thousands of books and stacks of papers and scrolls, and by walls that were hung with pictures and charts and maps and lined with the file cabinets, supremely well-organized, that helped him in

his work. And there were innumerable objects, too, attesting in aggregate to the extraordinary range of his travels and fascinations.

There were clay models of masks from the Beijing opera. Chinese chess pieces brought back by Dorothy's aunt Ethel. A small abacus. A bag from a sake brewery in Kyoto. A piece of the Berlin Wall. A model of a nineteenth-century beam engine. A baby's urinal "collected by Rewi Alley in Xinjiang." Seeds from a Chinese tea plant from Meijiawu. A Han dynasty bronze whistling arrowhead. An ivory box for keeping fighting crickets. A crossbow trigger, probably a Ming copy. A set of Chinese scales and a single slipper. A cigar holder engraved with Chinese characters written by Needham himself. Scores of seal ink containers, including one described as "very nice," from the Qianlong era, made when Lord Macartney was visiting China in the late eighteenth century. A plaque stating that October 28, 1984, was officially Joseph Needham Day in the state of Illinois. Two pairs of slippers for bound feet. A rice pounder. A Sichuan spinning top. A toy railway train and one piece of track. Two of Dorothy's earrings. Railway timetables and tickets galore. Photographs of churches from around the world. Pictures of himself morris dancing, while playing the accordion and smoking. A Chinese wooden puzzle. A sample

of gypsum. A model of a spoon once used as a lode-stone.

These props helped, as did the ginseng, for Needham was still managing to work—though dozing for much of the working day, it must be said—during the following three years, writing, filing, napping, writing. He would be wheeled over to the institute at noon, and return at five. When he came back he would eat ice cream and watch Chinese television, and sometimes he would sing—once singing "The Red Flag" so loudly he was asked to pipe down. He did not miss a day in the office, keeping to his routine of five hours at his desk laboring on the book, then going home to domestic letter writing, ice cream, and bed.

On Thursday, March 23, it was clear to all that the end was coming. His colleagues at the institute noticed that he was failing, and the next morning it was suggested that, for the first time in memory, he take the day off. It was a Friday, after all: he could make it a long weekend. He could charge his batteries for the week ahead. "All right," he said. "I'll stay at home."

He got up for a while and sat at his breakfast table, classical music playing in the background. At noon his nurses put him back to bed. The dean of Caius came by, unannounced, and said a brief prayer with him, saying he would return the next morning to give Joseph Holy

Communion. The old man slept through the early evening, wrapped in a sheepskin rug.

Then his caregiver asked if he was frightened. "Oh no," he replied, weakly. Christopher Cullen, his successor as director of the institute, asked him if he was in pain. "No, no pain," he returned, quietly. Stanley Bish later wrote that a friend and neighbor, the distinguished historian of literature and science, Elinor Shaffer, came by, though she had wondered if she should, since she had a bad cold. She brought a daffodil, a sign that the brisk March weather was nonetheless the start of another spring, the ninety-fifth through which Joseph Needham had lived.

She sat close to him, said Bish, telling him of her recent lecture tour, and believing that he understood the gist of what she was saying. At eight forty-five two nurses arrived, and someone told Joseph how lucky he was to have two beautiful young girls looking after him. He grinned wickedly, impishly, happily. A few moments later Elinor Shaffer got up to leave, having been invited to have a cup of tea in the living room next door to Joseph's bedroom before venturing out into the cold.

She stood up, and according to his caregiver grasped Joseph's hand, squeezed it, and said happily: "Goodbye, Joseph—I'll be in to see you soon." And with that Noël Joseph Terence Montgomery Needham, CH,

THE PASSAGE TO THE GATE • 419

FRS, FBA, sighed once, very slightly—there was no pain, no gasping, no more than a weary acceptance of the inevitable—and died.

It was eight fifty-five p.m. He had lived for ninety-four years and a little over three months. It had been a very full life indeed. It was a life during which, and all in consequence of his love for a Chinese woman, he had worked single-handedly to change the way the people of the West looked on the people of the East. In doing so he had succeeded, as few others are ever privileged to do, in making a significant and positive change to mankind's mutual understanding.

And now that was done, and his appointment at the Gate of Honour had finally come due.

人去留影

Written in elegant calligraphy beside the fireplace in Needham's old college room is the famous four-character Chinese aphorism:

The Man departs—there remains his Shadow.

Such is the reverence for history in Cambridge it is likely that this singular memorial to Joseph Needham will remain in place for decades, and maybe for centuries.

EPILOGUE: WITHOUT HASTE, WITHOUT FEAR

Four thousand years ago, when we couldn't even read, the Chinese knew all the absolutely useful things we boast about today.

—VOLTAIRE: *THE PHILOSOPHICAL DICTIONARY*, 1764

Much has changed in China since Joseph Needham's battered old transport plane first touched down there in the spring of 1943. The city where he was based, Chongqing—or Chungking, as it was written then, when it was the capital of Free China—is now like few places on earth, growing so fast and so furiously that it is hard to keep up with the speed of the changes. Chongqing is now by far the most populous city in

China, and by some counts can be regarded as the biggest city in the world. Thirty-eight million people live crammed within its metropolitan limits. The frantic rhythms of their lives capture the concentrated essence of everything, good and ill, about the awe-inspiring, terrifying entity that is today's new China.

The Yangzi still sweeps through the city, as ever, a turbulent winding sheet of thick brown sludge busy with countless hundreds of ships, sampans, junks, barges, and any number of other kinds of lumbering or scurrying watercraft. But the Yangzi is perhaps the only thing that someone returning after many years would recognize today. Now eight new bridges swoop over the river, and eight sparkling new monorail lines on stilts run along beside it. Clusters of skycrapers have sprung up in each of the half dozen commercial centers, all of them glittering by day, and at night becoming a pulsing, flashing, Technicolor light show, a gaudy urban entertainment, with neon stripes of vivid yellow and royal blue racing up and down the sides of the taller buildings, the highway crash barriers winking pink, purple, and green, the tops of buildings flashing stars and with sinuous curves of colored light crowning replicas of some of the world's best-known buildings: the Empire State, the Chrysler, the Grande Arche of La Défense.

Perhaps the Needhams and Gwei-djen would still just recognize the Liberation Monument, a pillar and a clock (that used to chime "The East Is Red" but now merely booms in the style of Big Ben), which was there when they were, dedicated in the 1930s initially to the memory of Sun Yat-sen; today it memorializes the defeat of the Japanese invaders in 1945. They might just remember the structure—but not its surroundings. There are hundreds of restaurants, selling popcorn and ice cream and various unidentifiable meats; there are cell-phone shops, gleaming department stores, and lines of young men and women holding placards advertising skills—translating, painting, cleaning earwax, walking dogs, bricklaying, personal training—that they will perform for extra cash. There are teeming masses of people, happy-looking, prosperous, loud, boisterous, well-dressed, well-coiffed, and well-fed, and all Chinese, flooding the square as though every day were a holiday and every moment fashioned for them alone, just to be enjoyed. Young policewomen weave their way through the crowds on roller skates, keeping a wary eye: and in the alleys there are riot police with dogs, just in case. All seems happy. All are watched.

Current figures attesting to Chongqing's size, growth, and standing are little short of stupendous. They are of a scale and sweep that Needham, work-

ing diligently among the ruins and devastation of sixty years ago, could never have imagined. Sixty years in the life of a city that, like Chongqing, is 1,500 years old might seem like nothing—London has changed dramatically in its past six decades, as have Paris, Cairo, Moscow, and Rome: yet in their essence these western cities are still today much the same as they always were, recognizable physically, familiar in the way they feel, sound, and smell. But this is manifestly not so for Chongqing: the same interval has brought about for this city changes few other urban centers in the world have ever experienced, creating a future world, part *Blade Runner*, part Shinjuku, part Dickensian London, that is profoundly unrecognizable, a place to take away one's breath.

The entire municipal entity that is known as Chongqing incorporates both the crowded inner city and an officially city-governed semirural hinterland, the two together occupying about the same area as Maine, a little bit less than Austria, slightly more than Tasmania. The population of 38 million puts it in a league not so much with other cities as with entire respectably sized countries—it is more populous than Iraq, for instance, bigger than Malaysia, bigger than Peru.

The arithmetic is relentless. Every day 800 babies are born in Chongqing and 500 people die—many of

them from emphysema, since the air quality is so bad, or by their own hand, so firmly have the new urban phenomena of angst and anomie taken hold. Thirteen hundred of the rural poor stream into the city each day to try to grab for themselves some of the riches that are so clearly being generated within. Thus some 1,600 new people every day are added to the population—the equivalent of all the people of Luxembourg welding themselves onto the city every year.

To accommodate these numbers new skyscrapers are being flung up with furious abandon. Developers rule. The old houses, the charming little slum lanes known as *hutongs*, Buddhist and Confucian temples, Soviet-style factories, schools built in the 1950s—all of them fall these days to the wreckers' ball and the bulldozers, and out of their ruins rise gleaming shopping arcades, office towers, and forests of apartment buildings, a ceaseless building frenzy.

There was a brief pause in the spring of 2007, when an engagingly defiant couple in Chongqing caused a fuss by refusing to move from their well-worn row house, the compensation offered being too miserly, they said. Their property then remained untouched for weeks, a solitary island of brick on its tower of foundation earth standing alone in the center of a vast pit of mud, with the developers of the new project—an office

building—waiting on the sidelines like vultures until the courts voted to tell the old owners to go. Inevitably, the courts did that—although the fate of what came to be known as the little "nail house"—since it looked like an unhammered nail, sticking up inconveniently and preventing all forward movement around it—became a worldwide sensation. It was pictured on the front page of the *New York Times* no less, and people said sagely that it demonstrated the battle for the rights of the Chinese individual over the rights of commerce, greed, and progress.

In the end, however symbolic the battle, the individuals lost and the developers won, and the march of Chinese progress resumed. Chongqing became a little bit more modern and its skyline a little bit more impressive; the nail house was forgotten; and the old couple, now seen as more querulous than engaging, took their money and moved to a new development somewhere out of town. An immense tower now stands where their cottage once squatted.

Chongqing is also a place of the most crushing poverty, a melancholy state of affairs made even more so when viewed against the knowledge that the city's economy grows by $14 million each day, and that there will be 150,000 square feet of new office floor space completed each evening. It is all the more painful when

it is seen—a crippled beggar here, a sickly ragamuffin there, a hollow-faced and hungry street musician waiting for coins—against a backdrop of lines of gleaming BMWs waiting in traffic jams, scores of construction cranes whirling against the skyline, elegant Thai restaurants jammed at lunchtime with young models wearing the *gipao*, nightclubs that breezily demand an entrance fee of $100 and are packed and heaving with local people until the small hours.

The dark side of Chongqing is very significant, too, if largely unseen. On the street corners, and noticeable everywhere if one chooses to look, are members of the ragged army of unemployed *ban-ban* men, freelance porters with thick bamboo shoulder poles at the ready, game for any job carrying anything, from a giant wardrobe to a sparrow in a birdcage. There are said to be 100,000 of these men, who will be lucky to earn a dollar a day—and the work ensures that they will die long before they are fifty. There are beggars, Dumpster divers, sickly-looking prostitutes, buskers, and an alarming number of children selling flowers— six-year-olds working late at night while their mothers complete their shifts as waitresses in the local hot-pot restaurants, or as bar girls in the dubious hostelries clustered down by the docks.

And of course there is the ever-present pollution, so

dreadful as to be barely credible. There are days when one wakes and cannot see a single building through the thick brownish yellow fog, and the sun even at its midday brightest is often just a vague coppery glare. Chongqing is one of the very few Chinese cities that have long been entirely devoid of bicycles—the steep mountainsides see to that—and so its streets are jam-packed with cars and annoying motorbikes that sound like insects, all of them belching gases into the foul air and making matters decidedly worse. The city produces 3,500 tons of rubbish every day, none of it recycled, all carted away to be buried in enormous holes dug on the outskirts, where garbage, landfill, and plastic sheeting are sandwiched together in a repeating pattern like lasagna until the void is full, the area is covered and seeded, and a golf course is built on top.

Joseph Needham and Lu Gwei-djen came back to Chongqing in 1982, and they spent an afternoon doddering about, looking in vain for the little house where he had lived forty years before. Even in the 1980s the city was in the throes of monumental change, and the lane where his embassy cottage was seemed to be no longer there; nor was it or the cottage to be found on any maps. The elderly pair left the place after an hour or so, muttering to themselves about the progress that had engulfed the old city.

They were more rueful than critical, though: Needham had always thought that China would turn out like this, sooner or later. It was simply a matter of time—and the Chongqing they saw in 1982 was for them a hint of the future he had predicted, rather than a keepsake of the past he mourned. Only its great river, rolling past so solemnly, with the steam tugs yelping and the long sea freighters moaning their way past the docks, presented them with a scene that was comfortingly unchanged.

Still, much else about China, even today, resists alteration. The rivers and the landscape will always be there, of course, to provide a backdrop, a climate, and indelible tracts of geology and topography. Some man-made creations have remained much the same over the years as well, no matter what prosperity may have done to China superficially.

The written language, for example—the very thing that so fascinated Needham when he first met Lu Gweidjen in 1937—remains intact, essentially unaltered from its origins more than 3,000 years ago. The cuisine is much the same—wheat noodles in the north, rice in the south, and chopsticks used throughout the country as they have been for thirty decades. The music, unique in register, timbre, tone, and rhythm, may bend

with the styles of the day, but a song from the Tang would be perfectly recognizable today, and even the most modern of Beijing operas is deeply influenced by the archaic and the traditional.

The physical appearance of the Han Chinese people survives, too. Maybe the Chinese are not so racially homogeneous as the Japanese or the Koreans. But as a continental people they remain distinct from many others—Americans, Russians, Europeans—in obviously belonging to one race, which is largely disinclined to dilution or change, and whose people much prefer (as the Tibetans can all too readily attest) periods of long-term ethnic stability and a cautious but relentless expansion.

Within this framework of changelessness there is also, entirely discernible, something else that resists change—something that can only be described as an *attitude*. It is a *Chinese state of mind*, and one which outsiders—and all who are non-Chinese are very much outsiders here—may occasionally find infuriating and insufferable, but which certainly exists, and at no great depth beneath the Chinese skin. It is an attitude, one might argue, that has been born of the very achievement which Joseph Needham attempted to catalog and describe in his series of books. It is an attitude of ineluctable and self-knowing Chinese *superiority*, and it

results from the antiquity and the longevity of the Chinese people's endeavors.

A list of Chinese endeavors—one version is to be found in Appendix I—illustrates how in almost every aspect of their lives, the people of old China seem to have been imbued with a deep desire for cultural improvement—for making life easier, better, and more truly civilized than it is anywhere else in the world. In that one sense the cumulative consequence of Needham's list is incontrovertible: by inventing a stirrup, a compass, a sheet of printing paper, a wheelbarrow, or a suspension bridge, the Chinese were always bent on making life steadily more comfortable for themselves.

Yet at the same time there was invariably a downside to this unending achievement—at least, so far as outsiders were concerned. The very fact that the Chinese achieved so much and so quickly (fifteen major inventions a century, Needham once calculated) appears to have created a sense of self-satisfaction and superiority—a kind of national smugness that led Emperor Qianlong to remark so famously to Lord Macartney, "We possess all things. . . . I have no use for your country's manufactures." And this self-congratulatory complacency, this hubris, inevitably contributed to the problems which caused the empire in time to flounder

and fall, and which led to the poverty and backwardness that characterized China for so long.

But China is neither poor nor backward anymore; and it is one of the ironies of history that the success of modern China derives in large measure from this very same sense—which aggrieved westerners like Lord Macartney might say was a peculiarly and infuriatingly *Chinese* sense—of self-certainty, of an unshakable confidence about its position at the center of the world. And all this certainty derives from the sturdy foundation of civilization that China built for itself so very long ago. Needham cataloged in the finest detail the robust antiquity of that civilization, illustrating the reason for all the self-confidence and self-assurance—the unique degree of self-knowledge that helps to make China *China*.

For silk, tea, bureaucracy, and the early invention of the compass as such do not make China what it is. What makes China different is the case-hardened sense of inner certitude that this vast array of invention has given to it.

Joseph Needham acknowledged and confirmed all this, and yet he fretted for decades over one single aspect of China's inventive history that seems at odds with the main story: the curious fact that after centuries

of scientific and technological creativity, everything in China suddenly ground to a halt.

The Chinese of the distant past—the ancient Chinese who lived before Europe's Christian era, the old Chinese living when Europe had its Dark Ages, and the medieval Chinese en masse of the twelfth and thirteenth European centuries—did essentially all the inventing. Come the sixteenth century, when the Renaissance was fully under way in Europe, the creative passions of China suddenly seemed to dry up; the energy began to ebb away and die.

Ever since that moment—AD 1500 is regarded as the approximate turning point—nearly all modern scientific advance transferred itself to where it remains today, becoming the nearly exclusive preserve of the West.

This intrigued Needham from the time he first discussed it with Lu Gwei-djen in Cambridge in the late 1930s. It haunted him so ceaselessly, and it pervaded so much of what he later wrote, that it was to become his memorializing eponym: it became known as the "Needham question."

Why, Needham asked—if the Chinese had been so technologically creative for so very long, and if they invented so much in antiquity—why did *modern* science develop not in China but in Europe and the West? Why

was China unable to hold on to its early advantage and creative edge? Why was there never a true industrial revolution in China? Why was there no firm embrace of capitalism? Why, by the eighteenth and nineteenth centuries, was China a nation known principally for being backward, hostile, and poor? How did the brilliant early nation evolve into Emerson's later "booby nation"?

Joseph Needham never fully worked out the answers. Perhaps it was because he was too close to the topic, seeing many trees but not enough forest. And though he makes an attempt at offering some answers in his final volume, he never seems fully convinced of his own arguments and never fully explains his reasons. It has been left to others to take up the challenge in his place.

The sum of their conclusions is that China, basically, *stopped trying.*

The Chinese could have achieved so much. Had they, for example, been equipped with "the European mania for tinkering and improving," as the sinologist Mark Elvin put it, they could probably have made an efficient spinning machine in the seventeenth century. It might have been trickier for them to make a steam engine, "but it should not have posed insuperable difficulties to a people who had been building double-acting

piston flame-throwers in the Song dynasty. The crucial point is that *nobody tried*."

Just why the Chinese stopped trying is a question sinologists will argue and debate until the Great Wall crumbles into sand. Some say it is because there was never a mercantile class in China to which clever young Chinese could aspire. For centuries the summit of a student's ambition was always to join the bureaucracy, rather than to enter a nonexistent world of competition and improvement—and absent this driving force, complacency ruled, incentive atrophied, and mediocrity became the norm.

Some others point to the immense size of a state that for long periods of its history was culturally unified into one vast, homogeneous bloc. Europe, by contrast, has always been packed with jostling and warring peoples and states who have collectively experienced hundreds of years of competing ambitions. If Italy needed to produce a better cannon than the French, then its technologists were cajoled into trying to do so. If British navigation equipment was more sophisticated than that invented by the Germans, it had a powerful advantage at sea, and Germany would have been bound to try to better it.

But there was no such intramural competition in ancient China, except perhaps during those periods when the country was racked by conflict and civil war.

More commonly the soldiers in Urumchi used the same weapons as those in Guangzhou, and a Manchu farmer used the same kind of plow as his opposite number in Kashgar. Plenty of technology existed abroad—but the Chinese had so little need to compete that there was no driving pressure to make things better and better over the centuries.

Others blame the endless climate of Chinese totalitarianism—whether imposed by emperors or by the Communists—that also acted to sap the will of the entrepreneur and the innovator. Étienne Balazs, a Hungarian scholar who was perhaps the greatest twentieth-century student of Chinese government, wrote once:

> It is the State that kills technological progress in China—not only in the sense that it nips in the bud anything that goes against or seems to go against its interests, but also by the customs implanted inexorably by the *raison d'État*. The atmosphere of routine, of traditionalism, and of immobility, which makes any innovation, or any initiative that is not commanded and sanctioned in advance, suspect, is unfavourable to the spirit of free inquiry.

Still others, in the way of academics, insist that the question itself is flawed—and that rather than asking

why modern science did *not* develop in China, one should be asking why it *did* develop in Europe. Asking for an explanation of a negative, they say, sets one on a pointless mission.

Whatever the reason, the phenomenon may be seen in due course as more of a hiatus, more of a hiccup in China's long history, than a permanent condition. Today's China has now so profoundly changed yet again—has become so rich, energetic, freewheeling, awesome, and spectacular—that the situation which engaged Joseph Needham and the small army of sinologists who have followed in his footsteps may itself well have come to a natural end.

It seems abundantly clear that creativity, true inventiveness, is starting to flow in China once again, with the new prosperity of the country. No longer is China the sinkhole of decay and desuetude that it was as recently as twenty years ago. Nowadays, in every field—in science and technology on the one hand, in literature and the plastic arts on the other—the new China is entering a time of intense activity and entrepreneurial energy.

If this continues to be the case, then perhaps some people will conclude that the "Needham question" never really needed to be asked in the first place. Perhaps China did dim its lights for three or four centu-

ries. Maybe the Qing dynasty, and the half century of turmoil that followed it, will never go down in China's history as a golden era, will never be another Tang dynasty or another Song dynasty. But for China that hardly matters: the country has so immensely long a history that a few hundred years when things were shabbier and duller than usual will, in the broad sweep of things, hardly signify. Scholars will continue to gnaw at the problem—but in that the intellectual dry spell now seems unlikely to spread into China's future, their quest may turn out to be quite fruitless.

A more interesting question will be this: how quickly and competently will the new China now manage to capitalize on its early, historical promise? Needham expressed the greatest confidence that in time it would. And he always knew that the great strength of his books lay precisely in their ability to catalog what that early promise was, and so to indicate to a fascinated world just where and how the new China and the new Chinese will now seek their best advantage. The books present a road map—to show where China has been, and where it is going next.

The third volume of *Science and Civilisation in China*—the first "real" volume, issued in 1959, in which Need-

ham begins to describe the early practical successes of Chinese science—is devoted to mathematics and, in large part, to China's age-old fascination with the stars. Needham quotes as his epigraph an eminent Viennese sinologist, Franz Kühnert, who wrote in 1884 that

> another reason why many Europeans consider the Chinese such barbarians is on account of the support they give to their Astronomers—people regarded by our civilized Western mortals as completely useless. Yet there they rank with heads of Departments and Secretaries of State. What frightful barbarism!

Maybe, say some people, Franz Kühnert made a mistake, meaning astrology rather than astronomy. But it doesn't really matter. The essential point remains the same. From antiquity, the Chinese were enthralled by the heavens and by heavenly phenomena, and they came to know, map, and chart the stars and planets in exceptional detail, centuries before any watchers of the skies in the West. The star charts that Needham was to study at the Dunhuang caves figure prominently in his studies: they show how obsessed China was with the universe, with the big picture, with the broad sweep of history and geography. The charts show that they were

a people who, as Needham had been advised to con-
duct himself so very long ago, were able to think big, to
"think in oceans."

There is a place in the far west of the country, the
desert, where today, and quite unexpectedly, one finds
the Chinese doing exactly that. It is a place to which
Needham traveled when he was on his way to the Dun-
huang caves, driving his wheezing truck along the old
Silk Road. These days the Silk Road is a modern four-
lane highway for much of its early length. But then after
1,000 miles or so the Great Wall, which runs beside it
on the northern side, begins to peter out. The road-
way narrows, then gets more rough. The Gobi Desert
sweeps to the road's very curb, and with jagged moun-
tain ranges to the south and the empty desert ahead,
the Silk Road can at this point suddenly look and feel
just as lonely as it did in the old days, when Arab cam-
eleers and Mediterranean traders would tread its path,
on their way to Medina and Antioch and the outside
world.

And then, two hours beyond Rewi Alley's village
of Shandan, one comes on a town that looks decidedly
neither of the desert nor of the far frontier.

It is called Jiuquan, and it is known in popular
legend as the place which grew the first rhubarb, and
as the town where an early Jesuit explorer, Bento de

Goes, was robbed and died destitute at the beginning of the seventeenth century. There is no evident history at Jiuquan now—no plaque celebrating rhubarb, no grave for Father Goes—but there is a town as modern and gleaming as any example of American exurbia. In the gray and gritty wilderness of the southern Gobi Desert there are suddenly scores of tall new buildings, each the experiment of some wildly adventurous young architect. There are wide boulevards, soaring over-passes, and, perched above acres of scrubby wasteland, construction cranes busily hauling up yet more apart-ment skyscrapers for a population that, to judge by the ghostly nature of the place, has evidently still to arrive.

Jiuquan is a space center—one of China's three most important launch pads for satellites, buried deep on the flat, sunny fringes of the Gobi Desert. It was first occupied in 1958—just thirteen years after Needham passed by.

In those ultrasecret times this was the site of the first tests of surface-to-surface missiles for the strategic ar-tillery divisions of the People's Liberation Army. The first nuclear-capable missile was sent into the strato-sphere from Jiuquan in 1966. These days the pad, far out of sight of the road, launches satellites commer-cially, claiming a 100 percent success rate. In October 2003 the people of Jiuquan sent Yang Lingwei, the first

Chinese astronaut, into space, and helped make him a national hero. For the first half century of its life Jiuquan was off-limits to all except its employees and party patrons; now, since Yang's fourteen successful orbits, the town and the launch center have been opened to tourists. But these tourists are Chinese nationals only. No foreigners may come. Not yet.

Joseph Needham would have wished to spend time at Jiuquan—if for no other reason than to see the sign that rises on a giant billboard at the entrance to the town. It is written in huge scarlet characters, and in enormous letters, in both Chinese and English. It proclaims a sentiment to which Needham readily subscribed, from the moment in 1948 when he first began writing his book, perhaps even from when he first went to China in 1943, perhaps from when he first met Lu Gwei-djen, and she introduced him to her language, in 1937.

The sign, simply and starkly, states: "Without Haste. Without Fear. We Conquer the World."

After its 5,000 years of patient waiting, watching, and learning, this is at last China's appointed time.

And Joseph Needham would not be dismayed by that; nor would he be the slightest bit surprised.

APPENDIX I: CHINESE INVENTIONS AND DISCOVERIES WITH DATES OF FIRST MENTION

The mere fact of seeing them listed brings home to one the astonishing inventiveness of the Chinese people.

—JOSEPH NEEDHAM, 1993, PUBLISHED 2004

From *Science and Civilisation in China,*
Volume VII, Part 2

Abacus	AD 190
Acupuncture	580 BC
Advisory vessels	3rd century BC
Air-conditioning fan	AD 180
Alcohol made from grain by a special fermentation process	15th century BC
Algorithm for extraction of square and cube roots	1st century AD
Anatomy	11th century AD
Anchor, nonfouling, stockless	1st century AD

Anemometer	3rd century AD
Antimalaria drugs	3rd century BC
Arcuballista, multiple-bolt	320 BC
Arcuballista, multiple-spring	5th century AD
Asbestos woven into cloth	3rd century BC
Astronomical clock drive	AD 120
Axial rudder	1st century AD
Ball bearings	2nd century BC
Balloon principle	2nd century BC
Bean curd	AD 100
Bell, pottery	3rd millennium BC
Bellows, double-acting piston-tuned bronze	6th century BC
Belt drive	5th century BC
Beriberi, recognition of	AD 1330
Blast furnace	3rd century BC
Blood, distinction between arterial and venous	2nd century BC
Blood, theory of circulation	2nd century BC
Boats and ships, paddle-wheel	AD 418
Bomb, cast-iron	AD 1221
Bomb, thrown from a trebuchet	AD 1161
Book, printed, first to be dated	AD 868
Book, scientific, printed	AD 847
Bookcase, vertical axis	AD 544
Bookworm repellent	
Bowl, bronze water-spouting	3rd century BC
Bread, steamed	

Bridges, releasable	4th century BC
Bridges, iron-chain suspension	6th century AD
Bridges, Li Chhun's segmental arch	AD 610
Bronze, high tin, for mirror production	
Bronze rainbow *teng* (camphor still)	1st century BC
Calipers	AD 9
Camera obscura, explanation of	AD 1086
"Cardan" suspension	140 BC
Cast iron	5th century BC
Cast iron—malleable	4th century BC
Cereals, preservation of stored	1st century BC
Chain drive	AD 976
Chess	4th century BC
Chimes, stone	9th century BC
Chopsticks	600 BC
Clocks, sand	AD 1370
Clocks, Su Sung's	AD 1088
Clockwork escapement of Yi Xing and Liang Lingzan	AD 725
Coal, as a fuel	1st century AD
Coal, dust, briquettes from	1st century AD
Coinage	9th century BC
Collapsible umbrella and other items	5th century BC
Comet tails, observation of direction of	AD 635
Compass, floating fish	AD 1027
Compass, magnetic needle	AD 1088
Compass, magnetic, used for navigation	AD 1111

Cooking pots, heat economy in	3rd millennium BC
Crank handle	1st century BC
Crop rotation	6th century BC
Crossbow	5th century BC
Crossbow, bronze triggers	300 BC
Crossbow, grid sight for	1st century AD
Crossbow, magazine	13th century AD
Dating of trees by number of rings	12th century AD
Decimal place value	13th century BC
Deep drilling and use of natural gas as fuel	2nd century BC
Diabetes, association with sweet and fatty foods	1st century BC
Dial and pointer	3rd century AD
Differential pressure	
Disease, diurnal rhythms in	2nd century BC
Diseases, deficiency	3rd century AD
Dishing of carriage wheel	
Distillation, of mercury	3rd century BC
Dominoes	AD 1120
Downdraft	1st century BC
Dragon kiln	2nd century AD
Draw loom	1st century AD
Drum carriage	110 BC
Diked/poldered fields	1st century BC
Ephedrine	2nd century AD
Equal temperament, mathematical formulation of	AD 1584

Equilibrium, theory of	4th century BC
Erosion and sedimentary deposition, knowledge of	AD 1070
Esculentist movement (edible plants for time of famine)	AD 1406
Ever-normal granary system	AD 9
Fertilizers	2nd century BC
Firecrackers	AD 290
Firelance	AD 950
Flame test	
Flamethrower (double-acting force pump for liquids)	AD 919
Folding chairs	3rd century AD
Free reed	1000 BC
Fumigation	7th century BC
Furnace, reverberatory	1st century BC
Gabions	3rd century BC
Gauges, rain and snow	AD 1247
Gear wheels, chevron-toothed	AD 50
Ginning machine, hand-cranked, and treadle	17th century AD
Gluten from wheat	AD 530
Gold, purple sheen	200 BC
Grafting	AD 806
Gravimetry	AD 712
Great Wall of China	3rd century BC
Grid technique, quantitative, used in cartography	AD 130

Guan xien system	240 BC
Gunpowder, formula for	9th century AD
Gunpowder, firecracker and fireworks	12th century AD
Gunpowder, government's department and monopoly on	14th century AD
Gunpowder, used in mining	Ming
Handcarts	681 BC
Handgun	AD 1128
Harness, breast strap	250 BC
Harness, collar	AD 477
Helicopter top	AD 320
High temperatures, firing of clay at	2nd millennium BC
Hodometer	110 BC
Holing-irons	AD 584
"Hot streak" test	AD 1596
Hygrometer	120 BC
Indeterminate analysis	4th century AD
Interconversion of longitudinal and rotary motion	AD 31
Kite	4th century BC
Knife, rotary disk, for cutting jade	12th century AD
Lacquer	13th century BC
Ladders, extendable	4th century BC
Leeboards and centerboards	AD 751
Lodestone, south-pointing ladle	AD 83
Magic mirrors	5th century AD
Magic squares	AD 190

Magnetic declination noted	AD 1040
Magnetic thermoremanence and induction	AD 1044
Magnetic variation observed	AD 1436
Magnetism, used in medicine	AD 970
Malt sugar, production of	1st millennium BC
Mangonel	4th century BC
Maps, relief	AD 1086
Maps, topographical	3rd century BC
Masts, multiple	3rd century AD
Matches (nonstriking)	AD 577
Melodic composition	AD 475
Metal amalgams used to fill cavities	AD 659
Metals, to oxides, burning of	5th century BC
Metals, densities of	3rd century AD
Mill, wagon	AD 340
Mills, edge-runner	200 BC
Mills, edge-runner, water-power applied	4th century AD
Mining, square sets for	5th century BC
Mining, differential pressure ventilation	5th century BC
Mirror with "light penetration surface"	11th century BC
Mold board	2nd century BC
Mountings, vertical and horizontal	1st century AD
Mouth-organs	9th century BC
Moxibustion	3rd century BC
Multiple-spindle silk-twisting frame	AD 1313
Negative numbers, operations using	1st century AD
Noodles (filamentous) including bread	AD 100

Nova, recorded observation of	13th century BC
Numerical equations of higher order, solution of	13th century AD
Oil lamps, economic	9th century AD
Paktong (cupronickel)	AD 230
Paper (invention of)	300 BC
Paper, money	9th century AD
Paper, toilet	AD 589
Paper, wall	16th century AD
Paper, wrapping	2nd century BC
Parachute principle	8th century AD
"Pascal" triangle of binomial coefficients	AD 1100
Pasteurization of wine	AD 1117
Pearl fishing conservancy	2nd century AD
Pearls in oysters, artificial induction of	AD 1086
"Pi," accurate estimation of	3rd century AD
Piece molding for casting bronze	2nd millenium BC
Place-value number system	13th century BC
Placenta used as source of estrogen	AD 725
Planispheres	AD 940
Plant protection, biological	AD 304
Planting in rows	3rd century BC
Playing cards	AD 969
Polar-equatorial coordinates	1st century BC
Polar-equatorial mounting of astronomical instruments	AD 1270
Porcelain	3rd century BC

Potassium, flame-test used in identifying	3rd century AD
Pound-lock canal gates	AD 984
Preservation of corpses	166 BC
Printing, bronze type	AD 1403
Printing, movable earthenware type on paper	11th century AD
Printing, multicolor	12th century AD
Printing, with woodblocks	7th century AD
Propeller oar, self-feathering	AD 100
Prospecting, biogeochemical	6th century AD
Prospecting, geological	4th century BC
Qin and *se* zither	
Recording of sun halves, parhelic specters, and Lowitz arcs	AD 635
Reel on fishing rod	3rd century AD
Refraction	4th century BC
Rocket arrow	13th century AD
Rocket arrow launchers	AD 1367
Rocket arrows, winged	AD 1360
Rockets, two-stage	AD 1360
Roller-harrows	AD 880
Rotary ballista	AD 240
Rotary fan	1st century BC
Sailing carriage	16th century AD
Sails, mat and batten	1st century AD
Salvage, underwater	AD 1064
Seawalls	AD 80

Seed, pretreatment of	1st century BC
Seed drill, multiple-tube	AD 155
"Seedling horse"	11th century AD
Seismograph	AD 132
Ships, construction principle of	1st century BC
Ships, paddle-wheel	5th century AD
Silk, earliest spinning of	2850 BC
Silk reeling machine	AD 1090
Silk warp doubling and throwing frame	10th century AD
Sluices	3rd century BC
Sluices, riffles added to	11th century AD
Smallpox, inoculation against	10th century AD
Smokescreens	AD 178
Snow crystals, six-sided symmetry of	135 BC
Soil science (ecology)	5th century BC
South-pointing carriage	AD 120
Soybean, fermented	200 BC
Sprouts, for medicinal and nutritional purposes	2nd century BC
Spindle wheel	5th century BC
Spindle wheel, multiple spindle	11th century AD
Spindle wheel, treadle-operated	1st century AD
Spooling frame	AD 1313
Square pallet chain pump	AD 186
Stalactites and stalagmites, records of	4th century BC
Stars, proper motion of	AD 725
Steamers, pottery	5th millenium BC

Steel production, cofusion method of	6th century AD
Sterilization by steaming	AD 980
Steroids, urinary	AD 1025
Still, Chinese-type	7th century AD
Stirrup	AD 300
Stringed instruments	9th century BC
Tea, as drink	2nd century BC
Thyroid treatment	1st century BC
Tian yuan algebraic notation	AD 1248
Tilt-hammer, water-powered spoon	AD 1145
Toothbrush	9th century AD
Trebuchet (simple)	4th century BC
Trip hammers	2nd century BC
Trip hammers, water-powered	AD 20
Vinegar	2nd century BC
Water mills, geared	3rd century AD
Waterwheel, horizontal	AD 31
Weather vane	120 BC
Wet copper method	11th century AD
Wheelbarrow, centrally mounted	30 BC
Wheelbarrow, with sails	6th century AD
Windlass, well	120 BC
Windows, revolving	5th century BC
Winnowing machine	1st century BC
Wu tong black palatinated copper	15th century AD
Zoetrope	AD 180

APPENDIX II: STATES, KINGDOMS, AND DYNASTIES OF CHINA (PRINCIPAL UNIFIED STATES IN CAPITALS)

	Xia Kingdom	2000–1520 BC
	Shang Kingdom	1520–1027 BC
	Western Zhou	1027–771 BC
	Eastern Zhou	771–221 BC
FIRST UNIFICATION	QIN	221–207 BC
	WESTERN HAN	206 BC–AD 9
	Xin interregnum	AD 9–25
	EASTERN HAN	AD 25–220
First partition	Three Kingdoms	AD 220–265
SECOND UNIFICATION	WESTERN JIN	AD 265–316
	EASTERN JIN	AD 317–420

Second partition	Southern Song	AD 420–478
	Southern Qi	AD 479–501
	Southern Liang	AD 502–556
	Southern Chen	AD 557–588
	Northern Wei	AD 386–553
	Eastern Wei	AD 534–549
	Western Wei	AD 535–557
	Northern Qi	AD 550–577
	Northern Zhou	AD 577–588
THIRD UNIFICATION	SUI	AD 580–618
	TANG	AD 618–907
Third partition	Five Dynasties	AD 907–960
	Ten Kingdoms	AD 907–979
FOURTH UNIFICATION	SONG	AD 960–1279
	LIAO	AD 916–1125
	WESTERN XIA	AD 1038–1227
	JIN (Tartar)	AD 1115–1234
	YUAN (Mongol)	AD 1279–1368
	MING	AD 1368–1644
	QING	AD 1644–1911
	REPUBLIC OF CHINA	AD 1911–1949
	PEOPLE'S REPUBLIC	AD 1949–PRESENT

ACKNOWLEDGMENTS

My first thanks must go to Mike McCabe of Salisbury, Connecticut, who in 1995 sold me my first book from the *Science and Civilisation in China* series. It was a secondhand copy of Volume IV, Part 3, *Civil Engineering and Nautics*; and the fact that his Lion's Head Books—a store now long defunct and still greatly missed—had the book in stock and priced very nearly affordably allowed me to snap it up on impulse, to read it outside in the store's parking lot, and to be rendered instantly enthralled by the sweep and scope of the mind behind it—the extraordinary mind of Joseph Needham.

The Needham Research Institute in Cambridge—where the ashes of Joseph, Dophi, and Gwei-djen, now commingled by time, lie beneath a tree in the gardens—is the present-day keeper of the flame, and I owe the very greatest of thanks to its director, Professor Christopher Cullen, who made me most welcome

and allowed me full access to all those papers and artifacts that did not happen to be held in the immense collection of Needham documents across Grange Road in the Cambridge University Library. John Moffett, the NRI's librarian, was also tirelessly helpful; both he and Dr. Cullen read the first draft of the typescript and each made many valuable suggestions. I hope that what appears now meets with their approval; should any errors of fact or judgment either remain or have crept in, they are my responsibility alone.

I wish to record my thanks also to the institute's longtime administrator, Sue Bennett, as well as to archivist Joanne Meek; former director Ho Peng Yoke; and Sir Geoffrey Lloyd, scholar-in-residence and one-time chairman of the East Asian History of Science Trust, which generally oversees the institute. Lady Pamela Youde, who is the widow of the fondly remembered governor of Hong Kong, Sir Edward Youde, and who succeeded Sir Geoffrey as chairman of the trustees, was also extremely supportive.

At Caius College, Cambridge, I wish to record my thanks to the Master—and former British ambassador to China—Sir Christopher Hum; to Yao Ling, the college president; to Iain Macpherson, a fellow of Caius, a longtime friend of Needham's and executor of his estate; the distinguished fellows Mikulas Teich,

Anthony Edwards, John Robson, and Jimmy Altham; the historian and archivist Christopher Brooke; and the college librarian Mark Statham. While I worked in Cambridge, the Master of Darwin College, Professor William Brown, placed rooms, as well as dining and research facilities, at my disposal, for which I am most grateful.

I should like to thank the unfailingly helpful staff of the Documents Room at the University Library, Cambridge; I was also ably assisted here by Helen Scales, a marine scientist and expert on seahorses, who took time out from her own work and very kindly sought out some much-needed Needham papers for me; and by my son Rupert, who helped as he so often does with my book projects, in this case by sedulously transcribing scores of pages from Needham's China diaries.

Staff at the China offices of the British Council were perhaps naturally predisposed to help a visitor who was researching the life and work of their most distinguished predecessor, who happened to be first-ever council officer based in the Middle Kingdom: So I was assisted generally by Michael O'Sullivan and Robin Rickard in the Beijing headquarters, and later and more especially, by David Foster and his delightful wife, Connie Lau, in Chongqing. The British consul-general at Chongqing, Tim Summers, together with his

wife, Lucy Chan, proved the most hospitable of guides. Peter Bloor in the council's London offices also looked up some valuable archival material for me.

Professor Gregory Blue, who teaches world history at the University of Victoria, British Columbia, served as Joseph Needham's personal assistant in Cambridge through most of the 1980s; the advice and assistance he offered to me was quite invaluable, as was his hospitality when I traveled to Victoria.

H. T. Huang, who was Needham's secretary and long-suffering travel companion during most of his wartime years in China, offered much help and advice from his present home in Alexandria, Virginia. His own long life—with its interludes as escapee, refugee, distinguished scholar, and science policy maker—could well be the subject of a fascinating book. I greatly enjoyed meeting him in Washington and listening to his reminiscences.

Red Chan, who teaches at the Centre for Translation Studies at the University of Warwick, accompanied me on all my journeys throughout China, acting most ably as translator and general fixer. I am greatly indebted to her.

I should also like to record my gratitude to the following, who had specific knowledge of aspects of Needham's life, or of China, and who were happy to

share their knowledge or advice: Paul Aiello (Hong Kong), Robert Bickers (Bristol), Anne-Marie Brady (Canterbury, New Zealand), Francesca Bray (Edinburgh), Tom Buchanan (Oxford), Daniel Burton-Rose (Berkeley), Eric Danielson (Shanghai), Alan Donald (London), Ryan Dunch (Alberta), Gisele Edwards (London), Stephen Endicott (Toronto), Daniel Fertig (Hong Kong), Stephen Forge (Oundle), Edward Hammond (The Sunshine Project, Austin, Texas), May Holdsworth (London), Elisabeth Hsu (Oxford), John Israel (Kunming), Ron Knapp (New Paltz, NY), William Mackay (Hong Kong), Martin Merz (Hong Kong), George Ngu (Fuzhou), Peter Nolan (Cambridge), Michael Ravnitzky (New York), Priscilla Roberts (Hong Kong), Donald Saari (Irvine, California), Elinor Shaffer (London), Michael Sharp (Cambridge), Nathan Sivin (Philadelphia), Martha Smalley (Yale), Neil Smith (Dulwich School), Rob Stallard (SACU), Michael Sullivan (Oxford), Tony Sweeting (Hong Kong), Michael Szonyi (Harvard), David Tang (Hong Kong), Robert Temple (London), Dan Waters (Hong Kong), Jocelyn Wilk (Columbia U.), George Wilson (Bloomington, Indiana), Frances Wood (British Library), Lilian Wu (Hong Kong).

My agents—especially Suzanne Gluck of the William Morris Agency in New York, with the able

assistance of Georgia Cool and Sarah Ceglarski, and together with the help of Eugenie Furniss of the William Morris office in London, championed this book from the moment they first saw it, and did much to keep my spirits high through any trying times during the writing and editing process. Sophie Purdy kindly read the first rough draft of the manuscript and identified the more egregious of the *longueurs*, arguing forcefully for their excision or distillation.

In Henry Ferris I am fortunate to have one of the most robust and scrupulous editors in New York, and he managed, with just the right mix of courtesy and firmness, the delicate business of trimming and adjusting the manuscript that I first submitted. His enduring assistant, associate editor Peter Hubbard, helped also with the task of acquiring illustrations and maps: between the two of them the text was whipped into something infinitely more fit for publication than when it first arrived. Mary Mount also added the very considerable benefit of her perspective from London, and made countless suggestions for improving the text, almost all of which I was eventually very content to accept. The book drew great benefit from the work that these three performed upon it; my gratitude to them is boundless.

SW

SUGGESTED FURTHER READING

The bulk of Joseph Needham's personal papers are held at the University Library, Cambridge, where all have been cataloged and most are available for inspection. A few personal files remain closed at the discretion of the librarian until 2045. A small number of documents relating specifically to college business are held in the archives of Gonville and Caius College. Documents relating to Needham's involvement in the Korean War are held in the library of the Imperial War Museum, London. Papers relating to the creation of the series *Science and Civilisation in China* are held at the Needham Research Institute, Cambridge. Cataloging was completed in July 2007. Dorothy Needham's personal papers are held by Girton College, Cambridge.

Beaton, Cecil. *Far East.* London: Batsford, 1945.

Bergsten, C. Fred, et al. *China: The Balance Sheet: What the World Needs to Know Now about the Emerging Superpower.* Center for Strategic and International Studies and Institute for International Economics. New York: PublicAffairs, 2006.

Brady, Anne-Marie. *Friend of China: The Myth of Rewi Alley.* London: RoutledgeCurzon, 2003.

————. *Making the Foreign Serve China: Managing Foreigners in the People's Republic.* Lanham, MD: Rowman and Littlefield, 2003.

Brooke, Christopher N. L. *A History of the University of Cambridge, Vol. 4, 1870–1990.* Cambridge: Cambridge University Press, 1993.

Broomhall, A. J. *Strong Tower.* London: China Inland Mission, 1947.

Brunero, Donna. *Britain's Imperial Cornerstone in China: The Chinese Maritime Customs Service, 1854–1949.* London: Routledge, 2006.

Bukharin, N. I., et al. *Science at the Crossroads: Papers from the Second International Congress of the History of Science and Technology 1931.* Foreword, Joseph Needham. London: Frank Cass, 1971.

The Caian: The Annual Record of the Gonville and Caius College, Cambridge, 1 October 2003–30

September 2004. Cambridge: Gonville and Caius College, 2004.

Chambers, James. *The Devil's Horsemen: The Mongol Invasion of Europe.* London: Weidenfeld and Nicolson, 1979.

Ch'ang Chiang Pilot, 3rd ed. London: Royal Navy Hydrographic Department, 1954.

Chang, Gordon G. *Nuclear Showdown: North Korea Takes On the World.* New York: Random House, 2006.

Chang, Iris. *Thread of the Silkworm.* New York: Basic Books, 1995.

————. *The Rape of Nanking: The Forgotten Holocaust of World War II.* New York: Basic Books, 1997.

Chang, Jung. *Qian Zhongshu: Fortress Besieged.* London: Penguin, 1979.

Chang, Jung, and Jon Halliday. *Mao: The Unknown Story.* New York: Knopf, 2005.

Chang, Raymond, and Margaret Scrogin Chang. *Speaking of Chinese: A Cultural History of the Chinese Language.* New York: Norton, 1978.

Chen, Guidi, and Wu Chuntao. *Will the Boat Sink the Water? The Life of China's Peasants.* New York: PublicAffairs, 2006.

Cheng, Pei-kai, et al. *The Search for Modern China: A Documentary Collection*. New York: Norton, 1999.

Chow, Tse-tung. *The May Fourth Movement; Intellectual Revolution in Modern China*. Stanford, CA: Stanford University Press, 1960.

Clegg, Arthur. *Aid China 1937–1949: A Memoir of a Forgotten Campaign*. Beijing: New World, 1989.

Collis, Maurice. *Foreign Mud: An Account of the Opium War*. London: Faber and Faber, 1946.

————. *The Great Within*. Freeport, NY: Books for Libraries, 1970.

Colquhoun, Archibald R. *China in Transformation*. New York: Harper, 1898.

Cronin, Vincent. *The Wise Man from the West*. London: Rupert Hart-Davis, 1955.

Crow, Carl. *Handbook for China*. Hong Kong: Oxford University Press, 1984.

Cullen, Christopher. *The Dragon's Ascent: The Civilisation the World Forgot*. Hong Kong: PCCW IMS, 2001.

Dalley, Jan. *The Black Hole: Money, Myth, and Empire*. London: Penguin, 2006.

Dawson, Raymond. *The History of Human Society: Imperial China*, ed. J. H. Plumb. London: Hutchison, 1972.

Dyer Ball, J. *Things Chinese*. Hong Kong: Oxford University Press, 1982.

Elcoat, Geoffrey. *A Brief History of the Vicars of Thaxted*. Thaxted, UK: Elcoat, 1999.

Elvin, Mark. *The Retreat of the Elephants: An Environmental History of China*. New Haven, CT: Yale University Press, 2004.

Endicott, Stephen, and Edward Hagerman. *The United States and Biological Warfare: Secrets from the Early Cold War and Korea*. Bloomington: Indiana University Press, 1998.

Epstein, Israel. *From Opium War to Liberation*. Peking: New World, 1956.

Fairbank, John K., and Denis Twitchett, eds. *The Cambridge History of China*, 15 vols. Cambridge: Cambridge University Press, 1986– .

Fei, Hsiao-tung. *China's Gentry: Essays on Rural-Urban Relations*, ed. Margaret Park Redfield. Chicago, IL: University of Chicago Press, 1953.

Feifer, George. *Breaking Open Japan: Commodore Perry, Lord Abe, and American Imperialism in 1853*. New York: Smithsonian Books and HarperCollins, 2006.

Fenby, Jonathan. *Generalissimo: Chiang Kai-shek and the China He Lost*. London: Free Press, 2003.

Feuerwerker, Albert. *China's Early Industrialization:*

Sheng Hsuan-huai (1844–1916) and Mandarin Enterprise. New York: Atheneum, 1970 (1958).

Fleming, Peter. *The Siege at Peking.* London: Rupert Hart-Davis, 1959.

Friedel, Robert. *A Culture of Improvement: Technology and the Western Millennium.* Cambridge, MA: MIT Press, 2007.

Garrett, Martin. *Cambridge: A Cultural and Literary History.* Oxford: Signal, 2004.

Girardot, Norman J. *The Victorian Translation of China: James Legge's Oriental Pilgrimage.* Berkeley: University of California Press, 2002.

Goldsmith, Maurice. *Joseph Needham: Twentieth-Century Renaissance Man.* Paris: UNESCO, 1995.

Goullart, Peter. *Princes of the Black Bone: Life in the Tibetan Borderland.* London: John Murray, 1959.

Gribbin, John. *History of Western Science, 1543–2001.* London: Folio Society, 2006.

Guest, Captain Freddie. *Escape from the Bloodied Sun.* London: Jarrolds, 1956.

Habib, S. Irfan, and Dhruv Raina. *Situating the History of Science: Dialogues with Joseph Needham.* New Delhi: Oxford University Press, 1999.

Hahn, Emily. *China to Me.* Boston, MA: Beacon, 1944.

Han, Suyin. *Destination Chungking*. London: Mayflower, 1969.

Harman, Peter, and Simon Mitton, eds. *Cambridge Scientific Minds*. Cambridge: Cambridge University Press, 2002.

Herzog, Maurice. *Annapurna: Conquest of the First 8000-Metre Peak*. London: Jonathan Cape and Book Society, 1952.

Hibbard, Peter. *The Bund: Shanghai*. Hong Kong: Odyssey Books and Guides, 2007.

Hinton, William. *Fanshen: A Documentary of Revolution in a Chinese Village*. Berkeley: University of California Press, 1966.

Ho, Peng Yoke. *Reminiscence of a Roving Scholar: Science, Humanities, and Joseph Needham*. Singapore: World Scientific, 2005.

Hogg, George. *I See a New China*. Boston, MA: Little, Brown, 1944.

"Holorenshaw, Henry" (pen name for Joseph Needham). *The Levellers and the English Revolution*. Foreword, Joseph Needham. London: Victor Gollancz, 1939.

Hook, Brian, ed. *The Cambridge Encyclopedia of China*. Cambridge: Cambridge University Press, 1982.

Hsiung, James C., and Steven I. Levine, eds. *China's Bitter Victory: The War with Japan 1937–1945.* Armonk, NY: Sharpe, 1992.

Huang, Ray. *1587: A Year of No Significance—The Ming Dynasty in Decline.* New Haven, CT: Yale University Press, 1981.

———. *China: A Macro History.* Armonk, NY: Sharpe, 1997.

Ingram, Jay. *The Velocity of Honey: And More Science of Everyday Life.* New York: Thunder's Mouth, 2003.

Israel, John. *Student Nationalism in China, 1927–1937.* Stanford, CA: Stanford University Press, 1966.

———. *Lianda: A Chinese University in War and Revolution.* Stanford, CA: Stanford University Press, 1998.

Jinshi, Fan. *Dunhuang Grottoes.* Beijing: China Travel and Tourism Press, 2004.

Johnson, Gordon. *University Politics: F. M. Cornford's Cambridge and His Advice to the Young Academic Politician.* Cambridge: Cambridge University Press, 1994.

Kahn, E. J., Jr. *The China Hands: America's Foreign Service Officers and What Befell Them.* New York: Viking, 1975.

Keynes, Margaret. *A House by the River: Newnham Grange to Darwin College.* Cambridge: privately printed, 1984.

Kynge, James. *China Shakes the World: A Titan's Rise and Troubled Future—and the Challenge for America.* New York: Houghton Mifflin, 2006.

Landes, David. *The Wealth and Poverty of Nations.* London: Abacus, 1998.

Lee, Sherman E. *A History of Far Eastern Art,* 5th ed. New York: Abrams, 1994.

Legge, James. *The Chinese Classics,* vol. 1. Hong Kong: Lane, Crawford, 1861.

Levathes, Louise. *When China Ruled the Seas: The Treasure Fleet of the Dragon Throne, 1405–1433.* New York: Oxford University Press, 1994.

Li, Guohao, et al. *Explorations in the History of Science and Technology in China: Compiled in Honour of the Eightieth Birthday of Dr. Joseph Needham.* Shanghai: Shanghai Chinese Classics, 1982.

Lifton, Robert Jay. *Thought Reform and the Psychology of Totalism: A Study of Brainwashing in China.* Chapel Hill: University of North Carolina Press, 1989.

Lin, Yutang. *Moment in Peking: A Novel of Contemporary Chinese Life.* London: William Heinemann, 1940.

Lindqvist, Cecilia. *China: Empire of Living Symbols.* Reading, MA: Addison-Wesley, 1989.

Low, Morris F., ed. "Beyond Joseph Needham: Science, Technology, and Medicine in East and Southeast Asia." *Osiris*, vol. 13. Chicago, IL: University of Chicago Press, 1998.

Lu, Gwei-djen, and Joseph Needham. *Celestial Lancets: A History and Rationale of Acupuncture and Moxa.* Cambridge: Cambridge University Press, 1980.

Lyons, Thomas P. *China Maritime Customs and China's Trade Statistics 1859–1948.* Trumansburg, NY: Willow Creek, 2003.

Macartney, Lord [George]. *An Embassy to China: Being the Journal Kept by Lord Macartney during His Embassy to the Emperor Ch'ien-lung 1793–1794*, ed. J. L. Cranmer-Byng. London: Folio Society, 2004 (1962).

Macfarquhar, Roderick, and Michael Schoenhals. *Mao's Last Revolution.* Cambridge, MA: Belknap Press of Harvard University Press, 2006.

Maclure, Jan. *Escape to Chungking.* London: Oxford University Press, 1942.

Mateer, Rev. C. W. *A Course of Mandarin Lessons, Based on Idiom.* Shanghai: Presbyterian Mission Press, 1922.

Mayor, Adrienne. *Greek Fire, Poison Arrows, and Scorpion Bombs: Biological and Chemical Warfare in the Ancient World.* Woodstock, NY: Overlook, 2003.

McAleavy, Henry. *The Modern History of China.* London: Weidenfeld and Nicolson, 1967.

McCune, Shannon. *The Ryukyu Islands.* Newton Abbot: David and Charles, 1975.

Mendelssohn, Kurt. *In China Now.* London: Paul Hamlyn, 1969.

Miyazaki, Ichisada. *China's Examination Hell: The Civil Service Examinations of Imperial China.* New York: Weatherhill, 1976.

Mukherjee, Sushil Kumar, and Amitabha Ghosh, eds. *The Life and Works of Joseph Needham.* Calcutta: Asiatic Society, 1997.

Needham, Joseph. *Time: The Refreshing River (Essays and Addresses, 1932–1942).* London: George Allen and Unwin, 1943.

———. *Science and Civilisation in China.* 24 vols. Cambridge: Cambridge University Press, 1954–2004.

———. *The Grand Titration: Science and Society in East and West.* London: George Allen and Unwin, 1969.

————. *Within the Four Seas: The Dialogue of East and West.* London: George Allen and Unwin, 1969.

Needham, Joseph, and Dorothy Needham, eds. *Science Outpost: Papers of the Sino-British Science Co-Operation Office (British Council Scientific Office in China) 1942–1946.* London: Pilot, 1948.

Owen, Bernie, and Raynor Shaw. *Hong Kong Landscapes: Along the MacLehose Trail.* Hong Kong: Geotrails Society, 2001.

Pan, Lynn. *China's Sorrow: Journeys around the Yellow River.* London: Century, 1985.

Payne, Robert. *Chinese Diaries 1941–1946.* New York: Weybright and Talley, 1945.

————. *Chungking Diary.* London: William Heinemann, 1945.

Pomfret, John. *Chinese Lessons: Five Classmates and the Story of a New China.* New York: Holt, 2006.

Powell, Timothy E., and Peter Harper, eds. *Catalogues and Supplementary Catalogues of the Papers and Correspondence of Joseph Needham CH FRS (1900–1995).* Bath: National Cataloguing Unit for the Archives of Contemporary Scientists, University of Bath, 1999.

Preston, Diana. *The Boxer Rebellion: The Dramatic Story of China's War on Foreigners That Shook the*

World in the Summer of 1900. New York: Walker, 2000.

Price, Ruth. *The Lives of Agnes Smedley.* New York: Oxford University Press, 2005.

Raverat, Gwen. *Period Piece: The Cambridge Childhood of Darwin's Granddaughter.* London: Faber and Faber, 1952.

Redding, Gordon. *The Spirit of Chinese Capitalism.* Berlin: Walter de Gruyter, 1990.

Ronan, Colin A. *The Shorter Science and Civilisation in China: An Abridgement of Joseph Needham's Original Text.* Cambridge: Cambridge University Press, 1981.

The Seige of the Peking Embassy, 1900: Sir Claude MacDonald's Report on the Boxer Rebellion. Uncovered Editions series. Tim Coates, series ed. London: Stationery Office, 2000.

Serres, Michael, ed. *A History of Scientific Thought.* Oxford: Blackwell, 1995.

Shaw, Raynor. *Three Gorges of the Yangtze River: Chongqing to Wuhan.* Hong Kong: Odyssey Books and Guides, 2007.

Simon, W. *How to Study and Write Chinese Characters.* London: Percy Lund, Humphries, 1959.

Snow, Edgar. *Red Star over China.* New York: Random House, 1938.

———. *The Other Side of the River: Red China Today.* London: Victor Gollancz, 1963.

Spalding, Frances. *Gwen Raverat: Friends, Family, and Affections.* London: Pimlico, 2004.

Spence, Jonathan D. *To Change China.* New York: Penguin, 1969.

———. *The Gate of Heavenly Peace: The Chinese and Their Revolution, 1895–1980.* London: Faber and Faber, 1981.

———. *The Search for Modern China.* London: Hutchinson, 1990.

———. *The Chan's Great Continent: China in Western Minds.* New York: Norton, 1998.

———. *Treason by the Book.* New York: Viking, 2001.

Stilwell, Joseph W. *The Stilwell Papers*, ed. Theodore H. White. New York: William Sloane, 1948.

Sun, Shuyun. *The Long March: The True History of China's Founding Myth.* New York: Doubleday, 2006.

Temple, Robert. *The Genius of China: 3,000 Years of Science, Discovery, and Invention.* Introduction, Joseph Needham. London: André Deutsch, 2007 (1986).

Tennien, Mark. *Chungking Listening Post.* New York: Creative Age, 1945.

Teresi, Dick. *Lost Discoveries: The Ancient Roots of Modern Science, from the Babylonians to the Maya.* New York: Simon and Schuster, 2002.

Thai, Vinh. *Ancestral Voices.* London: Collins, 1956.

Tokayer, Marvin, and Mary Swartz. *The Fugu Plan: The Untold Story of the Japanese and the Jews during World War II.* New York: Paddington, 1979.

Tuchman, Barbara W. *Sand against the Wind: Stilwell and the American Experience in China, 1911–1945.* London: Macmillan, 1971.

Tyson Li, Laura. *Madame Chiang Kai-shek: China's Eternal First Lady.* New York: Atlantic Monthly Press, 2006.

Vincent, Irene Vongehr. *The Sacred Oasis: Caves of the Thousand Buddahs Tun Huang.* London: Faber and Faber, 1953.

Waley, Arthur. *Three Ways of Thought in Ancient China.* Stanford, CA: Stanford University Press, 1982 (1939).

———. *The Opium War through Chinese Eyes.* London: George Allen and Unwin, 1958.

Waley-Cohen, Joanna. *The Sextants of Beijing: Global Currents in Chinese History.* New York: Norton, 1999.

Walker, Annabel. *Aurel Stein: Pioneer of the Silk Road.* London: John Murray, 1995.

Watson, Peter. *A Terrible Beauty: The People and Ideas That Shaped the Modern Mind*. London: Phoenix, 2001.

Weber, Max. *The Religion of China: Confucianism and Taoism*. New York: Free Press, 1951.

Webster, Donovan. *The Burma Road: The Epic Story of the China-Burma-India Theater in World War II*. New York: HarperCollins, 2003.

Wei, Peh-T'i, Betty. *Shanghai: Crucible of Modern China*. Hong Kong: Oxford University Press, 1987.

Wenley, A.G., and John A. Pope. *China: Smithsonian Institution War Background Studies*, no. 20. Washington, DC: Smithsonian Institution, 1944.

Werskey, Gary. *The Visible College: The Collective Biography of British Scientific Socialists of the 1930s*. New York: Holt, Rinehart and Winston, 1978.

White, Theodore H., and Annalee Jacoby. *Thunder Out of China*. New York: William Sloane, 1946.

Whitfield, Roderick, et al. *Cave Temples of Dunhuang: Art and History on the Silk Road*. London: British Library, 2000.

Whitfield, Susan. *The Silk Road: Trade, Travel, War, and Faith*. London: British Library, 2004.

Whitfield, Susan, and Ursula Sims-Williams, eds. *The Silk Road: Trade, Travel, War, and Faith*. Chicago, IL: Serindia, 2004.

Wieger, Dr. L., S.J. *Chinese Characters: Their Origin, Etymology, History, Classification, and Signification—A Thorough Study from Chinese Documents.* Ho-kien-fu: Catholic Mission Press, 1927.

Wilkinson, Endymion. *Chinese History: A Manual.* Cambridge, MA: Harvard University Press, 2000.

Wilson, Dick. *The Long March 1935: The Epic of Chinese Communism's Survival.* New York: Viking, 1971.

———. *When Tigers Fight: The Story of the Sino-Japanese War, 1937–1945.* New York: Penguin, 1982.

Wood, Frances. *A Companion to China.* London: Weidenfeld and Nicolson, 1988.

———. *No Dogs and Not Many Chinese: Treaty Port Life in China 1843–1943.* London: John Murray, 1998.

———. *The Silk Road: Two Thousand Years in the Heart of Asia.* London: British Library, 2003.

Wright, Arthur F. *Buddhism in Chinese History.* Stanford, CA: Stanford University Press, 1959.